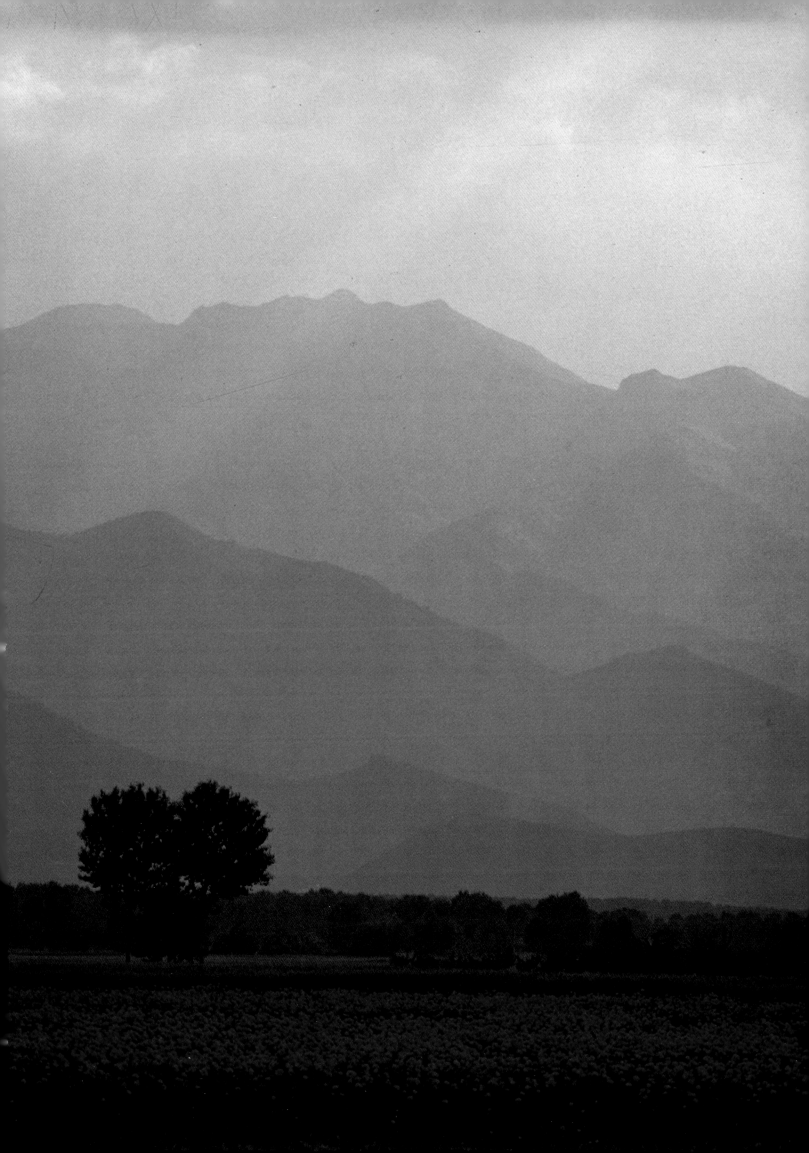

Page 1: Near Philippi in Green Macedonia, the Pangaion Mountains loom over a valley carpeted in summertime with fields of poppies.

Pages 4-5: This peaceful farm in Evesham, England, photographed in December 1955, was the site of one of Britain's historic battles—the bloody, two-hour clash in August 1256 in which the forces of Prince Edward destroyed those of the rebellious Baron Simon de Montfort.

ON ASSIGNMENT: DMITRI KESSEL, LIFE PHOTOGRAPHER

PHOTOGRAPHS AND TEXT BY DMITRI KESSEL

FOREWORD BY EDWARD K. THOMPSON

HARRY N. ABRAMS, INC. PUBLISHERS, NEW YORK

Project Director: Robert Morton
Editor: Beverly Fazio
Designers: Peter Bradford, Ray Komai, and Joyce Rothschild

Library of Congress Cataloging in Publication Data

Kessel, Dmitri.
On assignment.

1. Kessel, Dmitri. 2. Photography, Journalistic.
3. News photographers—United States—Biography.
I. Title.
TR140.K43A36 1985 770'.92'4 [B] 85-5972
ISBN 0-8109-1404-2

**FOR MY WIFE, SHIRLEY,
AND FOR LEE AND ED THOMPSON**

Acknowledgments: My special thanks to Time-Life Editorial Services, especially to those in Picture Collection who gave so generously of their time to pull thousands of photographs from the files for my selection. Also, I thank my friends in Time-Life Photo Lab for making black-and-white and color prints.

I am grateful to Beverly Fazio of Harry N. Abrams, Inc., for her adept editing of my text.

My friend Milton Orshefsky helped me to organize and correct my text, to smooth over rough spots, and to add that professional touch.

My warmest thanks go to Nancy and Louis Hector for their encouragement and for keeping me under their roof for months while I was working on this book in New York.

FOREWORD BY
EDWARD K. THOMPSON

On *Assignment* reveals to the general public what editors and fellow craftsmen know well—Dmitri Kessel is a giant among photographic giants. He shares generously his vast technical knowledge with other photographers, although there is no way they can assimilate his mastery of lighting or his eye for beauty and spectacle. Intuitively he organizes images so that every frame he exposes seems to be perfectly composed. As for editors, it is my observation that he makes them look good. They are lucky to have him as their ambassador to the outside world.

I have known Dmitri—sometimes as a colleague, often as a boss, always as a friend—since 1937, when he returned from a stint in Czechoslovakia with his first LIFE pictures. A taste of journalistic photography had convinced him that this was a way of life he much preferred to industrial work, which he had been doing since 1934, and at which he was already a great success. Born in the rural Ukraine, he was on his way to becoming a man of the world.

The Kessel world, shared by millions of magazine readers, is vast. Geographically it ascends from the deep gorges of the Yangtze to the soaring peaks of the Andes. In mood it rises from the subsistence level of life in smelting plants in central Africa to the exaltation of great art in splendid cathedrals, from the grimness of war to the jubilation of royal weddings.

Dmitri was at home all over the world, though he never lost track of his Ukrainian roots. By 1937 those of his family who were coming had all made it to America, where they kept in close contact; they continued to call each other by the diminutives of their names—Manya, Minya, Milya, Polya, and Mitya (Dmitri).

Neither did his accent ever prevent Dmitri from communicating with anyone. This was demonstrated to me when we covered some United States army maneuvers in Louisiana in 1941. The war games were realistic enough so that even we correspondents could be "captured." On one occasion Dmitri's conversation rendered our "captors" so bemused that we were able to "escape" in the confusion.

And the maneuvers taught me another thing: that there *is* one thing Dmitri will not do to get a story. Correspondents participating in the games had to sense where the next important skirmish would take place. Acting on a rumor one night, Dmitri and I set off in a rented car to search for a mechanized cavalry division presumably approaching from the Texas border. I was dead tired from chasing around all day, so I pointed out that our map indicated a straight road ahead and offered to teach Dmitri to drive well enough to spell me for a while. He refused. Somehow we found our way, bleary-eyed, to the division camp by dawn. There we saw the commanding general, shaving in the mirror of his jeep—and going nowhere. Our all-night trip wasted, Dmitri felt so completely vindicated in his refusal to learn to drive that he remains today strictly an automobile passenger.

The maneuvers were not Dmitri's first photographic encounter with military subjects. Earlier that year, on assignment for a special Fourth of July defense issue I was preparing, he had turned in what I considered flawless coverage. For that same issue, another photographer, this one assigned to General Patton's armored division, had produced pictures I thought were dull. I simply laid Dmitri's color transparencies on a light table in front of him and pointed. The other photographer left without a word and, without a trace of resentment, proceeded to reshoot his story.

The Kessel treatment brings out hidden beauty in subjects others consider banal while it enhances those that are spectacular in themselves. In periodicals or books his photographs attain lasting value, allowing the reader to savor them at leisure. Editors do not assign photographers to take pictures for the ages, but superior craftsmen like Dmitri Kessel do just that—out of seemingly ephemeral situations.

Take the story he did on the Yangtze. The assignment started out as a first look, after

years of Japanese occupation, at a great river and its ancient civilization. An article by John Hersey—Dmitri's idea—was to complement the pictures. But those were unsettled times in China—and in the offices of Time Inc., where Henry R. Luce's pro–Chiang Kai-shek China policy was causing a deep division. When the Yangtze pictures and text were delivered to LIFE, Luce, hurt and angry over the refusal of Hersey and others to support him, would not look at anything Hersey reported out of China. I assured Dmitri, "the pictures are great, they will run," but I was not yet managing editor, and the conventional wisdom on the staff was: "The boss is against it, the story is dead." And so it seemed.

I could not, of course, have anticipated that after years in the files Dmitri's Yangtze pictures would again have demonstrable current value. In 1956 John Hersey called to tell me that he had written a short novel based on his earlier experiences on the river, *A Single Pebble.* Since he had been on a LIFE expense account at the time, he felt conscience-bound to let us bid on magazine rights. There was a catch, though: every word would have to be used. I couldn't clear enough space, but I proposed to Hersey that we use the Kessel Yangtze material with quotations from the novel as captions. It would be a sort of book review with pictures. There wasn't a word of dissent from Luce, and the story ran in LIFE's June 11, 1956, issue. Hersey's comment later was, "It's nice to be working with pros again." The photographs, as fresh as when first made, constitute Chapter Five of this book.

A mark of Dmitri's technical mastery of photography is his high reputation as a master art copyist. Admittedly, there are more Kessel contributions visible in his pictures of people and places than in his reproductions of paintings. There is more value, however, in his copies than Dmitri admits to finding. In fact, it is really an understatement to call them only copies. He brought genuine creativity to this aspect of his work as to all others, creativity that is perhaps best evidenced by his photographs of Tintoretto's huge, be-

grimed paintings of the life of Christ that hang in the Scuola di San Rocca in Venice. Dmitri discovered that by the use of Polaroid filters he could reproduce brilliant colors that could no longer be detected with the naked eye. That the colors in his pictures were the same as when Tintoretto originally painted them was proved by the curator, who produced a small portion of the frieze that had been folded under, protected from centuries of dust, light, and atmosphere. Dmitri's photographs of the paintings resulted in a twenty-page article in a Christmas issue.

Kessel's skill as a photographer is enhanced by his effectiveness as an arranger and a diplomat. His broad smile lighting up his wide, Slavic features, Dmitri's charm is irresistible to both the lowly and the great—and to those who consider themselves great. He was quietly tolerant, for example, of the Shah of Iran's pretensions, even though he knew the shah to be of humble origins. (I, meanwhile, was silently fuming in New York over the chief of protocol's attempts to deify his boss by capitalizing "He" and "Him" in letters.) Dmitri's disarming manner won the shah over and allowed him to get pictures unmatched by any other photographer.

Wherever he travels, Dmitri makes friends for himself. Now I propose that you join other of his friends in enjoying and being uplifted by his photographs, and by his personal history. I won't attempt any further specific guidance: as an editor I would never allow caption writers to say, "this pretty girl" or "this great picture"—these qualities should be obvious to the reader. I will warn you, though, that the more Dmitri can do for *you,* the more he will cherish you as a friend—as long as you don't expect him to chauffeur you on an all-night drive.

Edward K. Thompson
Managing Editor and Editor of LIFE, 1949–67;
Editor and Publisher of *Smithsonian,* 1968–80

8

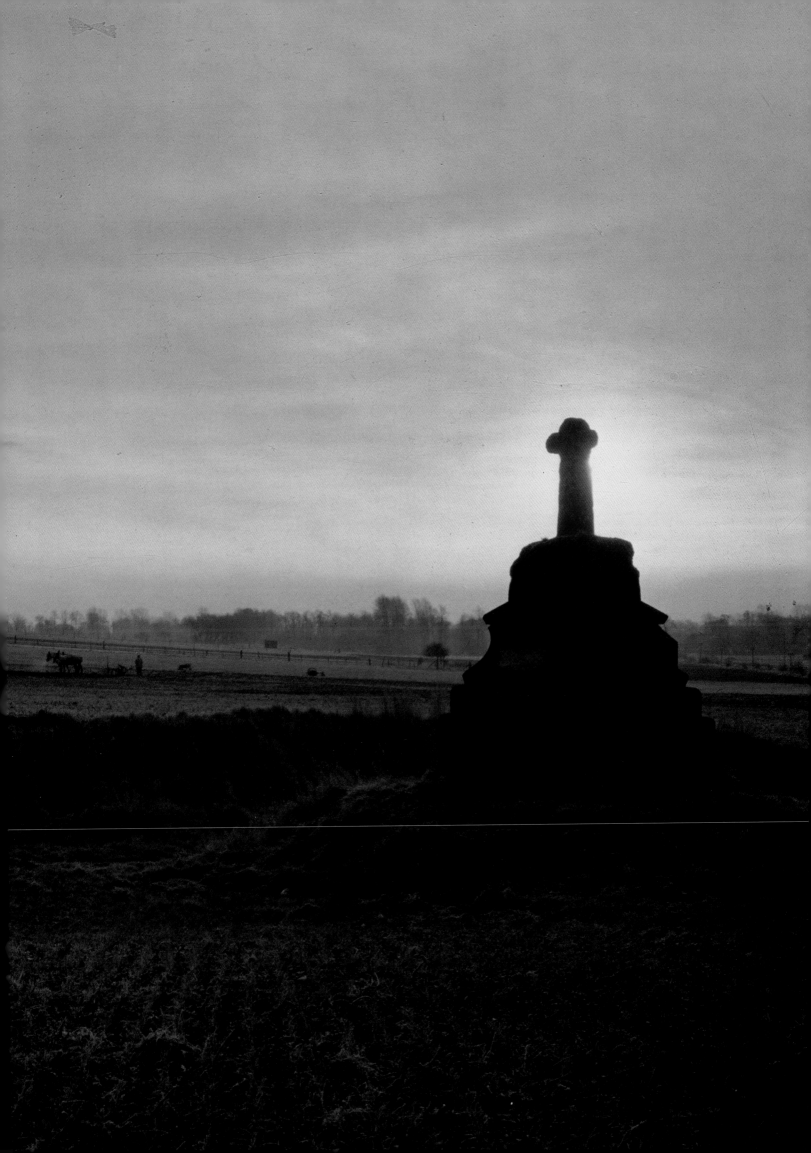

CHAPTER 1:
EN ROUTE

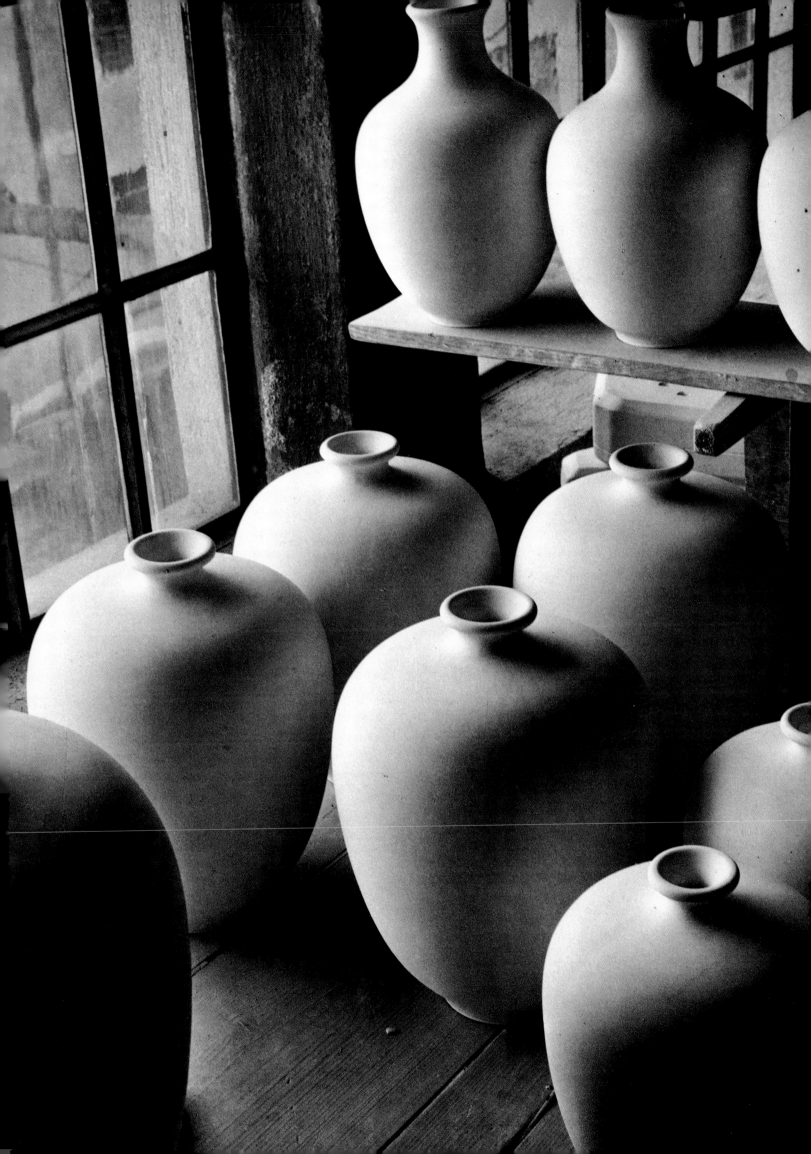

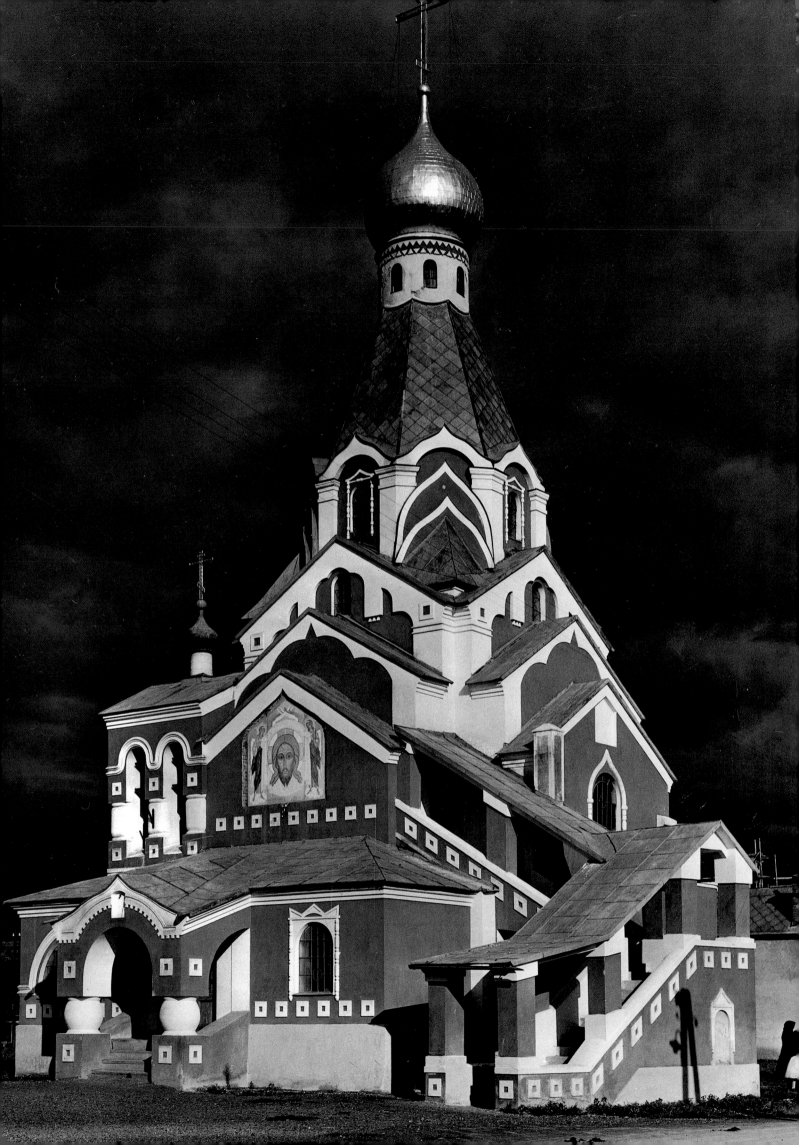

The hero of my childhood was my mother's cousin Arkady. He was what Russians called an "agent for special missions." Actually, his "special mission" might have been only a trip to supervise the loading of goods for a merchant who needed urgent delivery, or a property survey for a prospective buyer who had neither the time nor the desire to do it himself. But it meant *travel!* and that, to me, sounded like a great adventure.

I remember a special visit he paid us in the summer of 1914. We were living in a farming village near my father's sugar-beet plantation in the Ukraine, about two hundred miles south of Kiev. Arkady arrived standing upright in the back of a horse-drawn flatcart. At his side was a shiny new motorcycle. His hands were firmly on the handlebars. He was dressed all in leather—jacket, breeches, and leggings—and he wore a helmet with goggles. He was thirty and looked like a picture of a flying ace I had once seen in the illustrated magazine *Niva*. A mob of screaming village children and barking dogs followed the cart. His was the first motorcycle our village had ever seen.

Cousin Arkady was on a cross-country trip to show off his beautiful new machine to relatives and friends. (He was yet to discover that it was not very suitable for unpaved Russian roads that were covered, in dry summer weather, with inches of powdered dust, and in the rainy season, with a foot of mud.) He stayed with us a few days, tuning the motor, trying to get the dust out of it. During his stay I listened wide-eyed as he recounted to my parents the stories of his trips to faraway places in Russia and even of his one trip abroad, to Germany. I began dreaming at age twelve of becoming one day an "agent for special missions."

When war broke out in Europe in August 1914, I was living and studying at a *gymnasium* (high school) in Nemirov, about a hundred miles from my village. Every boy from fifteen to eighteen years old was required to take two hours daily instruction in officer's training; upon graduation at eighteen the successful trainee would be inducted into the army as a junior officer. War sounded to all of us teenagers like a glorious patriotic adventure, and we in the junior classes hoped that it would last at least until we graduated.

Life in Russia during the war was chaotic enough; it became even more turbulent, and dangerous, when the Bolsheviks seized power in the Revolution of November 1917. In the Ukraine the new local government was reluctant to be entirely swallowed up by the Soviet regime. When the Red Army moved into the Ukraine in February 1918 and occupied Kiev, the capital, the Ukrainians appealed to Germany and Austria for help. Together with Ukrainian troops, led by General Petlyura, the German and Austrian forces drove out the Soviets and reoccupied Kiev. By August 1918 there were thirty-five divisions of German and Austrian troops in the Ukraine. As the army of occupation, they began to disarm the Ukrainian army, which prompted dissident units to form guerrilla bands, fighting first against the Germans; then against the Bolsheviks, who reinvaded the Ukraine in November 1918; and even against the White Army of General Dinikin, who occupied the Ukraine in the summer of 1919.

Because of the military and political uncertainties, my family had moved in 1918 from our farming village to the relative safety of a larger, nearby town. But my father, who was still working as a contractor supplying sugar beets grown by peasants in our district to a sugar refinery, continued to spend a great deal of time in our village home. One day when he was driving his horse-drawn carriage toward the village, a friendly peasant warned him that there was a guerrilla band in the village looking for him. The peasant invited him to stay at his home until the bandits left. But my father, who had always had very friendly rela-

On my first foreign assignment, to Czechoslovakia in 1937, I spent four months, sometimes on specific assignments but also photographing everything else that interested me, such as a Russian Orthodox church in Uzhgorod (opposite) at the foot of the eastern Carpathian mountains, and the porcelain products (preceding page) turned out by the Bohemia Moser plant near Carlsbad.

tions with the peasants, did not believe that the guerrillas would harm him. He continued to drive toward the center of the village. There the guerrillas seized him and killed him. He was a Jew.

In the fall of 1919 I graduated from the *gymnasium*, a year early due to the pressing requirements of the war, and was inducted into the Red Army with the rank equivalent of second lieutenant in the cavalry. I was seventeen. I learned quickly, as does every soldier who has ever fought on the front lines, that war is less a romantic adventure than an ugly, brutal battle for personal survival.

Russia had signed a peace treaty with Germany and Austria but was still fighting for its life against foreign and domestic military forces. On our front, the immediate enemy was Poland.

The Russo-Polish War was a swift campaign of movement—attack, counterattack, retreat, counterretreat. Then the tide shifted against us decisively, and we were forced to retreat; by May of 1920 the Polish army, including two Ukrainian divisions of General Petlyura, had taken Kiev.

At one point we were cut off by the Polish cavalry. We took cover in woods nearby, dismounted, and opened fire on the charging Poles. We were firing on command, in salvos, the most effective defense against a massed cavalry charge. The Poles halted, turned around, and beat a full retreat. We remounted and galloped in pursuit. The Polish cavalry soon disappeared from sight. Ahead of me a single Pole was kneeling in the otherwise deserted field, his arms raised above his head. Approaching him, I got a glimpse of his deathly pale face turned toward the sky. Only the whites of his eyes were showing; his lips moved soundlessly either in prayer or a plea for mercy. He trembled violently. I shut my eyes and passed him. A fraction of a second later I heard a sharp crack. Looking over my shoulder, I saw the giant figure of our regimental commissar waving his carbine, which he held by the muzzle, high above his head. He had just crushed the skull of the

unfortunate Pole. He galloped alongside me and hissed one word: "molokosos," which, roughly translated, means "milksop." That night I did not close my eyes. I could not get the Pole's face out of my mind. I finally cried myself to sleep.

A few weeks later the Poles were retreating from the Ukraine. Our cavalry unit and others were operating behind enemy lines. Communications between our units were carried by mounted messengers; they often fell into enemy hands, so we knew only vaguely where our other units were. We lived off the local farmers or raided Polish supply columns; often we went hungry for days. One cold, rainy day I walked into a peasant's house hoping to get something to eat. From the look of the place it belonged to a prosperous family. Dripping wet, I entered and greeted the owners, a large, middle-aged man and his tall, handsome wife. A large loaf of brown bread was on the table. I asked for something to eat. The man shouted, "There's nothing! Get out!" I could have pointed my gun at him and walked out with the bread, but his wife turned to him angrily. "How can you say that?" she shouted. "Look at the kid. He's half dead from hunger!" Then, turning to me, she said, "Sit down, son." She cut a thick slice of bread and put it in front of me. Then she went to the oven and pulled out a large pot, from which she ladled a plateful of hot, thick, peasant soup. As I ate greedily, she watched me with tears in her eyes. When I finished, I bowed and thanked the woman. She pressed another thick slice of bread into my hand as I headed for the door.

One night our squadron was discovered and pursued by the Polish cavalry. We crossed the river Bug back to our lines and settled for the night in the forest on the eastern bank of the river. During the night terrific shooting erupted on the western bank of the river, small-arms fire followed by machine guns and heavy artillery. We could hear the horses neighing and screaming, and we assumed that it was a fight between the Poles and one of our cavalry units. The shooting went on for

what seemed like many hours, then suddenly stopped.

At daybreak I was sent with two of our scouts to reconnoiter the area. The rising sun illuminated a gruesome sight. Dozens of dead horses lay on the wide western bank, many of them on their backs, their legs pointing to the sky. We could only guess what had happened. Apparently two Polish cavalry units in pursuit of our group had run into each other in the dark and had fought. That awful scene of the dead horses made a sickening and deep impression on me.

Not long afterward I was stricken with typhus. Lying on the straw-covered floor of a makeshift field hospital set up in a farmer's barn, I was running a high fever and was delirious. Hazily, I heard the nurse asking the doctor, "What shall we do with the 'heavy ones'?" The hospital was pulling out before the advancing Polish army; the "heavy ones" were the seriously wounded and the sick who were unable to manage on their own.

"We will have to leave them," the doctor replied. That meant abandoning them to certain death, for the Poles were known to kill some of their prisoners, especially the wounded and the sick.

An elderly nurse knelt beside me and prayed. I vaguely heard her murmuring, "Gospodi, Pomilui, Gospodi, Pomilui"—God have mercy. I was the youngest of the patients. Whether because of her prayer or the shock of what was about to happen, I returned to total consciousness and made a move to rise. The nurse helped me to my feet, led me out of the barn and through the courtyard to the village road. Holding me up, she pleaded with the drivers of passing transports, mostly commandeered peasant carts, to take me. Finally, a peasant whose cart was half-empty stopped and helped me on. He drove to the railroad station, where the sick and wounded were being transferred to freight cars for removal to the interior.

In my boxcar there was a group of soldiers who looked perfectly healthy. They laughed a great deal, drank *samogon* (homemade vodka), and played cards. They fed me gruel cooked on a wood-burning stove. At one stop a young, handsome, woman doctor in a snappy uniform entered the car, accompanied by two orderlies, and began to examine the patients. When she had looked me over, she turned to the orderlies and asked, "Who put this kid in with this bunch of syphilitics?" They moved me to another car.

Finally I landed in a hospital in Poltava, deep in the Ukraine, where I stayed six weeks. Before being discharged from the hospital, I applied for entrance into the army's staff officers school, and was accepted; for the next four months I attended crash training courses. Upon completion, I was sent back to our division headquarters as an assistant to the operations officer. That was in January 1921; the war was over. Later that year I was demobilized because of my age. I was eighteen and a half years old.

I had the status of a reserve officer, so I had to register with the military authorities in the town of Berdichev, where I stopped to visit my sister. They asked me to work temporarily as an assistant chief of staff of the district commissariat until a replacement arrived in a few weeks. It was strictly a desk job, but when I had been there only three weeks the commissar decided to make the rounds of his territory to deal with a band of Ukrainian nationalist guerrillas who were reportedly terrorizing the countryside, attacking villages and small, undefended towns, killing Soviet officials and uncooperative peasants. The commissar asked me to come with him, and I gladly accepted: I had a personal score to settle with Petlyura's guerrillas.

We traveled from our base near Berdichev by chauffeured car, my first ride in an automobile. We were to rendezvous in Kazatin, about twenty miles away, with a cavalry squadron and an infantry company in horse-drawn carriages with mounted machine guns. About three miles before we reached Kazatin our luxurious limousine broke down, and we had to walk the rest of the way. When we started out the following morning we bor-

rowed two horses, one for the commissar and one for me. The minute I mounted my horse I could feel that he had little or no "military" training.

For the next ten days we toured the countryside, checking isolated farms and patches of woods. Local peasants sent us from place to place on rumors that cavalry bands had been seen. We found nothing. Finally the commissar decided to give up the search and return home.

When we were about fifteen miles from Berdichev the cavalry squadron and the infantry were sent back to their base in Kazatin, leaving us with only six cavalrymen. A short distance outside Berdichev, about a mile from the highway, there was a large farm surrounded by poplar trees. Starshina, our cavalry warrant officer, decided to take a look and galloped toward it while we waited. Moments later a peasant appeared from nowhere and told us that there was a band of *petlyulovtzi* (guerrillas) on the farm. The commissar shouted to Starshina to warn him, but he was too far away to hear; a few minutes later he disappeared behind the poplars. "Pogib Starshina," exclaimed the commissar—Russian for "Dead, gone."

Suddenly we saw Starshina dashing out of the farm, waving his sword above his head, and shouting, "Squadron attack!" A group of about fifty guerrilla horsemen were riding out of the farm at a slow trot. There were seven of us. We were not about to follow his order to attack, but we trotted toward him. I fired my carbine at the guerrillas, a wild shot. My horse, who apparently had never heard gunfire, took off at a furious gallop in the direction of the now-retreating band. I could not stop him; soon I would have been among the retreating guerrillas. But by pulling at the reins with all my strength I finally slowed him down. We came to a halt when we were just close enough to have seen the faces of the retreating riders. Frustrated, Starshina, his horse prancing, kept shouting, "Squadron attack!" By now the *petlyulovtzi* were riding away from us at a fast trot. The commissar

sent two men galloping back to Kazatin for reinforcement. He rode alongside me and said, "That was brave but childish of you to charge." I told him that I had not meant to, my frightened horse had run away. He did not believe me. We followed the band at a safe distance. By the time the cavalry squadron from Kazatin caught up with us we had lost sight of the guerrillas. The commissar ordered the squadron to continue the search. The rest of us rode back to Berdichev.

A few days later, the chief of staff told me in confidence that the commissar had recommended me for a decoration for bravery in action. I never got it: my replacement arrived soon thereafter, and I was free.

My first civilian employment was as an assistant maintenance manager in a leather-tanning plant near the town of Berdichev. One day my boss told me that he was giving me a very important assignment: I was to organize the transport of fuel oil from the town's storage area to the factory. The factory's fuel tanks were almost empty, and the tank train carrying oil to the factory was held up. There was enough fuel for only a few more days. The situation was critical and, with the unusually severe winter, if the plant furnaces went cold, could become catastrophic.

My job was to "mobilize" all available transport—which consisted of privately owned one-horse-drawn sleighs for hire—fill the oil drums at the oil storage, load them on the sleighs, and deliver them to the factory about five miles out of town.

It sounded simple until I got to the storage depot and told the manager what I was supposed to do. He smiled and asked me to follow him. He led me to a huge metal storage tank, which was sitting on four concrete blocks about three feet off the ground. "Watch this," the manager said as he turned on the large spigot. Not a drop of oil came out; it had coagulated in the freezing temperature and would not flow. "So, how are you going to transport it?" he asked.

"What if we warmed it," I asked, "by building a fire under the tank?" "Well," he replied,

"if you want to blow up the depot and yourself with it, go ahead." Two tanks next to the oil tank were filled with kerosene. "Okay," I said. "I have to try."

First I went to the marketplace, where the freezing sleigh drivers waited with their shivering horses for customers. I hired all fifteen of them and instructed them to be at the gas depot in about an hour, ready to work the rest of the day and probably most of the night. Then I took two sleighs with me to buy some wood for heating.

Back at the depot, I placed the wood under the tank and started a fire. The depot manager showed me how to turn on the spigot and where the empty oil drums were stored, then quickly ran off. The oil soon began to flow, and in less than an hour the first sleigh, carrying three full oil drums, started for the factory. All through the night we had a continuous convoy of sleighs shuttling between the plant and the gas depot.

When I reported to my plant the next morning I was told to see the chief engineer, a tall, aristocratic-looking, elderly gentleman, who wanted to know how I had managed to get the oil out of the storage tank. When I told him, he blanched. "My God," he said. "If I had been aware of what you were planning to do, I would never have allowed it!"

Word of my exploit got to the plant director, who summoned me to his office to thank me. A couple of weeks later I was again called to the director's office. "I have another very special job for you," he said. "We are having trouble with the transport of rawhides to the plant. The freight cars carrying the hides often get sidetracked and sit at the station for days. Your job is to expedite the movement of the loaded cars. You will be provided with papers, signed by the highest authorities and addressed to the railroad management, asking for their fullest cooperation. You will be given a few dozen pairs of leather soles and a few pelts for boots as gifts for you to hand out to stationmasters as extra incentives." (The leather for a pair of boots was an exchange commodity worth a fortune, while the inflated paper currency of that time did not have the value of its weight.)

My orders stated that I was an "Agent of the USSR Ministry of Industry for Special Missions." At the age of nineteen my dream had come true.

Travel by train at that time was a nightmare. The post-revolution railway was in a state of chaos. There was rarely anything resembling a passenger train. People traveled mainly on freight cars, which were only occasionally heated by wood-burning stoves; more often, passengers had to huddle against one another on the train floor for warmth. The trains did not run on schedule. One simply went to the railway station and waited— sometimes for days—until a train going in the right direction showed up. When it did arrive it was usually packed with mobs of starving refugees fleeing northern Russia, then plagued by one of the worst famines in its history: hordes of refugees were wandering over the Ukraine in search of food. Those who could not find a place inside the crowded cars perched on the roofs; many of them froze to death between stations. The dead were simply pushed off the roof to make room for the new arrivals.

The waiting rooms of the railway stations were filled with people sleeping on the floor. Special sanitary units went through the stations daily, collecting the dead, piling the corpses on old railroad ties, and then cremating them. Often groups of shivering refugees would huddle silently around the gruesome bonfire to warm themselves.

When I finally got back after two weeks of "travel," bringing six carloads of rawhides a distance of three hundred miles, I called it quits as an "agent for special missions." I decided what I really wanted to do was continue my education.

With the recommendation of the director of the tannery I applied to the Institute of Chemical Engineering in Kiev and was accepted in the spring of 1922. Since the school term did not begin until the fall I returned to my sister's home in Berdichev. I

was surprised to find most of the family—my mother, two other sisters, my brother-in-law, and my brother—gathered there. (Only my fourth sister, Dina, and her husband were still in Moscow, at the university.) When I asked why they were all in Berdichev, my mother told me, "We are going to Poland and then on to America." My mother had four brothers and one sister already living in the United States. They had left Russia before the war, and they were worried about our future in Russia with my father dead and the Communists firmly in power. To get us all out, they had hired someone in Poland to "escort" us to Rumania, where we had relatives, and then ship us to the United States. "Escort" really meant "smuggle": it was strictly illegal for ordinary Russians to travel out of the Soviet Union at the time.

"I'm so glad I returned from Kiev in time to say good-bye to you all," I said. I had no intention of emigrating.

"You are not here to say good-bye," my mother replied. "You are coming with us."

I was about to protest when my brother-in-law made a sign to me to keep quiet. Later he took me aside and said, "Go ahead with them, and then, when they cross the frontier into Poland, stay behind and come back."

The frontier was a short train ride from Berdichev. There we were met by the man who had been commissioned to smuggle us across. My older sister, her husband, and my brother were the first to leave, the night after our arrival. My mother, my youngest sister, and I were to follow the next night. I suggested to my mother that she go with my sister and that I would come the following night. But she, suspecting I might stay behind, insisted that I go with them. When I protested, she said that if I did not accompany them she would not go either. So the next night, past midnight, we left. It was an eerie crossing. We followed our escort as silently as possible, walking about an hour before we came to a small river where two men were waiting in a flat-bottom boat. We were helped aboard and rowed across the river. After a

short walk through the high reeds our guide whispered to us to squat down while he went to speak to a figure, barely visible, ahead. After a few minutes of conversation that we could not hear, the figure, a soldier of the Polish border patrol, moved out of the way. Our guide returned and told us to follow him. We were in Poland.

We walked at least another hour. The sky in the east was turning gray when we came to a field of tall grass. The guide told us to lie down there and keep quiet. "Do not talk to each other, not even in a whisper," he warned. "I will be back soon to pick you up." And he went off. It was a chilly night and my mother was shivering. The sky in the east turned red, and soon we heard a peasant in a field not far from where we were. He was mowing hay. From time to time he stopped to hone his scythe. My mother whispered, "What an ominous sound." And it was. We were in a strange country hiding in the grass. What if our guide had abandoned us?

After what seemed like hours, our guide returned and motioned to us to follow him. He led us to a narrow dirt road where a peasant cart loaded with hay was waiting. We climbed in. The guide and the peasant covered us with freshly mown hay, and we drove off slowly. After about an hour's drive we were transferred to a two-horse carriage and driven into the city of Rovno in style.

Our "agent" had rented a small house for us in Rovno, where we were to stay until he could arrange our trip to Rumania. One day my brother-in-law ran into an old schoolmate in a barbershop there. After a happy reunion, they exchanged addresses, promising to get in touch again. The next day a Polish plainclothesman came to our house; my brother-in-law was the only one home. The policeman asked him if he was Sam Sweetsky and, when he said yes, arrested him. His schoolchum was a Polish police informer.

Now our guardian had to get my brother-in-law out of jail. All that took was dollars to bribe the jailor. My brother-in-law was out in ten days. Our guardian then decided that it

would be safer for us to leave Rovno. He was sure that the police would try to pick up Sam again, or another one of us, to hold for more ransom. We moved on to Lvov, a large city. Lvov had once been the capital of the western Ukraine and was formerly part of the Austro-Hungarian empire, but then, in 1922, was part of Poland. We were in the hands of a man who was to take us, again illegally, to Bucharest. My brother and I were the first to leave. We were taken to a small border station where travelers' documents were checked, usually on the train. Our man kept us at the end of the station platform while the officials checked the train. Then we were to jump aboard the moving train as it left the station. We made it, but just barely.

The first large town along the way to Bucharest was Yassy, where passengers' papers were checked again. Our escort told me to get off the train and to remain on the station platform until the train was ready to leave. The moment I stepped on the platform, a Rumanian gendarme stopped me and asked me where I was from. I did not answer and was arrested. In the railroad police station a friendly plainclothesman interrogated me. He was from Bessarabia and spoke Russian. He was about to let me go when a young officer walked in. After a short talk with the plainclothesman he interrogated me in Rumanian, which I could not understand. Then he tried French. I shook my head. He turned to the plainclothesman and began to argue with him heatedly. All I could understand was one word: "Bolshevici." I supposed that meant he suspected me of being a Soviet agent. "Sorry," said the friendly cop, "I cannot let you go." So I landed in jail in Yassy.

The jail was not too bad, not a real jail actually, rather a temporary detention center. I shared a large whitewashed room with a dozen inmates who did not seem to be criminals, except for one pickpocket from Odessa. The room had bunks with pillows and blankets. A single small light was on all during the night.

Among my cellmates was a well-dressed, middle-aged man who spoke a little Russian. His bunk was next to mine. He was a lawyer, he said, jailed because he refused to pay a police officer a bribe. He offered me a cigarette from a silver case.

During the night I woke up and saw the pickpocket going through the pockets of my neighbor's trousers. I sat up quickly, and the pickpocket slunk away. The next day I asked my neighbor if anything was missing from his pockets. He checked and found nothing gone. The pickpocket gave me a murderous look. The following night I was awakened by movement near my pillow. I jumped off my bed and got a glimpse of the pickpocket getting back into his. I looked under my pillow. There was the silver cigarette case. I carefully slipped it back under my neighbor's pillow. In the morning I told the pickpocket, a skinny fellow about five feet tall, "Look, you little bastard, you do that once more and I will kill you." Suddenly he jumped up, grabbed the low ceiling beam, swung himself backward and forward, and, before I could step out of the way, struck me in the chest with his feet with such force that I careened to the floor.

I was stunned for a fraction of a second, then jumped up raving mad and went after him. He swung at me again but I stepped aside, and as he was swinging back I caught his leg and pulled him down. He screamed like a wounded beast. The guards came running and grabbed me roughly. The pickpocket kept screaming and pointing at me. He was shouting that I had tried to kill him. Some of the inmates who had watched the incident but had not interfered told the guards what had happened.

We were both taken to the office of the warden, the pickpocket still screaming and pointing at me. The warden told him to shut up and spoke to me, but I did not understand him. One of the guards told him I was Russian. The warden sent him out; he returned with a young civilian, a clerk, who spoke Ukrainian. My Ukrainian was almost as good as my Russian, so through the interpreter I explained to the warden what had happened.

When I finished the warden smiled. Then, still smiling, he turned to the pickpocket and said something. The interpreter translated for me: "Too bad he did not kill you," the warden had said. They sent me back to my cell, but not the pickpocket. He came later to pick up his belongings. Before he left he told me, "I will find you. I promise I will find you and I will cut your throat." Then he was transferred to a city jail.

Two days later I was taken, handcuffed, by an armed soldier to the railroad station. I was being sent to Kishinev, the capital of Bessarabia. This was bad. Usually from Kishinev Russian refugees were deported back to Russia, where they were harshly treated; sometimes they were shot without even a trial. I was put in the Kishinev jail, a really morbid-looking place; by comparison the Yassy detention jail was a Hilton hotel. There were about thirty men in my cell and no bunks. The prisoners slept on straw mattresses on the floor. Early in the evening the guards came for one prisoner from our cell. About an hour later he was brought back supported by two guards, his face swollen, blood trickling from the corner of his mouth. He had been interrogated by the Rumanian police, well known for their brutality. A few minutes later my name was called. One of my fellow prisoners counseled me. "Tell them you are sick. Tell them you have a bad heart. Maybe they will not beat you." I walked shakily to the cell door. The guard thrust into my hand a large package wrapped in brown paper. It contained about two dozen rolls, sausages, ham, and cheese. I smiled, relieved, and offered the food to my cellmates. One of them slapped me on the shoulder saying, "Don't worry now. Someone is taking care of you, probably a lawyer. Everything will be all right." Two days later I was out.

After my release I stayed with friends in Kishinev while waiting for a permit to stay in Rumania. I left for Bucharest a few days later, armed with not only a temporary residence permit, but also a letter of recommendation from the governor of Bessarabia asking the American consul in Bucharest to expedite my visa to the United States. All this resulted, I learned later, from a single bribe of a thousand lei (worth about six dollars at the time) to a clerk in the governor's office.

I joined my family in Bucharest, where they had arrived a week before, as a "legal." My brother, who had remained on the train in Yassy, had reached Bucharest without any problems: there was no passport control in his carriage. Had I stayed on the train I would have avoided arrest. It had taken about three months for all of us to get from the Ukraine to Bucharest.

We lived in Bucharest almost a year, awaiting our visas to the United States. Finally, in August 1923, my brother and I left for New York. My older sister and her husband followed a month later. My mother and youngest sister stayed on in Rumania with relatives for six years before they joined us. My two other married sisters remained in Soviet Russia. I never saw them again.

I got my first camera when I was thirteen years old. I had been given a water-color kit at Christmas, but, since I was not interested in painting, I swapped it with a school friend for a camera he had received for Christmas. It was a Kodak box Brownie, 2¼ x 3¼ inches. With it came a film-processing kit. I took some pictures of our horses and dogs, but without much enthusiasm, especially when it came to developing the exposed film and making contact prints.

The summer of 1918 a squadron of Polish legionnaires was stationed in our school town of Nemirov. Since neither the Ukrainian government nor the Soviets kept them supplied with food either for themselves or for their horses, they requisitioned it from the peasants in the neighboring villages. One day the peasants rebelled. They came to town by the thousands, most of them armed with hayforks and axes, some with shotguns and rifles. They besieged the barracks of the legionnaires, who, although well armed, put up very little resistance. Instead the Poles surrendered,

and within minutes they were massacred.

When the sound of the fighting died down a fellow student—a Pole—and I ran to the scene. The bodies of the dead legionnaires, stripped by the peasants to their undershorts, lay scattered in the barracks' courtyard. I had my box Brownie with me and took a picture of the scene. My Polish friend was crying. A peasant noticed him and asked menacingly, "Are you crying for those bastards?" My friend said that the legionnaires had wanted to go home but could not because the German armies were blocking their way to Poland. Another peasant asked me what the box I had was. I told him it was a camera to take pictures. He took it from me, shook it beside his ear, and then hit me on the head with it. It was loaded with glass film plates and it hurt. I did not take another picture during the rest of my stay in Russia.

In New York in 1924 I bought what seemed to me a rather sophisticated camera—a folding Kodak—for thirty-five dollars. I began taking pictures of my friends, who, impressed by the results, often encouraged me to become a professional. I was not interested because I imagined a professional photographer as someone who took formal portraits against painted backgrounds with a big camera or who shot still lifes for advertisements.

But early in the 1930s I saw a *Fortune* magazine for the first time and was very impressed by the dramatic pictures of industrial plants. I decided to take a course in photography at a school run by a well-known photographer, Ben Rabinovitch.

Rab, as we called him, was a portrait photographer who originally had his studio on 57th Street near Carnegie Hall; in the display box at the entrance was a beautiful photograph of Katherine Cornell. When he moved to a large, floor-through flat on 56th Street he continued to practice portrait photography, but he also started a school for photographers. Rab was a short, stocky, bald, bear of a man who wore a blue smock and smoked a short-stemmed pipe, which he waved around when he talked. A great lover of music, he often sat alone in his empty studio, his eyes closed, listening for hours to recordings of classical music. He had a great deal of free time, because not many people came to him to have their pictures taken. The problem was that he photographed his sitters as he saw them and not as they imagined they looked; the results were seldom flattering. As a hobby, he photographed nudes and calla lilies in very high key, spending hours in the darkroom making prints that looked like charcoal drawings. He insisted that nudes posing for him have their pubic hair shaved. He did the shaving job himself, working up the lather with a shaving brush and using an old-fashioned straight razor.

His classes usually consisted of six or eight students, some of whom were amateurs taking the course for fun. Among them were society women, rich widows, and even a grand duchess—Marie of Russia—who later opened her own portrait studio in Bloomingdale's, photographing only women. The majority of the students, however, hoped to make photography a profession. We all had to begin with a short course in darkroom technique, with emphasis on black-and-white printing. Rab insisted that printing was more than skill; it was the photographer's self-expression. After a photographer made a good negative under the best lighting conditions, natural or artificial, he would strive in the darkroom to produce a print by making the overall image, or parts of it, darker or lighter, until he arrived at the desired effect.

Rab was against miniature cameras. He claimed that a good picture taken with a Leica, for example, was really an accident because you could neither really see nor compose through a miniature viewfinder.

The front part of Rab's loft served as a gallery where group shows of the works of former and present students were on display, open to the public; sometimes there was a one-man show. In my graduating class exhibit I had a photograph of a nude done in Rab's high-key style. One day a young man came to see the show and asked Rab how to get in 21

touch with me. He turned out to be an art director for an advertising agency, and he wanted me to do a nude for an ad for one of his agency's clients—a manufacturer of ladies' lingerie. My fee was to be $200; it was my first professional job.

I was thrilled but also worried: nudes were not my specialty. The art director told me that the ad would appear in national fashion magazines and that the photo would have to be discreet—not very sexy—like a fine pencil drawing of a young girl with a good, slender figure. The text with the picture was something like: "Although you are endowed by nature with a perfect body, you can make it appear even more beautiful by wearing our bra and girdle . . . blah, blah, blah."

We agreed to meet at Rab's studio. I was to choose the model. For photo sessions in Rab's school we used young art students as models. There was one who Rab thought would be right for the picture. She showed up on the day of the shooting and undressed. The advertising man thought she was perfect. Rab was sharpening his razor in the bathroom. In the studio was a long, narrow worktable, which we covered with white cloth and placed against a white background. The nude, now shaved, climbed on the table and lay flat on her back. The art director wanted her to prop up her torso by leaning back on her elbows and to bend her legs at the knees. I began to move the lights around to get the proper lighting. When I was fussing with the lights and

My first commercial assignment—a reclining nude for a lingerie ad, made in New York in 1934. I felt a little like a Peeping Tom and photographed only one other nude in my entire career.

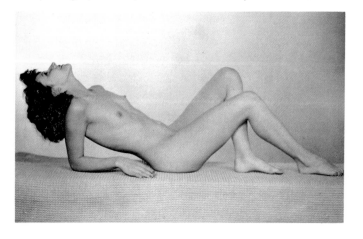

seeing the beautiful nude girl brightly illuminated by a battery of floodlights, she was nothing to me but an object to be photographed, like a bowl of fruit for a still life. But when I got my head under the black cloth and saw her image on the ground glass isolated from the rest of the room, I felt like a Peeping Tom. The minute I got out from under the black cloth I was okay again.

After a few exposures we stopped to give the girl a rest. She wanted to get off the table and have a cigarette, but the advertising man did not want her to step on the dirty floor and soil her feet. He offered to lift her off the table. He put his arms under her back and her legs and lifted her. For a moment I thought he might drop her as he held her in midair, his face red and dripping with perspiration. He managed to lower her slowly into a chair.

I did one more nude assignment and never again.

My favorite subjects were industrial plants, architecture, and bridges. I would spend days with a 4 x 5 Graflex camera walking around the waterfronts of Manhattan, Brooklyn, and New Jersey looking for pictures. To me industrial plants, with their massive architectural patterns and their stacks bellowing clouds of smoke, were fascinating. Through a friend I obtained permission to photograph the Lukens steel plant in Pennsylvania, both exteriors and interiors. The Lukens plant at that time was operating the largest rolling mill in the country. This giant machine looked like a dragon, breathing fire and smoke, and thundered as it swallowed big, red-hot ingots and spit them out again. A single man at the control panel, dwarfed by the giant machine, manipulated it, sending the ingots back and forth until they became thin sheets of steel.

While still in school, I had built up a small portfolio of pictures of industrial plants, which I planned one day to show to *Fortune.* In 1936 I went to see the picture editor there. A young assistant asked me to leave my portfolio with her for a day or two. When I came to

pick it up I was complimented on my photographs but told that there were a number of photographers already working for *Fortune*. I was asked to leave my address and telephone number just in case. A few days later I received a phone call from the picture editor asking me if I were free to go on assignment. I was. The story was on the Simmons Company and the problem was how to make pictures of mattresses and beds interesting. My solution must have worked, for *Fortune* published my pictures. It was my first editorial assignment and my first publication in a magazine.

It was extremely important for an industrial photographer to have his pictures published in *Fortune*. The magazine gave a prominent credit line, which was duly noted by editors of industrial magazines as well as by advertising agencies. I gradually began to get advertising and promotion assignments from big names in industry—Union Carbide, Republic Steel, Lederle Laboratories, and other large corporations.

In the spring of 1937 I went to Czechoslovakia for my first foreign assignment. *Architectural Forum* magazine had given me a small retainer against page rates for a story on modern Czech architecture, and *Fortune* gave me a similar deal for a story on the Bata shoe works. LIFE gave me no guarantee but asked to see all my pictures when I returned. I stayed in Czechoslovakia for four months.

In addition to the stories to which I was assigned, I did a story on my own on the Czech army, which at that time, only a year before the German invasion, was one of the best in Europe. Many of the Czech officers spoke Russian: they previously had been officers in the Czech legions formed in Russia during World War I to fight Germans; later, under Admiral Kolchak, commander of the White Russian armies, they fought the Soviets in the Russian Far East.

A few days before my scheduled departure from Czechoslovakia, Thomas Masaryk, chief architect and first president of the Czech Republic, died. I stayed on to cover his

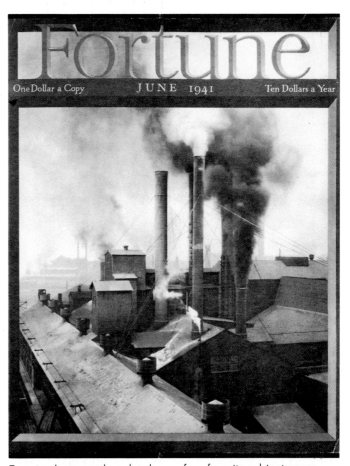

Even in photography school one of my favorite subjects was huge industrial plants. In several years of freelancing, I made three covers of *Fortune*, this one in June 1941—of the Union Carbide plant in Niagara, New York.

funeral. LIFE bought the exclusive rights to my pictures of the funeral but never published them. However, LIFE did publish later that year a five-page story on Czechoslovakia, using pictures I had taken during my four months there; it was my first story in LIFE.

The editors were so impressed by my photographs of Bata's huge, highly mechanized shoe-manufacturing plant in Zlin that when a fashion assignment came up on platform shoes they thought of me. Now there is no real relation between a picture story of an industrial plant that manufactures shoes and a fashion story of a model wearing platform shoes. But the editors must have thought: "Shoes? Let's see. Ah! Kessel!" That was my first assignment for LIFE, and it too was published in 1937.

That success seemed to make me, in the eyes of LIFE at least, a fashion photographer. The magazine gave me another fashion assignment shortly after, and my first LIFE

23

cover was a black-and-white shot of a girl wearing a camisole. I had never done fashion before that year and was not much interested in it, although I did not mind trying. But I wanted to do stories on industry, so LIFE soon began giving me assignments in that field.

Although I much preferred doing editorial stories for LIFE than advertising and promotion assignments for large corporate clients, the simple fact was that, in those early days, I could not afford to work solely for LIFE. Large corporations were paying a lot of money to photographers specializing in industrial photography (their day rates were about five times higher than those paid by magazines, including LIFE), so that when in 1943 LIFE offered me a staff job to replace the monthly retainer contract they had given me in 1942, I

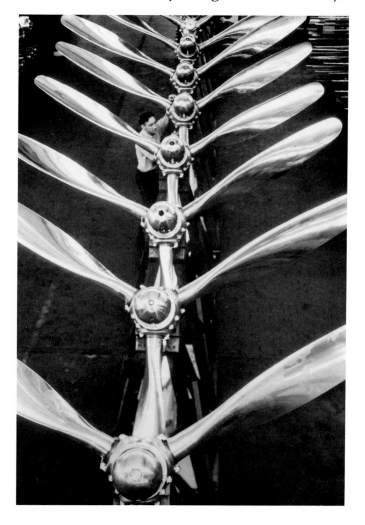

turned it down. In the fall of 1944, however, when I was on assignment in Greece, I decided that photojournalism was what I wanted to do more than anything else, and so I accepted a staff photographer's job.

I remained on staff from 1944 until 1967, when I retired. Then I continued to work for the magazine on a contract basis until its demise in 1972 and, when LIFE became a monthly, in 1979, on an assignment basis, right up to the present time. I had no idea, of course, when I first signed on that working for LIFE would surpass my most fanciful childhood dreams—of travel, excitement, and adventure—all on someone else's money. A friend of mine once called working for LIFE "the greatest traveling fellowship in the world." He was right. I have traveled extensively in five continents. LIFE has sent me on assignments throughout the United States and Canada all the way to the Arctic Circle. In South America I worked in almost every country, including four different assignments in Brazil over a period of fifteen years. I worked in nearly every nation in Europe and the Middle East. In Africa I photographed in Morocco and Tunisia, Gambia, Sierra Leone, Liberia, Ghana, Zaire and the Congo, Kenya, Tanzania, Zambia, and Rhodesia. In Asia, I did stories in Pakistan, India, Ceylon, Thailand, China, and Japan.

Cousin Arkady would have been proud of me—and maybe even a little bit envious, though I never in my life went anywhere on a motorcycle.

In 1941 I was still specializing in industrial photography. Opposite: At the Sun Shipbuilding and Drydock Company in Chester, Pennsylvania, a ship's giant screw. Left: At the Pratt and Whitney plant in East Hartford, Connecticut, a workman checks a line of propellers for war planes.
Overleaf: La Girotte Dam under construction in France in June 1950. This was one phase of a tremendous project, largely financed by the United States, on the Rhone River between Lake Geneva and the Mediterranean. More than 16,000 workers were building 18 dams and hydroelectric plants to produce 13 billion kilowatts of electricity annually.

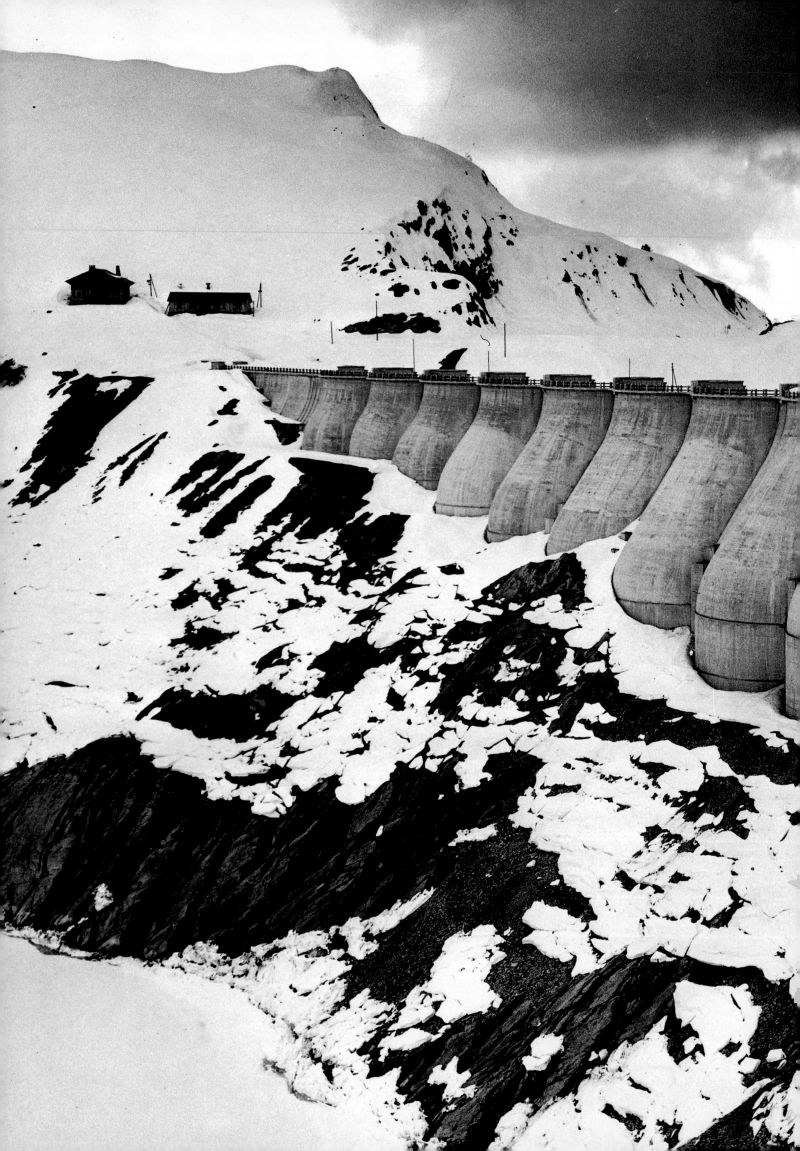

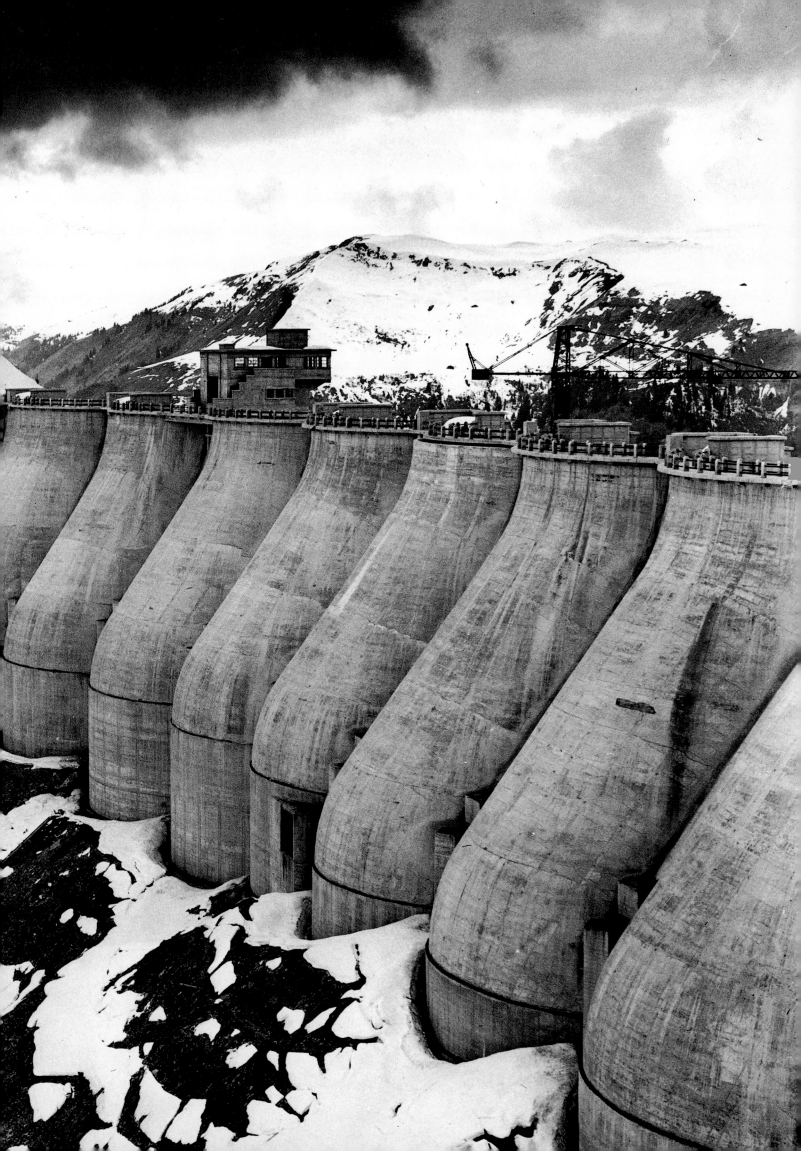

CHAPTER 2:
AROUND THE WORLD

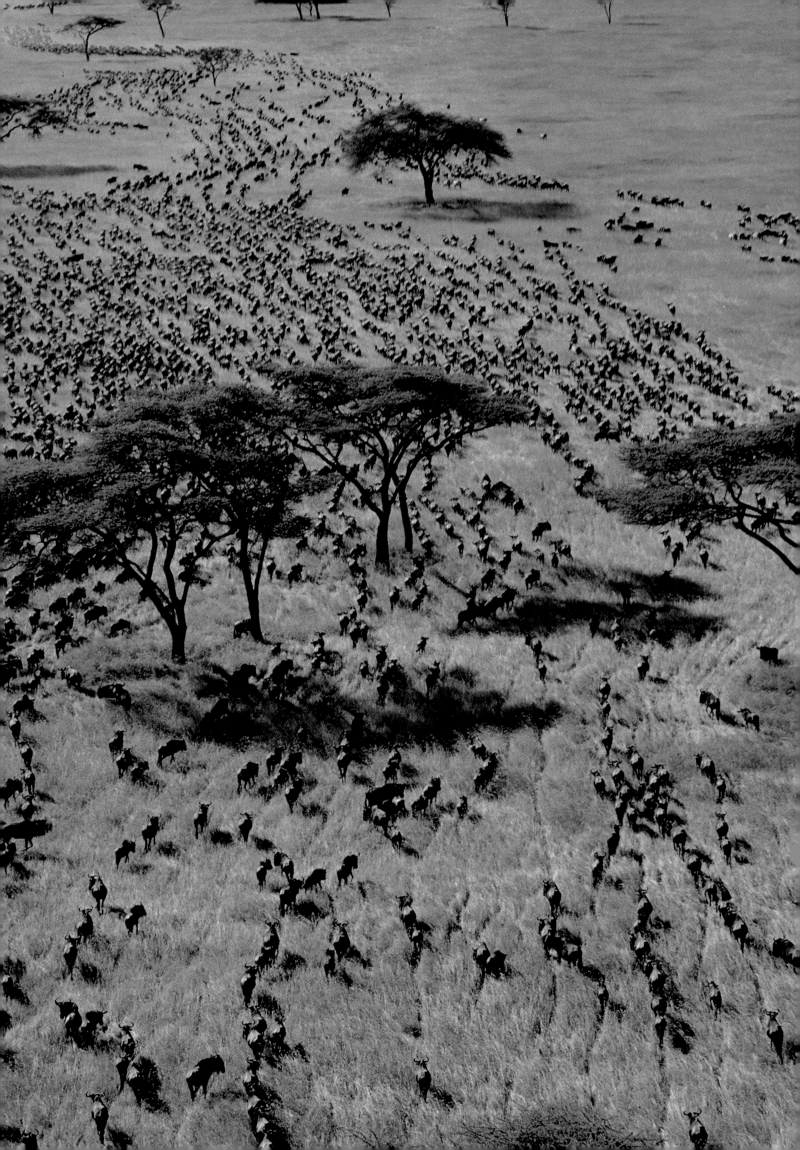

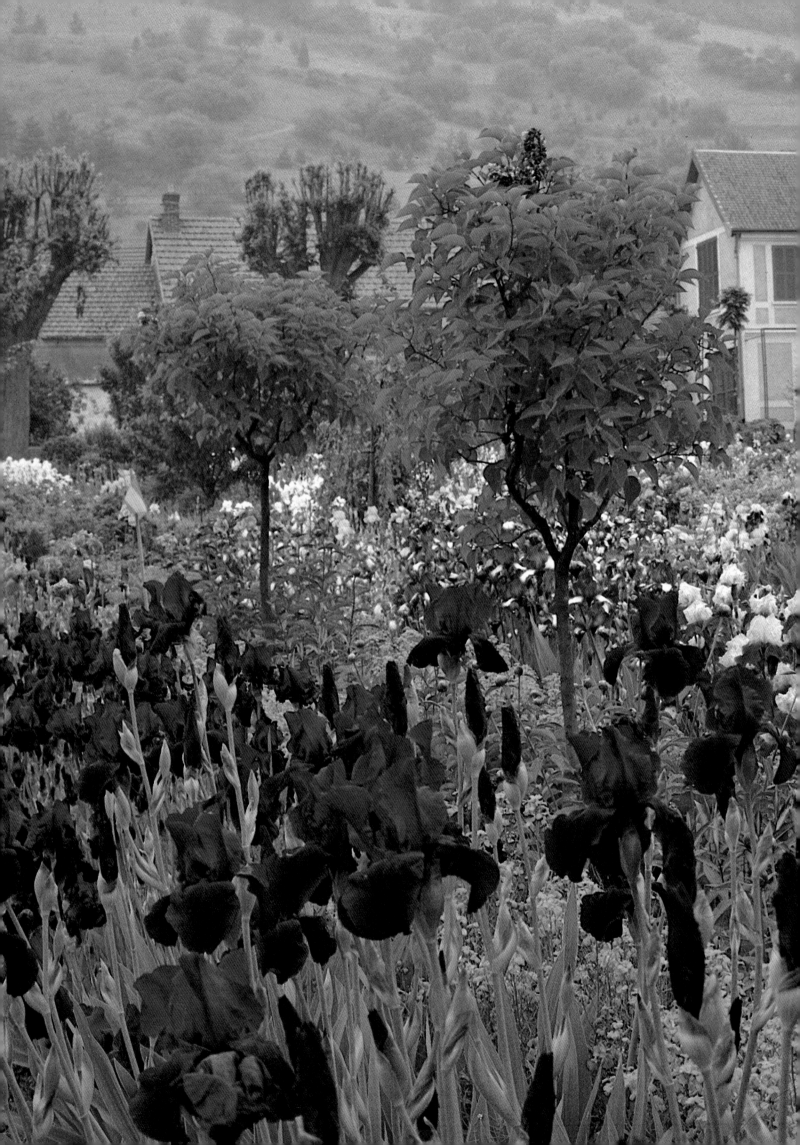

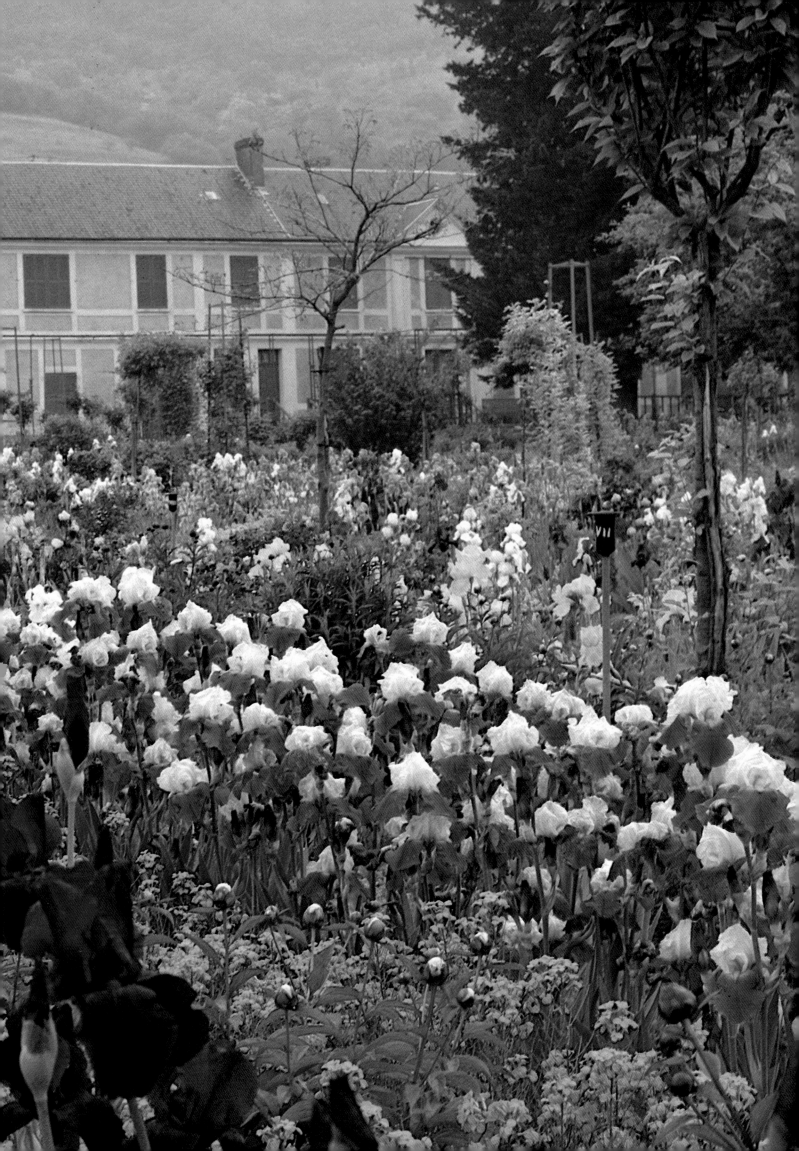

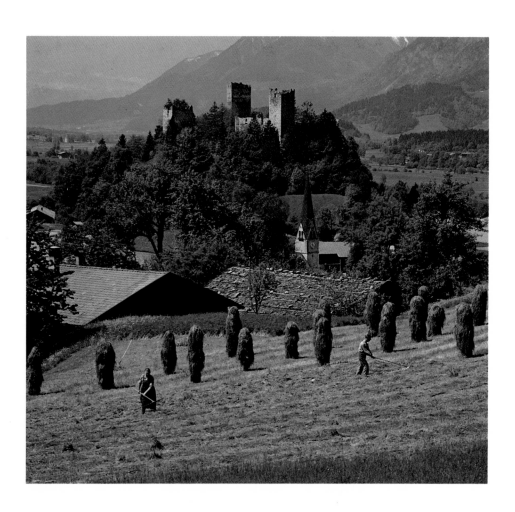

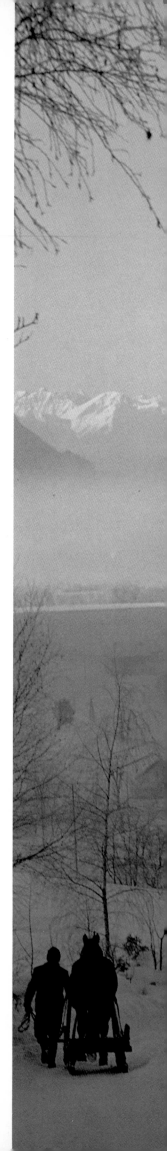

Spring and winter in the village of Saint Gertrude in the Austrian Tyrol. On the hill in the background are the ruins of the thirteenth-century Kropsfsberg Castle.
Preceding pages: The house and garden in Giverny, France, where the great Impressionist Claude Monet lived and painted.
Page 29: The largest annual migration in the world: a contingent of the 300,000 wildebeests on the plains of Serengeti National Park in Tanzania during their spring move to greener pastures.

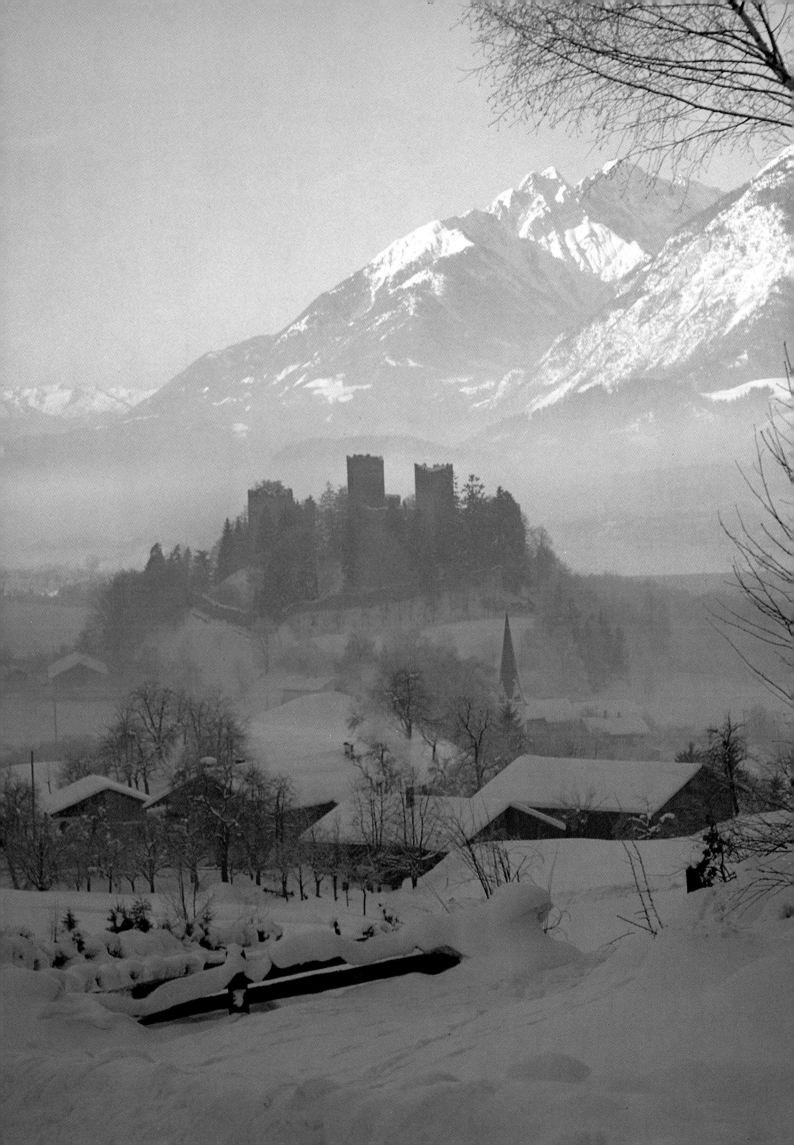

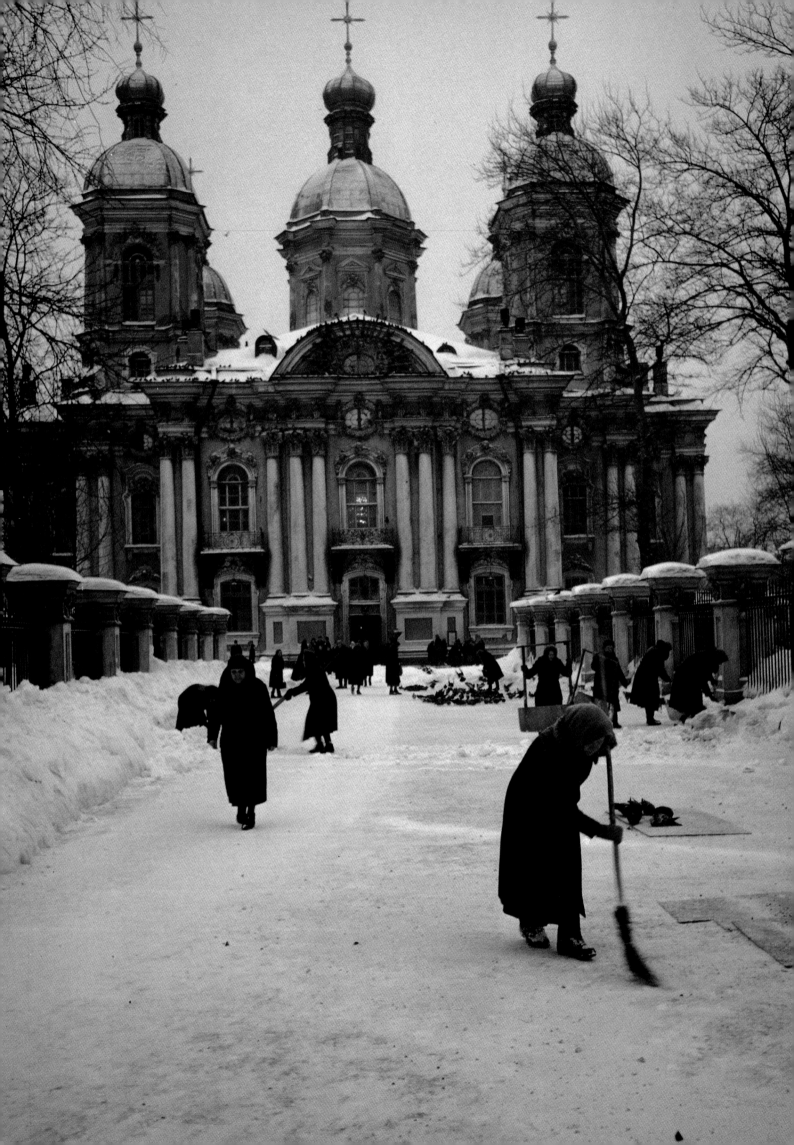

One of the best things about being a LIFE staff photographer was the working conditions. Expense accounts were very liberal. Travel was first-class, whether by ship, plane, or train, and we always stayed in the best hotels. Unless the story had an absolute deadline, we were never hurried when working; for a major essay, it was not unusual to take anywhere from two to five months. We could call on stringers or bureaus for help, and if we needed translators or extra photographic assistants, we hired them. If we needed an aerial, or simply had to go somewhere in a hurry, we chartered a plane or a helicopter. LIFE didn't care, within reason, how long it took to get a story, or how much it cost—as long as you *got* the story.

Still, I was somewhat surprised when I was assigned to do a color essay on the Greek islands in 1962 and the editors told me to charter a yacht instead of using the regular steamers that plied the Aegean. They had selected ten islands to be photographed, but they also wanted me to photograph any other lesser-known islands I found pictorial. It was decided that a yacht would give me more mobility: I would be free of the timetables of regular, sometimes weekly, steamships, and I could get to islands seldom, if ever, visited by tourists and never photographed.

So I chartered a yacht—a sixty-foot sailboat with an auxiliary diesel engine. It had a crew of six, including a chef and a steward. There were three staterooms for the three of us: my wife, Shirley; myself; and Takis Kirkis, a young Greek interpreter-assistant assigned to me by the public relations office of the prime minister of Greece. I felt like a millionaire on a pleasure cruise.

We loaded provisions at Piraeus, then sailed through the myriad enchanted islands of the Cyclades, Dodecanese, and Sporades. Along our route we would stop at island after island to investigate if there was anything worth photographing; if not, we moved on.

Opposite: In the winter of 1965 women shovel and sweep away snow to keep the main entrance open to Saint Nicholas Cathedral in Leningrad.

Each island had something different to offer pictorially: Santorini, its grim volcanic landscape; Rhodes, the Crusaders' castle, old Turkish quarters with crumbling mosques, and the Temple of Athena in Lindos; Patmos, its eleventh-century fortresslike monastery; Naxos, the monumental entrance to the ruined temple of Dionysius; Skyros, in the northern Sporades, a tight cluster of cubed, flat-roofed houses at the foot of a toylike church with a square belltower. And the bays of many of the fishing villages offered groups of multicolored caiques lying at anchor. Some islands were rocky and bare, others lush green with silvery olive groves.

One sunrise we saw the Fujiyama-like conical mountain of the island of Astypaleia seemingly ascending from the sea. Touched by the light of the rising sun the clusters of little white houses at its summit gave the illusion of a snowcap. It was one of the most beautiful sights I have ever seen. We spent two days on the island. The people were very friendly, treating us as guests, inviting us into their homes, and offering us wine and wonderful goat cheese. There were no tourist accommodations so they rarely saw foreigners.

On Patmos the following night I photographed the celebration of the Greek Orthodox Easter mass in the famous Saint John's monastery. It was a very impressive ceremony led by handsome, bearded priests in gold-encrusted vestments. We were back in the monastery at six o'clock the next morning for the Easter day service. That day our crew prepared the traditional Easter dinner, which included *mayeritsa* soup made mostly from lamb's intestines, eggs, and lemon. They invited us to be their guests.

If a LIFE photographer did not have to be a very good accountant, one did on occasion have to be a shrewd negotiator, a diplomat, and a fixer. The enormous prestige of LIFE, of course, was a great help; in most cases, the two words "LIFE magazine" were enough to open all doors.

On an assignment at the Plymouth plant of

35

Chrysler Corporation, I wanted to get a picture of the huge production line. At that time, 1939, we had no way of synchronizing seventy flashbulbs to freeze the movement of the line. So the plant officials simply stopped it. I shot one picture, then took ten minutes to change the bulbs for a second exposure. After we finished, the plant manager said that the stoppage of the production line had cost the company about $45,000. But he wasn't complaining: if the picture appeared in LIFE magazine, it was worth it. That particular picture did not appear, but a few others that I had shot in the plant did. So everyone was happy.

In 1965 I was sent to the USSR, with a LIFE team that included the art director and a writer, to negotiate permission to take pictures for a book planned on the Hermitage Museum. LIFE had already published a three-installment, sixty-page story on the Hermitage which I had photographed a year earlier. Now they wanted me to take more pictures at the museum. Knowing that the Russians might ask for money, the LIFE editors authorized me to offer them three thousand dollars in advance plus fifty percent of the book's profits.

In the USSR representatives of foreign publications usually dealt with the official news agency, Novosti. At the conference table with Novosti management we explained our mission. The chief of Novosti agreed, but set a fee of thirty thousand dollars for arranging the necessary permissions. That was out of the question, I said; LIFE was to publish the book at a huge expense and Novosti would get fifty percent of the profits. "How will we know what the profits are?" he asked. I said that in our country everything is kept on the books so it is not easy to cheat. He smiled, and our first conference ended.

That same evening a Novosti representative, with whom I had worked before on other stories and with whom I was on very friendly terms, came to the hotel to have a drink with me. He offered his help to arrange an agreement. He said that his boss had exaggerated his demands and he was sure some-

thing could be done. "Now, tell me, Dmitri, what would be your counteroffer?" I said, "Two thousand dollars." He recoiled. "My God, Dmitri, I can't go back with that kind of offer. It is almost an insult. I will get fired if I even mention it. No!" So we had another drink in silence. After a while my friend said, pleadingly, "Come, Dmitri, make me another offer." "All right," I said. "My very last offer is three thousand dollars." "I'll take it!" he said.

It was a different story when I negotiated for Time Inc. with Henri Matisse to design a stained glass window for a corporate Christmas card. I was told to start with a fee of five thousand dollars, but it was implied that I could go much higher if necessary.

I had photographed Matisse on several occasions and we got along fine. I telephoned Lydia, his Russian secretary, who said that Matisse would see me at his home in Nice. When I told him what our people had in mind, he agreed to do a collage for the window for five thousand dollars. However, if the window were executed by a good window maker in France, so that he could supervise the final results, the fee would be four thousand dollars. I said, grandly, "D'accord." The collage and the window are now in New York in the Museum of Modern Art, a donation from Time Inc.

The moment I first set foot in Italy I fell in love with the country. With each visit I became more and more attached to it and to the Italians. I feel more at home there than in any other part of the world.

My first trip was in 1948, to cover the Italian general elections in Milan. It was a critical political moment in postwar Italy. The Italian Communist party was the largest in Europe, and there was a fifty percent chance that the Communists would win and take power.

Barbara O'Connor—a LIFE reporter in the Paris bureau—and I were driven to Nice, where we were met by Time-Life stringer Piero Saporiti. Saporiti was an Italian journalist who had spent the last years of the war working in Portugal. The day after our arrival in

Milan we met Vincenzo Carrese, a press photographer and owner of the most prestigious photo agency in Italy, Publifoto. That meeting developed into one of my closest friendships. Until Vincenzo's death in 1981 we tried to see each other every time I visited Italy.

In Milan that day Vincenzo lectured me on how to behave with Italian Communists. They were tough, he said, and they did not like journalists, especially press photographers. They felt that the press as a whole was anti-Communist. That evening we went to Milan's Piazza del Duomo, where the Communists and the Christian Democrats usually held their rallies, often very stormy affairs, which occasionally ended in shouting and fist fights.

We went through the Galleria, Milan's glass-roofed arcade lined with shops, bars, and restaurants. Carrese told me to stick close to him. At one point I saw the flash of his camera as he took a picture of someone a few feet in front of us. The next moment he was mobbed. When he broke loose, he looked pale and shaken. He was unhurt but empty-handed; his 9 x 12cm camera was gone. I rushed over to him and asked what happened. "Nothing," he said. "The damned Communists! I took a picture of one of their leaders. He did not want his picture taken." "What about your camera?" I asked. "They took it," he explained, "but I will get it back." Sure enough, a few minutes later a young fellow came over with the camera and told Vincenzo that they had exposed the film in the magazine to the light. That was my introduction to political demonstrations in Italy.

Two days later it was LIFE's turn. A mass meeting of the Communist party was scheduled that night in Duomo Square, and I wanted to photograph it. To get elevation from which to photograph an overall with the famous cathedral in the background, we—Barbara O'Connor, Piero Saporiti, a young, English-speaking, Italian assistant, and I—found a place on the second floor of an office building facing the square. We installed ourselves there long before the meeting started

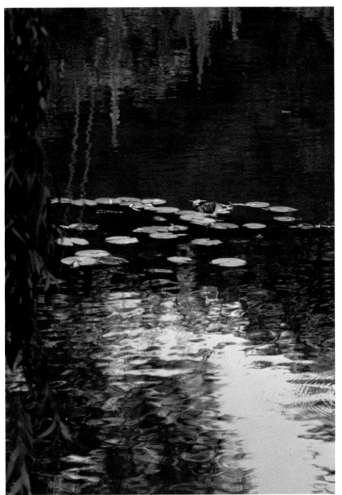

A section of Monet's "water-gardens" at Giverny, which he created by diverting a tiny river nearby, and which became the inspiration for some of his most famous work, including the *Nymphéas* series of his last years.

and set up the multi-flash system needed to illuminate the entire square.

Around ten o'clock, when the square was full and there was a great deal of shouting, I shot the first picture. The light from our four large flashbulbs seemed to paralyze the crowd. There was a split second of silence, then the crowd began shouting in rage. We heard banging on the locked door of the building. The concierge, panic-stricken, came up in the elevator. "Mamma mia! Mamma mia!" he kept shouting. Meanwhile, my assistant had the presence of mind to shove most of my equipment into the elevator and remove it to the floor above. Saporiti went with him. The assistant came back—without Saporiti—just as we heard the front door break open and the thumping of many feet running up the wooden stairs. There were about thirty men, led by a stocky, pugnacious-looking fellow

who kept his right hand in the pocket of his leather jacket to make us think he had a gun.

"*Macchine!*" (cameras) he shouted. My 4 x 5 camera was on a tripod. I had not used it; the first picture I shot was with a Rolleiflex. So I handed him the unexposed film pack that was in the 4 x 5 camera. He went over to the open window, shouted to the crowd below, and threw it down. The crowd responded with a roar of approval. I asked the interpreter what the man said. "Here is the film! Next I will throw the photographer!" he translated. Barbara O'Connor was very frightened. Having noticed, however, on several occasions, that in Italy when opposing parties face one another there is a great deal of noise but seldom any bloodshed, I was not too worried.

Below in the square, some Communists had started a little bonfire and were burning my film. Some of the men who had confronted us full of fight in the office began to drift away after our interpreter told them that we were American journalists working for LIFE magazine. Only the leather-jacketed leader was still belligerent. I told him, through our interpreter, that I did not think he was a Communist at all, but rather a *provocateur* trying to bring about an international incident by attacking foreign correspondents, thus making the Communists lose face. As the interpreter was translating all this, I continued: "I can tell a *provocateur* when I see one. I am a Russian and lived through the Russian Revolution and have met many *provocateurs*. You sound and act like one of them." Down below, the crowd began to chant, "Saporiti! Saporiti! Dov'è, Saporiti?" We did not know how they knew that Saporiti was with us, but his name was familiar in Milan: his father had been a member of the Fascist government.

I continued talking with the leader. "Tell you what," I said. "Tomorrow morning I will be at the Communist party headquarters. Let's meet there. I want to face the party leaders with you. Name the hour!"

"Sure you'll be there!" he said skeptically. "Do you expect me to believe that?"

"I will be there whether you are or not," I replied. "I am going to make a complaint. Would you please give me your name?" Of course, he would not. I saw that he was beginning to lose his cockiness. His followers split into little groups, conferring *sotto voce*, and then began to drift slowly toward the exit. The crowd below was still repeating, "Saporiti! Saporiti!" as a squad of *celere* (Italian special police) led by a major burst into our room, machine guns at the ready. They did not arrest anyone but simply told the intruders to scram. We collected our equipment and left. There were four police jeeps in the square. The crowd kept on chanting, "Saporiti! Saporiti! Fascista, Saporiti!" There, in the middle of the crowd, shouting his own name, was Piero.

The major told us to get into his jeep, he would take us to our hotel. We got in, and, as we were about to start, Piero jumped in, too. We reached the hotel by midnight. Before leaving the major advised Piero to return to France.

The next morning we went to Communist party headquarters, where we were met by the party's public relations officer. He was a short, intellectual-looking young man with rimless glasses. He apologized for what had happened the night before. The incident had been reported to him, and he was grateful that we had come to see him so he could explain.

"There was a misunderstanding," he said. "You see, recently we have noticed that some priests or monks, agitators working on behalf of the Christian Democratic party, were coming to our peaceful meetings to provoke incidents that would give the police an excuse to break up the meeting. This happened last night. A young priest got into a violent argument with some of our comrades in the square. As they were ganging up to get rid of him, you took your picture. They looked up in the direction from which the flash was fired and saw you, with a monk standing next to you on the balcony. So they thought it was a planned provocation. One monk starts a fight and another takes the picture, in order to

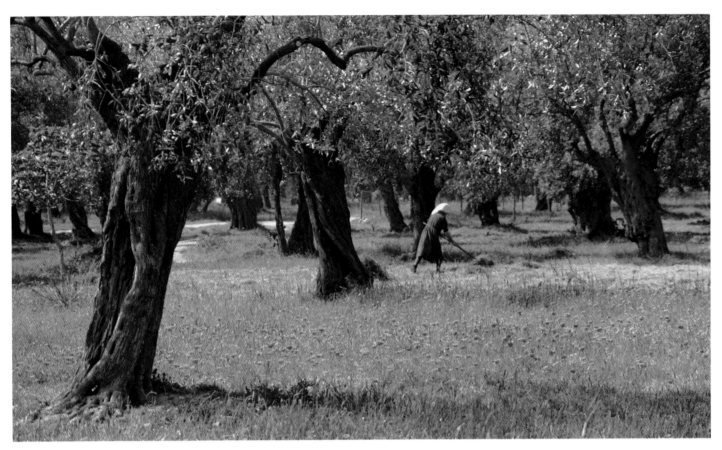

On the Greek island of Thasos in the northern Aegean, a woman works in an olive grove, taking care of that staple of the economy and of the Greek diet.

have it published in capitalist publications, to show us attacking a poor, innocent priest. As it turned out, they realized too late that they mistook you, miss," he smiled at Barbara, "for a servant of God."

I could see his point. Barbara O'Connor was a tall, slender girl, and she had been wearing a long black overcoat that night. Silhouetted against the light of the room, she could easily have been taken for a monk. The Communist public relations man apologized and assured us that we were perfectly welcome to cover all his party's pre-election activities. We were issued letters promising fullest cooperation and assistance from the members of the party in carrying out our task. They even gave us a sticker for our car windshield indicating that we were friends. A young man was assigned to accompany us whenever we planned to photograph Communist meetings or demonstrations. So we were "in" with the Communists and, also, of course, with the Christian Democrats. Now we could cover both sides freely.

In the spring of 1949 I was doing a story on formal Italian gardens. Milan was the jump-ing-off point for Villa d'Este on Lake Como, Lago Maggiore, and a mansion near Genoa, Castello di Montalto Pavese. When I arrived in Milan and told Carrese what I was supposed to do, he said, "All right, we go!" "Wait a minute," I said. "It is very nice of you to offer to help but I was planning to hire a car with a driver to get me to all these places." He just waved me aside. "We go!" There was no arguing with him. He was very stubborn, and I knew he would be hurt if I refused his offer. So we went. He took me to Villa d'Este, a short drive from Milan, and left me there. Two days later he came back to take me to Lago Maggiore, where I stayed for almost a week. Again he picked me up, this time with his wife, Lydia, to drive back to Milan. A day later he drove me to Castello di Montalto Pavese. This was the most spectacular garden I have ever photographed, and before I knew it, I ran out of film. We had been invited to lunch, but Carrese excused himself, saying he had to see someone in Genoa. He promised to be back

shortly. What he did was drive back to Milan, almost sixty-five miles; by the time lunch was over, he was back with more film. He was a very good, very fast driver; on our way to the castle he drove his Alfa-Romeo at eighty-eight miles an hour.

It was Vincenzo who, in 1965, arranged for me to be knighted by the Italian government. He felt that I deserved the rank of "Cavaliere della Repubblica" for all the publicity Italy received from the stories done by me and published in LIFE. I would be in illustrious company: other foreigners who held the rank were Charles de Gaulle and John Glenn.

When he telephoned to tell me that I was to be knighted, Vincenzo said he thought it would be wonderful if I would come to Milan personally, so that the prefect of Milan could present me with the decoration in a small ceremony.

If I could not come to Milan, I could pick up my decoration at the Italian embassy in Paris. LIFE's editors, however, thought I should certainly be there for the presentation. I called Vincenzo to tell him I was coming and begged him not to make a fuss about the decoration ceremony. "No, no," he said, "just a few friends."

I should have known better. It involved more than "just a few friends." First, there was a ceremony in the prefect's palace, which Italian television had floodlit for their coverage. After the ceremony Carrese hosted a lunch for sixty people, including government officials and press, at the Circolo della Stampa (Press Club), which was housed in the Palazzo Serbelloni, an ornate edifice where Napoleon once slept.

The medal of "Il Cavaliere dell'Ordine della Repubblica Italiana" is not the only decoration I have received from a foreign government, but it is the one of which I am most proud.

My favorite city in Italy—in all the world — is Venice. I love Venice, its hordes of tourists, its millions of pigeons. I love the sounds and smells of the city. I love the canals and the darting *vaporettos* and their stations with romantic names like "San Zacharia," "Salute," "Accademia," "Giudecca," "Ca D'Oro." I love the elegant crumbling palaces leaning drunkenly every which way along the canals; the gondolas and the amiable thieving gondoliers; the great hotels, formerly noblemen's palaces: Venice, the city that looks the same today as it did when it was painted by Canaletto, Carpaccio, Guardi, and Bellini. Their paintings, copied and sold today as postcards at newsstands, are like present-day color photographs.

Venice to me is a most relaxing city. There are few madly rushing pedestrians and, most important, no automobiles. You can even walk the streets reading a newspaper—of course, you may fall into a canal if you get too absorbed in the news. There are no car horns honking, no police or fire-engine sirens. All you hear are the muffled rumble of boat engines, the occasional sound of a boat horn, the tolling of the Campanile bells. And, above all, you hear the sound of human voices, especially laughter.

I have photographed Venice in the winter when a rare heavy snowfall turned the city into a fairyland. I have photographed it when the city was flooded with *aqua alta* (high water), when gondolas could be seen floating in the Piazza di San Marco. In sun, rain, fog, snow, photographing Venice was, for me, a labor of love. On my way to the Venice airport or to the railway station to leave the magical city, I am always overcome by a wave of sadness and a longing to come back soon.

In January 1947 I was sent to the Yucatán, Guatemala, and Honduras to do a story on Mayan civilization. The assignment was triggered by the success of a book just published on the subject by Dr. S. G. Morley, an associate of the Carnegie Institute, who had studied the Maya for forty-two years. At the time, all I personally knew about the Maya was that they were Central American Indians with a very interesting history. But Dr. Morley had offered LIFE his fullest cooperation, so

I felt better, although I was warned before I left to be very tactful with him, as he was a venerated scholar.

At seven o'clock in the morning, just three hours after my arrival in Merida, I was awakened by banging on the door of my motel room. Wearing only my undershorts, I opened it. There stood a chubby little "Mexican" in an enormous sombrero, white shirt billowing over his cotton trousers, sandals on otherwise bare feet. I was just about to slam the door on him when he asked, "Kessel?" "Yes," I answered. "Hombre! I am Morley!" he shouted, and he threw his arms around me.

Dita Camacho, then assigned to LIFE's Mexico City bureau, was also in Merida when I arrived. Born in France of Colombian origin, Dita spoke perfect Spanish and was to work with me during my stay in Mexico.

We were in the hands of Dr. Morley, who lectured us on Mayan history and made lists of pictures he felt essential to our story. He asked his contacts at various sites to give us full cooperation and he found a Mayan interpreter for us. He had a standby crew of three men with machetes ready to clear paths through the jungle to secondary monuments in case we decided to photograph them. He also suggested that we photograph a contemporary Mayan against a sculpture of an ancient Mayan in order to show the continued resemblance.

The most photogenic sites were Uxmal and Chichén Itzá, which had imposing temples, great pyramids, a ball court, and an observatory. While working in Uxmal we went to the nearby town of Tikul to look for the Mayan to photograph. It was market day and the town was full of farmers. We went to see the mayor, who was expecting us. Dita went into the town hall to discuss our quest with the mayor while I waited in the courtyard. A few minutes later she and the mayor came out, and before Dita had time to introduce us the mayor pointed straight at me and said, "*There* is a perfect example of a true Mayan." I was very sunburned and, like some of the natives, wore a khaki shirt and slacks.

Dita burst out laughing and told the puzzled mayor who I was.

Dr. Morley believed that Mayans were of Asiatic origin. He claimed that every true young Mayan child has a purple spot at the base of his or her spine, just as those of Mongolian races do. He suggested we photograph a child with such a spot. Since it would be embarrassing to ask a woman in the street with a baby in her arms whether her child has a spot on its spine, I devised a trick. Along with my young assistant and my middle-aged Mexican driver (who was quite a comedian), Dita and I went to an outskirt of Tikul populated by Mayans. When we saw a woman with a baby, the driver would stop her and, cooing over the infant, tell her what a beautiful child she had. Then he would ask her if he could hold it for a moment. When he took the baby my assistant would surreptitiously lift its skirt. After several tries, we found one with a spot. The mother had no objection, so I photographed its bottom.

Another picture Morley suggested was of the beautiful Temple of the Sun at Palenque, the great cultural center of the old empire, deep in the Chiapas jungle. We flew first to Tuxtla Gutiérrez. From there one could either charter a plane or travel by donkey for four days; we chose the plane. At the airport we were met by a tall Mexican who told us that there had been a slight change in plan. "That was your pilot," he said, pointing to a bandaged body being loaded into an ambulance parked on the runway. "There was a little accident, so I will fly you instead."

After two days in Palenque—making a total of two months on the entire Mayan assignment—I headed back to New York. As soon as the plane landed at La Guardia airport, I heard an airline hostess paging me: there was a message to telephone my office immediately. When I called from the airport, Wilson Hicks, LIFE's executive editor, told me of two assignments in the works—one in India, the other in South America. He wanted me to choose between the two. When I asked if I could think about it, he told me that the

41

decision had to be made that day because the photographer going to India would have to leave almost immediately. "In that case," I said, "I'll take South America, which I hope is not as pressing as India." "Fine," he said. "You can leave in a couple of weeks. But I should warn you, it is a long assignment. There are four stories to be done and you may have to stay there about five months."

The biggest assignment in South America that trip was a story on the Andes. The Andes!—3,500 miles of majestic scenery stretching along the west coast of South America. Snowcapped mountains and extinct volcanoes, lush tropical rivers, the great Atacama Desert, Lake Titicaca at an altitude of 12,500 feet, monuments of ancient Inca and Spanish colonial civilization: what a treasure for a photographer!

In Ecuador I photographed Mount Chimborazo, a 20,500-foot-high extinct volcano. It was a comparatively short trip, about 150 miles from Quito, where we were based, to Chimborazo.

We went to the spot, chosen the day before, from which I planned to shoot the mountain. It was a beautiful morning with a sky absolutely clear except for a single cloud that covered the snowcapped peak of the mountain. We sat for hours waiting for the cloud to disappear. But instead of passing away or rising it simply circled the peak, obscuring it the entire time. It was the same story the next day. On the third day we were lucky: the peak was in the clear for about fifteen minutes, long enough for us to take our picture.

Glacier Lake Parron in Peru is 13,645 feet high. I had taken aerial pictures of it but I also wanted to photograph it from the ground. Dr. Hans Spann, a young German geologist who worked for the Peruvian government, and I planned a trip up to the lake. We hired an Indian guide and five horses, three for us and two to carry our equipment or, if necessary, to be used as spares.

It was unlikely that we could get there and back on the same day, so we prepared to spend the night near the lake. The evening before our departure we went to the local bakery to buy some bread for our trip. Much to our dismay, the buxom Indian shopkeeper said she was out of bread. After a long and heated discussion she stuck her hand in her blouse, pulled out four rolls, very warm, and sold them to us for double the price.

We left at daybreak. The area through which we were traveling was infested with flies that carried a terrible disease, *Verruga Peruana*. The flies come out only at night and at low altitudes. To prevent the spread of the disease the government had burned down a number of Indian villages and moved the inhabitants elsewhere. Both natives and travelers were forbidden to be out after dark, and anyone who spent the night in the open was liable to be quarantined for ten days in the clinic of a nearby research center.

At first our climb was gradual. But as it became steeper our horses began to breathe heavily, and soon they sounded like steam locomotives. After a while I could no longer stand their wheezing. I dismounted and continued on foot, holding on to the saddle's stirrup. Soon I began to breathe as heavily, if not as noisily, as the horses. We made frequent stops to rest and catch our breath. It took us more than five hours to get to the lake shore. When we arrived there was nothing to see— we were in a cloud. My companions began to set up lunch while I got my cameras ready. Suddenly the cloud began to lift. It was an eerie sight, like a slow-motion film; a rising curtain of fog revealed a sapphire-blue lake and then the jagged mountain peaks around it. I shot a sequence of the scene, ending with a shot of the lake and the mountains in the clear. I had my picture.

The Indian guide assured us that if we started back right away we could get home before dark. We had a quick bite and began our descent. In single file we rode, with me at the head, followed by the geologist and then the Indian guide leading the two spare horses. Soon after we started, one of the spare horses got loose and wandered off. The geologist and I waited for about an hour before our guide

found the horse and we could resume our descent. Later the other horse got away, and the guide went after it. We waited for what seemed hours. Finally the geologist went looking for the Indian. I was alone, and the sun was setting fast, so I just let my horse amble on, hoping he knew his way back.

It soon got dark. I was wearing riding breeches, boots, gloves, and a parka with a hood, which I lifted over my head, pulling the string tightly at the neck, so that only my face was exposed. I kept tapping my face constantly to prevent the killer flies from settling. It was late at night when I heard the sound of trotting horses behind me. My companions had finally caught up with me. We dismounted on the outskirts of the village and proceeded on foot to the inn where we were to spend the night. Once there, we spread some money around to keep our nocturnal wanderings secret. "You don't want to spend ten days in quarantine, do you?" asked the geologist. "If they hear in Lima that we were out after dark, they could easily send us back here to be quarantined."

Working at high altitudes is a strain on the heart and lungs. Lack of oxygen can bring on high-altitude sickness called *soroche*, which causes excruciating headaches. One evening in La Paz, about twelve thousand feet high, I saw a Pan Am crew check into a hotel with small oxygen tanks. I asked if they intended to sleep with the oxygen masks on. They laughed but told me they always kept oxygen with them in case of headaches.

I soon found out what altitude sickness was. I was photographing in Potosí, a very picturesque town about thirteen thousand feet high in the Bolivian Andes. With its narrow cobbled streets and old Spanish architecture, Potosí had retained its colonial charm. Silver lodes had been discovered there in 1545, and Emperor Charles V conferred upon the town the title of "Villa Imperial." One evening I was walking with our Bolivian correspondent, Walter Montenegro, along the almost deserted main street when we saw a neon sign, "American Bar." I suggested we go in, but Walter was against it. "Alcohol at this altitude," he said, "is poison. It will kill you." But I wanted to see what the bar was like.

We walked in. A single customer was seated at the bar, a bottle of Old Grandad bourbon in front of him. He introduced himself; he was an American engineer working for the Bolivian government. He was living alone and lonely. There were no real American bars in Potosí—this one was in name only. He came here with his own bottle to have a drink or two. He invited us to have one with him. Walter refused, saying he could not drink at high altitudes, and cautioned me again to take it easy. I had two drinks with the hospitable engineer, who seemed happy to have someone to keep him company.

We stayed in a motel, a crude replica of an American roadside motel. My room had no windows. I woke up during the night with a murderous headache, gasping for breath. I staggered out of bed and opened the door. It was a very cold night, and I gulped the freezing air. After a while, cold and shivering but feeling better, I went back to bed. I swore off liquor for the duration of my stay at high altitudes.

The final assignment on my South American list was a story on the exclusive, prestigious Jockey Club of Buenos Aires. Buenos Aires!—where in those days a luscious two-pound steak cost only about twenty-five cents and where if you ordered a "whiskey," you got a four-ounce shot of Scotch in a glass. (If you wanted less, you ordered a "half-whiskey"; that was two ounces.) And where you never had to worry about *soroche.*

In June of 1964 LIFE sent me to Leningrad to photograph the famous Hermitage Museum. It was my first trip back to Russia since I left it in 1922. I was a bit nervous, wondering what my emotional reaction would be coming back to the motherland. When my wife, Shirley, and I got off the plane in Leningrad, I felt no emotion whatsoever, but was slightly worried about customs clearance of the half dozen cases of photographic

43

equipment I had with me. There were no problems because we were met by Felix Rosenthal, our Russian correspondent, who knew his way around, and we were on our way to the hotel by midnight. It was still light outside: it was that time of year the Russians call the "White Nights" because there are almost twenty-four hours of daylight.

Driving to the hotel, I looked out the car window, searching for a sign of the Russia I remembered. But there was none. Leningrad had been built by European architects, mostly Italians—Bartolomeo Rastrelli, Giacomo Quarenghi, Carlo Rossi—and it looked like an eighteenth- or nineteenth-century European city. It had nothing of my boyhood Ukraine in it.

After a year of negotiations with the Russian authorities for permission to photograph the Hermitage treasures, LIFE got a general clearance for the story. But we were limited to photographing only one hundred works of art. Dorothy Seiberling, LIFE's art editor, and her husband, Professor Leo Steinberg, an art historian, were already in Leningrad when I arrived. Pepi Martis, a lighting expert and assistant who worked in the Paris LIFE bureau, was to join us later.

The first task for Dotty and Leo was to choose the hundred objects of art and archaeology out of the more than one million on display. To see all the objects, one had to walk through the 322 exhibition halls of the museum, about fifteen miles. The museum consists of four buildings, five including the theater. Originally, the "Winter Palace" was built by Rastrelli as a 1,050-room residence for the Empress Elizabeth, Peter the Great's daughter.

For days Dotty Seiberling and her husband walked through the museum making their selections. Finally the list was prepared and sent to Moscow, to the Ministry of Culture, for their okay. We were told that approval would be granted or denied in a couple of days. Meanwhile, Pepi arrived from Paris. The museum assigned to us two young student assistants, two electricians, a custodian,

a fireman, and a curator. There were also two photographers from the Russian news agency, Novosti, who were there to learn our Western methods of photographing works of art.

At first the museum stipulated that no pictures could be removed from the walls. We would have to photograph them where they were and only on days when the museum was closed to the public, which was Thursdays. That was a big problem. Technically, for best results in copying, a painting should be illuminated by specially controlled artificial light; daylight and artificial light cannot be mixed. This means that paintings should be copied in windowless rooms or at night when no daylight enters. In Western museums, photographers copying paintings are allowed to work at night. This was out of the question as far as the Hermitage was concerned. Had we been permitted to work at night it still

The columns, table, urns, etc. in the Hermitage Museum's Malachite Hall are all made from malachite quarried in the Ural Mountains. Visitors from all over the USSR flock to the Hermitage, averaging more than 5,000 per day, twice that on weekends, not to see the individual works of great art held there, but to walk through the halls of the palace itself—the prerevolutionary home of the czars.

would have been difficult since daylight lasted almost around the clock. So we pressed the museum administration to give us a room we could black out; we could then shoot the paintings, at least the small ones, there.

We realized that the very large paintings, especially Rembrandt's *Prodigal Son* and *Danae*, could not possibly be moved. So we began to make arrangements to photograph them where they were. Fortunately, they were hung in the same gallery, not far from each other. There were fourteen large windows in the gallery, each about eighteen feet high. To black out windows we usually use rolls of black background paper from six to eight feet wide, which is both simple to use and inexpensive. No such paper existed in Russia, so we had to use black cloth. We went from store to store before we finally found the only material that could serve our purpose: black gabardine, used mainly to make raincoats. There were 150 yards of it on the shelves of the store, and we bought it all. That raised the suspicions of the salesgirl: "Why should Americans want all our gabardine?"

The authorization finally arrived from Moscow. We decided to begin that first Thursday with the paintings of Rembrandt. It took us half a day to black out the exhibition hall, using our gabardine over the windows. First we photographed the *Prodigal Son*. It was about three o'clock when we got set up to shoot *Danae*. Suddenly, a little Russian man appeared and told us to stop. "Why?" I asked. "There is a Japanese delegation visiting the Hermitage," he said. (In Russian, any official visitors are a *delegazia*, even if there are only two of them.) I told the little fellow that we would stop as soon as his delegation, which was still miles away, reached our location. "No, no," he said very authoritatively, "you have to stop now and move your equipment out of the way." I said I would not do it until I had finished photographing *Danae*. His eyes popped; he could not believe that anyone, especially a foreigner, would refuse to obey his orders. He glared at us for a second and then disappeared. A few minutes later we saw

a tall figure coming down the aisle. It moved toward us in slow measured steps. It looked as though Peter the Great himself had dismounted his horse and was coming to get us. As the figure, clad in a blue uniform with gold shoulder bars, approached, we saw that it was a woman, the chief of museum guards. There are four hundred guards in the Hermitage, and almost all of them are women. The chief was handsome with a pleasant face. As she stopped in front of us, Pepi, who usually stutters when he gets excited, bowed low to her. "B-b-bonjour, m-m-madame," he said. "M-m-mes compliments, m-m-madame." She smiled. "Chto ohn govorit?" (What does he say?) she asked Felix. Felix translated. She smiled again. Then Felix told her that it took us most of the day to get set for the picture and it would take us another hour to finish. She told us to go ahead.

When the museum director learned that it took us an entire day to do only two paintings and realized that at that rate we might be in his hair for months, he assigned us a room in which we could work six days a week, copying paintings that were brought to us. We finished the job in three weeks.

That first assignment in Russia lasted five weeks. I spent all of it, except for three days in Moscow, in or around Leningrad. I had no interest in visiting the Ukraine, even if the Russians would have permitted it (unlikely, since where I had lived was not part of their Intourist set-up). My two sisters who had remained in Russia were dead. Their children were still living somewhere in Russia, I knew, but we had heard nothing from them in years, and I felt it was probably better for them if I made no attempt to find them.

I have since returned to Russia on assignment many times—for stories on the movie industry, Siberia, the composer Scriabin, and, in 1979, the pre-1980 Olympics. The Russians were always cooperative and sometimes friendly. But even though I felt "in" because I spoke the language, I never felt that I was visiting my homeland. For me, every trip there was just another assignment.

story suggestions for LIFE flowed in regularly from a variety of sources: correspondents and stringers in the field; department editors and reporters in the New York office; and occasionally, non-editorial executives who, on their trips in this country and abroad, came across something they thought might make a LIFE story. Bureaus had the authority, and were expected, to hop on any fast-breaking news story without waiting for clearance from the editors in New York. But for almost any other kind of story, a suggestion had to be okayed by New York.

That procedure, I learned, seemed to apply even to *le grand patron* himself, Henry R. Luce, founder and editor-in-chief of Time Inc. In 1952 I was on assignment in Spain where Mr. and Mrs. Luce were on vacation. One day, at lunch in a Madrid restaurant, Luce asked me whether I had been to Valladolid and seen the polychrome art at the National Museum of Sculpture. I said I had. "Don't you think that museum is a natural story for LIFE?" he asked. I agreed. The Luces had visited it the previous day. "When you go to Valladolid," asked Mrs. Luce, "would you please photograph for me personally the little angel that is on the pedestal in the right corner of the second exhibition hall? I want to use it for a Christmas card." "I would be glad to," I said, "if I go there." "*If* you go there?" she gasped. "What do you mean *if* you go there?" Then, turning to Luce, who was in conversation with Dita Camacho, she said, pointing to me, "Henry, he is not going to Valladolid." Luce turned to me. "Why?" he asked. "Don't you like the idea?" Very tactlessly I said, "I have not been assigned yet," meaning that I had not been assigned by LIFE editors. "Don't you worry," Luce said. "I will sell this story idea to Ed Thompson." Ed was managing editor of LIFE at the time.

We were to continue working in Spain for three more weeks or so. To clear the Valladolid story suggestion, Dita Camacho sent a cable to the chief of foreign correspondents in New York telling him about the conversation with Luce and his interest in the story.

She asked him what we should do about it. The answer came back: "Nothing."

A year later Luce was in Paris. At a cocktail party given for him at the Hotel Crillon he talked enthusiastically to Dita and me about a picture story idea on Tyrol in spring when the apple trees are in bloom. Tyrol is famous for its acres and acres of apple orchards. He wanted them to be photographed from a helicopter. He had forgotten about the Valladolid story, or at least he never mentioned it, and I never did find out whether he tried to sell it to Ed Thompson or not.

We sent a telex to New York about the Tyrol story. The editors were not interested.

Almost two years later I was in Rome and was invited to dinner by Luce at Villa Taverna, the United States ambassador's residence. Claire Luce was then the ambassador to Italy. The dinner was for Gene Farmer, LIFE foreign news editor, who was in Rome; Jim Bell, *Time* bureau chief in Bonn, and Frank White, *Time*'s Paris bureau chief, were also there. During dinner the Tyrol story came up again. Luce turned to Farmer and said, "I've tried to sell this story for years without success. Now, Gene, do you have authority to assign Dmitri to do it?" "I guess so," Gene mumbled, not very sure of himself. Luce then turned to Jim Bell. "I am sure you can get a helicopter," he said, meaning from the United States military in Germany.

When we got back to the Excelsior Hotel, where we were all staying, and settled in at the bar for a nightcap, Jim Bell turned to Gene Farmer, who did not look too happy, and said, "Well, Gene, what are you going to do about the Tyrol story? Luce has been bugging us about it for years." "I'll think about it," Gene said. The next morning he found a solution. He sent a telex to New York addressed not to Ed Thompson, the managing editor, but to the assistant managing editor in charge of the editorial budget. "Luce just assigned Dmitri Kessel to shoot the story on Tyrol in spring. So I suppose we have to do it." The assistant managing editor was not about to argue with the boss. He telexed back for us to go ahead.

When spring came, we went to Tyrol. Pepi Martis drove us to Innsbruck. He had been assigned to work with us on the Tyrol story, which made him very happy since he was Austrian by birth. John Dille, LIFE's Bonn bureau chief, met us at Innsbruck. He had already made arrangements to charter a helicopter from a Swiss company; the military in Germany could not provide us one since our story had nothing to do with the U.S. military presence in Germany.

The helicopter was supposed to arrive in Innsbruck the day we arrived or the next morning. Meanwhile, we drove out to see the apple orchards. The trees were not in bloom. Pepi asked a passing farmer when he thought they would be blossoming. "Well," he said, "the trees should be in flower in about a week or so. But there will not be many blossoms this year because we had a very heavy crop last year. This one should be very poor. It usually goes that way." Since we had the helicopter anyway we decided to shoot some of Tyrol's beautiful valleys and rivers and leave the blossoms for the following year.

Tyrol in spring is a panorama of natural splendor. The emerald-green valleys are framed by snow-capped mountains. Freshly mown hay piled in man-sized stacks fills the broad Ziller Valley, row on row, like a great army of soldiers lined up for parade review. Along the winding Inn River picturesque villages with neat two- and three-story chalets, some with frescoes painted on their walls, nestle side by side. Ruined medieval castles and elaborately decorated Baroque churches sit on the hilltops. Mountain streams fed by melting snow rush madly down the valleys. Tyroleans greet the spring with colorful festivals; concerts, dances, and costume parades offer unlimited picture possibilities.

The farmer was right: there were not many apple trees in blossom. We went to Tyrol the following spring for a few pictures of the blossoms to go with the pictures we had already taken. The essay on Tyrol ran in 1957—four years after Luce had made his original suggestion.

Luce had faster success with another of his story suggestions. Deeply interested in international affairs, he used to travel extensively all over the world to see for himself what was happening, politically and economically, in areas he judged vital to American interests. In 1950 he toured Iran, which was then stirring violently to nationalistic sentiments. There was a serious campaign in the country to drive out the Anglo-Iranian oil company, then the largest producer of oil in the Middle East, and nationalize Iran's oil industry. The United States and the rest of the West were worried that the turmoil might result in Russia's increasing control over the area. As LIFE put it a little later, "Men everywhere wonder if Iran's oil will feed the fires of World War III."

Luce had been given a red-carpet tour of the country, including a rare—for civilians—visit to the Russo-Iranian frontier. On his way back to the United States Luce stopped off in Paris to have lunch with the bureau staff to tell us about his impressions of Iran. What seemed to have made the greatest impression on him was his trip to the frontier. One small town there is divided by a river spanned by a railroad bridge. Smack in the middle of the bridge was a locked iron gate. That was the frontier: to the north is the Soviet Union; to the south, Iran. In describing that scene Luce became very animated. "My God, I actually faced the Iron Curtain! *That's* the picture, Dmitri. You've got to do an essay on Iran."

Not many people on LIFE ever questioned Luce's suggestions where political matters were concerned. I don't know whether he cleared the essay with the New York editors or not. In any case reporter Dita Camacho and I went to Iran.

Like Luce, we too were given red-carpet treatment. Both the minister of the court of the shah, Hussein Ala, and the prime minister, General Ali Razmara, were extremely cooperative. Razmara gave us his home telephone number and said, "Call me if you have any problems." During the four months we were there we saw him about four times at his home and several more times in his office. In

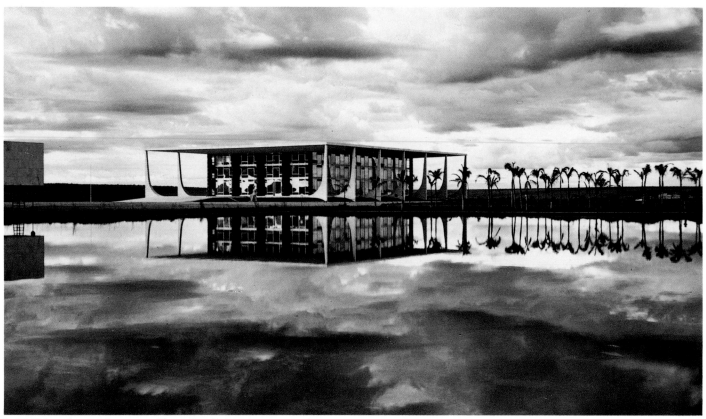

In 1960 Brazil moved its capital from Rio de Janeiro to a newly created complex of modernistic buildings and gardens set down at Brasília in the middle of the jungle 580 miles northwest of Rio. This is the new Supreme Court Building.

his home he had an American-style bar of which he was very proud, but when I asked for a martini, he said, "Better mix it yourself, I don't know how to make a good one yet."

Like Luce, also, we were permitted to visit, and to photograph, the Russo-Iranian frontier, a great scoop during that time of the Cold War. We drove the length of the frontier, surreptitiously photographing with a telephoto lens the Russian installations and sometimes the Russians themselves.

An Iranian colonel accompanied us. Whenever we were in sight of the Russians, he insisted that I wear an Iranian officer's cap. One night at Jolfa (a border town half in Iran, half in Russia, divided by a river) we heard a loudspeaker blasting from the Russian side that a team of American spies, posing as journalists, was driving along the Russian frontier and photographing it. The Iranian military was very nervous, afraid that the Russian frontier guards might take a shot at us, especially where the borders between Iran and Russia were ill-defined, marked only by a

plowed furrow between the two countries. We were told that sometimes the Russians would sneak out during the night and plow a new borderline a few yards deeper into Iranian territory.

One very cold night on a narrow ice-covered road we had to stop because of an overturned truck lying across the road. There was a steep drop to the right of the road and a high bank on the left. There was no room to pass and no one in sight: evidently the driver had gone on foot to the next village for help. We did not know what to do, so we waited.

Our big rented American car had no heat but it did have a radio. The broadcast we heard was loud and clear in Russian. A Kolkhoz chief of Russian Azerbaijan was saying: "Under the leadership of comrade Stalin our chickens this year laid eight hundred thousand eggs." I translated for Dita and our Iranian colonel, who thought I was joking. It was getting very cold, and we began to worry about the prospect of spending the night there. Suddenly we saw lights approaching behind us. They were from Iranian tanks patrolling the frontier. After a short conference between the tank unit commander

and our colonel it was decided that we should back up our car to the wider stretch of the road so that one of the tanks could pass and push the overturned truck to one side. After that, we continued on our way.

We traveled along the Russo-Iranian frontier for almost three weeks. Tabriz was the only town with a hotel, a dilapidated, two-story structure with little heat and no plumbing except for a filthy communal toilet on the ground floor. Outside of Tabriz, we would spend nights either in one of the numerous army camps along the frontier area or, as arranged by the army, with well-to-do Iranian families.

Once we spent the night with a very rich family. They "owned six hundred villages," a typical Iranian expression to evaluate the wealth of landowners. In Iran most of the arable land belonged to several families, including the royal family. The tenant farmers who worked the land had to turn over four-fifths of the crop to the landowner, who supplied them with seeds for planting and let them live on the land. The landlord was absolute owner of not only the land but also the settlements or villages where the tenant farmers lived.

The family we stayed with lived in a great two-story mansion made of brick and carved wood in the style of the summer mansions built by the Russian nobility at Crimean resorts on the Black Sea. It had some twenty rooms but no running water or toilet. There was a primitive outhouse in the courtyard.

There were now two colonels in our party, including the commanding officer of the frontier garrison of the area. We were served a sumptuous dinner of quail grilled on a spit and a variety of rice pilafs, which we washed down with vodka. When Dita, before retiring, asked to be directed to the ladies' room, she was sent out in the night with a man carrying a lantern and a shotgun. When I asked what the gun was for, our hosts told me it was to keep away the wolves who often came into the courtyard at night.

Part of the Iran assignment took me to Abadan to shoot Anglo-Iranian's oil refinery, then the world's largest. Reporter Camacho remained in Teheran to work. When I met her back at the capital, she was in tears as she broke the news: Prime Minister Razmara had just been assassinated. Four days earlier he had submitted a report to the Iranian parliament that nationalization of the oil industry was not feasible. (Mohammed Mossadegh, a fiery nationalist, became prime minister the following month. Within three days of his accession to power a bill proposing nationalization was passed and approved by the shah.)

Our essay on Iran ran for twelve pages in June 1951 (the picture of the railroad bridge at Jolfa that had piqued Luce's interest made the layout, but only about the size of a playing card.) The essay was titled "The Fires of Iran" with a subhead reading, "In the land of ancient Persepolis, oil feeds new flames." Among the things LIFE said in the story was: "there is serious danger Iran's blazing nationalism may spread oil anarchy across the whole Middle East, giving the Reds a chance to move in." *Plus ça change, plus c'est la même chose.*

When photographing landscapes, seascapes, or cities, a photographer is faced with the problem of doing something special, not just a postcard picture, not even a beautiful postcard picture. To come up with something extraordinary, the photographer must study his subject from sunrise until sunset to determine the best time to photograph it. The important factor, of course, is weather. In most cases fog or mist or rain are enemies. But in some cases they are welcome.

I am not an early riser and hate to be awakened at daybreak. But there are a number of striking pictures I have taken at dawn. Mauro Sales, a young Brazilian newspaperman who helped me with a story on Brazil in 1957, urged me to take a picture of Rio de Janeiro at sunrise. I was not eager, and, besides, a picture of Rio was not really essential to a story on the industrial development of Brazil, which was my assignment. But the

day before my departure I finally gave in to Mauro. He picked me up at 3:30 A.M. and we drove up to Corcovado mountain, where the famous statue of Christ looks down on the city. We set up cameras on tripods just as the sky in the east began to turn orange. Sugar Loaf mountain, silhouetted against the now golden sky, was obscured in the middle by a passing cloud. It was a breathtaking sight. I was extremely grateful to Mauro for getting me out of bed.

As illustrations for Churchill's *History of the English-Speaking Peoples*, I photographed several historic English battlefields. In 1265 at Evesham Prince Edward destroyed the forces of Simon de Monfort in a bloody battle that lasted two hours in fog and rain. Today the place is farmland with a farmhouse and stacks of empty vegetable crates—nothing to suggest that a ferocious battle once took place there. But seen vaguely through a heavy fog the crates seem to resemble ammunition boxes, and one can imagine that ancient battlefield. Had this picture been taken in spring in bright sunlight, it would have looked like a lyric English countryscape.

In France, for the same story, I photographed the battlefield at Crécy-en-Ponthieu where, on August 26, 1346, Edward III, king of England, defeated the French, led by Philippe VI, king of France. There is a cross in the field erected in 1360 on the spot where Jean de Luxembourg, the blind king of Bohemia (allied with Philippe), having begged his men to lead him into battle, was killed. We were taking the picture at sunrise in December 1955. The light was very weak, and color film, which at that time was very slow, needed a long exposure, about two or three seconds. In the background a farmer was plowing his field, moving behind his horses. He would have made an undesirable blur in my picture. I wanted to have him in it, if only he would keep still. But because in a couple of minutes the sun, now hidden behind the monument to the king of Bohemia, would rise above it and glare right into my lens, I decided the man had to go. My assistant, Pepi Martis from the Paris bureau, said, "Wait, I have a feeling the farmer will stop to make pee-pee." His intuition was right: the farmer stopped to urinate and stood still beside his steaming horses long enough for me to take three exposures with a large-format camera.

For a special double issue of LIFE on "The Wild World" in 1967 I was assigned to photograph the migration of wildebeests (gnus) in the Serengeti National Park in Tanzania. LIFE's assistant managing editor, Ralph Graves, who had suggested the issue, and his wife, Eleanor, also one of LIFE's editors, stopped in Paris on their way home from East Africa. Ralph briefed me on the migration picture. He had been told in Tanzania that the migration usually takes place around the middle of May—sometimes, but very seldom, earlier and often later. Ralph suggested that I go to Tanzania early in May to be absolutely certain that I did not miss my picture. It was to be only a single double-truck (two pages) but it was a "must" for the issue. The migration, once it starts, lasts only about forty-eight hours.

I flew to Kenya May 3. In Nairobi the Time-Life bureau suggested I go to Serengeti to look over the land.

I flew to Serengeti in a small chartered plane, a popular mode of travel from Nairobi. By chance I ran into Myles Turner, chief warden of the Serengeti park, at the airport. He was returning home after a visit in Nairobi. I offered him a lift in my plane. On the flight Myles briefed me on the wildebeest migration. He told me that the animals would not move until the rains stopped. As long as the grass was green and plentiful and there were pools of water in the plains, they would stay. Within days after the rains stopped the water pools would begin to dry up and the grass would turn brown. Only then would they be ready to move into the hills where the water and food supply was abundant.

It was still raining on and off, and Myles Turner thought I might have a long wait. He suggested that I set up in Serengeti, where I

might be able to get the picture I wanted even before the actual migration started. He said that large herds of wildebeests move every few days from one grazing area to another. They move in narrow files, sometimes miles long; it looks just like the migration.

For four weeks my young guide and I toured the plains of Serengeti in a Landrover. We did see many herds of wildebeests, but they were either in an area without an elevation from which I could take a picture of them or not in long enough lines to look like a migration.

Finally the rains stopped, and within days the herds of wildebeests began to assemble into larger and larger masses. I was now sure that the only way I was going to get my picture was from a plane or helicopter. Helicopters were not allowed over Serengeti because their noise disturbed the wildlife, and planes were normally not allowed to fly at an altitude below a thousand feet. I was given special permission to fly at five hundred feet.

One day Myles Turner told me to have a plane come from Nairobi immediately because he thought the migration would begin any day. In fact, it began the next day. It was a magnificent spectacle. An estimated three hundred thousand animals were on the move. I could see from the air an endless line of wildebeests, only a few abreast, with zebras on their flanks, moving toward the hills. At five hundred feet we were too high. As we got down to about three hundred feet the noise of the plane's engine caused the animals to scat-

ter. The pilot then tried something different. We circled high toward the end of the line. He asked me to indicate the angle from which I wanted to shoot my picture. When I did, he told me to get ready. He shut off the engine, and we glided lower and lower until I had a fantastic view in my camera. The pilot switched the engine back on to climb for another pass. By now some of the animals were at the foot of the hills, entering the wooded area. Again the pilot positioned me behind the moving animals, shut off the motor, and glided down. When we landed I asked him how high we were flying or gliding when I shot my picture. He said, "Fifty feet." "What would have happened if the motor had not started when you switched it on at the end of our glide?" I asked. He smiled and said, "We would have had a rough landing."

That evening there was a garden party given by the park director. There I met an American couple. The lady told me that she and her husband had just flown in from Florida to see the migration. "The night before last we were at the opera, wearing evening dress," she said. "When we came home we found a cable from Myles Turner telling us the migration was about to begin. So the next morning we were on the plane to Tanzania. This is our second trip here and we would not miss this great show for anything in the world." Even though I had spent five weeks and God knows how much money, I had to agree. And I had got the double-truck picture the editors wanted.

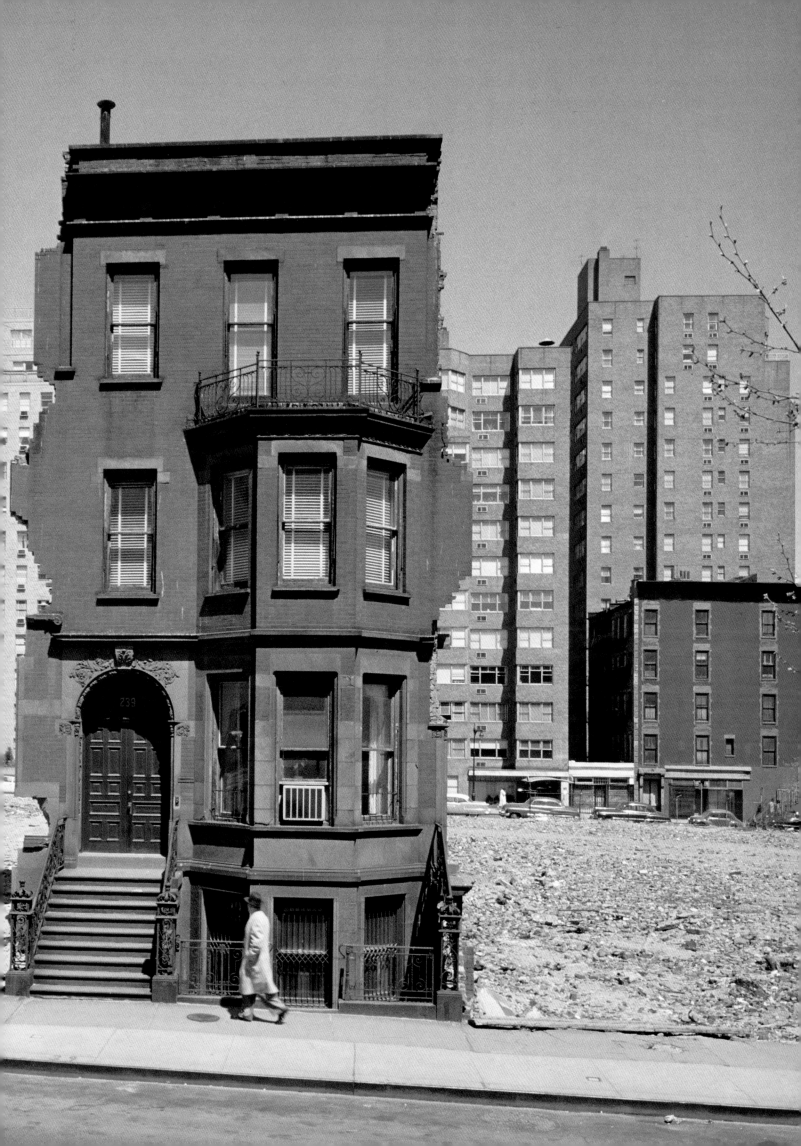

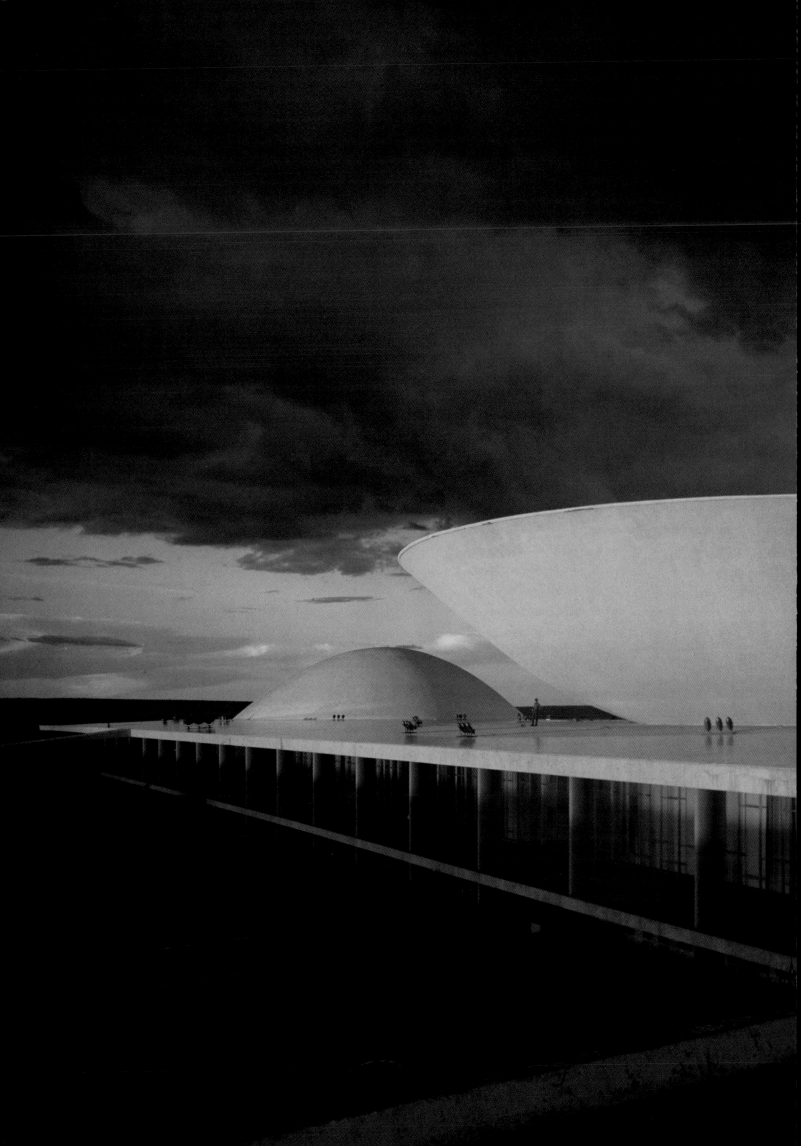

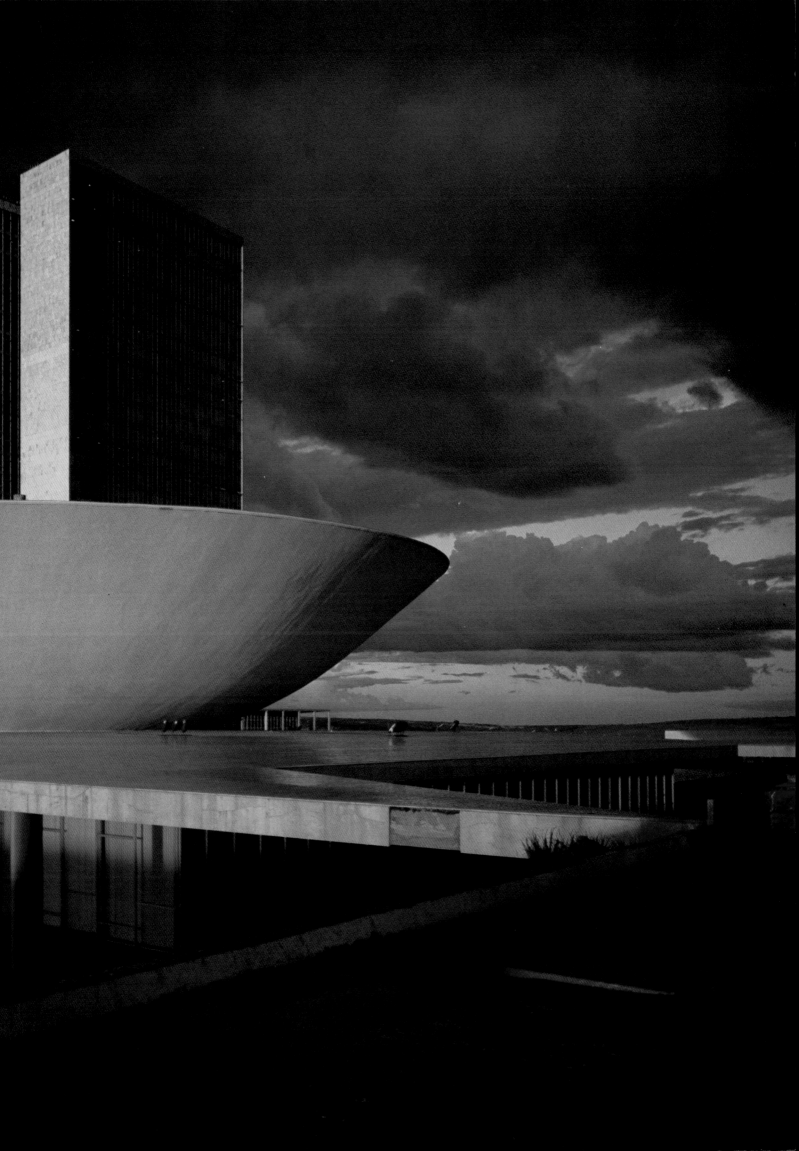

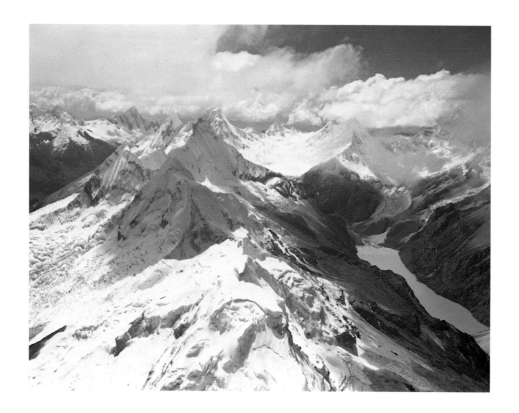

Two jewels in the Peruvian Andes—one natural, one manmade. Above: Over 14,000 feet above sea level lies glacial Lake Parrón, 3,300 meters long, 500 meters wide, and 76 meters deep. Geologists fear it may one day break through its moraine dike, hurling 80 million tons of water down the Santa Valley. Opposite: Part of the ruins of the "lost city" of Macchu Pichu, the last stronghold of the Incan rulers against the Spanish conquistadors. Preceding pages: In Brasilia, capital of Brazil, the Chambers of Congress building. The deputies meet in the two massive, windowless concrete bowls.
Pages 52–53: In the East Sixties, New York City, in 1959, a lone brownstone forlornly awaits the wrecking crew.

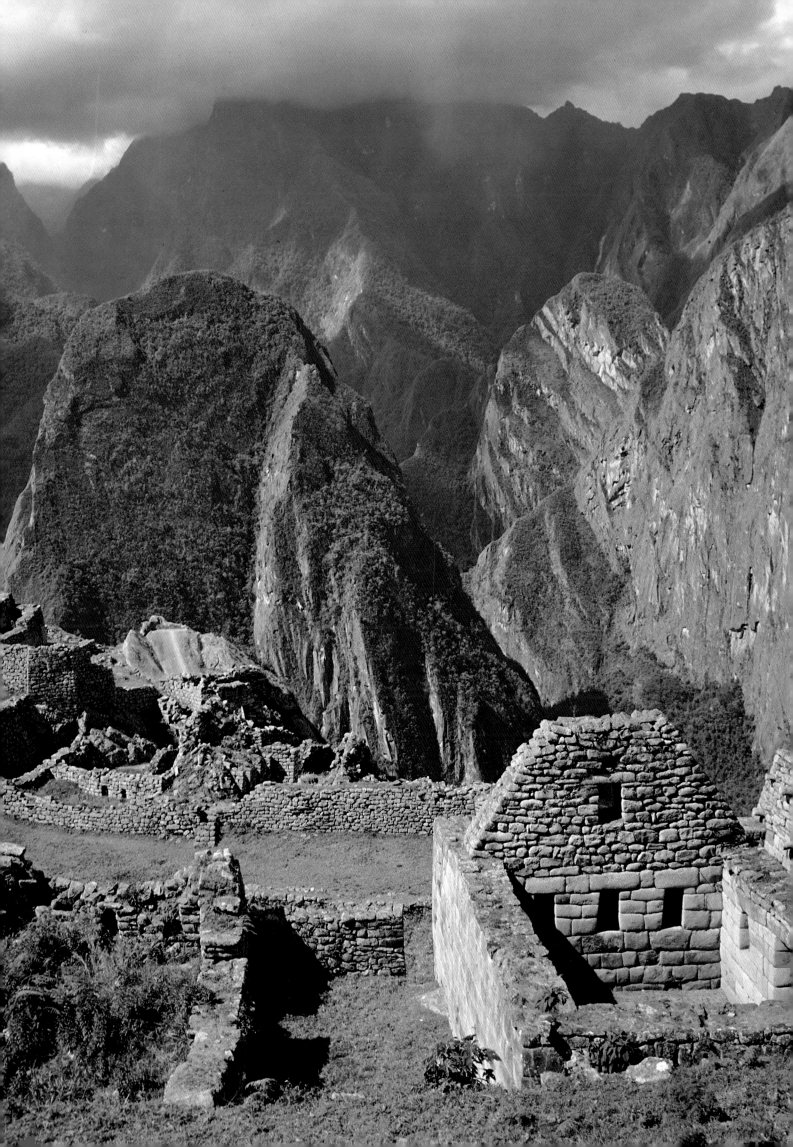

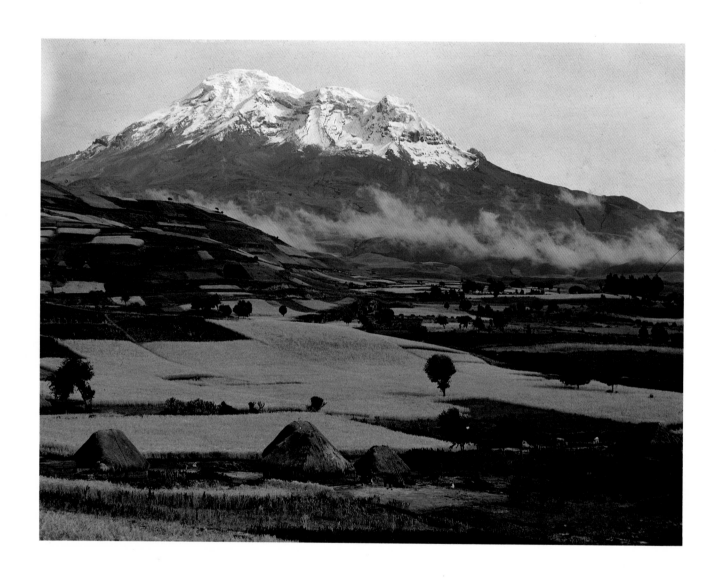

Above: Mount Chimborazo in Ecuador rises 20,577 feet and, although within two degrees of the Equator, its summit is always covered with snow. The Indian village and its barley fields are 12,000 feet below the mountain's peak.
Opposite: Guarding the entrance to the Mayan temple of Chichén Itzá in the Yucatán is the serpent column at the left, the standard of Kukulcan, the godlike leader of the Itzás. In the background is Castillo, the ancient city's largest temple and sanctum sanctorum.

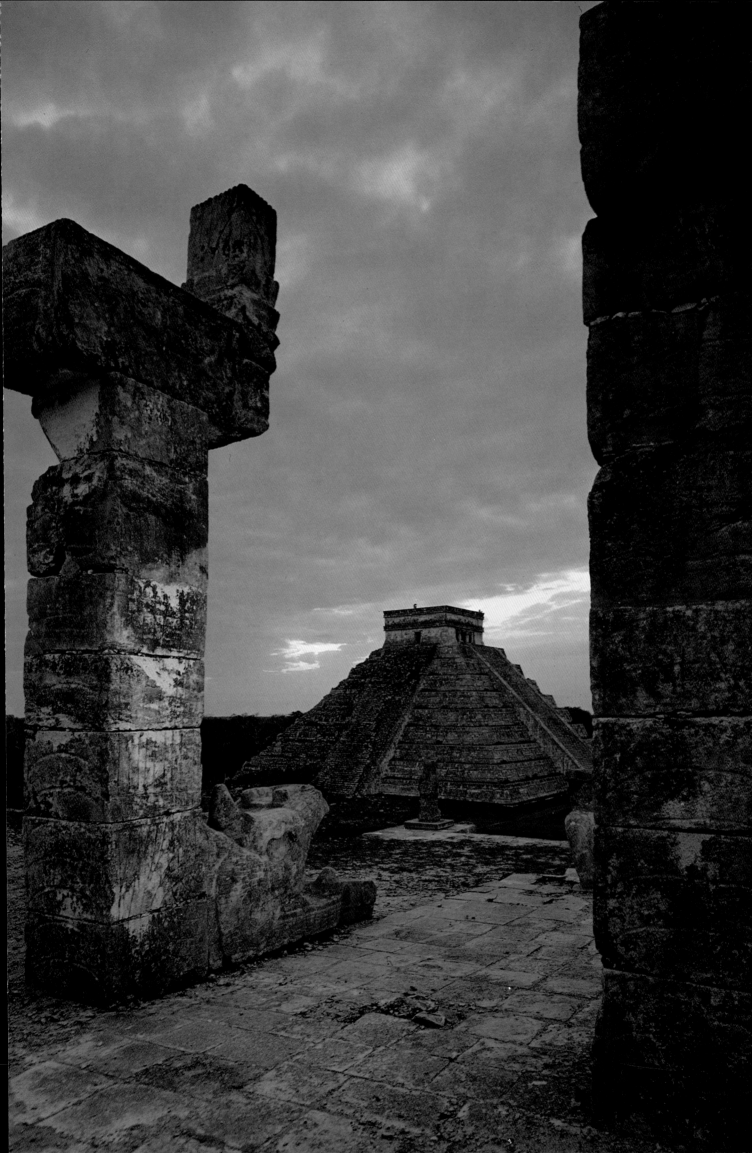

Above: The Maya of today is—facially at least—hardly distinguishable from his ancestor of seven centuries ago, as this portrait attests: an Indian in 1947 in the village of Tikul, Mexico, against a bust of a Mayan man who lived in nearby Uxmal during the flowering Mayan civilization.

Opposite: On the steps of the Roman Catholic church of Santo Tomás at Chichicastenango, Guatemala, in 1947, Mayas were still worshiping their old gods, sending their prayers upward in puffs of incense.

Overleaf: Sunrise at Rio de Janeiro, Brazil. Sugar Loaf mountain rises in right center.

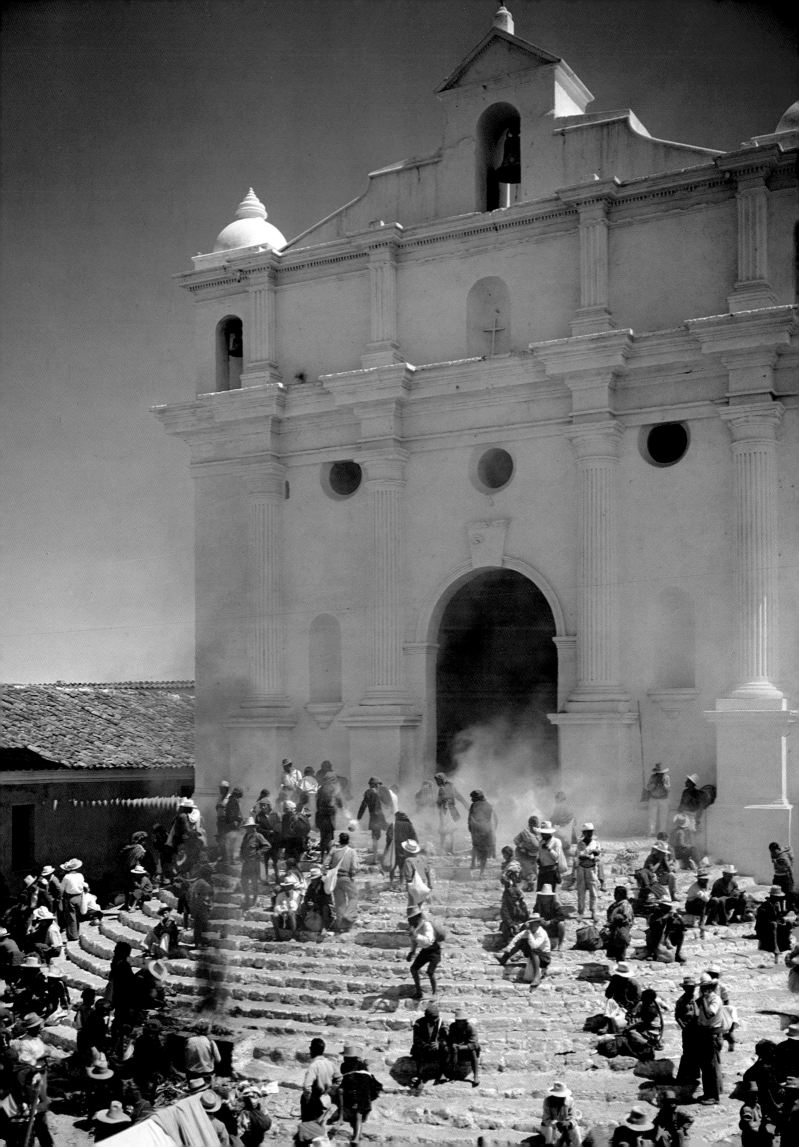

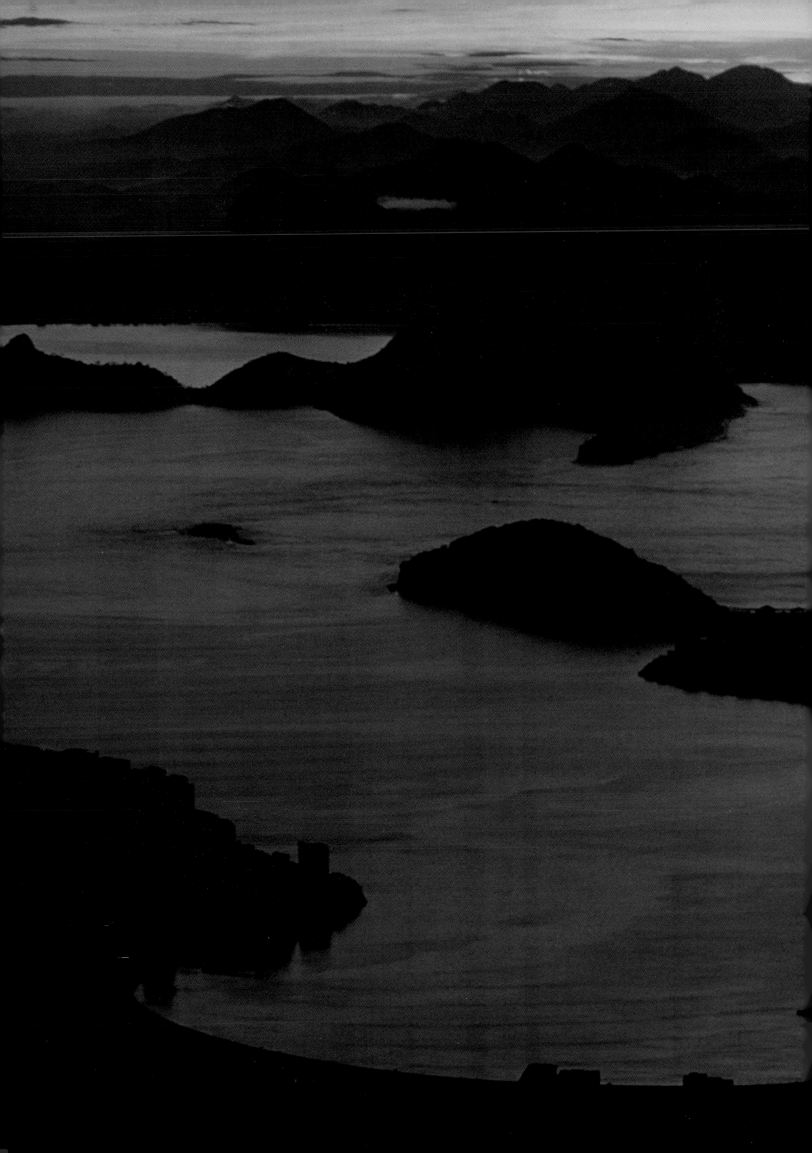

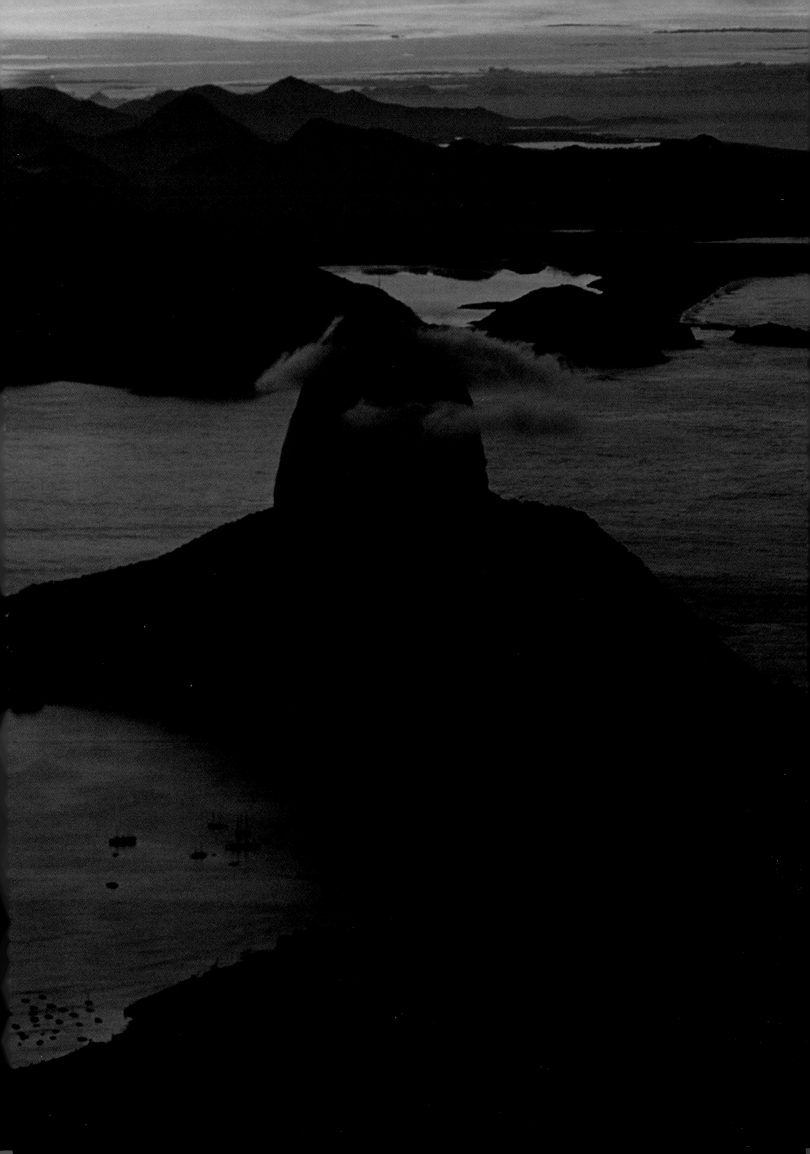

An Iranian soldier mounts guard in 1951 on the Russo-Iranian border at the Gamishan mountain barrier near the city of Khoi. The Iranian army had orders to blow up the few roads leading

through the mountains, making the border impassable.

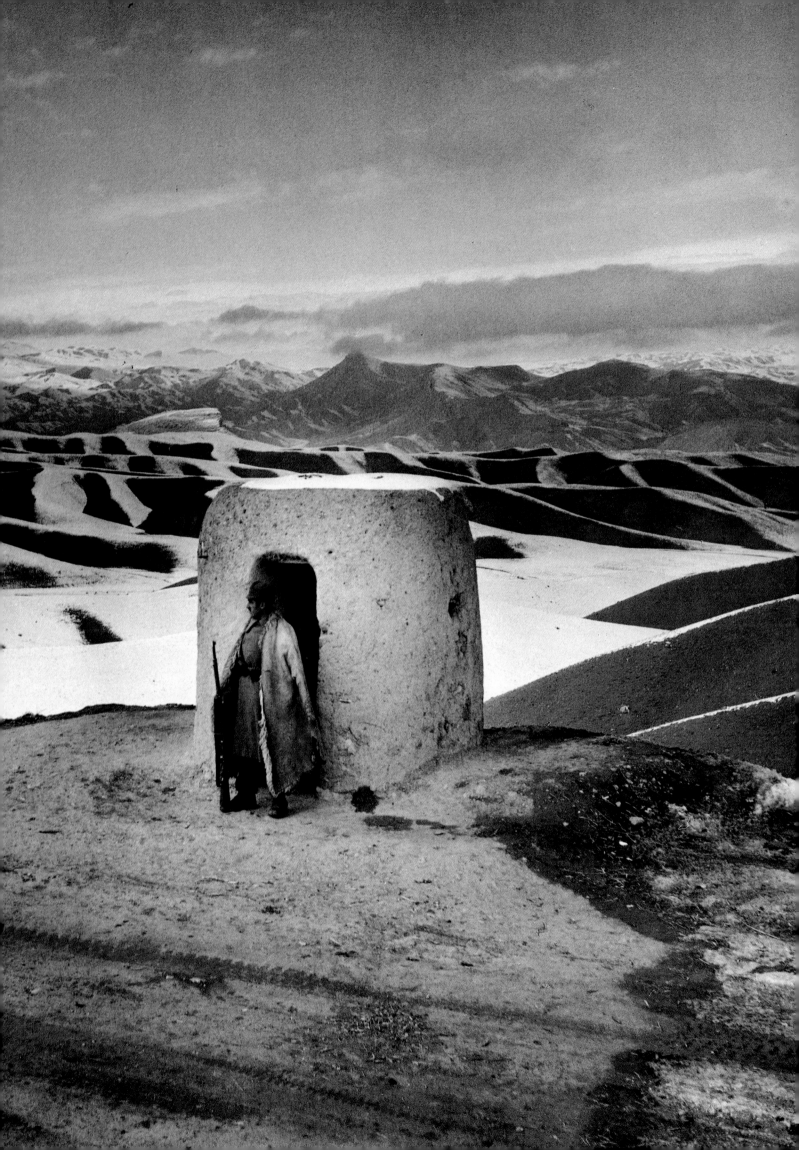

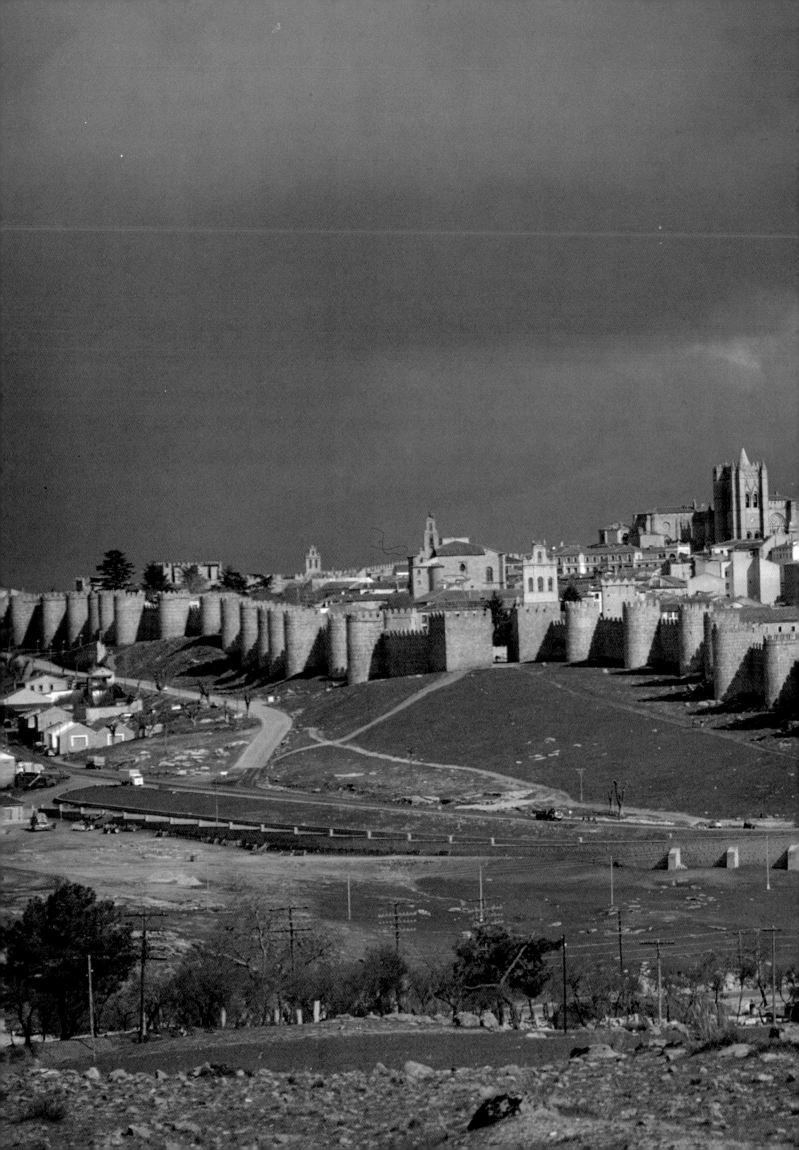

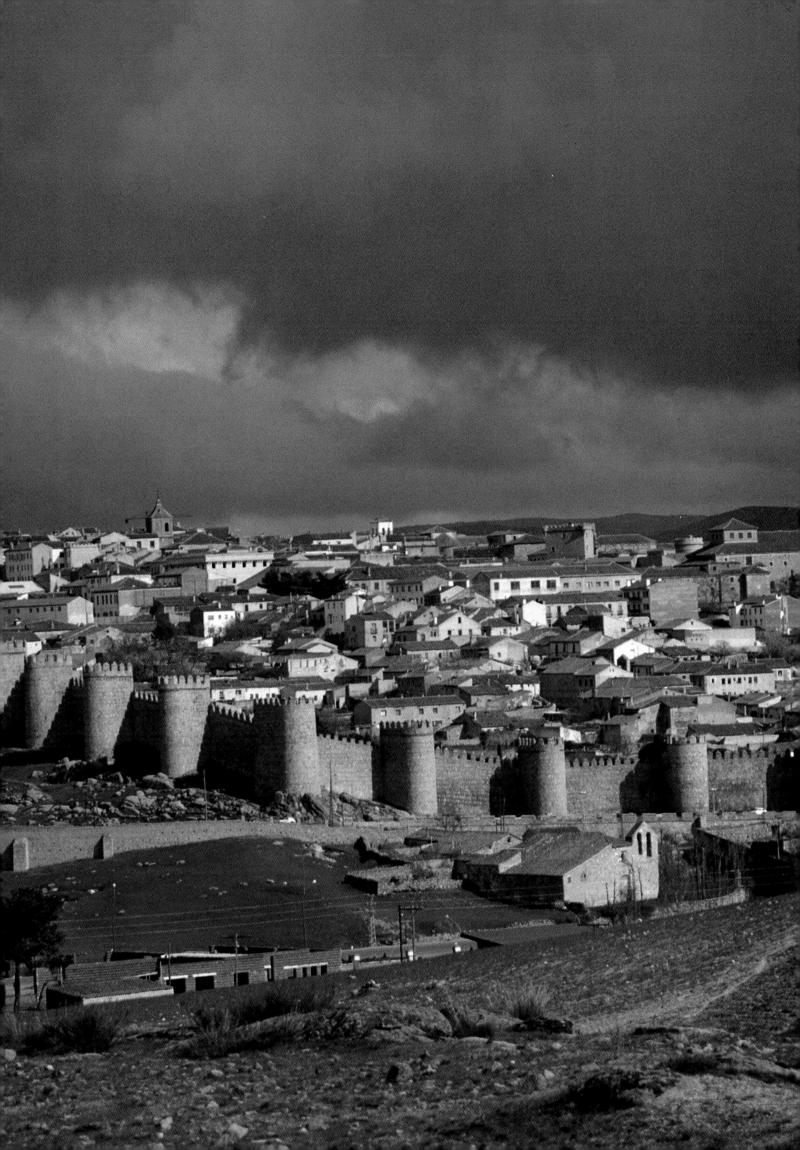

Opposite: In southern Spain, olive trees can be seen everywhere over the red, rolling hills.
Preceding pages: After a violent summer thunderstorm the afternoon sun illuminates the walled city of Avila, Spain, strongly reminiscent of El Greco's *Toledo*. Founded by the Romans, fought over in long wars between Christians and Moors, the walls of Avila were rebuilt in 1090 by Alfonso VI and ringed with 88 towers.

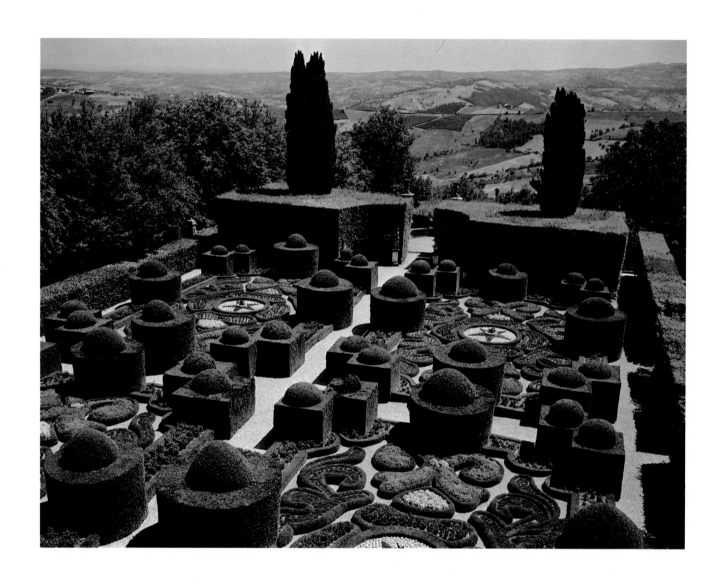

Designed in the eighteenth century, the garden of Castello
di Montalto Pavese (above), between Milan and Genoa, is
considered the most beautiful in Italy.
Opposite: The gardens of the Villa la Pietra were designed and
created in the fourteenth century. When I photographed them in
1950, the property belonged to Sir Harold Acton. In 1983 Sir
Harold willed it to New York University on the condition that he
live there until his death.

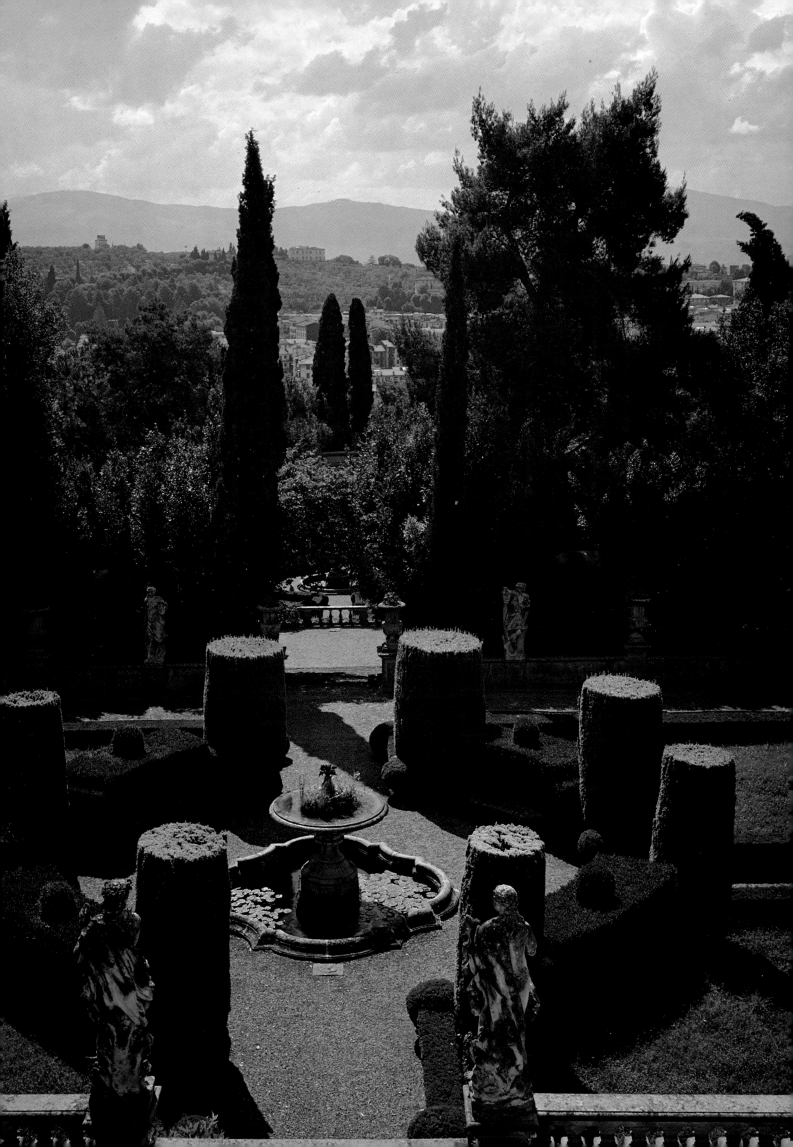

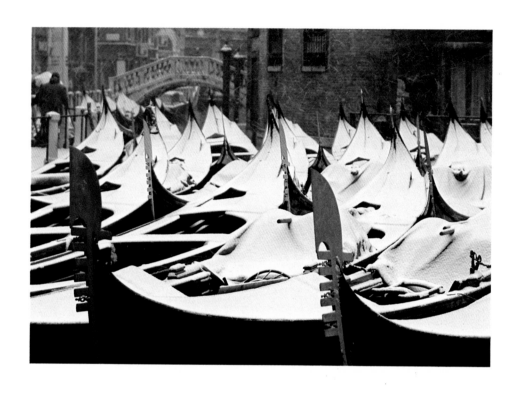

Winter in Venice—snow, rain, fog—is always spectacular.
Opposite: Gondolas, draped in snow, are moored in the Orselo
basin near the Grand Canal, northwest of Piazza San Marco.

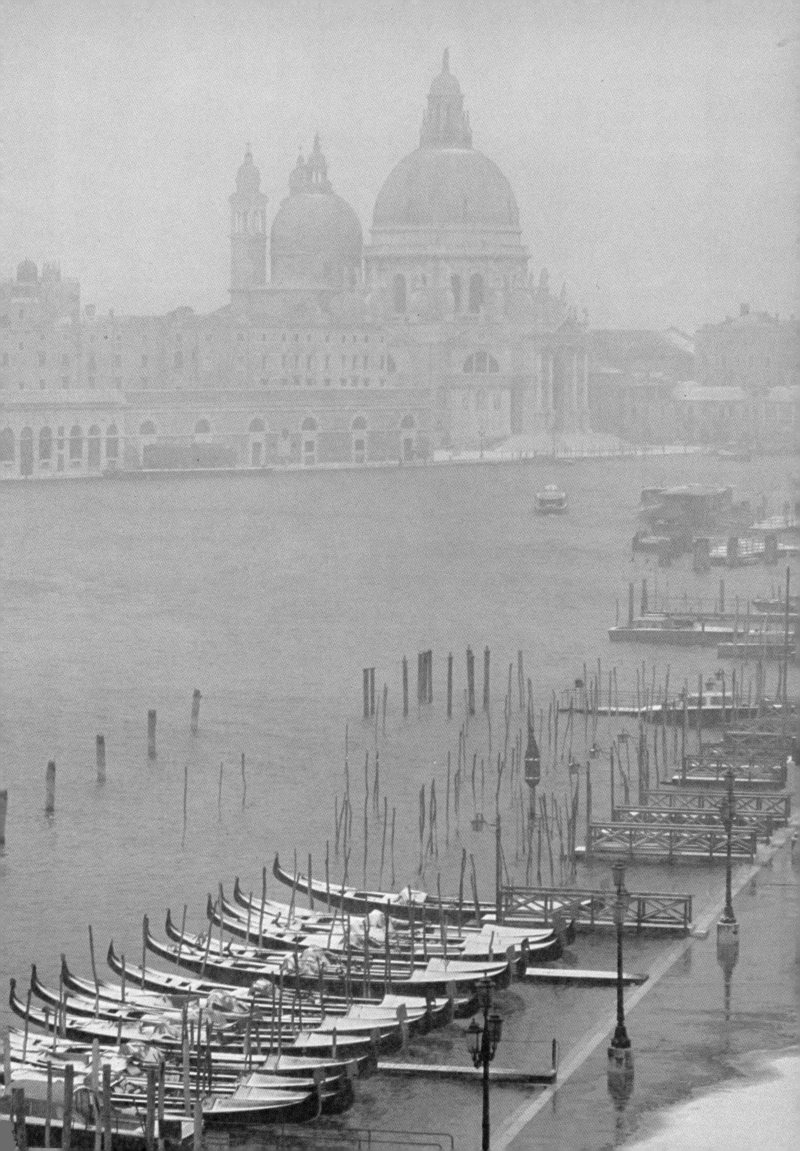

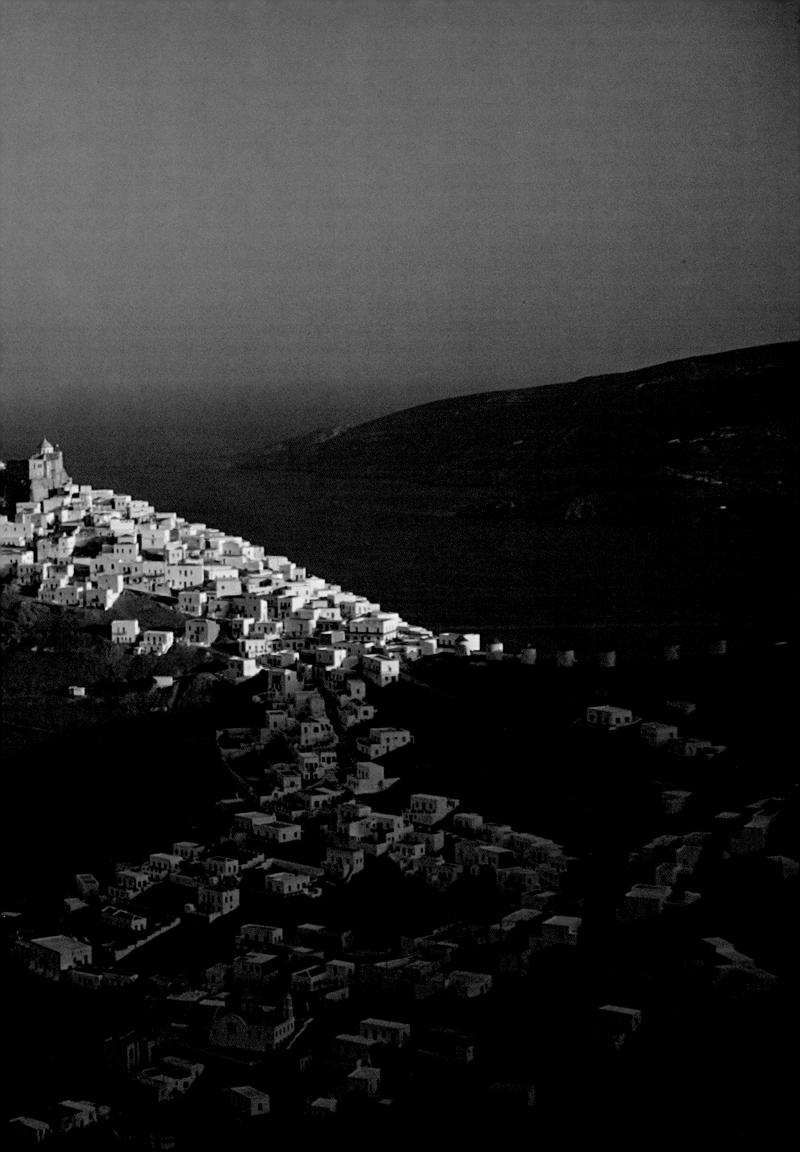

Scattered through the Greek isles in the Aegean are a multitude of monasteries and chapels of whitewashed stone, like this one of Mykonos. In 1963, when I took this picture, Mykonos had 360 chapels and 4,000 people.
Preceding pages: The rising sun brings to life the village of Astypáleia, clinging to the summit of the Greek island that bears its name, northwest of the isle of Rhodes.

76

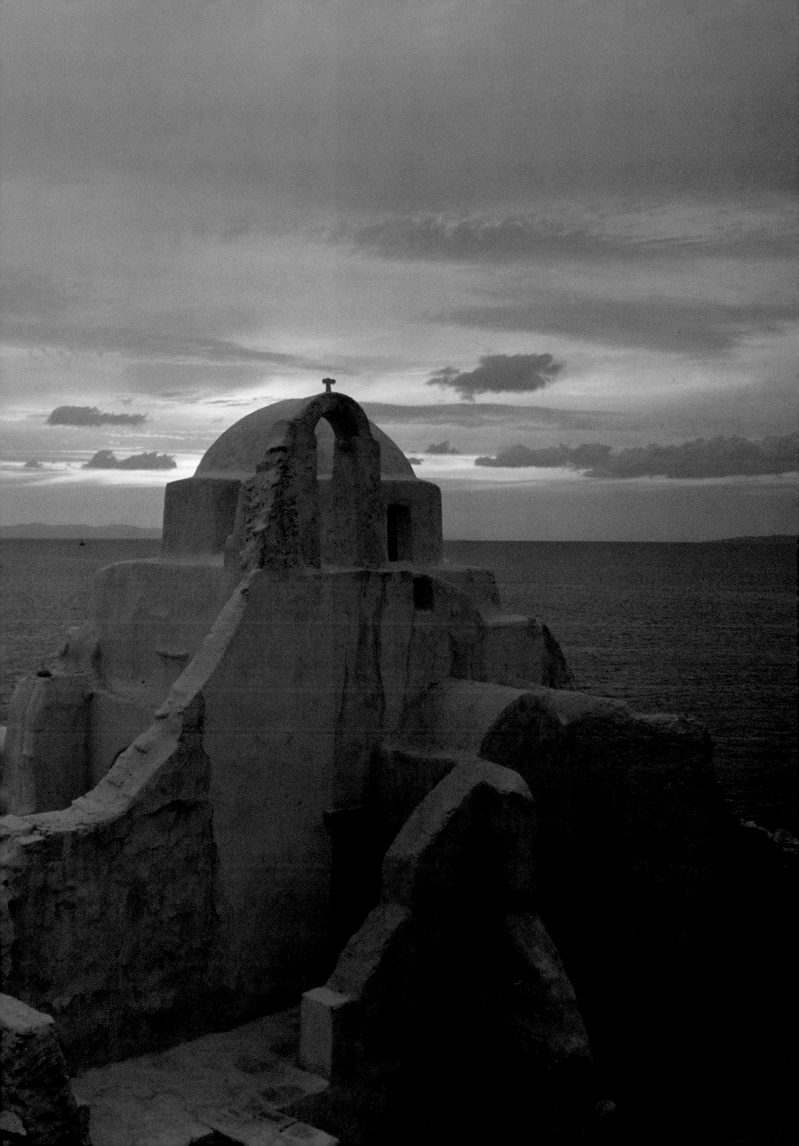

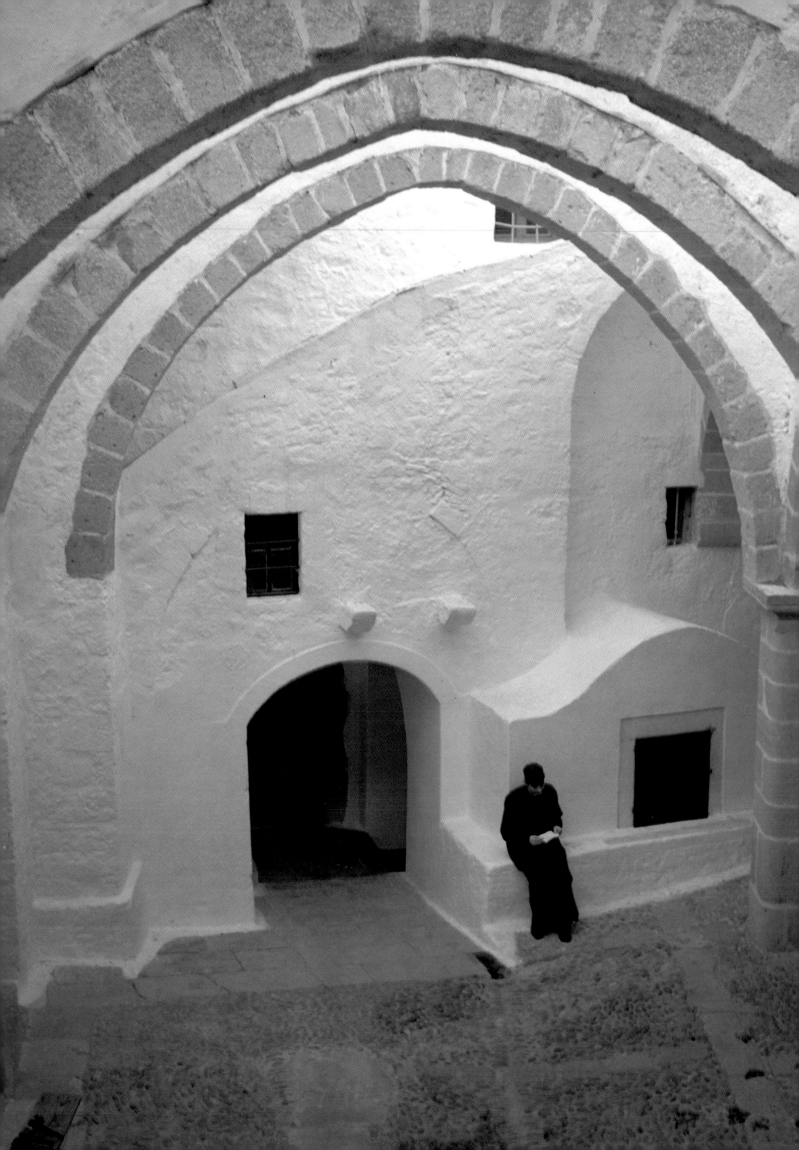

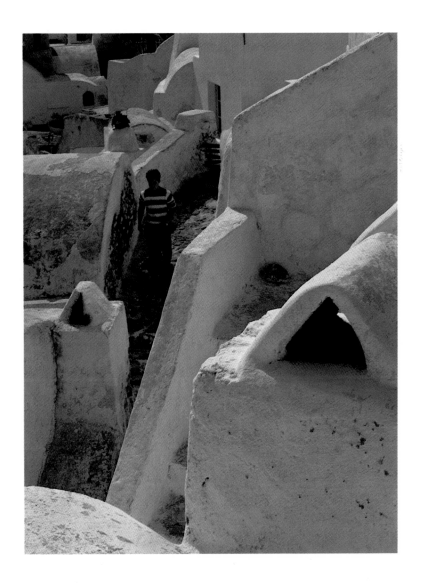

Above: On Mykonos an islander makes his way through the warren of spotless alleys that run through the village.
Opposite: On the isle of Patmos, a young monk reads a letter in the courtyard of Saint John's monastery, built in the eleventh century.

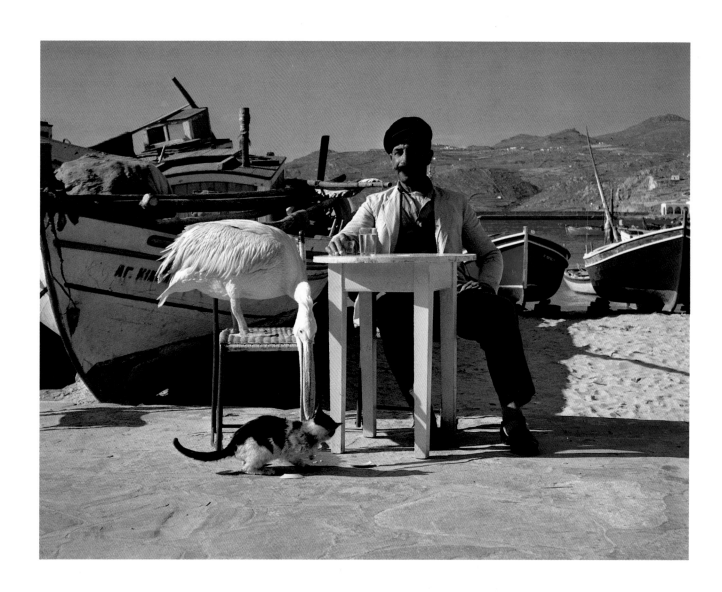

Above: Theodoris Kiradonis, a Mykonos fisherman, and his pet,
Peter the Pelican. In 1958 Peter flew to Tinos, six miles away. The
Tinians refused to give him back, and the Mykoniots threatened
to boycott the national elections until they did. The government
convinced Tinos to return Peter, who promptly had his wings
clipped by his master.
Opposite: A patchwork of roofs on the isle of Skyros in the
Aegean, dominated by church belfries.

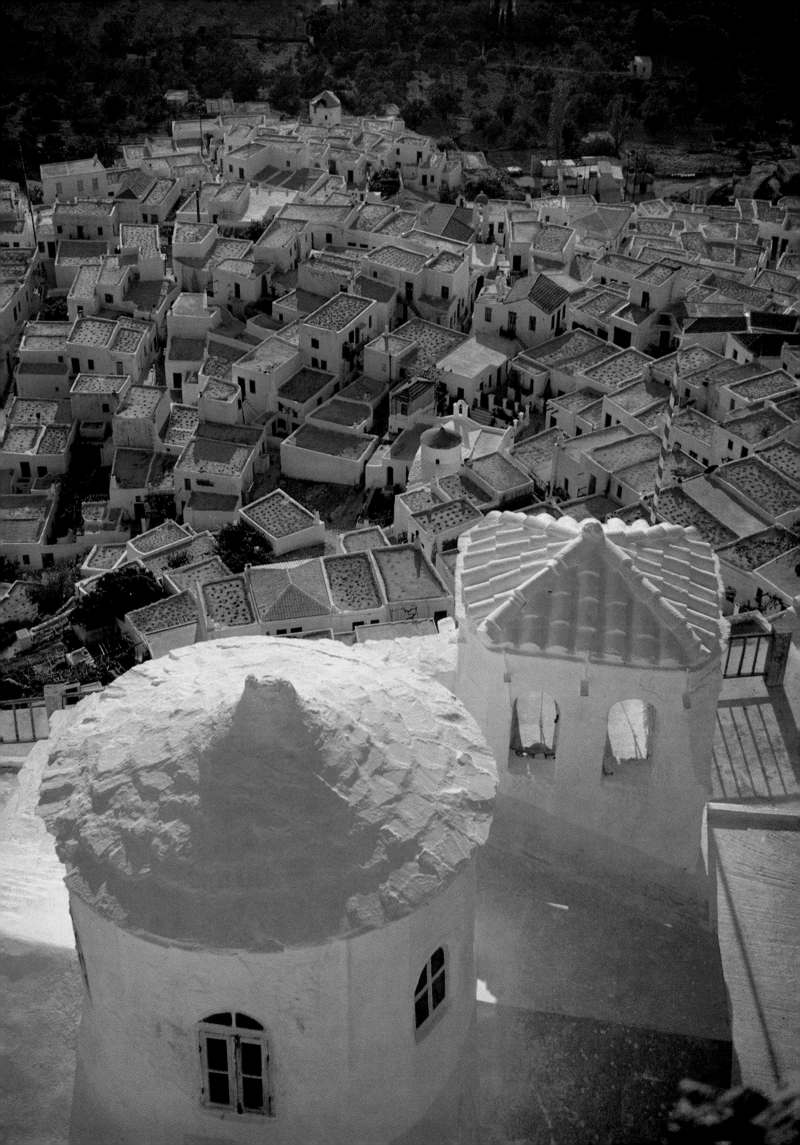

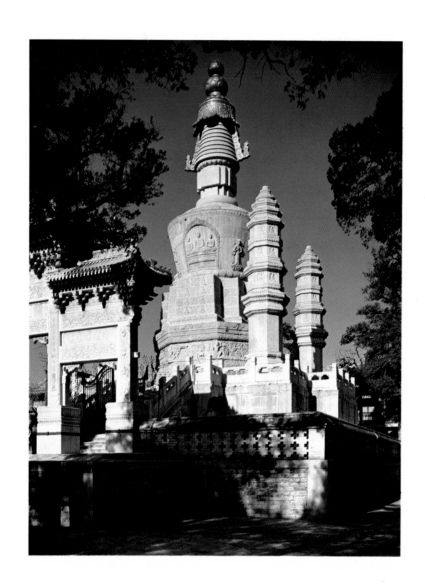

Above: The Marble Pagoda in Peking, built in 1871. Opposite:
The ruined fortress of Sigirya in Ceylon, a 400-foot rock on which
King Kasyapa built his palace in 477. Overleaf: In salterns on the
southeast coast of Ceylon, villagers collect salt crystals from
evaporated seawater. Pages 86–87: On Ceylon's south coast in
1958 fishermen still fished the old way—by planting poles in the
sand and waiting for the tide to come in.

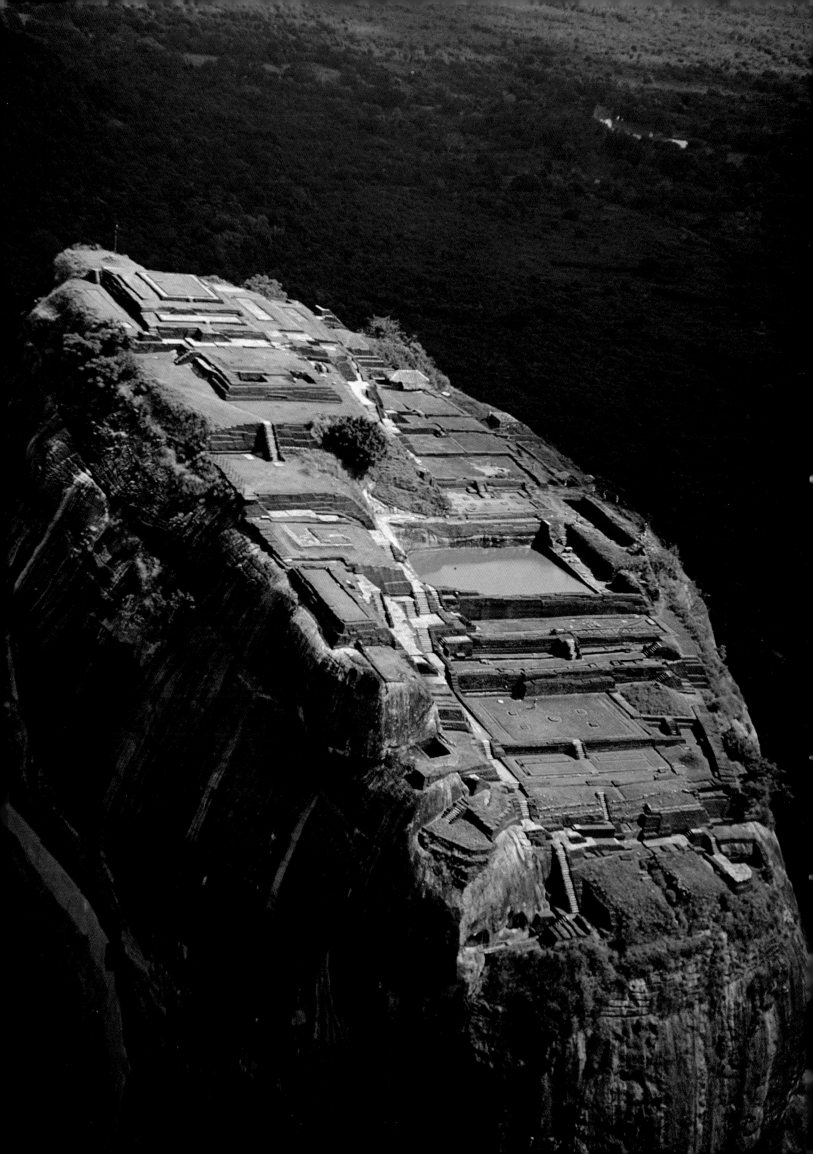

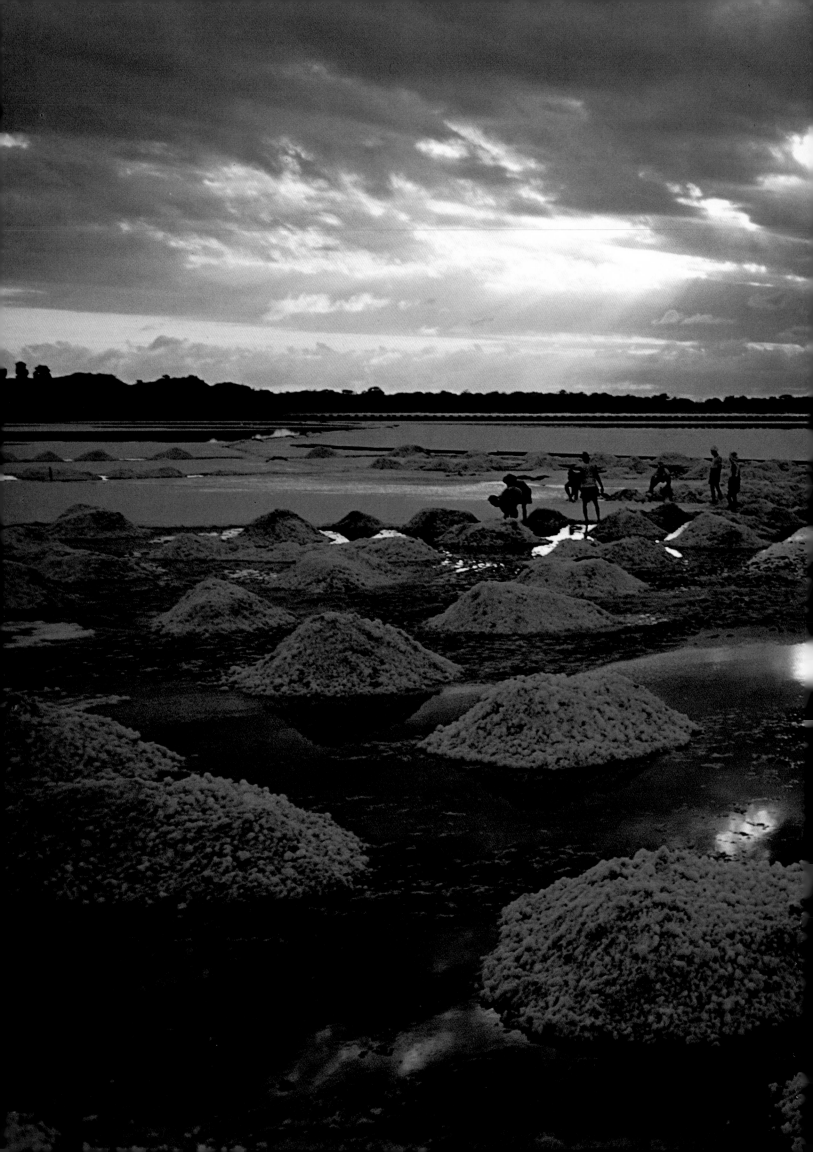

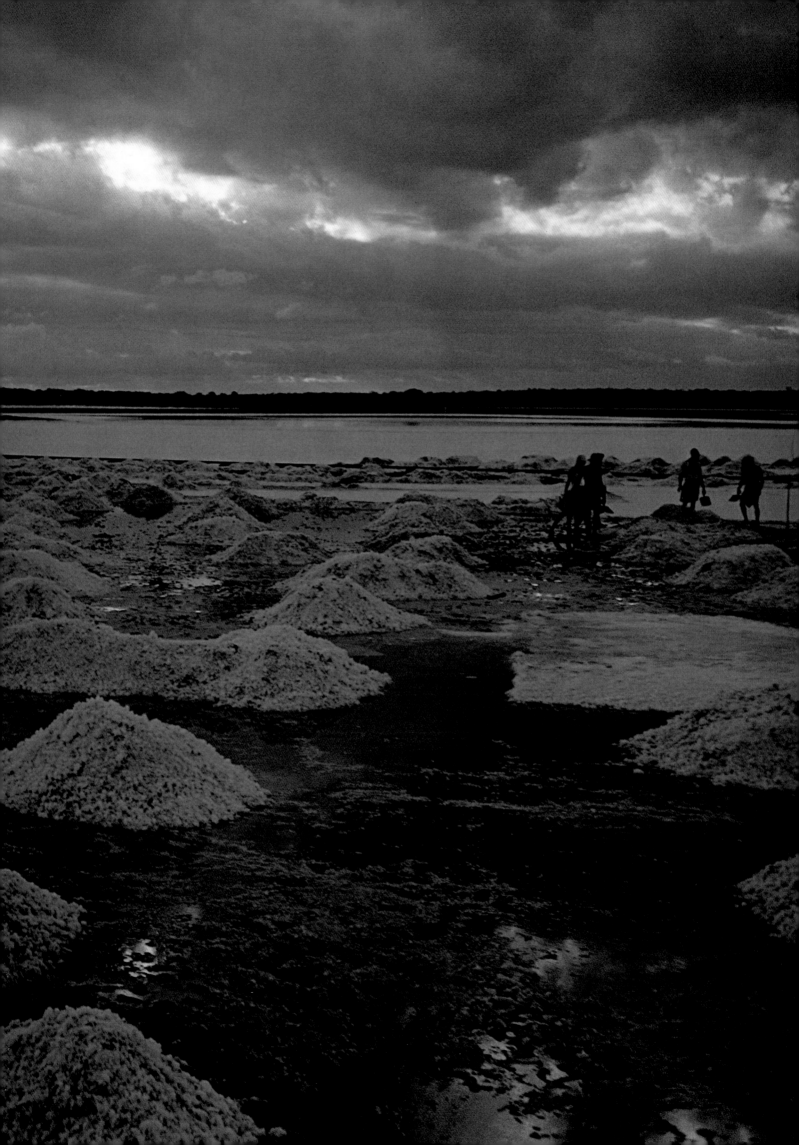

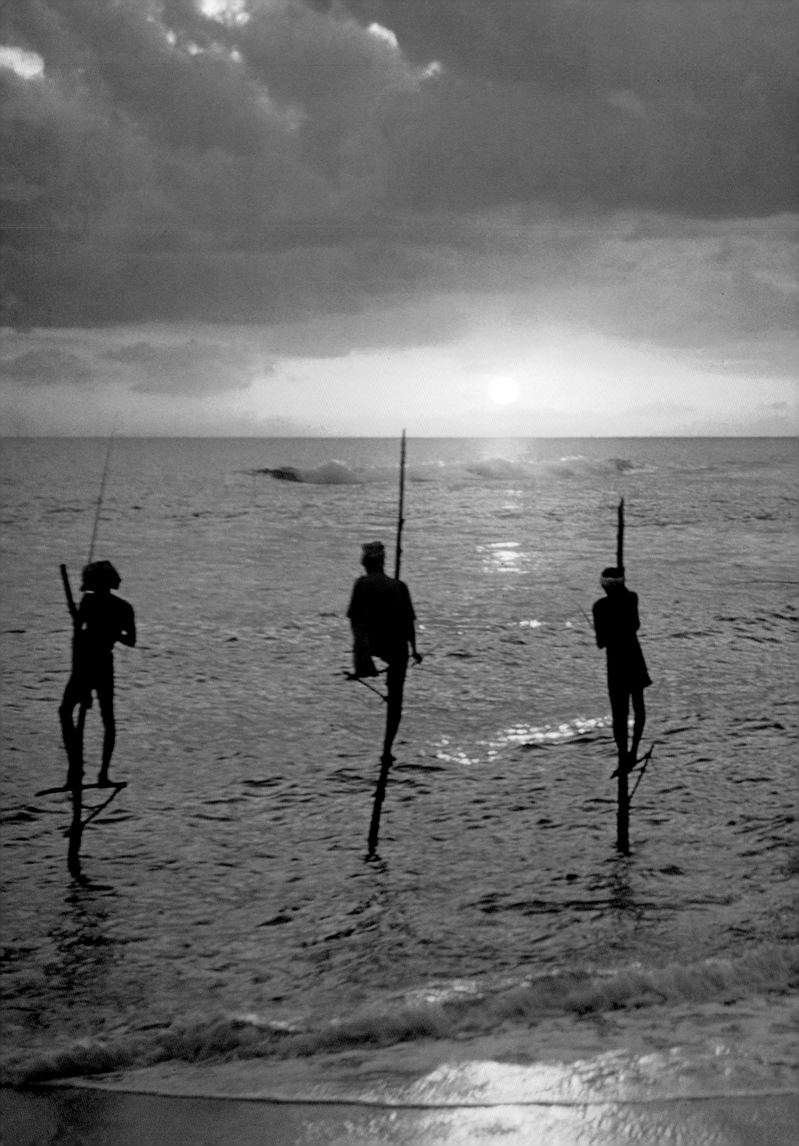

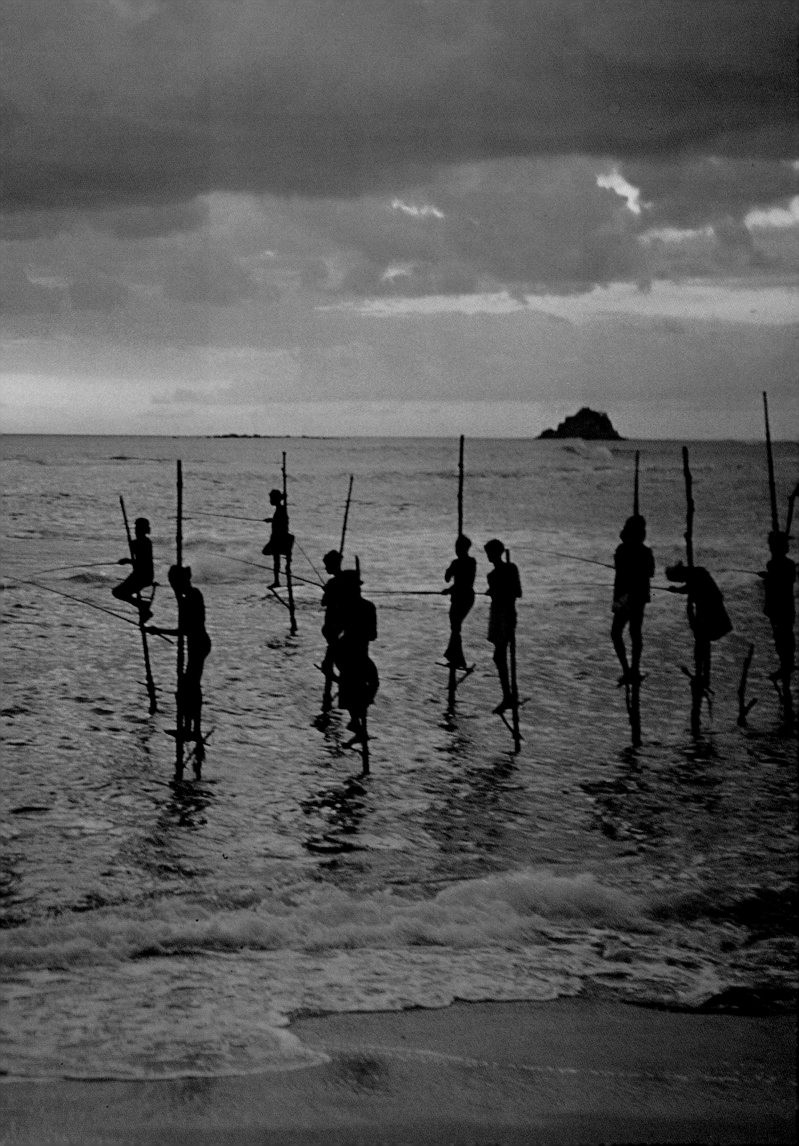

CHAPTER 3:
GREECE, 1944

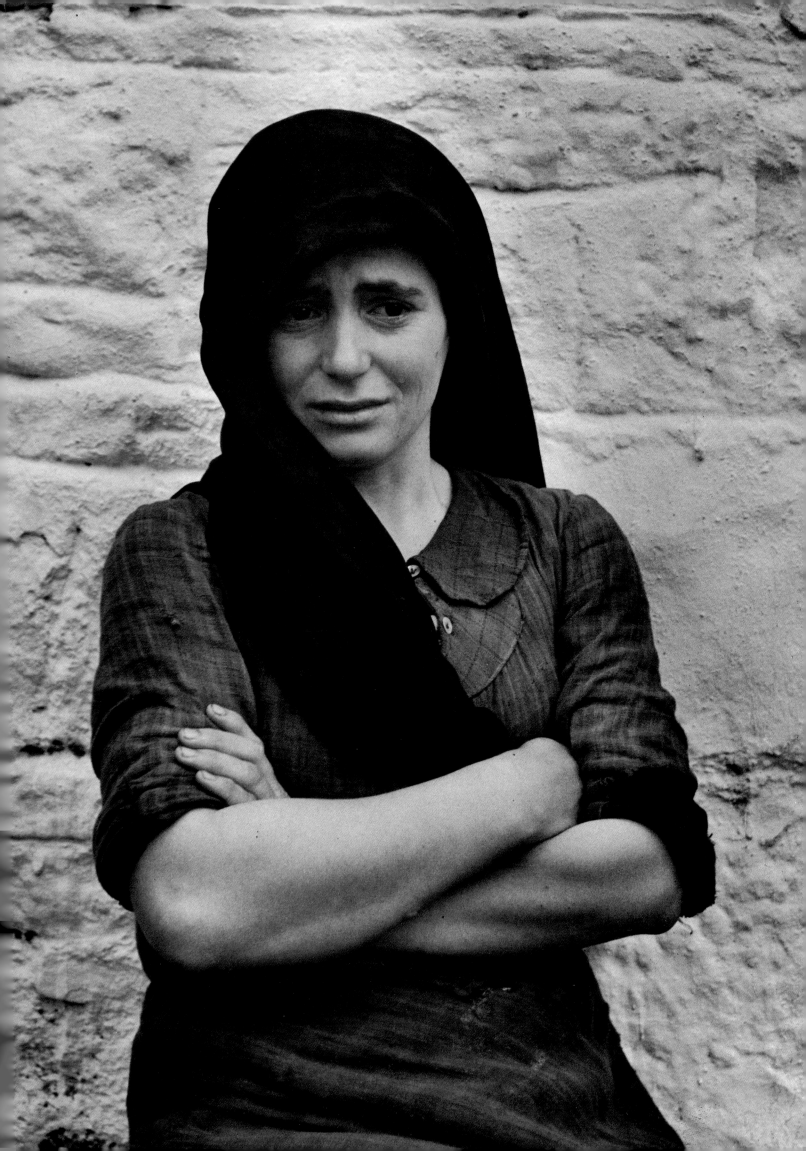

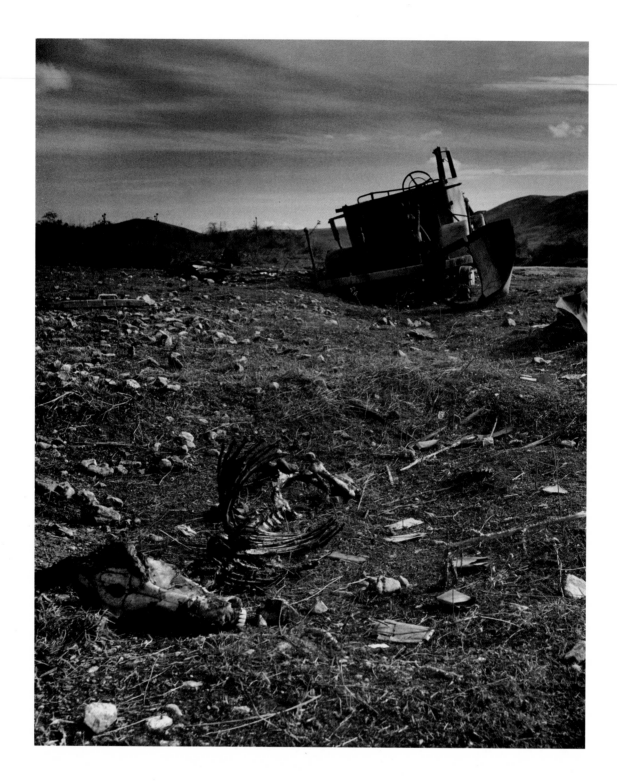

Above: The debris of war near Kozani marked the Germans'
retreat from Greece.
Opposite: A Greek partisan ready for battle; he must have been
in his seventies.
Preceding page: Maria Padiska, four months after the Germans
killed her mother in the Distoma massacre. They spared her
because she was so pretty, they said, and only laughed when
she begged them to kill her instead of her mother.

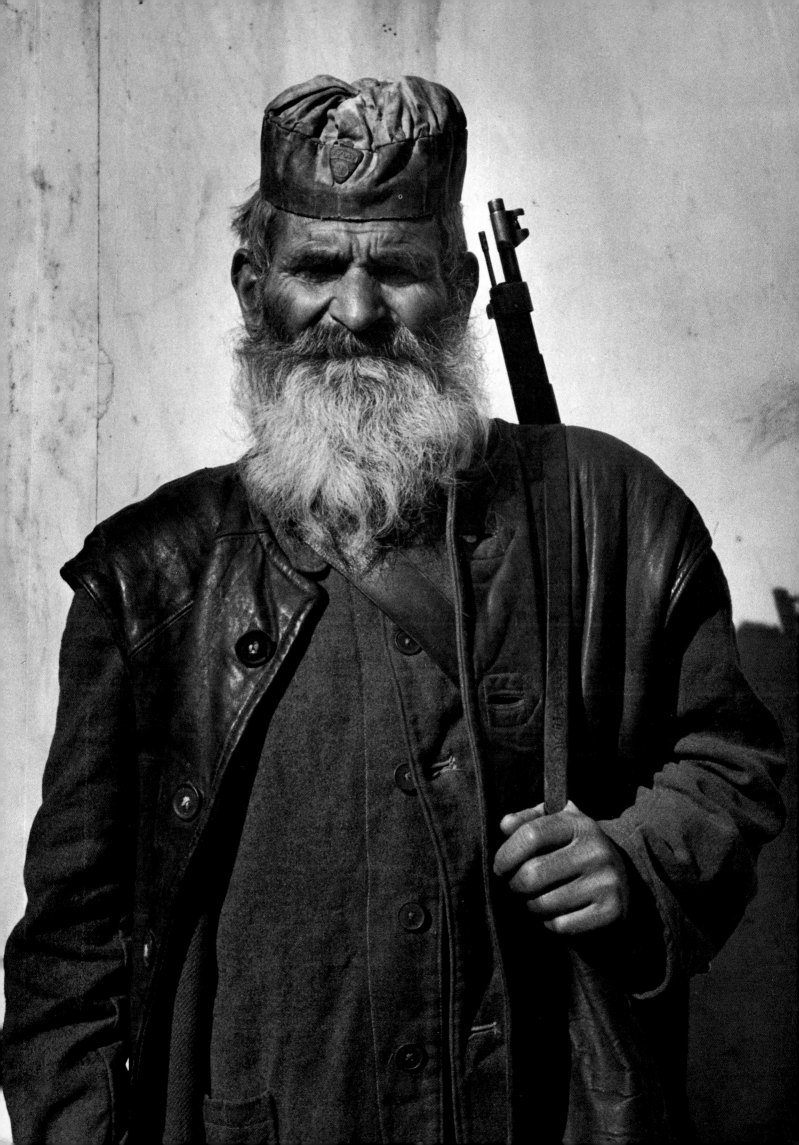

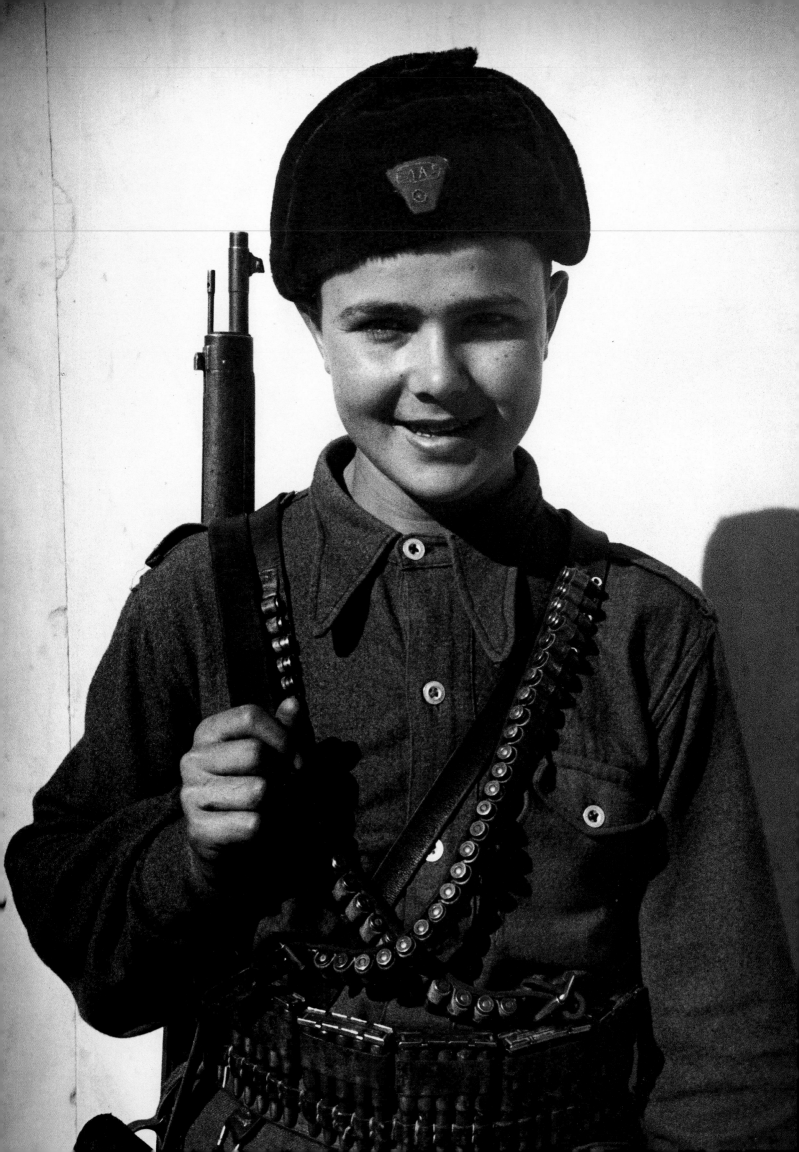

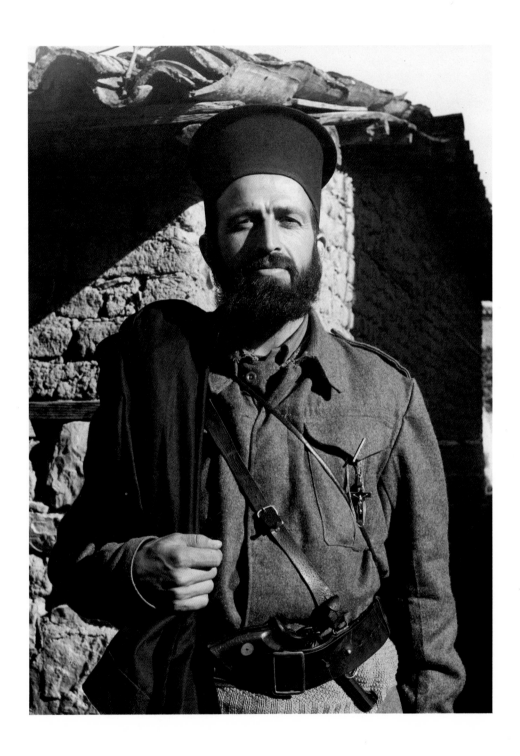

Greeks old and young flocked to join ELAS in the partisan strug-
gle against the Germans. At the end of the war they numbered
50,000, well-trained in the hills, where they had officers' schools,
hospitals, and other facilities.
Above: A Greek Orthodox priest, but also a partisan fighter.
Opposite: A fourteen-year-old boy-soldier.

I feel a special attachment to Greece and the Greeks, perhaps because I became emotionally involved there. I saw what the Germans did to Greece during the occupation, and I lived with the Greeks through the horrors of their civil war.

I landed in Athens with the British troops in October of 1944, when the Germans were beginning their retreat from Greece. The landing troops were welcomed by crowds of Athenians. The men hugged and kissed the squirming British soldiers, but the women—unlike Parisian women, who had enthusiastically welcomed the liberators of Paris—stood apart on the sidewalks and applauded.

Four years of German occupation had left Greece in a pitiful state. From the beginning the Germans seemed to pursue a cold-blooded plan to exterminate the Greeks—through starvation or wanton murder. In the winter of 1941–42 alone almost half a million Greeks died of hunger. By the time the Germans were driven out nearly every Greek was suffering some form of malnutrition. Many women had become barren because of the hardships of their lives, and in some places in Greece the tuberculosis rate among children ran as high as eighty percent. More than two thousand villages had been destroyed.

Greek partisan groups had fought back with courage and determination as best they could through guerrilla operations. There were two main guerrilla forces: the Communist-controlled EAM-ELAS (National Liberation Front and National Popular Liberation Army), which had about fifty thousand men; and the much smaller, right-wing group known as EDES (National Republican Greek League), led by General Napoleon Zervas. The two partisan groups cooperated (along with British paratroops) on only one joint action against the Germans and sometimes fought each other, but their independent actions against German troops kept at least six Nazi divisions fully occupied.

The Germans had deliberately destroyed Greece's economy and left it in ruins. On the streets of Athens peddlers sold at black-market prices anything they could get their hands on—individual cigarettes, razor blades, toilet articles, bread, and canned foods. Inflation had made drachmas worthless. I saw a restaurant owner shopping in the market. His assistant pushed a wheelbarrow loaded with paper notes in denominations of one million drachmas. He bought a few heads of cabbage, some onions, and potatoes. The purchases took up less space in the wheelbarrow than the money had.

Greeks who had dollars changed only enough of them into drachmas for immediate use because the drachma was falling daily in value. They would change one or two dollar bills at a time and spend the drachmas the same day; they might be worth half as much the next day.

After a few days in Athens I went north to catch up with British troops and Greek partisans pursuing the retreating Germans. I hired a car and an interpreter, paying for the car in British gold sovereigns that I had bought in the British paymaster's office in Cairo. I had also changed some traveler's checks there. The paymaster strongly advised me to take cash to Greece in single dollar bills. I thought it was a strange idea. Who wanted to carry packets of dollar bills?

"I can't tell you why, but I'm sure you will be grateful for the suggestion," he said.

So I took three hundred dollars in singles. As it turned out, I was grateful. A single U. S. dollar in Athens had the buying power of two dollars in larger denominations, especially of twenty-dollar bills or larger. The Germans had circulated counterfeit American dollars in Athens, but they did not bother with small denominations; they printed mainly bills of twenty dollars and up. A German Rolleiflex camera was priced at one hundred dollars in single dollar bills and two hundred in twenty-dollar bills.

Along the path of their retreat I saw many signs of what the Germans had done to

Greece. They had burned and mutilated her face, tortured, raped, and massacred her people. The charred ruins of villages lay along the highway, pathetic little wooden crosses marking the graves of victims of reprisals. Sometimes a cluster of crosses or a single cross with a number of names painted on it marked the graves of entire families. Along my three-hundred-mile trip from Athens to Kozani I saw thousands of new graves.

About seventy miles north of Athens, near the village of Agorani, stood a little mill. Alongside were ruins of a burned house. In that house, which the Germans had burned on August 5, 1944, were found bodies of twenty-six men, women, and children. Petros Latinopoulos—a miller who lost ten members of his family in the massacre—had difficulty speaking when he tried to tell me the story. His neighbors helped him:

It was Sunday when the Germans came. They seized Petros's father and mother and his sister and her husband and their children—two girls, aged seven and seventeen, and a boy, fourteen. They also took the wife of Petros's brother and their two children—one two years old and one ten months old.

The Germans lined them all up along with sixteen other Greeks behind the house near the mill and shot them, first cutting the babies' throats. Then they piled the bodies in the house and burned it.

Petros's brother became demented after the massacre. He stood by the roadside near the mill smiling foolishly at the retreating Germans. A soldier in a passing truck shot and killed him.

Petros himself escaped death only because he was away from the village visiting his wife's family when the Germans came. When he returned he had difficulty in identifying the charred bodies. He buried them in the back of his mill.

On the road between Levadia and Distomo at a place called Karakolithos was a little chapel. Near the chapel was a burned house. A frightened little old man lived in the ruins; he was dressed in rags. The Germans had come there in April. They brought 123 Greeks in trucks and parked the trucks two hundred yards from the chapel. Then they led the men, ten at a time, to the chapel and shot them while the others watched from the trucks, waiting for their turn. The people had been brought from Levadia, and no one knew why they were killed. After the shooting the Germans burned the house near the chapel and went back to Levadia, killing every Greek they met on the road.

The most infamous massacre took place about seven miles farther north in Distomo. In June of 1944 a small detail of German soldiers on its way there met Father Sotirios Zissis, the village priest. They asked him if there were partisans in the village. He said no, there were not any when he had left, so they continued on their way. When they reached Distomo they were ambushed, and some of them were killed. The next day the Germans came back to Distomo in force. They seized Father Zissis and cut his throat while his wife looked on. They ordered the villagers inside their homes and told them to shut the doors and windows. Then they went from house to house spraying the interiors with machine-gun fire. In two hours they killed 270 of Distomo's population of 1,900. Then they looted the village and set fire to it.

After the massacre the survivors, afraid that the Germans would come back, fled to the hills. They had no time to give their dead a formal burial in the village cemetery, and there was no priest, so they hastily buried them in the backyards of their homes. "It is no good to have the dead buried right in your backyard," said one man. "No good for the women. They cry too much. Sometimes in the middle of the night a woman at one end of the village starts crying over the graves of her dead and another, at the other end, picks it up. Soon all the women of the village are wailing. It gives you the chills."

The retreating Germans had dynamited bridges and long stretches of highway, forcing us to make long detours through muddy fields and tracks. Outside Larissa we joined

the column of ELAS. They were not, as I had imagined, a ragtag band of guerrillas, but a smart military unit, well outfitted, mostly in British battle dress. Some of them were wearing boots taken from dead Germans or from German supply dumps. The band included young boys of fifteen, old men in their sixties, and a young, handsome, bearded priest with a large silver cross hanging from a chain on his neck and a pistol tucked into his belt. There was also a detachment of young girls, who, I was told, were just as tough fighters as the best of the men.

The bridge across the river in Larissa had been blown up, so we left our car in Larissa and were rowed across the river. There ELAS had put at our disposal a captured German command car driven by a young partisan. Along the road north of Larissa were hundreds of German vehicles blasted by the British Royal Air Force and by ELAS. Bodies of horses and men were lying in the sun, filling the air with the stench of death. Near Kozani we came to a spot where two days earlier ELAS had ambushed the rear column of the retreating Germans. It had been a hot day and the Germans had halted on the road above the riverbanks to bathe. The partisans opened fire on them with machine guns from the hills on both sides of the river. The Germans ran toward their vehicles. Many of them did not make it. There were naked bodies along the riverbanks and on the road. Some of them were black; I was told that Spanish Moors, some of Franco's volunteers, were fighting on the German side. On a stretch of road winding toward the hills lay a single naked body of a German soldier.

At Kozani the bridge across the river had also been blown up, so I decided to return to Athens. On the way back we stopped at the city of Lamia, headquarters of ELAS. The British mission, which had parachuted into Greece two years earlier, was also quartered there, headed by Major Sam Forshall. The British had taught the partisans the skills of demolition and sabotage. The officers and men were billeted in a small house where they invited me to stay with them. Also with the ELAS in Lamia was a Russian military mission made up of four officers and headed by Lieutenant Colonel G. Popov.

One evening the British invited the Russians to dinner. A British sergeant major carved a large roast turkey at the table and passed it around. Then he sat down to eat with the rest of us. I was seated next to Colonel Popov. He turned to me and said in Russian, "Our hosts are trying to impress us with their democratic attitude toward the lower ranks. I am sure when they are alone the sergeant eats in the kitchen." I told him that he was mistaken, that when living together and sharing danger behind German lines, they make little distinction between the ranks. Of course, he did not believe me.

The political situation in Greece was complicated and tense. The king was in exile; EAM-ELAS had already set up a new provisional government in the mountains, but the British were not about to let postwar Greece go Communist. When they landed in Athens in October 1944 they brought with them Georgios Papandreou, a liberal Greek politician, to form and head a new coalition government that would include the Communists. The Communists agreed, reluctantly. But when the government demanded that all former partisan forces, including ELAS and EDES, disarm and disband so that the only military forces in Greece would be the national Greek Mountain Brigade troops (the well-trained, four-thousand-strong, pro-royalist military unit that came straight from Italy, where it had fought the Germans alongside British troops) and the British (presumably temporarily), the Communists refused. They said that they would disarm only if the Mountain Brigade disarmed too.

In Lamia I met the commander of the guerrilla forces, Aris (the God of War) Velouchiotis, a very handsome, impressive man with a long bushy beard. He wore bandoliers of cartridges on his chest and a silver dagger in his belt. Velouchiotis was reputed to be a fierce fighter and a merciless killer, not only of

Germans but also of Greeks who collaborated with the Germans or were political opponents. (A Communist, he was killed the following summer by Greek government troops; his head was displayed in the main square of Trikkala.)

On Sunday, December 3, I was in Constitution Square in Athens with an American reporter, Connie Poulos of Overseas News Service. There was a large demonstration forming: EAM sympathizers were protesting the disarming of the ELAS forces. The police, who had been ordered to stop the demonstration, had thrown a cordon across the street.

The previous day EAM had been given the government's permission to demonstrate. But late that night the permission was revoked. EAM officials said that it would be impossible to call off the demonstration on such short notice and decided to go ahead with it.

As the huge crowd moved down the street, it swept back the cordon of police. Suddenly, a few shots were fired, followed by a fusillade. Connie and I were outside the old palace across the street from the police station. When the shooting started, we were caught between the first ranks of EAM demonstrators and the station. We squatted down behind the low wall of the palace driveway. At the first sound of shots, the demonstrators with their banners went down. "They are firing blanks!" Connie said. "Yeah," I replied, "look at the man on the left." Not more than fifty feet from us a man, his face covered with blood, was trying to push himself off the ground. He was holding his hand to his stomach, blood poured through his fingers.

The sporadic shooting stopped in a few seconds. The demonstrators sprang to their feet and began to disperse into Constitution Square. A number of bodies remained on the pavement. A man was crying for help. The wounded who were able to walk were led off by their comrades.

After a short pause, the police again fired on the demonstrators, who were in retreat farther down the street. When the shooting seemed to finally have stopped, some of the demonstrators came out of Constitution Square to remove the dead and seriously wounded. Again the police fired and drove them back.

In all, the police killed 23 and wounded 140, among them many women. But that did not stop the demonstrators. They reassembled in Constitution Square and began to charge toward the police station where they were driven back by renewed firing.

Meanwhile, British armored cars and tanks that had been parked along University Street moved in to protect the station, forming a wall around it. Then the British military police appeared in the street, to a tumultuous reception from the demonstrators, who rushed out of Constitution Square to hug and kiss them. A British military police major shouted to the Athens police chief, Angelos Evert, standing on the balcony of police headquarters, "Cease fire immediately!" Evert replied innocently, "Who's firing?"

Again the demonstrators reassembled; this time, carrying a huge American flag, they moved slowly down the street shouting in chorus: "Roosevelt! Roosevelt! Roosevelt!" They did not attempt to rush the police station. Soon the streets were almost deserted. Some men and women placed crosses crudely fashioned from tree branches or sticks on the bloody spots where victims had fallen. Other women scooped up the blood into paper bags or old cans. The next day at the funeral of the twenty-three victims, we found out why.

The last rites took place in the Metropolitan cathedral. The overflow of mourners knelt in prayer in the small square outside. From there the funeral cortege moved toward Constitution Square. The coffins were borne in single file to the site where the victims of the Sunday shooting had fallen. The mourners knelt in silent prayer. Some carried banners written in the victims' blood. One large banner at the head of the procession read: "When the people face the danger of tyranny, they must choose either chains or weapons." It was splattered with blood.

The streets along the route of the procession were lined with thousands of Athenians. One well-dressed man at the entrance to the graveyard spoke in English to a group of American and British correspondents: "This is a sad day for the Greeks. All of us, right or left, are mourning today. We have been burying our dead often during the last four years… too often. They were the victims of German reprisals, victims of starvation. Our people died, but the hope of liberation and brighter days never died. Then you came, our allies. The Germans have gone and we rejoice. We thought the days of funerals and mourning were over at last and that the days of rejoicing and laughter had returned. But," he said, pointing to the passing coffins, "today we are crying again!

"From the way I'm talking," he continued, "you may think I am a Communist. I am not, not even a socialist. I belong to what you might call the upper middle class. I am a businessman. But, above all, I am a Greek, and I am sick of seeing Greeks killed. We have always had differences among ourselves, but we always came to some sort of agreement."

From the hills near the Acropolis and from the direction of Piraeus came sporadic rifle fire and machine-gun bursts. The ELAS was squaring accounts with the neo-fascist-royalist group "X" (pronounced "Chi"). They were also attacking the police substation in Piraeus. The civil war had begun.

Throughout the night of Monday and all day Tuesday there were sounds of rifle shots and, occasionally, machine-gun fire all over the city. On Wednesday the British forces were sent into action. British paratroopers attacked and occupied the Communist party headquarters. That morning the streets of Athens were deserted. A blue curtain of smoke hung over the city. The shooting was heavy. The crump of artillery and mortar fire merged with the sounds of rifle and machine-gun fire.

Most of Athens was in the hands of ELAS. The Grande Bretagne Hotel became the center from which Lieutenant General Ronald M. Scobie, commander of the British forces, directed operations. Members of the Greek government, some with their families, moved into the hotel. The "front line" was a few blocks down at Omonia Square. In the other direction the territory held by the British and right-wing Greeks ended at the Acropolis. We American correspondents were urged by General Percy Sadler, chief of the American military mission, to wear small American flags on our shoulders so that snipers would recognize us as noncombatants. This annoyed our British colleagues because we had the advantage of being able to cross the lines with only a slight risk of being shot in "no man's land."

ELAS partisans received us gladly and let us photograph and interview them. The British correspondents, of course, were not accepted by ELAS. This sometimes led to the accusation by Greek royalists that American correspondents were Communist sympathizers. We were not, but we could not remain indifferent to the plight of the Greek people, who had just been relieved from the suffering of the German occupation only to suffer again. So many innocent Greeks, children and women among them, were dying.

The people living in central Athens, surrounded by ELAS and cut off from the countryside that supplied them with farm produce, began to feel hunger. The British set up outdoor food kitchens in the center of town. There was a restaurant, Vasili, near the Grande Bretagne, where we correspondents used to eat. One day I walked in to greet the owner. The chairs were piled on the tables. The owner sat finishing a frugal meal. A large chicken was pecking at bread crumbs on the table. "You see," he told me, pointing at the chicken, "he is still alive. I would like to eat him but I have no heat and no water in which to cook him." Electric and water supplies had been cut off after the outbreak of the fighting.

In the hotel we had only candlelight until the British installed generators. Water was rationed. The British army set up mess halls for all those who lived in the hotel, including

war correspondents and members of the Greek government. There was a well-stocked officers' club called the "Fortress Bar."

The officers of the Russian mission also had their meals at the Grande Bretagne mess. Usually they went back to the Russian Embassy after dinner, but if the shooting outside were too intense they would stay the night, sharing rooms with others in the hotel.

One evening I was having a drink with a few other correspondents at the hotel bar. A British paratrooper major joined us. "Would any of you chaps like to go to the Acropolis?" he asked. "We are sending supplies to the Acropolis tonight and there is room for one or two of you to come along." We knew that paratroopers had captured the Acropolis on December 6 to prevent it from falling into the hands of the ELAS. Had ELAS fighters occupied it, they would have had a perfect position, dominating the city, from which they could have fired unmolested in any direction. The British would not have dared to use artillery or mortars to dislodge them for fear of damaging the Acropolis and causing an international outcry.

There was a moment of silence. I had had enough to drink so I raised my hand and said I would go. "Right," he said, "be ready in an hour. I'll pick you up here."

One of the correspondents turned to me and said, "You must be crazy. That means two trips through ELAS territory, going and coming back. And there's not even a story there!"

He may be right, I thought, but it is too late to turn back. So I went to my room and packed a few things in a musette bag, took my cameras, and went back to the bar.

The major picked me up. Ours was the second jeep in a convoy of six. We raced through the dark, empty streets, and in a few minutes we reached the foot of the Acropolis. To see if the jeep ahead of us had stopped, our driver flashed his lights on and off. Immediately we came under intense machine-gun fire from ELAS positions in Philopapos hill, west of the Acropolis. The paratroopers replied with machine-gun and mortar fire.

Then we dashed up the marble stairway.

The paratroopers were billeted in the museum. Guns, binoculars, and berets hung on the statuary. The men were sprawled on the floor writing letters, or reading by candlelight.

The next day I photographed them "at work." The Acropolis gate was blocked with heavy timbers and sandbags. The paratroopers, armed with machine guns, were positioned behind the fallen colonnades or at the Parthenon, where a communication post had been set up. I photographed a young paratrooper tending a radio set on the Parthenon, then returned to the museum to fetch more film. While I was reloading the camera, I heard a few loud explosions. When I came out, I saw stretcher bearers carrying a soldier. It was the radio operator; he had been wounded by a mortar shell that landed on the Parthenon a few minutes after I left.

That night a supply convoy took me back to the Grande Bretagne. As we got into the jeeps to leave, the paratroopers laid a heavy barrage on the ELAS to keep them down.

American correspondents in Athens were invited to a traditional Christmas turkey dinner by the American officers of Air Transport Command. Their headquarters were in the Hotel Kosmopolit, which was near Omonia Square in ELAS-held territory. When we were driven back late that night in a canvas-covered army truck, our driver was challenged. Before he could stop, we heard a few shots fired. Everyone hit the floor. The canvas was thrown back and a flashlight shone on us. We were ordered out. Nervous Greek police and a couple of British military police checked our papers. We were asked rather roughly by a Greek police officer what we were doing in ELAS territory. One of the correspondents told him that it was none of his business; as newsmen we were free to travel wherever we considered it necessary. The police officer shook with rage, but he could do nothing. The British MPs were not friendly either but softened up and smiled when we wished them a merry Christmas.

The following morning there was great activity outside the hotel. Army engineers and workmen were hauling burlap bags filled with dynamite out of manholes and piling them on the sidewalk. The ELAS had planned to blow up the hotel—General Scobie and the Greek government with it. American correspondents fell under suspicion by the British and Greeks at the hotel. How was it that all of us had been absent from the hotel the night it was to be blown up?

Later that day Prime Minister Winston Churchill arrived in Athens. He had come to try to bring the Greeks from both the left and the right to the conference table. He himself would be the arbitrator trying to end the civil war. Churchill was not in a jolly mood. He was under fire both at home and in the United States for Britain's role in the unpopular Greek war.

He was driven to the British embassy in an armored truck. The press officer did not tell the correspondents what would take place except that we would be briefed later at a press conference. He then took me aside and asked whether I still had some flashbulbs. I told him I did. "Good," he said. "I'll pick you up shortly." He asked me not to say anything about it to the other correspondents.

He picked me up and took me to the Greek Ministry of Foreign Affairs. When we arrived I understood why I had been invited. There was no electricity in the Ministry where the conference between the Greek government and ELAS, monitored by Churchill, was to take place. For illumination, about a dozen hurricane lamps had been placed on the huge conference table. The army photographer at the meeting had no flashbulbs. I did. So I shared the lighting with him.

The conferees filed into the room. On one side of the table sat Churchill, Anthony Eden, Field Marshall Sir Harold Alexander (Allied commander-in-chief in the Mediterranean), Archbishop Demaskinos, Colonel Popov, and the American Ambassador Lincoln Mac-

Veagh. Facing them were members of the Greek government headed by Papandreou. The ELAS delegates did not show up. I shot one overall picture with a flashbulb, then gave the remaining two bulbs to the British army photographer and continued to photograph using the existing dramatic lighting.

I shot my pictures from the Greek side of the table, focusing my camera on Churchill. After a few exposures he growled at me, "Take pictures of the Greeks! It's their show." So I went around the table and took a few pictures of them. Then I got behind the Greeks again and continued shooting Churchill. To steady my camera I placed my elbows on the shoulders of one of the Greeks and asked him to sit still while I rested my camera on his bald spot. Churchill, pointing at the Greeks, almost shouted at me, "Photograph them!" Suddenly there was a husky Canadian colonel behind me. "You heard him," he whispered. "Photograph the Greeks!" I took a few more shots of the Greek delegation and left.

The ELAS representatives had still not arrived. Later we learned that despite General Scobie's assurance of safe conduct, the ELAS delegation had been delayed coming through the lines.

A few days later a truce was signed by General Scobie and the ELAS representatives. The cease-fire became effective on January 15.

Athens was a forlorn city. It had managed to remain intact throughout the German occupation, but during civil war had been battered by artillery and rockets fired from Beaufighters. Many of its buildings were in ruin. Haggard Athenians poured into the streets looking for food or searching for relatives who had disappeared during the fighting. In the outskirts of the city the exhumed, decomposing bodies of the dead were laid out in long rows. Athenians looking for missing relatives ran along between the rows, their noses covered with handkerchiefs. For days after I left Athens I carried that smell of death with me.

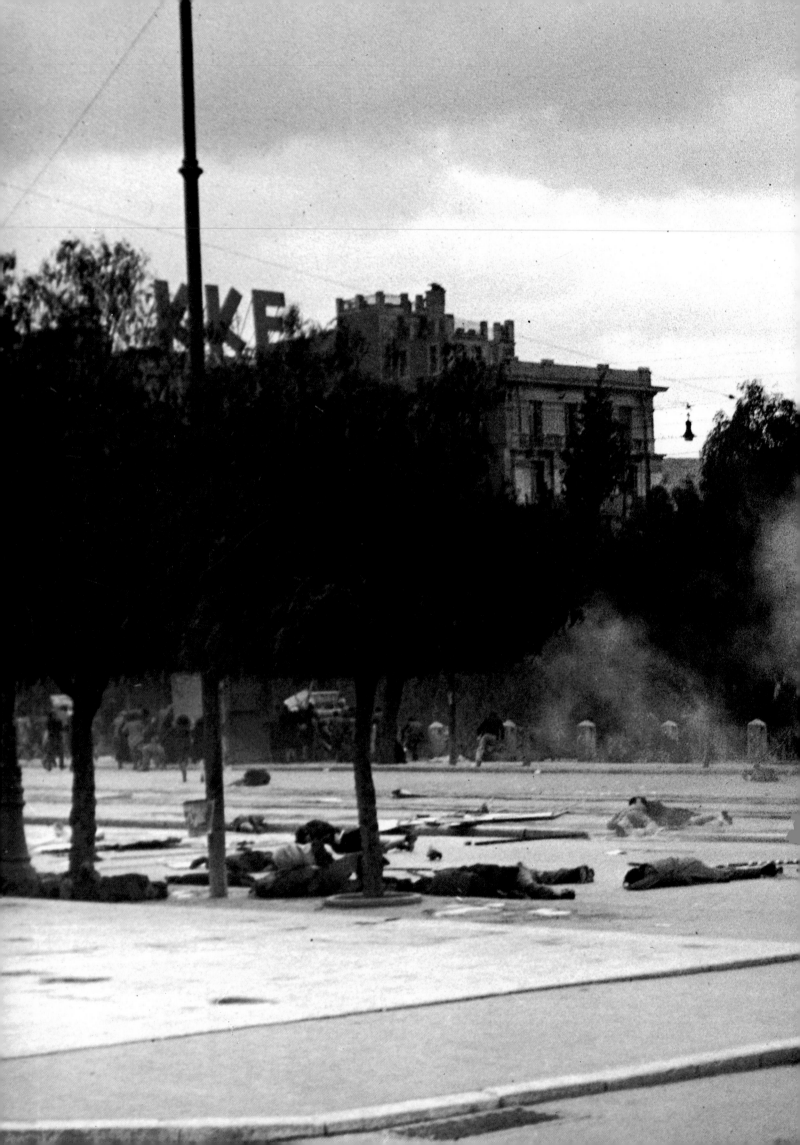

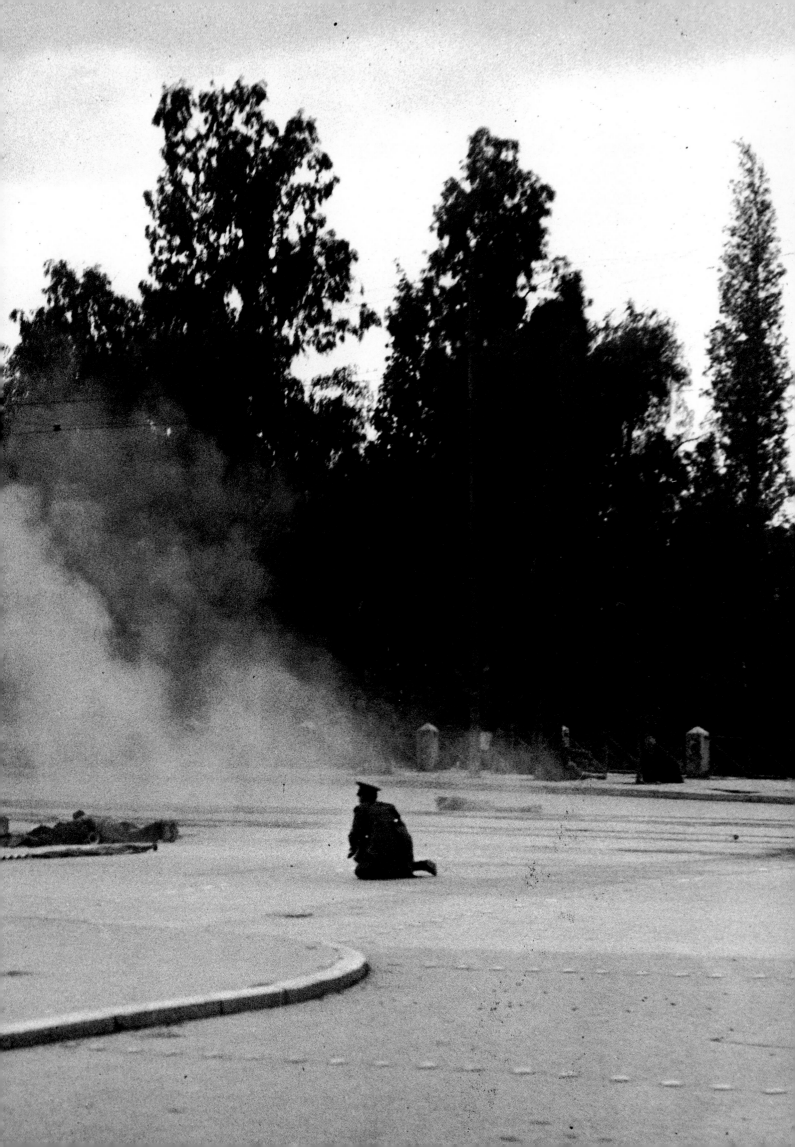

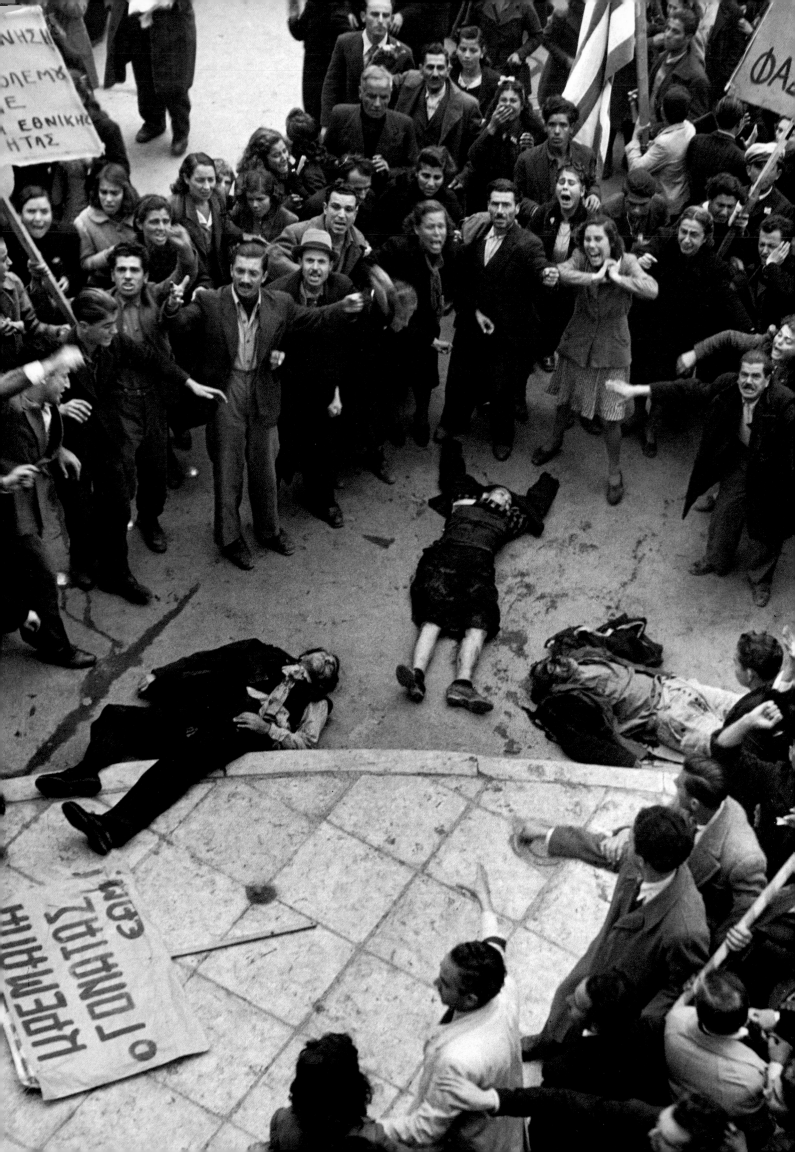

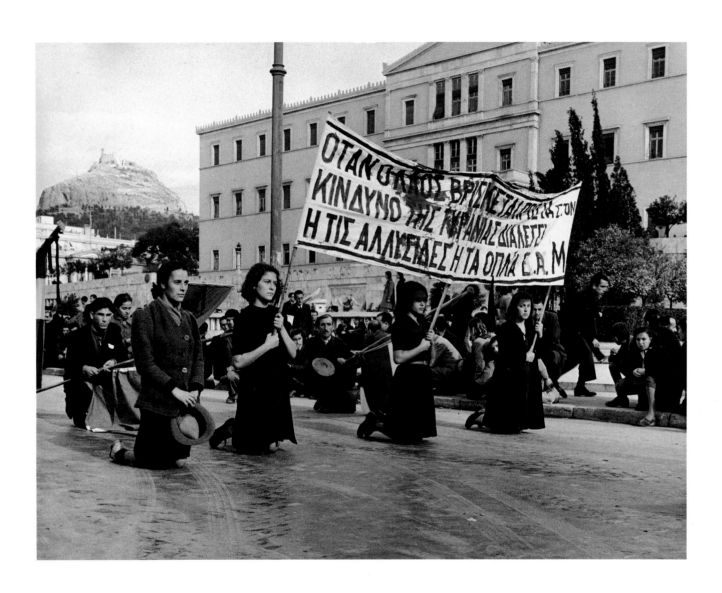

On December 3, 1944, the civil war began. In Athens's Con-
stitution Square the police opened fire on a demonstration of
EAM sympathizers (preceding pages) killing 23 and wounding
140. Left: Angry demonstrators gather round some of their dead
comrades. Above: The funeral ceremony the following day. The
banner, which reads, "When the people face the danger of
tyranny, it must choose between chains and weapons," is
splattered with the victims' blood.

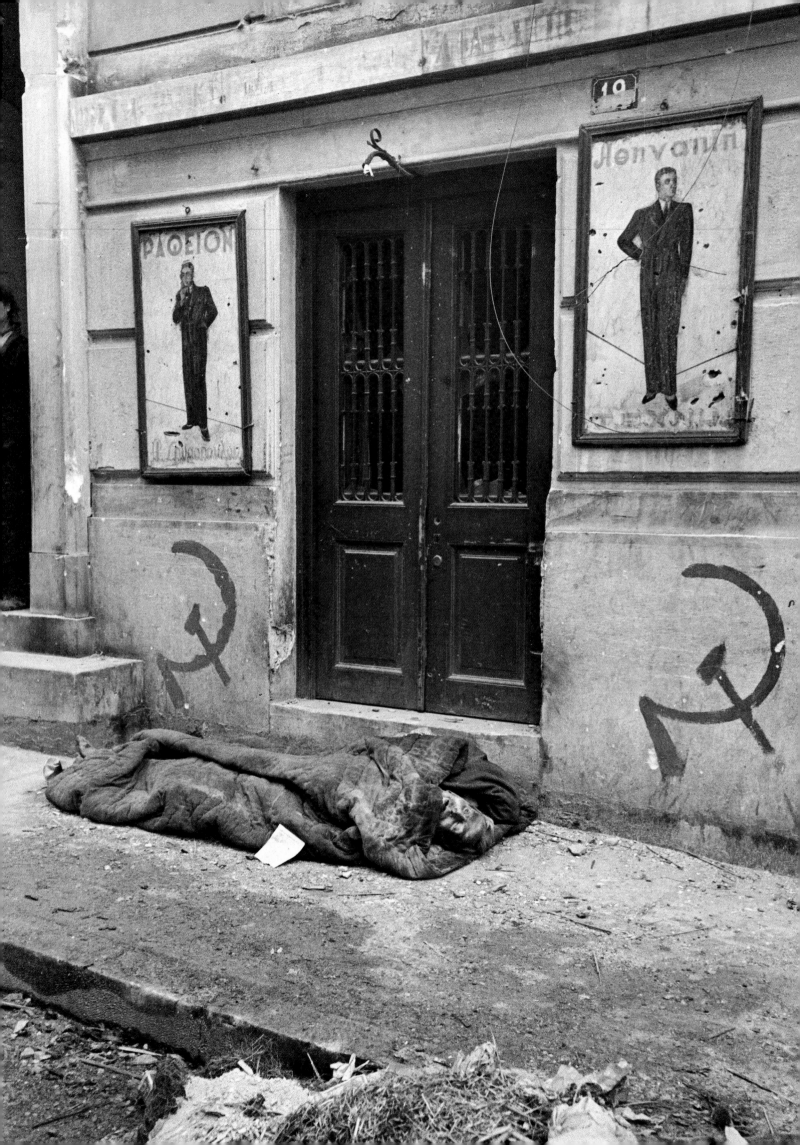

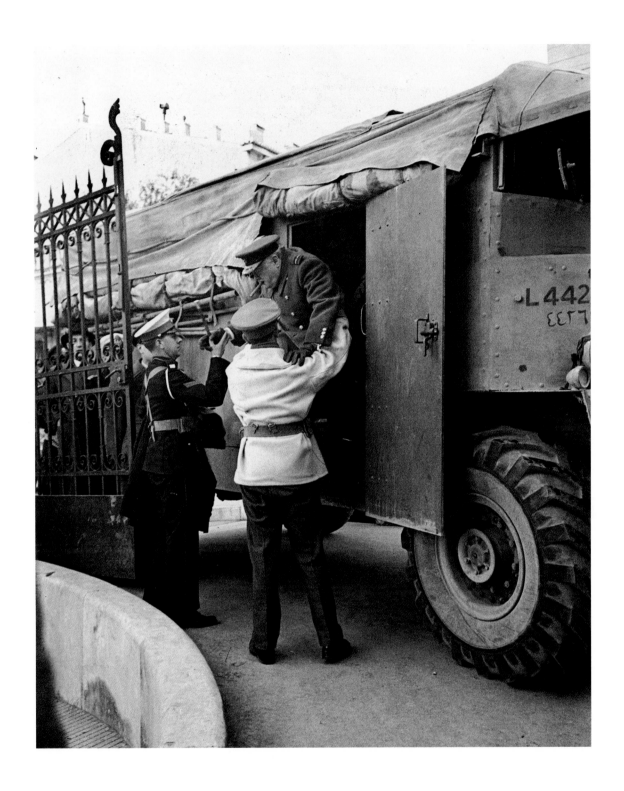

Opposite: A Greek demonstrator killed Christmas Eve in a street
fight lies on an Athens sidewalk.
Above: On Christmas Day Churchill arrives via armored truck to
try to negotiate a ceasefire.
Overleaf: Negotiating at the Ministry of Foreign Affairs, lit
only by hurricane lamps. On Churchill's left is Archbishop
Demaskino; on his right, Anthony Eden.

Above: British paratroopers billeted at the museum on the
Acropolis, which they took over as soon as civil war broke out.
Opposite: Two British paratroopers at the Parthenon carry one
of their wounded buddies to an aid station.

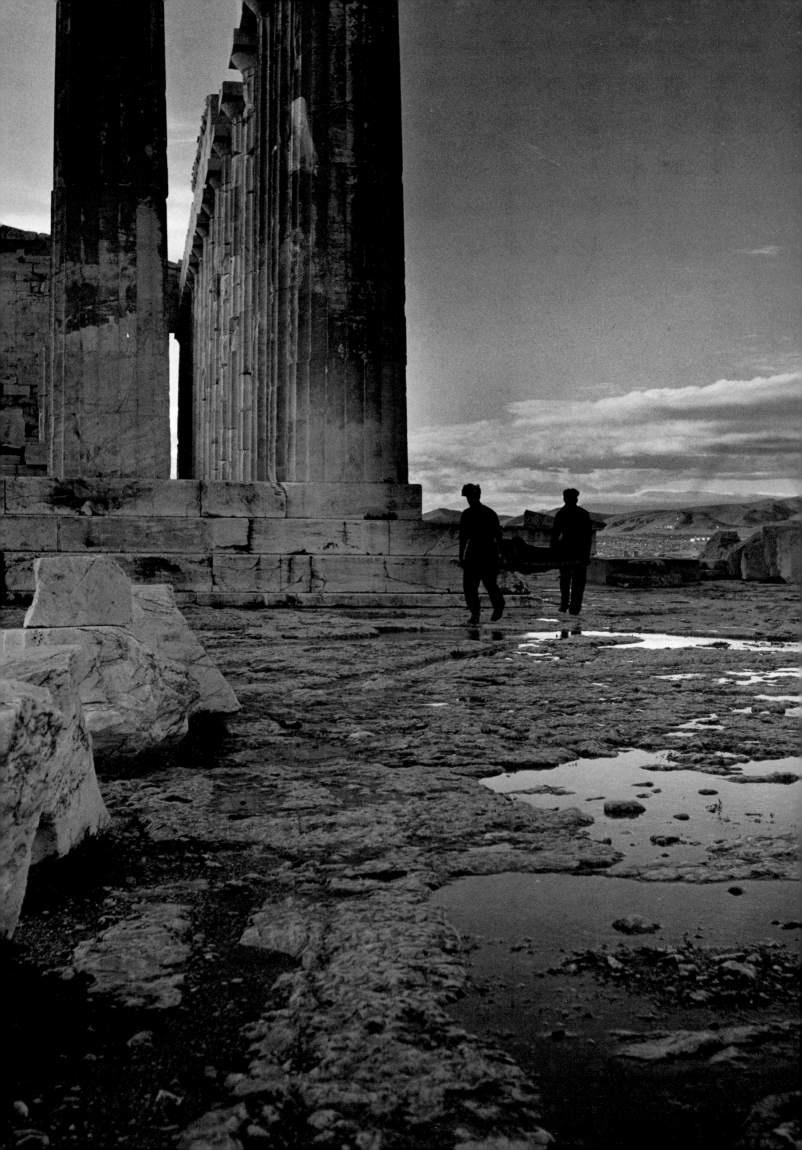

CHAPTER 4:
IN GOD'S GLORY

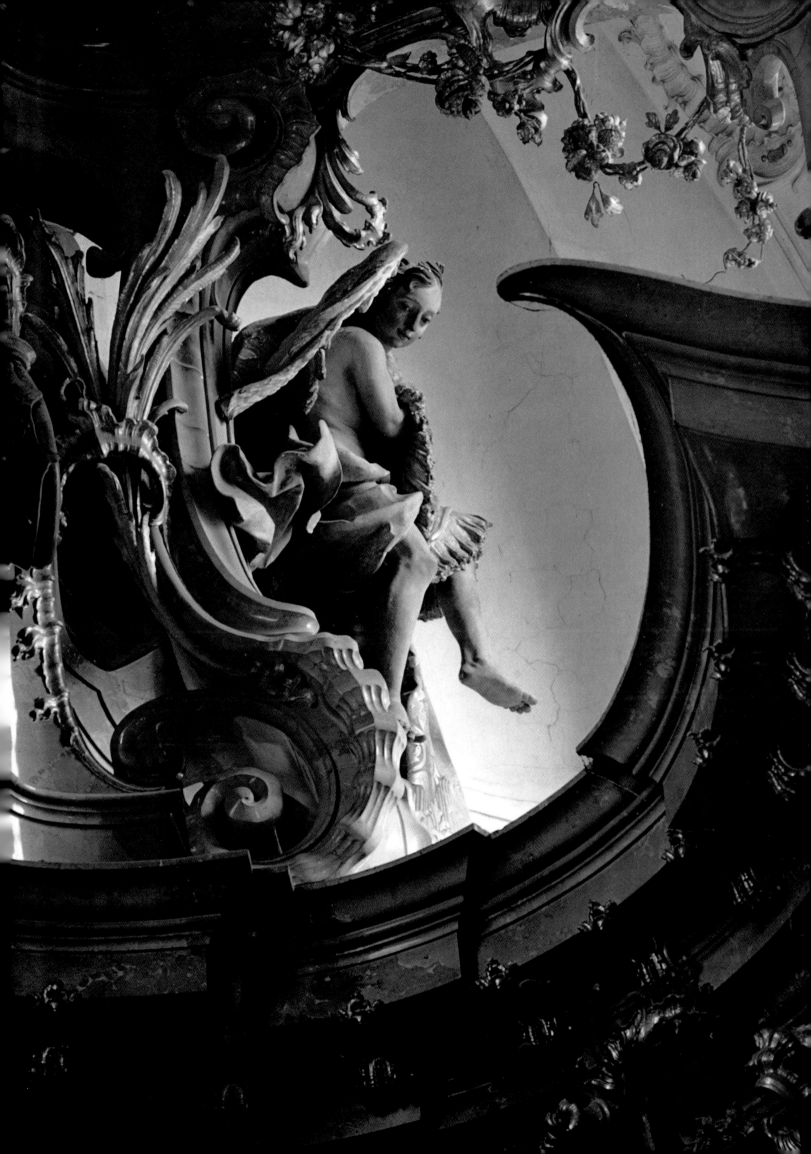

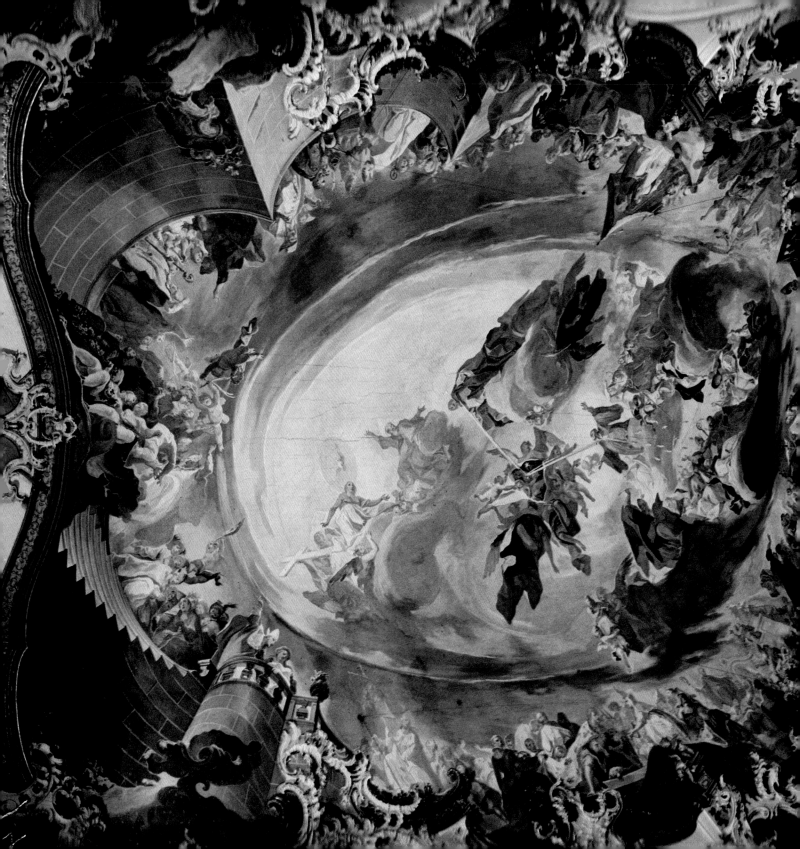

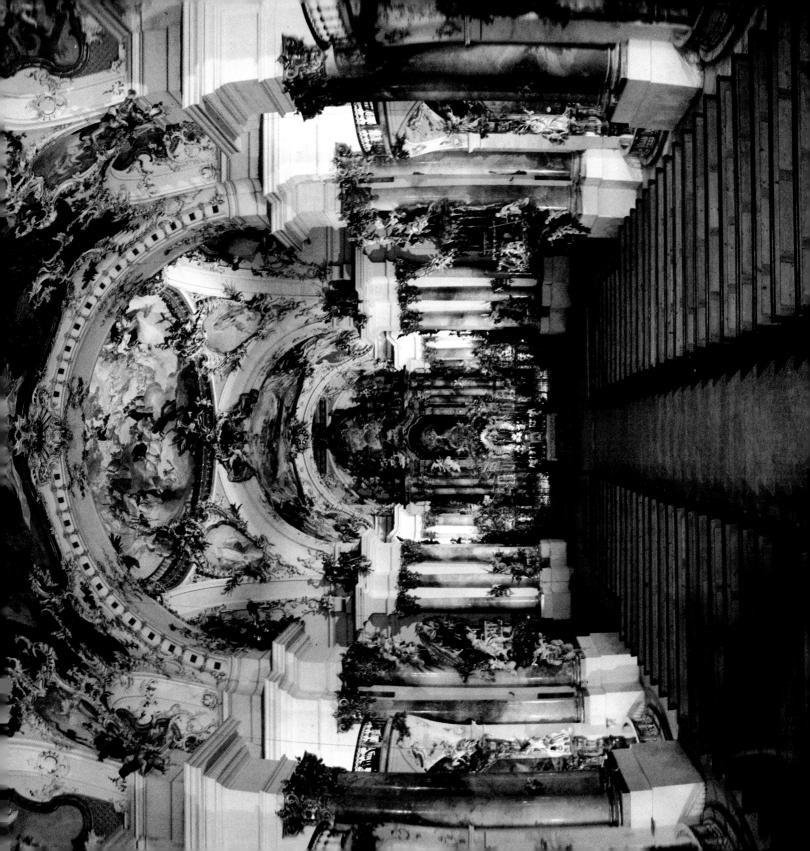

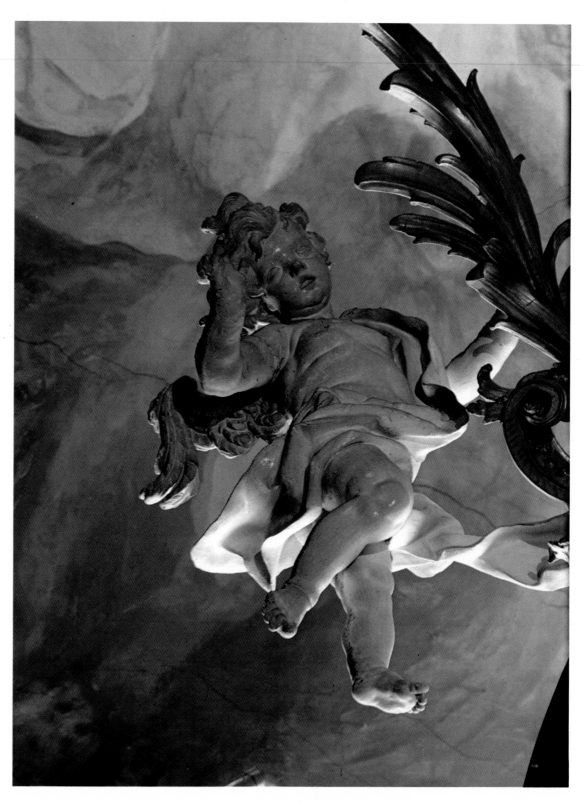

The cherub above and the angel on page 113 are part of the host of heavenly
inhabitants that covers the walls and ceilings of the interior (preceding pages) of the
Benedictine church at Zwiefalten, Germany, a masterpiece of rococo exuberance.
Opposite: In the Minster of Ulm, Germany, is found this wood sculpture of
Pythagoras playing his lute by Jorg Syrlin, the Elder.

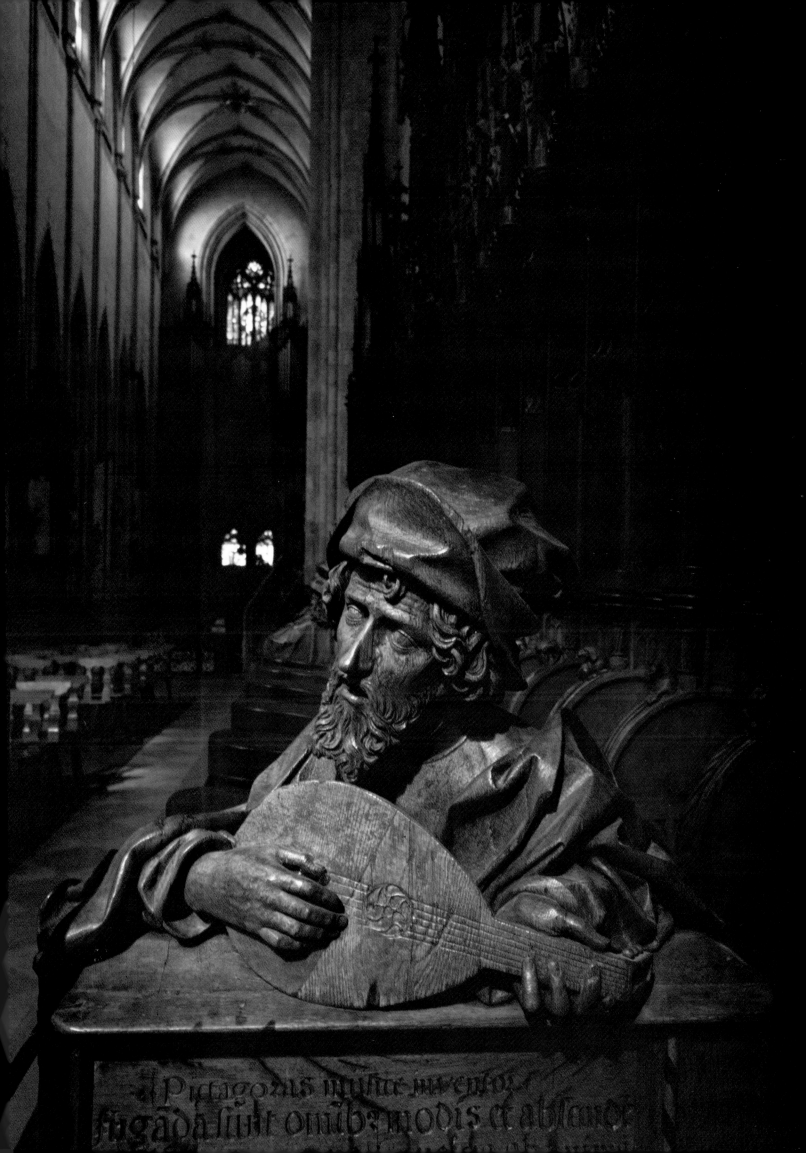

Pitagoras musice inventor
fugada siunt omibz modis et ab lutuoz

LIFE editors had a tendency to "type" their photographers. If one did an exceptionally fine job on a first assignment on a specific subject, the likelihood was that he would be called on again and again to work on similar stories. Some photographers became known as "sports" photographers; others became "breaking-news" or "food" or "people" or "girlie" photographers.

I got classified as a "church" photographer and as an "art" photographer, especially religious art. These labels stuck to me after I did one color story on the newly restored mosaics in the Hagia Sophia, originally a church, now a museum in Istanbul, in 1949, and another in 1950 on the recently completed church in Assy, France, to which such modern artists as Rouault, Léger, Matisse, and Bonnard had contributed their works. Church assignment followed church assignment—in 1953 alone five great cathedrals of Europe. In the fifteen years of 1949 through 1963 I had photographed so many cathedrals and so much religious art that in 1964 a book of my work, titled *Splendors of Christendom*, was published; it contains 267 pages, and all the photographs are in color, tipped in.

Every assignment involving church architecture or religious art offered different technical problems. The most complicated were the Tintorettos I was assigned to do in 1951 for a Christmas issue of LIFE.

The Tintoretto paintings in the Scuola di San Rocco in Venice depict the life of Christ in huge panels that cover the walls of the entire first and second floor. The curator was very cooperative. He was ready to close the museum to visitors if we preferred to work in the daytime, but we decided it would be more practical to work at night. Scaffolding had to be constructed for each panel and special electrical lines run to power our lights. It was quite a production. I was assisted by David Lees, a freelance photographer from Florence, and by Count Ottavio Zazio, a Venetian nobleman who was working as the Time-Life stringer in Venice. We hired an Italian electrician-scaffolding crew headed by Signor Mas-

eroni, an electrician formerly with an Italian movie company. From the London office LIFE sent a color lab technician, Denis Banks, who developed the pictures as soon as we took them so that we could check the results and reshoot if necessary. I wondered at the time why LIFE had decided to set up a field darkroom for film processing. I had never seen it done before; usually we just took our pictures, sent them to New York undeveloped, and kept our fingers crossed that they would be fine. I soon found out why LIFE was so generous about having a darkroom technician on the spot.

The first panel we photographed was *The Annunciation*. When we turned our lights on the painting, it turned into a foggy blur; it looked like a steamy mirror reflecting the light. I felt slightly sick; I knew we were in for serious trouble. We began to maneuver our lights, trying various angles. Nothing worked. While we were struggling with the problem, the curator came in to see how we were doing. He saw that it was not going well and sympathized with us. He told us that other photographers had tried the same thing without success. When the paintings had been cleaned and varnished the last time, some of the Venetian humidity had been trapped between the varnish and the painting. As a result, the canvas began to mold, which created a sort of cataract over the paintings that caused light to bounce back.

Fortunately, we had large sheets of plastic Polaroid filters. We decided to try polarized light, shielding our lights with Polaroid screens and then using a Polaroid filter over the camera lens. It worked: we could see the picture sharp and brilliant in all its detail, except that polarization had reduced the intensity of the light so severely that we had to multiply our exposure fortyfold. I had only four Polaroid screens with me. Using four thousand-watt lamps we had to expose for over two hours for each painting. We could not keep the lights on continuously for such a long period: the heat would burn the Polaroid screen. We would have to keep switching the

lights on and off. It took almost three hours to expose one sheet of film, and we usually shot three transparencies when copying paintings—one correct exposure, one slightly overexposed, and one slightly underexposed. As a result, by the time we finished photographing one painting it was 6:00 A.M.

The developed transparency was good. The trouble was it was *too* good: the colors looked as brilliant and fresh as if the paint were still wet. There was another problem: the upper right corner of the painting was not sharp. We could not understand why. That afternoon LIFE's art director, Charles Tudor, telephoned from New York, anxious to know how it was going. I told him we had problems but I thought we could do the job. "Are you sure?" he asked. "We have twenty pages reserved for the Christmas color. If Tintoretto looks impossible, we will have to look for a substitute." I said that I would send the first sample within a week and asked him to send me immediately twenty-four more sheets of Polaroid filters for my lights.

We went back to the museum at five that afternoon. The curator was absolutely enthralled when he saw our transparency. "How did you do it?" he exclaimed. "It has never been done before. My compliments! Aren't you happy?" "No," I replied. "Look at the color. It doesn't look anything like the

The first church I photographed—in September 1949—was the Hagia Sophia, now a museum, in Istanbul. I did not know at the time that this would be the first of many religious structures I would photograph for LIFE.

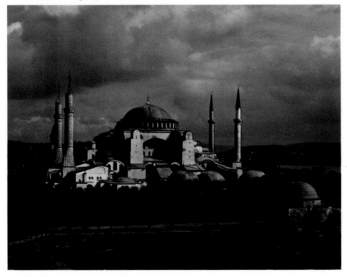

painting. It's too bright!"

"I want to show you something," he said. He led us to the upper floor where, at the end of the room on a table, there was a small, narrow, oil painting of three apples. The colors were very brilliant; it looked like a Renoir. "You know what this is?" he asked. Not waiting for a reply, he answered himself. "Tintoretto painted a narrow decorative frieze which ran along the top of the wall of the hall called Sala dell'Albergo. In 1905, when the room was restored, workmen discovered in the corner a piece of the frieze folded under the panel. Evidently the frieze that Tintoretto had painted was too long for the wall, so, when it was being installed, the excess length was bent back. There it had stayed, hidden from light and from the grime of pollution for more than three hundred years. Now you see what the original colors of Tintoretto's paintings were like. They are the same ones in the photograph you made and I say again, bravo!" "But that is not how they look now," I said. "Anyone seeing the paintings today would say the photographs published in LIFE are false."

The color could be corrected with compensating filters, but we still had to find out what had caused the blur in the upper right corner. We shot it again; the same blur showed up in the same corner. This time it looked definitely to have been caused by some movement. David Lees suggested that it might be the vibration caused by the bells of the Campanile, which tolled every hour on the hour as we were exposing. The following night we shot the picture again, closely watching the time. A few moments before the hour we switched off the lights, then after the bells tolled we continued. It did not help.

We began to suspect Venice itself. The city is built on piles. Was it possible that it was moving enough to cause the blur? We asked Zazio to call the city engineer. Sure enough: he confirmed that Venice is not very stable. What were we to do?

It was Denis Banks who solved the mystery. He noticed that the painting, which was not stretched tight on its frame, looked some-

how loose at the upper right corner. "I'll bet I know what the trouble is," he said. "The damp, cool air between the painting and the wall expands when you keep your hot lights on and pushes the loose corner of the canvas forward." I was sure he was right; the painting was not flush against the wall. So we tried again. This time we had the light on long before we actually began exposing the film. It worked: the blur was gone.

My Polaroid screens had arrived and we began to move ahead. Using eight thousand-watt lamps instead of the four we had used before, we didn't lose as much time in exposing. Still, we could not do more than one whole panel and some details in one night. We usually came to the museum at closing time, 5:30 P.M. Our crew would begin to erect the scaffolding. Then we would start arranging the lights, each one individually, making sure that they were absolutely covered by Polaroid screens. If the unpolarized light in only one reflector spilled on the painting, our night's work would be ruined. By the time

everything was set it would be eight o'clock. Then we would go for a leisurely dinner at a nearby outdoor restaurant, returning to work at ten. We would finish by 5:00 A.M. and be on our way home at 5:30.

One night the curator came with a group of friends to watch us work. We lent him a polarized screen so that he could show his friends how the painting looked seen through it and illuminated by polarized light. There were "ah"s and "oh"s, "incredibilè"s, "fantastico"s, and so on. It became routine for the curator to bring in his friends for the miracle of seeing original Tintorettos. During the long periods of time exposure we had to sit around waiting, so we did not mind the company.

Tintoretto's great painting of *The Crucifixion* was another problem. It was wall to wall, forty feet long and seventeen feet high, and there was not enough room to back up the camera to photograph all of it, even with a wide-angle lens. So our Signor Maseroni built a rail track on top of the scaffolding, which ran absolutely parallel to the painting. My camera, placed on a dolly, could move along the track to copy the painting in three sections that could easily be matched later.

It is such a joy to work with experts. When-

Photographer Kessel (far left) on a scaffolding in the Scuola di San Rocco in Venice, copying Tintoretto's paintings of the life of Christ. The other men include Signor Maseroni (second from left), David Lees (far right), and other assistants.

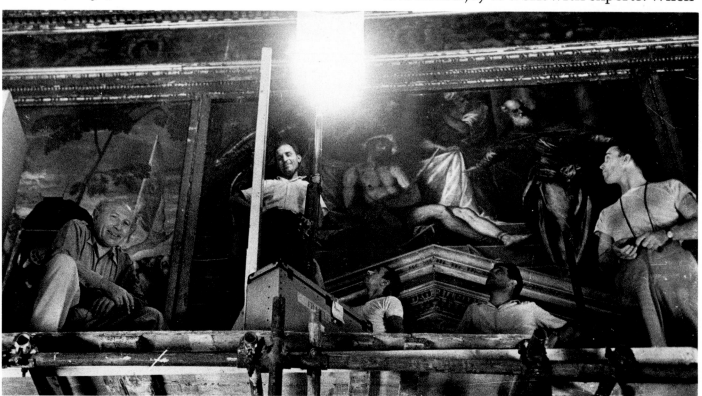

ever we had a technical problem, there he was, Signor Maseroni. "Comandi, Signor Kessel," he would say, not "What is it?" or "What can I do for you?" And when I would tell him what I wanted he would say, "Non si preoccupi. Ci pensoio" (Don't worry. I will take care of it). In practically every case he found a way to solve our problems. Without him, I'm sure I could not have done the job.

Of course, what helped too was LIFE's unlimited expense account. It cost about ten thousand dollars in expenses to shoot the Tintorettos for that one story. In 1951 that was a great deal of money; not many magazines would have been willing to spend as much.

Working in Saint Peter's was a very different story. To begin with, the Vatican always charges publications just for permission to photograph inside. There is an additional charge for the personnel assigned to work with the photographer. Although I already had my own electrician and two scaffolding men, the Vatican ruled that we would also have to have—and pay—four Vatican electricians, two custodians, three security men, and one fireman. Counting myself and my assistant, we were fifteen. When I protested to the Vatican official with whom we were negotiating that I was bringing my own electrician, he said that was okay. *His* electricians would not work with me but would simply stay at the electric switch panels of the cathedral to make sure that we did not cause any trouble by overloading the lines.

At seven o'clock each evening two guards would go out to buy dinner for the entire crew. The first night I ordered cold cuts, cheese, wine, and mineral water for everyone. When the dinner arrived, the Vatican employees arranged themselves on the steps of Bernini's Baldacchino to eat. Somehow, I felt that they were not too happy with their meal. The next night I told them to order whatever they wanted. They came back loaded with big bowls of hot pasta, hot roast chicken and veal cutlets. The mood was gayer.

To photograph the mosaics in the apse of the Monreale Cathedral outside of Palermo we had to build a forty-foot scaffolding and two steel towers for the lights. The little elderly priest with whom we negotiated permission had no objection, but he thought we ought to contribute something to the church. "We intend to," said David Lees. "How much, padre?" The priest thought for a moment and said, "Sixty thousand lire" (then about a hundred dollars). He looked at us anxiously, ready to reduce the sum if we bargained. "We will give you seventy thousand," said David. The priest stared at him incredulously. David gave him the money, and he ran off with it, afraid we might change our minds.

A couple of hours later a truck arrived and a dozen workers began unloading steel tubing and wooden boards for the huge scaffolding they had to erect and take down before the 6:00 A.M. mass. When our little priest saw what was happening he threw up his arms and, repeating "Mamma mia! Mamma mia!", disappeared. We did not see him again until the next morning, when, our job finished, the scaffolding and light towers were dismantled and loaded into the trucks. He came in timidly as though he were not sure the church was still there.

When shooting from the high scaffolding I could not remain there, even for a short exposure, because no matter how solid and stable scaffolding seems, there is always some movement. So, when I was ready to shoot, we would switch off the lights, I would open the lens shutter, climb down off the scaffolding in total darkness, wait a few minutes until the scaffolding stabilized, and then switch the lights back on for the length of the exposure. Afterward, I would climb back in darkness to shut the lens and change the film for the next exposure. To get to the top of the scaffolding the workers had arranged four twelve-foot ladders in zig-zag fashion. For the eight exposures I made that night I had to go up and down the stepladders sixteen times in complete darkness.

For a story on "Great Churches of Europe" I photographed the Minster of Ulm in Germany. Ulm, a medieval city on the left bank

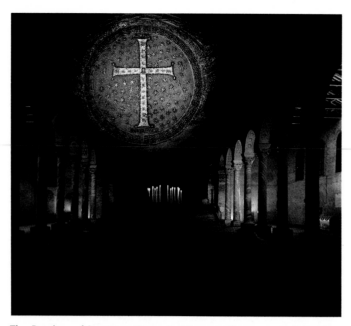

The Basilica of Sant'Apollinare in Classe in Ravenna, Italy, built in the first half of the sixth century. Among its most famous mosaics is this cross. The columns are of marble from the Sea of Marmara; the plinths and capitals, Byzantine-style.

of the Danube, had been heavily bombed during the war. The buildings around the church were completely destroyed, but the church itself, with its 530-foot spire (the highest in Christendom), had not been touched. One of its great treasures is a thirteenth-century stained-glass window, located about thirty feet above the floor. I told the city architect in charge of the church that we would have to build scaffolding in order to get to the window. "Scaffolding of that height will not be practical," he said. "I have a better idea. We will take the window down so that you can photograph it."

The window was small, about four by two and a half feet, but it was heavy. "How are you going to do it?" I asked. "Simple," he said, and called one of the workers over. He told him to get stepladders and bring the window down. I protested and begged him not to do it. If anything happened to the window, it would be a catastrophe. He just laughed. The workers brought in two stepladders, each about eighteen feet tall, tied them together, and placed them against the wall. They reached just under the window. A middle-aged worker climbed up and began to remove the window. I could not look: I expected both the worker and the window to come crashing down. The

most difficult part for the worker was descending the ladder with the window. He hugged the ladder, holding the window behind it with his hands. I was so nervous that I left the church and paced outside until I was informed that the window was safely down. I photographed it, then hastily retired while they returned it to its place.

In 1963 *Time* magazine borrowed me to do a story on the monasteries and monks of Mount Athos in Greece. It was to be an eight-page color act to run in *Time*'s "Religion" section in July 1963, the one thousandth anniversary of the founding of the Great Laura monastery, the oldest of the twenty monasteries on Mount Athos.

Mount Athos, 6,670 feet high, lies on the Akte peninsula that juts into the Aegean Sea about 200 miles north of Athens. It was held sacred long before Christ; Aeschylus refers to it as the "Peak of God." It has been the site of Christian religious communities ever since hermits began settling there in the middle of the ninth century. Great Laura was founded by Saint Athanasios in the year 959. He had opted to live on the holy mount rather than accept an appointment as confessor to the Byzantine emperor. There he and other monks began building the monastery atop a five hundred-foot promontory among cypresses overlooking the sea. A fortresslike compound with a square watchtower, it housed about eighty monks.

In 1963 there were still about two thousand monks living in the monasteries on Athos. They were all members of the Eastern Orthodox Christian faith, the third largest branch (after Roman Catholic and Protestant) of Christianity.

Lay outsiders seldom visit the monasteries. One needs special permission to go there; mine was issued by the office of Athenagoras I, the Ecumenical Patriarch of Constantinople (Istanbul to practically everyone except Eastern Orthodox Christians), the spiritual leader of the faith.

No women are ever allowed on Mount Athos, not even female animals. Years ago I

had read a book by a French woman journalist who claimed that she had gone to Mount Athos posing as a man. She had cut her hair very short, and, dressed in men's clothes, she might easily have passed for a man except for her large bosom. So, she claims, she had her breasts removed—a sacrifice considerably above and beyond journalistic duty. It was a very unlikely story, as was the rest of her account of the life of the monks on Mount Athos. She wrote about hearing monks in the garden outside her window passionately whispering words of love to one another.

Time's Athens stringer, Anthony Antonakakis, had arranged for me to travel to Athos on a Greek navy minesweeper. She was transporting back to Karyai, the capital of the peninsula, the miraculous icon, *Axion Esti*, which had been on exhibit in Athens. Also aboard were members of Great Laura's cele-

Below the illuminated Belfry Tower of the Halles in Bruges, Belgium, a passion play was performed in 1952. It re-enacted the arrival in 1150 of a Holy Relic brought from the Crusades allegedly containing blood from Christ's wounds.

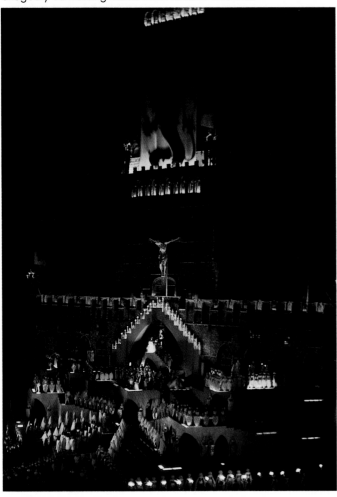

bration committee and a delegation of Greek Orthodox high clergy and some laymen.

With me was my young friend, Takis Kirkis, who had worked with me before on the Greek islands story, and a man whom Antonakakis insisted we take along as our guide and middleman to deal with the monks. I was given a nice cabin aboard the ship; Takis and our guide shared their cabins with other passengers. In the middle of the night Takis woke me up and asked if he could sleep in my cabin. He said his roommate, an old monk, had made a pass at him. As my cabin had two bunks, I said okay. The next day Takis looked gloomy: a handsome young man, he was worried about being isolated on Mount Athos with two thousand monks.

We took with us supplies of canned food, coffee, and a small kerosene camp stove. There were no hotels on Mount Athos, but every monastery had some guest rooms. Some were comfortable, others consisted of barren communal rooms with as many as a dozen beds. Laura's guest accommodations were quite comfortable. The price for a room, including meals, was about four dollars per person per night.

The monks on Mount Athos are divided into cenobites who live, work, and pray together, and idiorrhythmic monks who live in tiny cottages and apartments, often owned by them. The latter get together only for the Divine Liturgy or for common meals on great feast days. The main business on Athos is prayer, about ten hours a day beginning at 8:00 A.M. Byzantine time (2:00 A.M. Athens time). Some monks, to earn money, carve small religious statuary from wood; others paint icons. Elderly monks are cared for by young monks, their spiritual sons.

We were free to move around and photograph exteriors and interiors. We were also allowed to photograph the monastery's treasures and holy relics. Some of the older monks, however, were camera shy; when they saw me pointing a camera at them they would turn away. One monk, a former Greek army doctor from Karyai, nearly hit me with

his walking stick when he saw me trying to photograph him.

Our first evening on Mount Athos, Takis and I decided to take a walk after dinner in the monastery courtyard. Within a few minutes we were challenged by two monks who were on "night patrol." They escorted us back to our quarters. We did not know then about the strict curfew after dark.

A steep, winding path leads to Karoulya, a Mount Athos hermitage. High above the sea, hermits live in seventeen cliff-side shacks, as they probably did elsewhere on Athos a thousand years ago. A cable runs along the path so that one can hold on while climbing to the highest dwelling. Russian monks were the first to settle in Karoulya at the beginning of this century. There were eighteen monks living there in 1963: nine Greeks, eight Russians, and one Serb. They were very poorly dressed, some in rags or in burlap knee-length shirts tied at the waist by a rope. There was no source of water; it had to be collected during rainstorms and stored. For food, the hermits depended on donations from other monasteries. Saint Paul and Dionysiou, the two nearest to Karoulya, helped the most. There were a few hoisting wheels from which the hermits lowered buckets or baskets to the waterfront for the passing fisherman to fill with fish or, occasionally, bread. Some hermits earned a little money by carving small crosses and selling them in Karyai shops.

Two Russian hermits of opposite social backgrounds lived side by side. One, Father Nikodim, had been a driver of a horse-drawn tramway in Saint Petersburg before coming to Athos. His neighbor, Brother Nikon, was a former colonel in the Russian Imperial Guard. Nikon was tall and slender, and, although eighty years old, he still bore himself like a guardsman. He was a very cultured man; he spoke seven languages. Speaking to him in Russian, I asked him about his past. All he said was "Ya Zheel" (I lived), which in Russian implies living it up. He was almost blind and deaf. He had just received a letter from his brother who lived in Washington, D. C. He showed it to me, saying that he could not read it because he could not see. The letter was written in Russian so I offered to read it to him. But he, after a pause, said that it did not matter. I offered to get in touch with his brother when I returned to the States, but he just shook his head. The monks in Laura told me that Brother Nikon had been a Russian prince.

Another monk, Father Grigorios, was most friendly, cooperative, and helpful. He carved small wooden crucifixes, which he sold in Karyai. At the doorway to his hut was a bucket in which rested, neatly arranged, a human skeleton. When we asked him why it was there, he said, "Oh, it is my brother Nilos." Nilos has also been a monk. When he died, Father Grigorios bought Nilos's house from Laura for one thousand drachma (about thirty-four dollars). Because hermit monks have no "spiritual" relatives, Father Grigorios felt it was his duty to dig up the remains of his brother, according to religious custom, three years after he was buried, and bring him home.

Many of Athos's monasteries are dying out because of lack of recruits. One old monk said to me, "The monk business is no good, very slow. No new monks coming in." The Russian monastery, Saint Panteleimon, the largest on the Akte peninsula, once had more than two thousand monks. When I was there the population was only thirty, and the youngest monk was sixty years old. And I noticed that the huge pots in which monks once used to cook borscht for hundreds were slowly rusting away.

Opposite: Indian women offering a thanksgiving prayer at a harvest festival at Sachiapuram. Converts from Hinduism, they are members now of the United Church of South India, a merger of non-Catholic denominations.

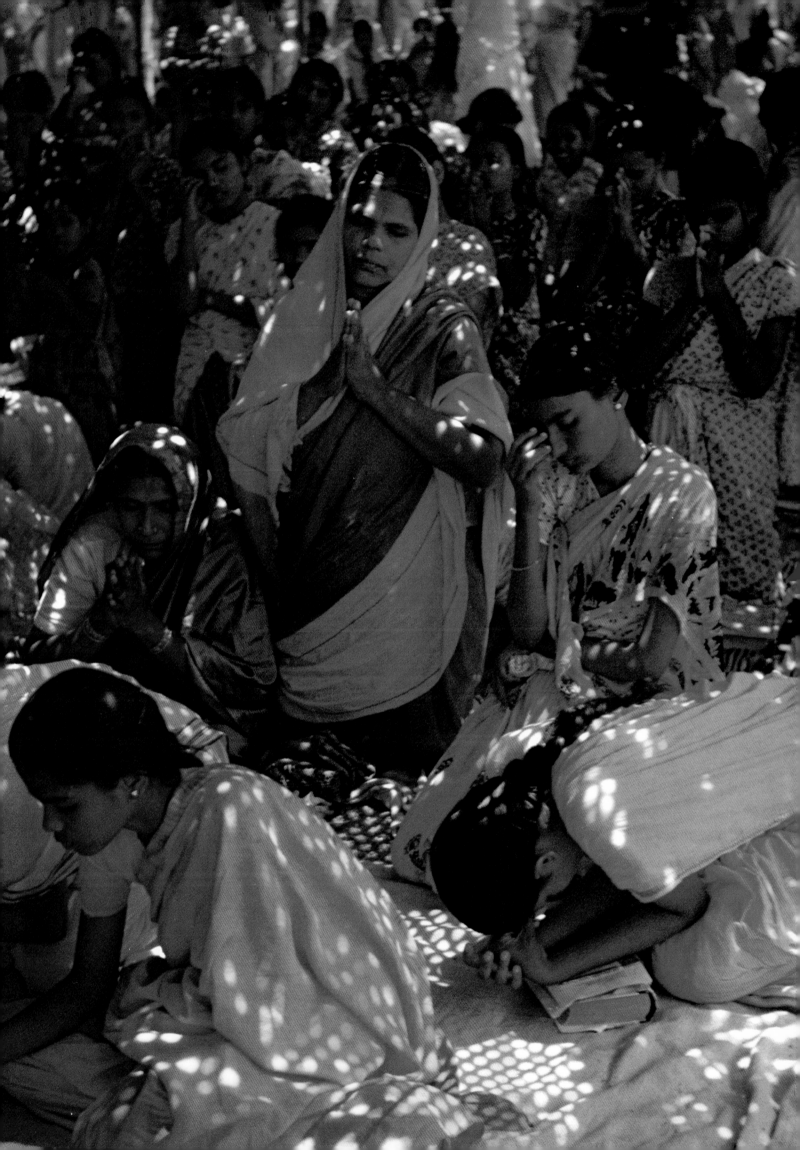

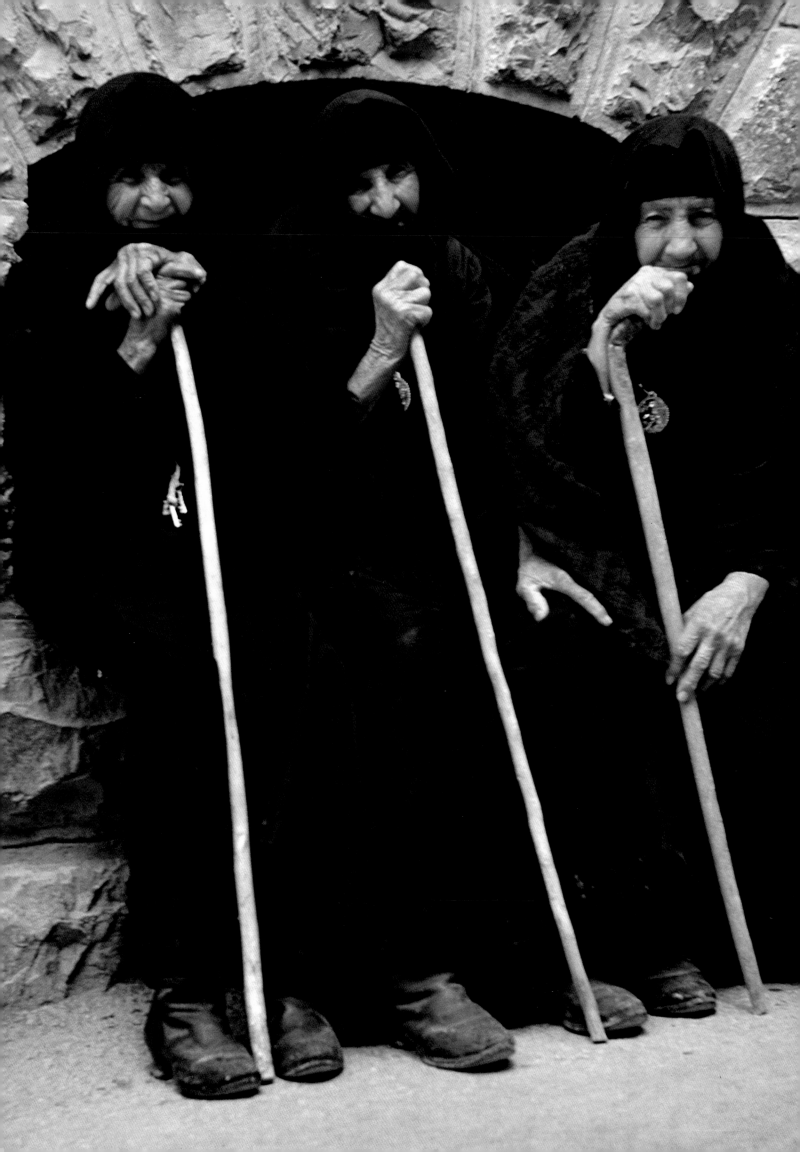

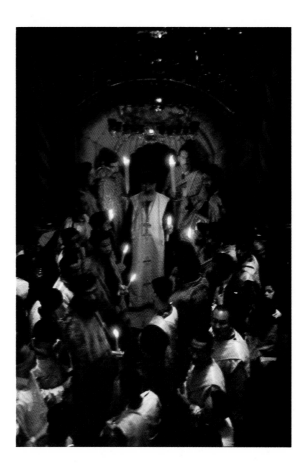

Above: At Christ's tomb in the Holy Sepulchre in
Jerusalem, Copts celebrate Holy Saturday—
the day before Easter, 1955.
Opposite: Three Greek women, pilgrims in Jerusalem
for the celebration of the Easter Week holy days, in
front of the Holy Sepulchre.

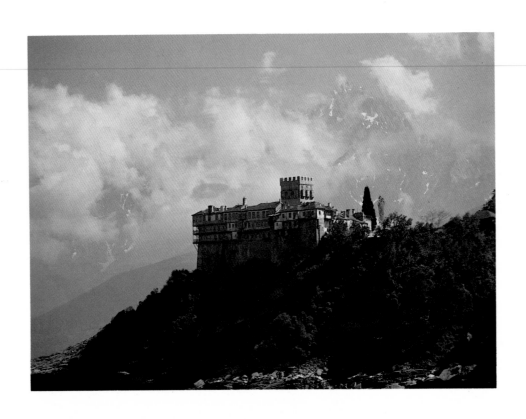

Above: Overlooking the Aegean is Stavronikita, newest of
Mount Athos's ruling monasteries, founded in 1542. Looming
over it is Mount Athos itself.
Opposite: Father Grigorios, a Greek hermit, carves crucifixes at
Karoulya Hermitage for-sale in Karyai. The bucket at right con-
tains the skeletal remains of his brother Nilos, a former monk.

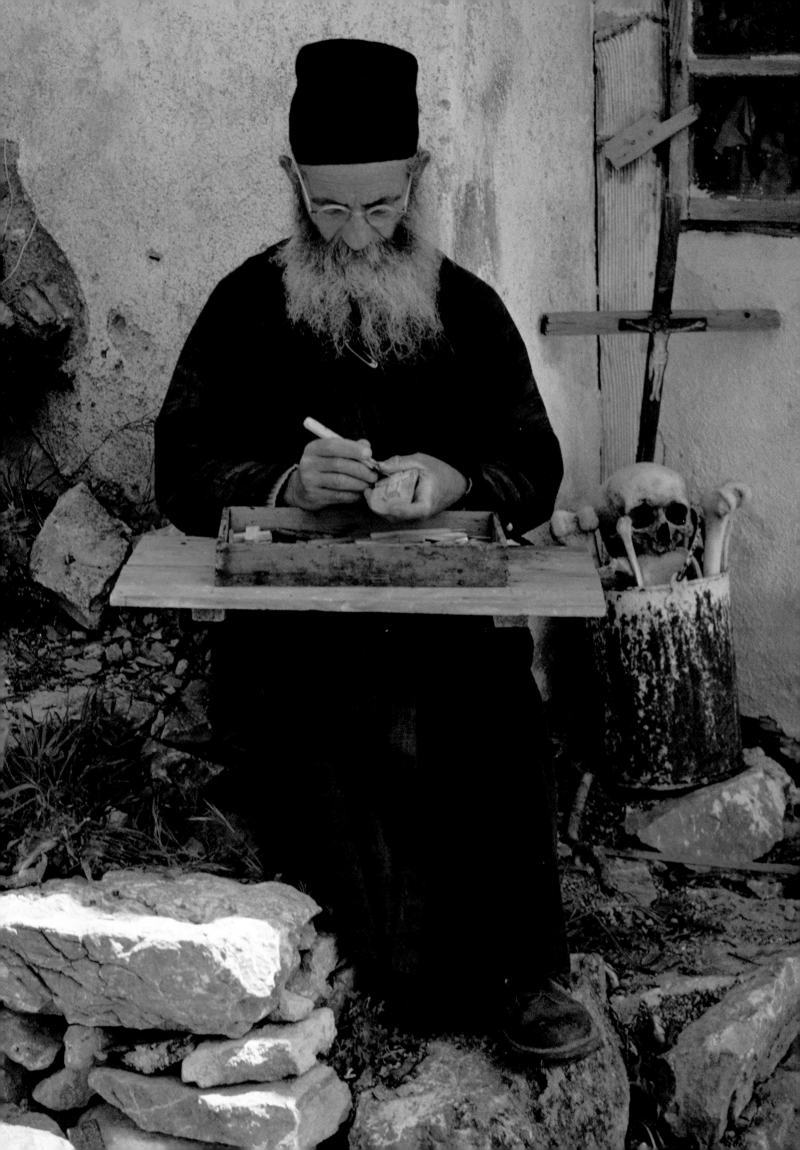

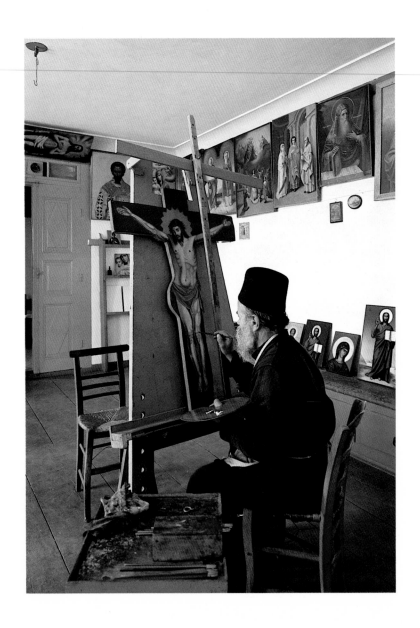

Above: A Mount Athos monk paints the crucifixion, which, along with the other icons he has made, will be offered for sale.
Opposite: Dining under the stern gaze of saints and martyrs in murals, including *Last Judgment* and *Host of Angels,* monks at the Dionysiou monastery, founded in 1375, listen to a fellow monk reading a warning against gluttony.

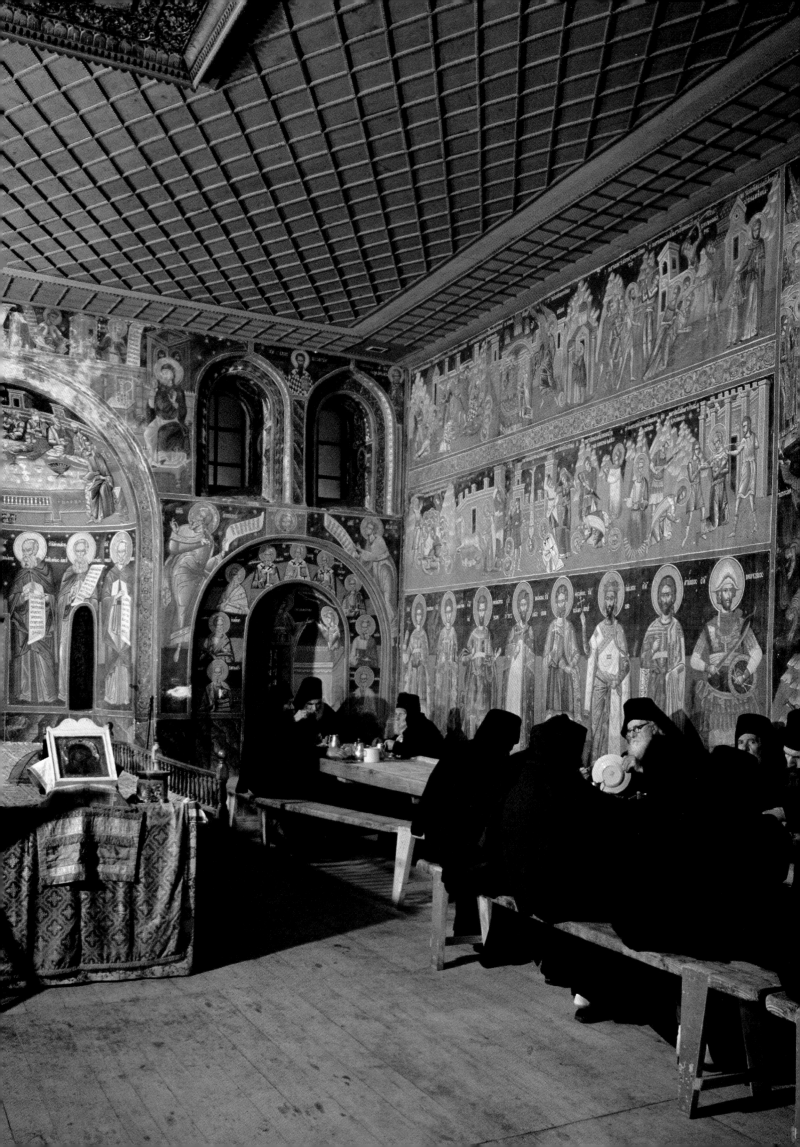

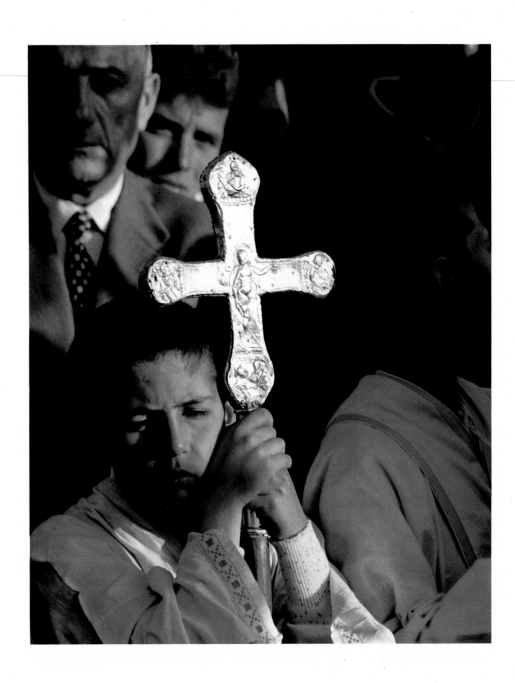

Above: On the Greek isle of Skyros a young choir boy takes part
in a ceremony honoring Saint George in June 1962.
Opposite: Perched atop a pinnacle of Meteora in the plains of
central Greece is this convent. Discovered in the twelfth century,
the stone spires of Meteora contained twenty-four monasteries
by the sixteenth. When I took this picture, in June 1962, there
were only five monasteries and the convent had only two nuns.

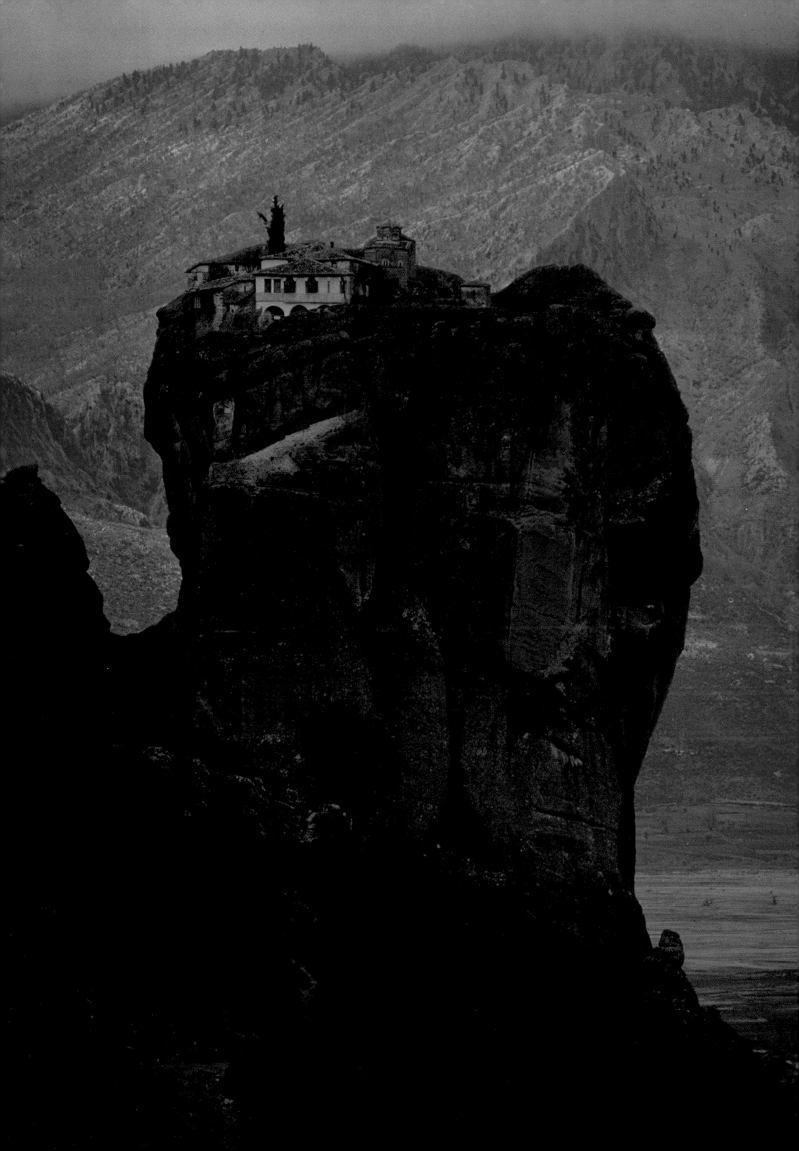

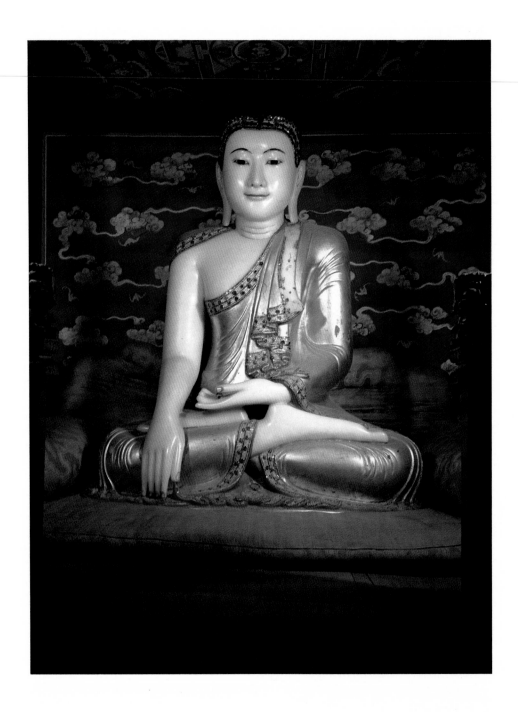

Above: The Jade Buddha, wearing its famed serene smile, sits in the "Circular City" of Peking. Actually, it is made not of jade but alabaster from Tibet.
Opposite: A Taoist priest burns incense before deities of the Taoist Pantheon in Peking.

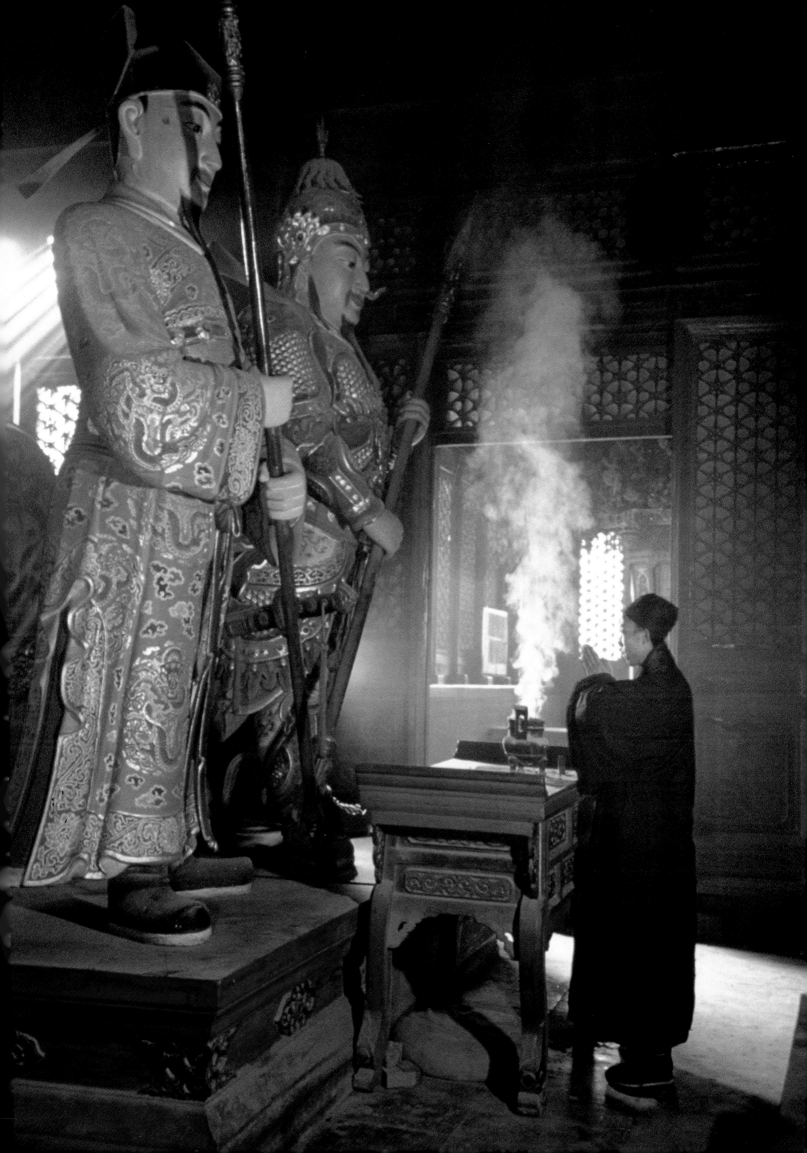

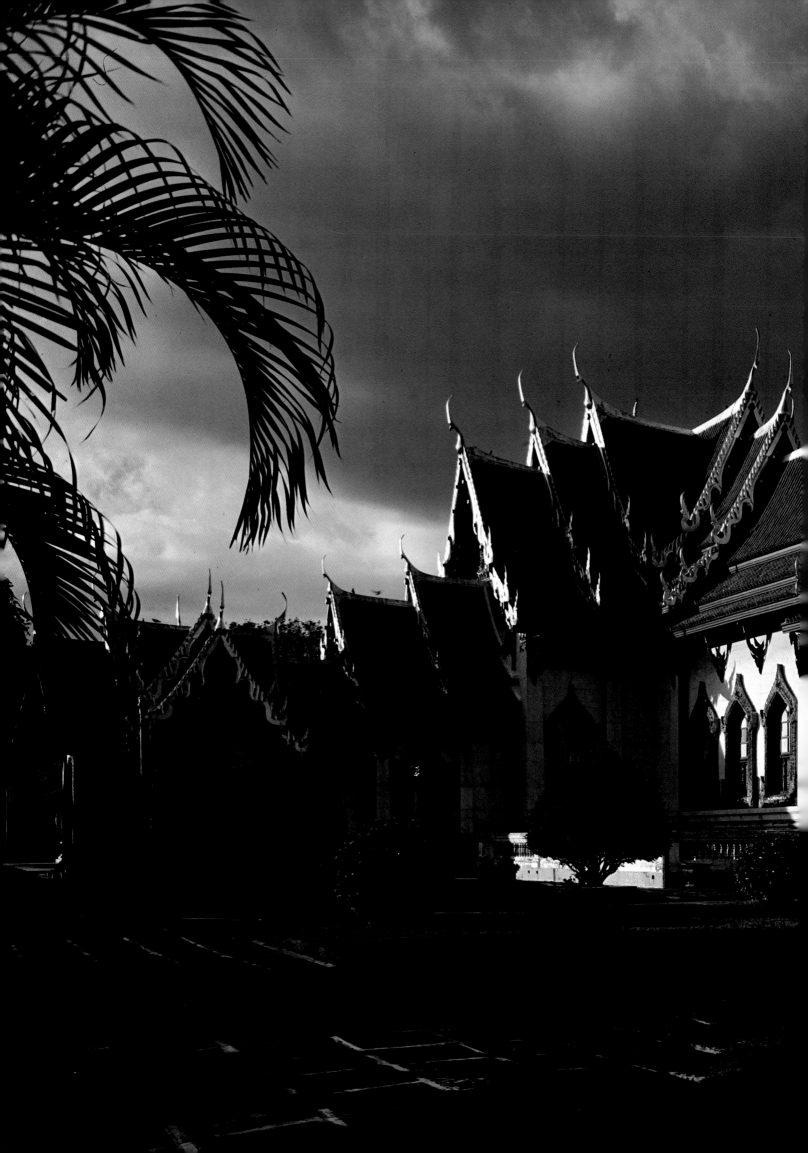

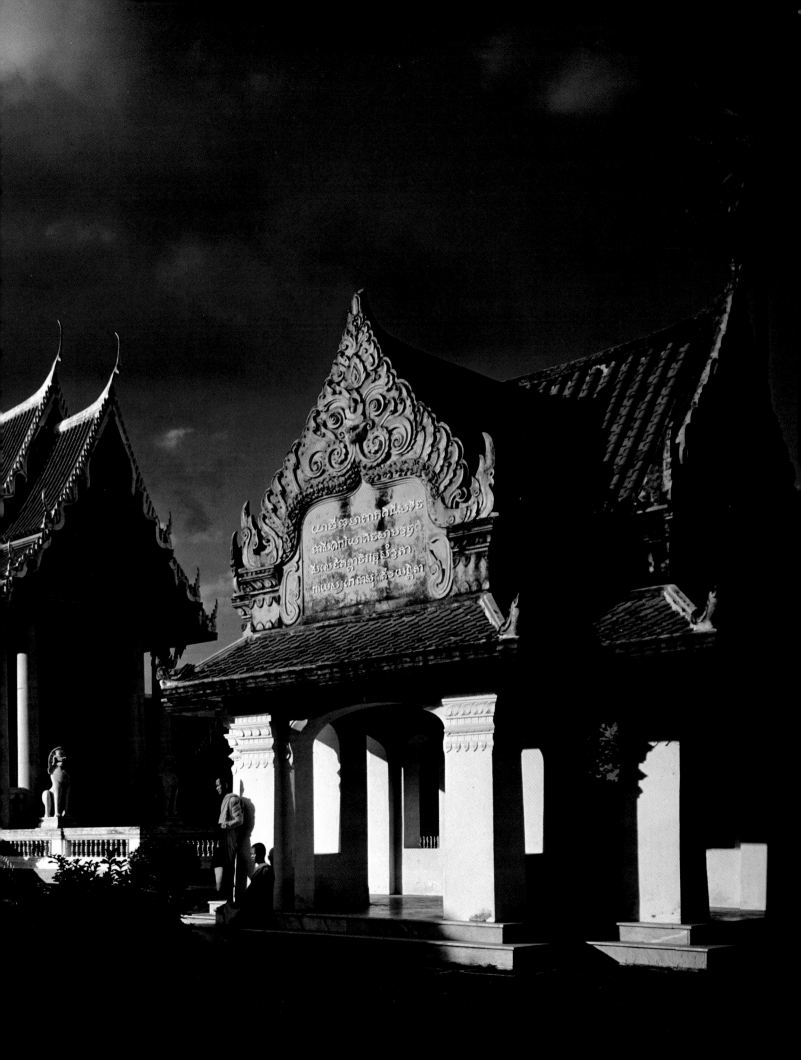

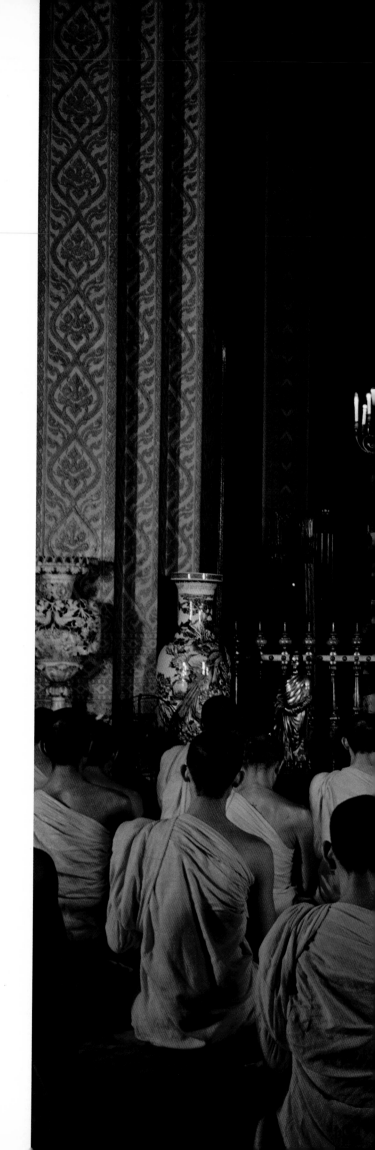

Buddhist monks pray before the Golden Buddha in the Marble Temple in Bangkok, Thailand. The Marble Temple, officially called the Wat Benjamabopit (preceding pages), is generally considered to be the most beautiful expression of Thai religious architecture. It was built at the turn of the century out of Carrara marble and is filled with images of Buddha from many countries. Overleaf: The Cave of Buddhas at Petchburi, Thailand. Pilgrims, in order to "gain merit," began placing images here about 300 years ago; the statues show the Enlightened One's many postures of meditation.

138

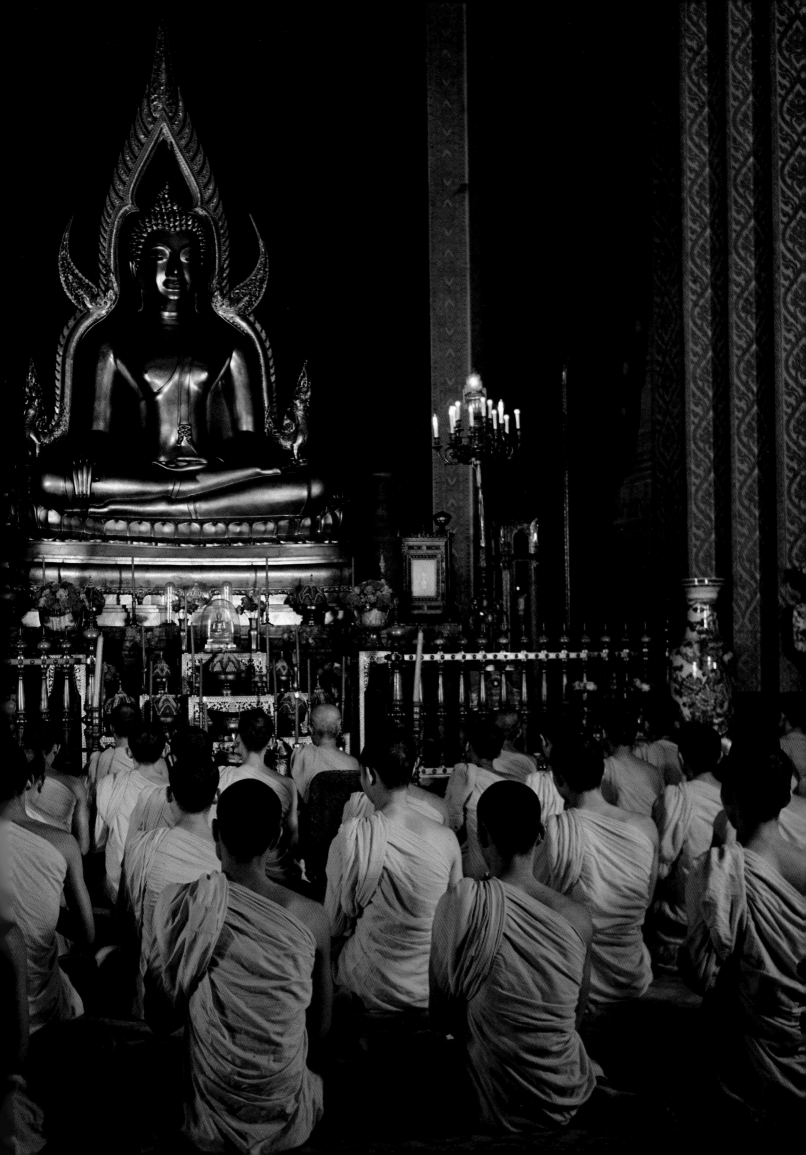

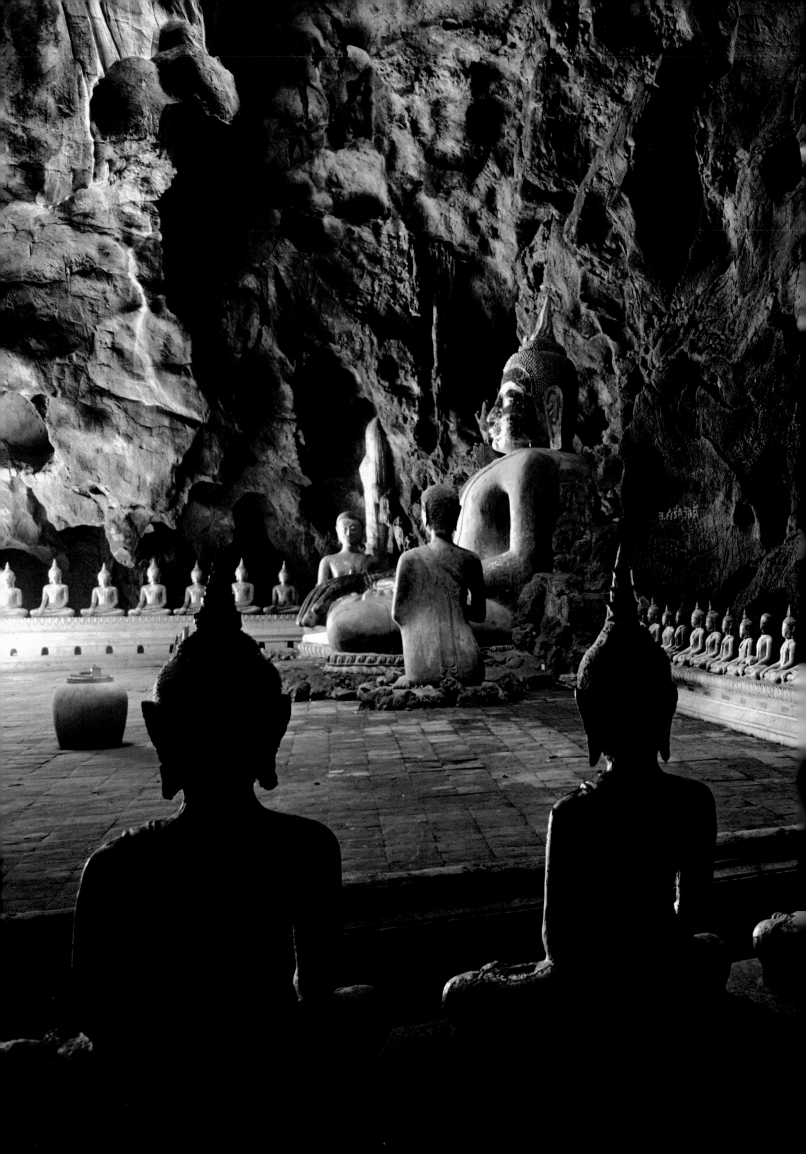

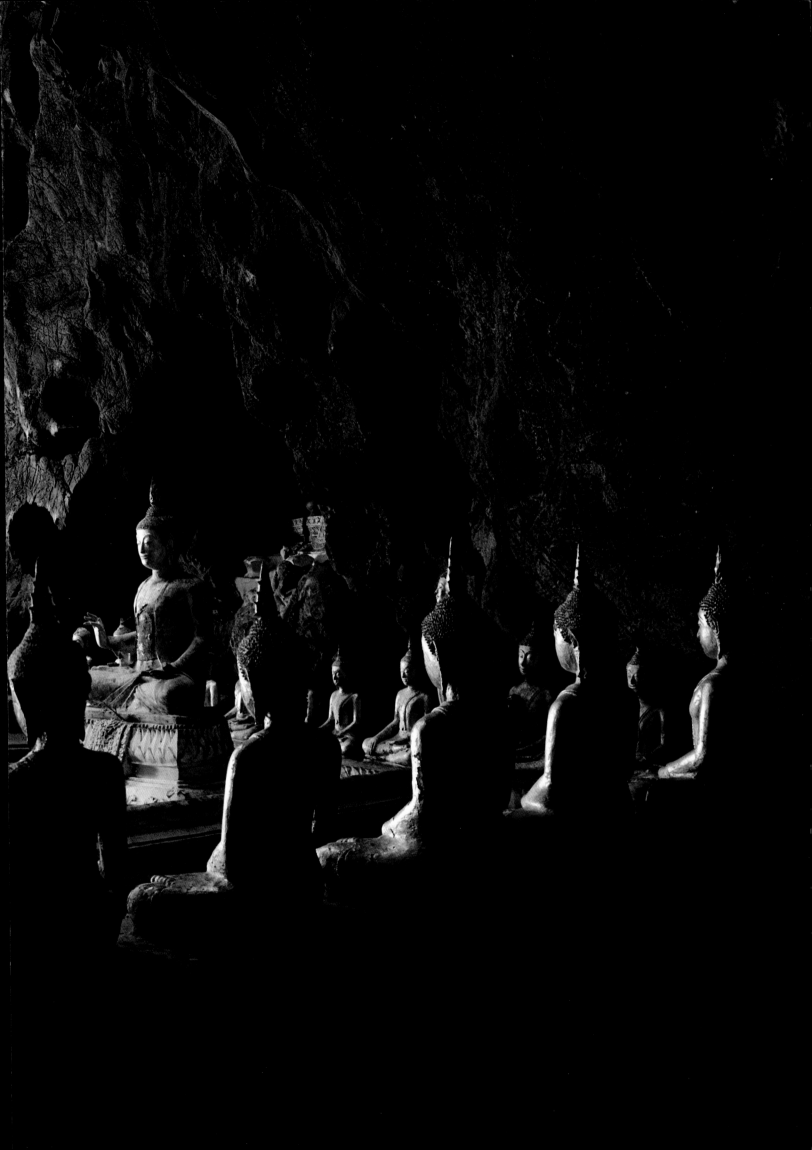

CHAPTER 5:
THE YANGTZE

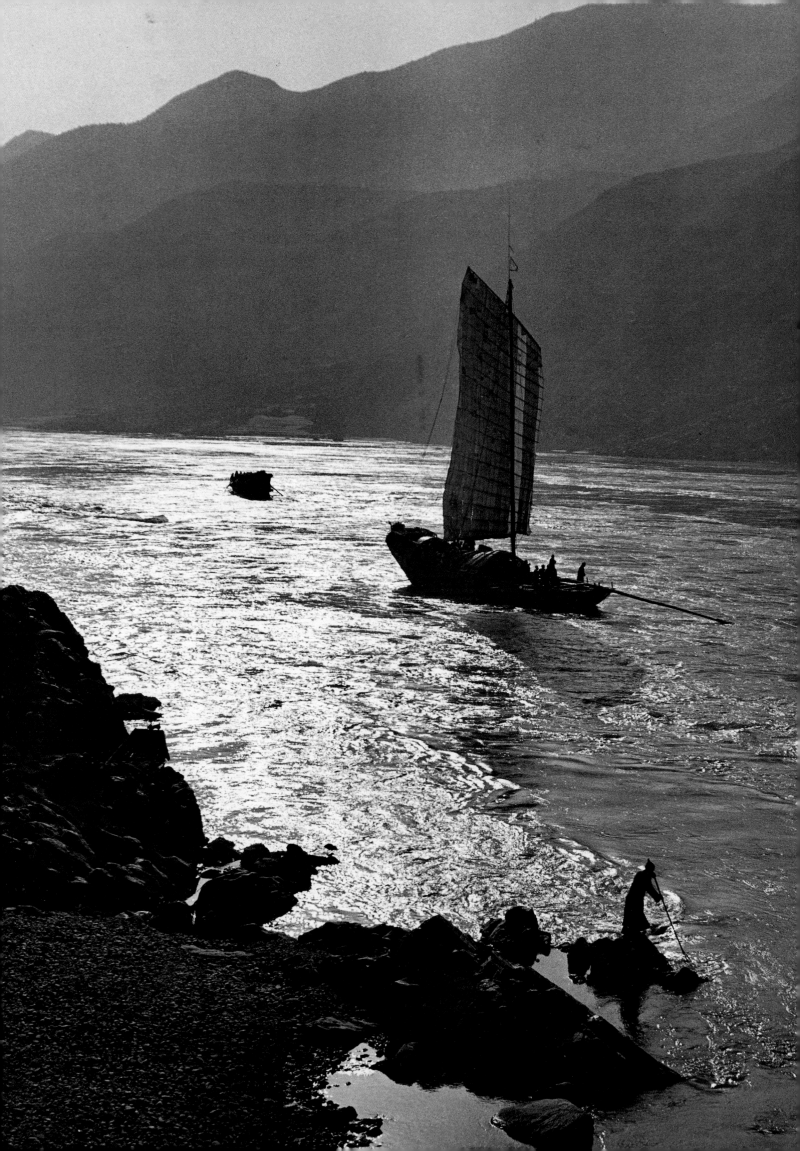

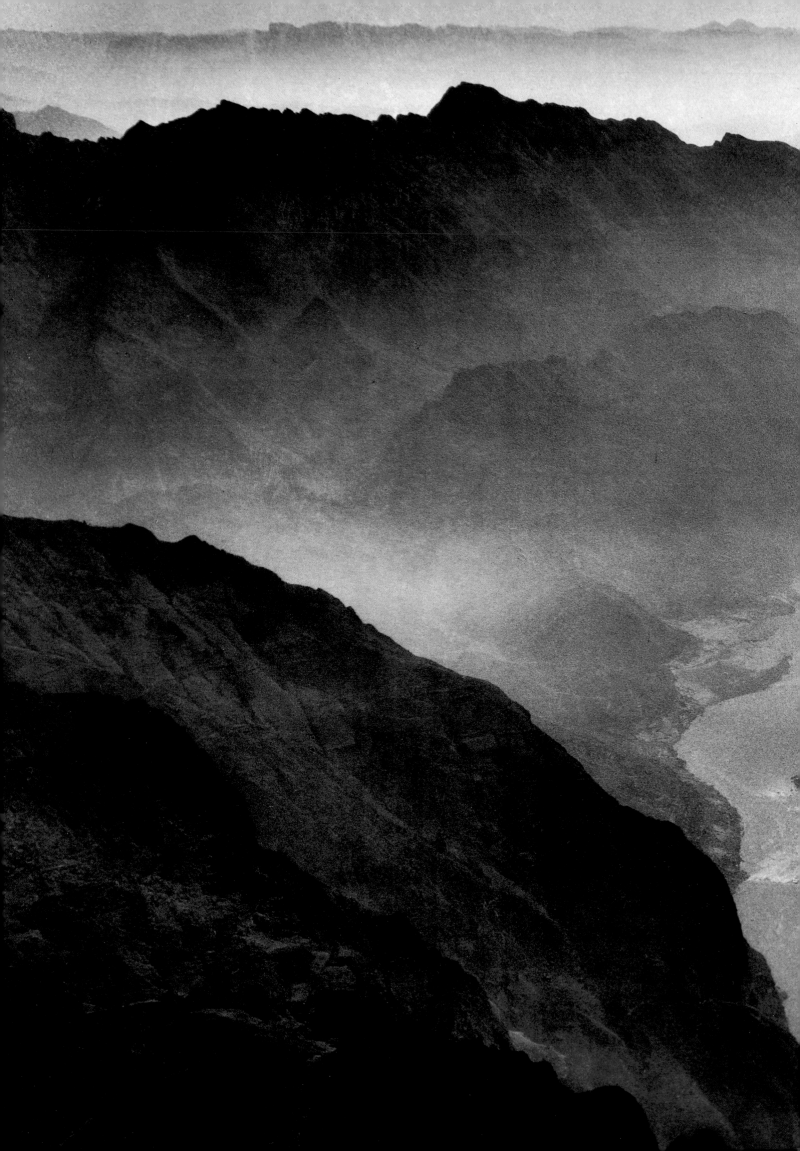

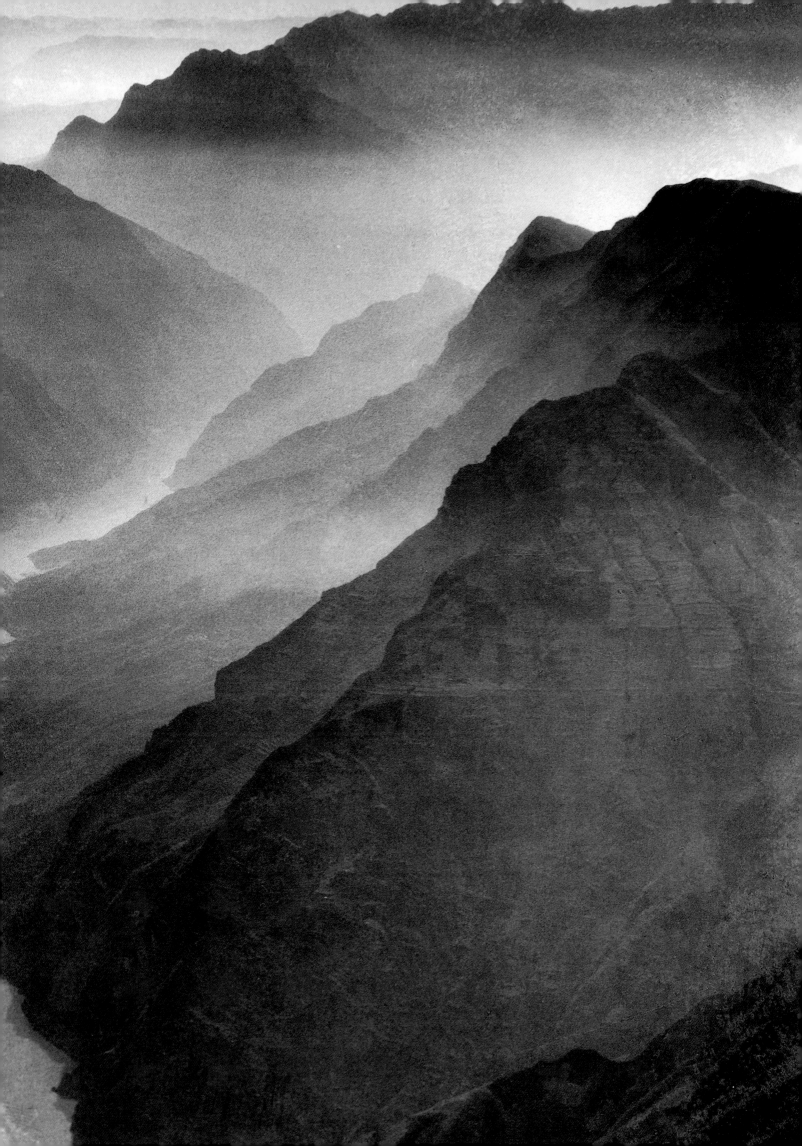

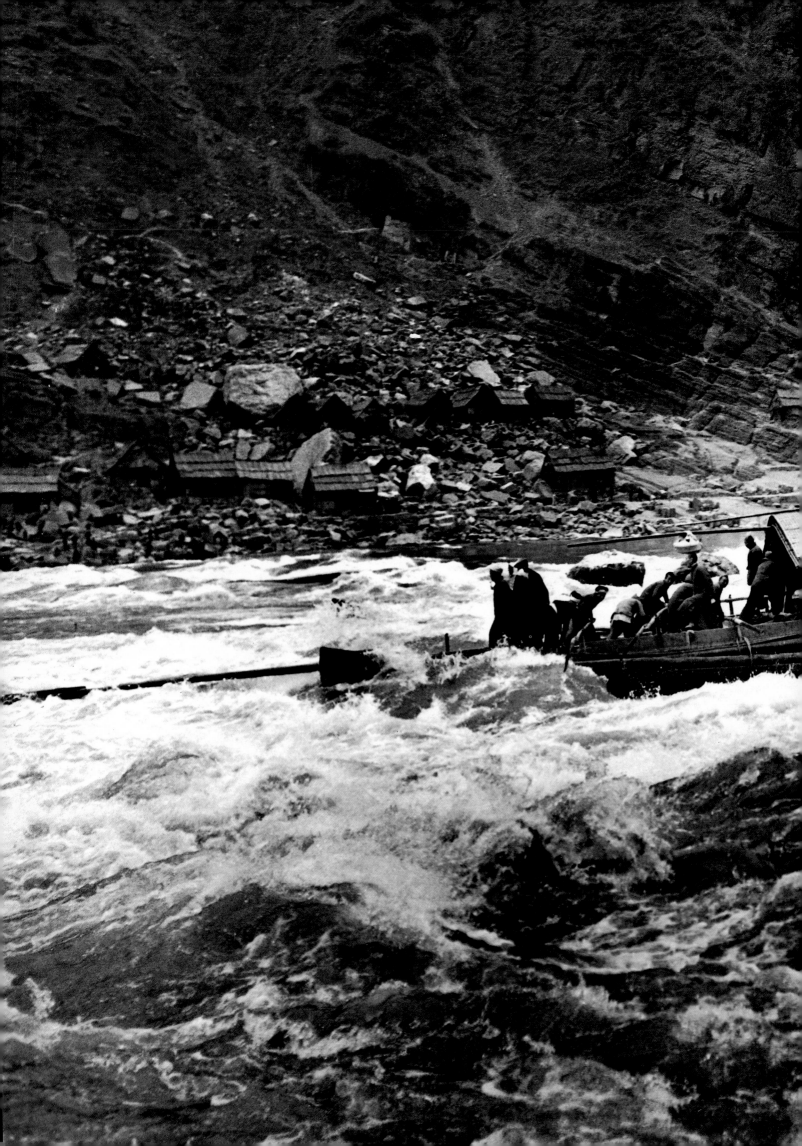

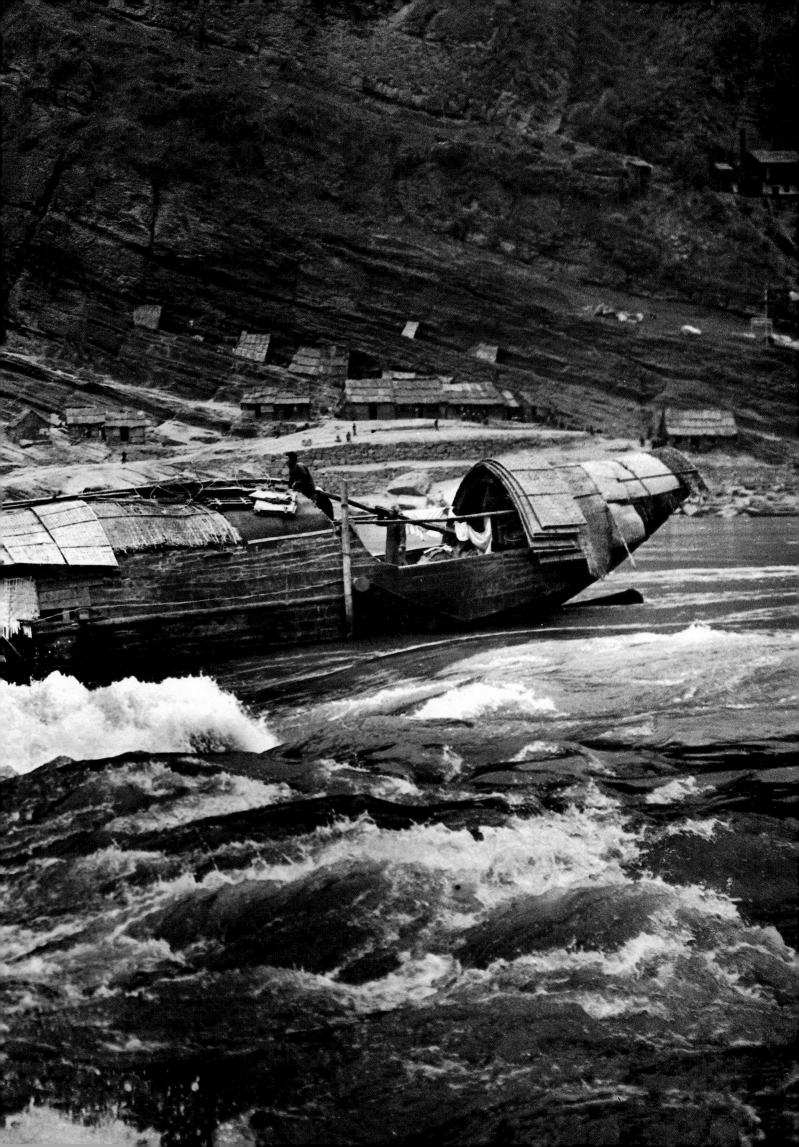

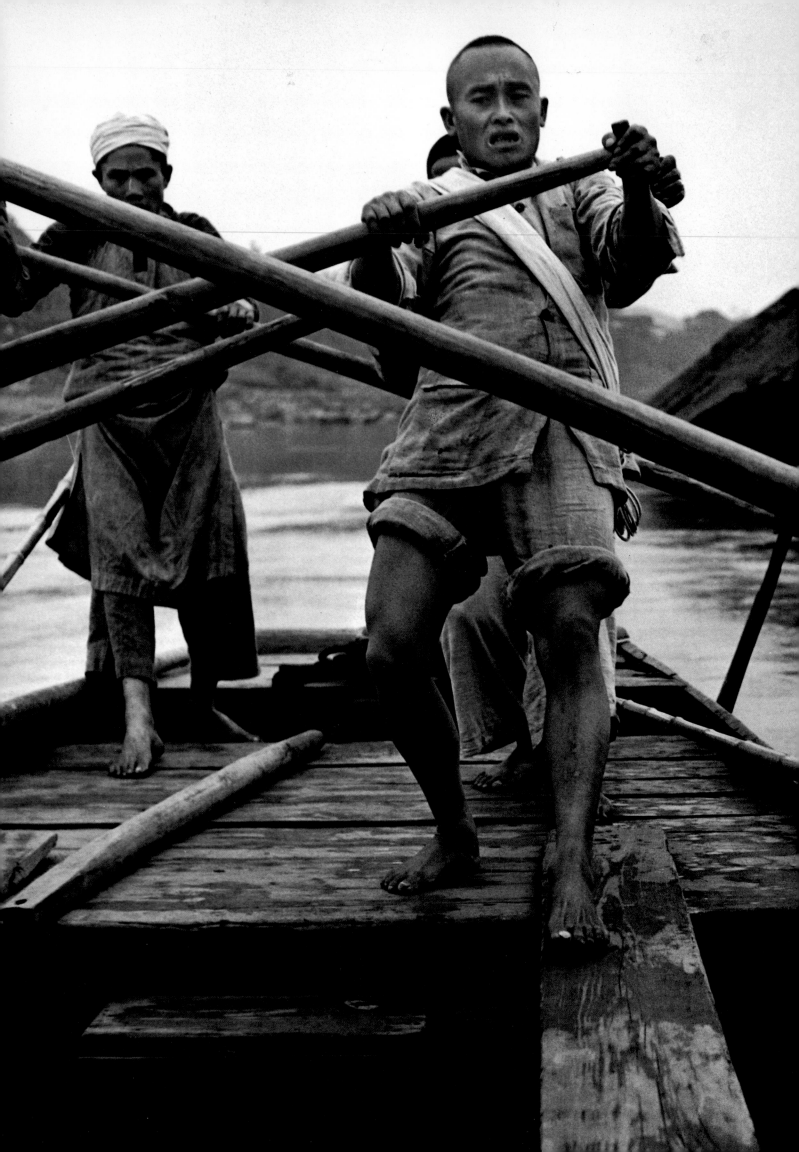

shortly after World War II ended in 1945, LIFE sent me to China to do two major essays—one on Peking, the other on the Yangtze River. The bureau then was in Shanghai, in a penthouse atop the Broadway Mansions, the city's most famous hotel. The company had taken over the penthouse in 1945 and would use it until the Communists came to power in 1949. In addition to office space it contained a grand living room and two bedrooms to accommodate visiting correspondents and executives.

When I checked in, John Hersey, then a contract writer for LIFE, was there. He had been assigned to do a text piece on a farming village called Red Pepper, typical of those in which ninety percent of China's huge population lived and worked. John suggested that I accompany him to the village, only about forty miles outside Peking, to make photographs to illustrate his piece. I said, fine, if he would accompany me to the Yangtze to do the text to go with my pictures. New York thought that was a great idea.

In Russia, during the war and the revolution, I had witnessed frightful scenes of callousness and brutality. Still, I was not prepared for one of the first things I saw in China. Since Hersey and I were still accredited war correspondents, the United States Marines in China had lent us a jeep and a driver for our daily commute to Red Pepper village. We also had a young Chinese interpreter working with us.

One morning on our way to the village we came across a man sitting in the middle of the empty, tree-lined road. He was holding his head in his hands and swaying from side to side, obviously badly hurt and in pain. We stopped, and our interpreter went over to the man to see what the trouble was. A few minutes later he came back. "The man is beyond

repair," he said. Nearby, a Chinese peasant was working his field at the roadside, completely ignoring us and the injured man on the road. The interpreter asked him what had happened. The farmer said that the man had fallen off the roof of the bus he was riding. "What are we going to do?" I said. "We can't leave the man here. We'll have to take him to the nearest town." "Sorry, sir," the young marine driver said. "We are forbidden to give rides to natives in our vehicles." "But we have to do something, damn it!" I protested. "Go ask the farmer," I said to the interpreter. "Maybe he can take him in. Tell him if he wants money I will give it to him." "It is no use, sir," he replied. "He will not take him in." "Go ask him!" I shouted. So the interpreter spoke to the farmer. When he came back he told me, "No, he refuses. You see, the law in China is that if a man dies while on your property and no relatives claim his body, you have to bury him. Chinese peasants bury their dead on their own property, usually in cultivable fields, then cover the grave with an earthen mound. That sacrifices some of their precious farmland, and they won't do that for a stranger. There are no public burial grounds in the little villages."

The headquarters of the Chinese military garrison in the area were in a nearby town, so we decided to drive there to report the accident and ask for help. We spoke to a very gallant colonel who promised to take care of the matter immediately. Relieved, we went on to our village.

On our return trip seven hours later the man was still there, still holding his head and swaying from side to side. The next morning we found him lying on the side of the road, dead. His body was still there the next day. At least someone had covered it with a few branches of a tree and some grass.

When I had finished my part of the village story, I began to work alone on the Yangtze essay; Hersey was to join me later. My only instructions from New York were to make sure I got aerial photographs of the famous Yangtze gorges. Anything else I wanted to

Opposite: Trackers pole their craft downstream.
Preceding pages: A junk shoots the perilous rapids at Shing Tan.
Pages 144–45: The breathtaking Wushan Gorge, or what the Chinese call "Magic Mountain Gorge."
Page 143: A junk moves downstream near Ichang. When the river begins to rise, the large rocks in the foreground will be submerged, forming dangerous rapids.

photograph on the river was left completely to me—as long as I came up with the aerials and enough else for a major essay.

The Chinese call the Yangtze "The Long River," "The Ten Thousand Mile River," or just "The River." Actually, it is only 3,430 miles long, the fifth longest in the world. It is formed by the conjunction of two rivers—the Min, with its source in Tibet, and the Chinsha (Gold Sands). The two rivers merge at Suifu (Ipin), southwest of Chungking, to become the Yangtze, which then rushes and meanders eastward across central China—past Wan-hsien, Ichang, and the Wuhan cities of Hankow, Anching, and Nanking—and finally empties into the East China Sea near Shanghai.

What makes the Yangtze so impressive (besides its deep, precipitous gorges) is that it is a working river, teeming with activity. It drains a basin of some 600,000 square miles, which contained a population at that time of more than 200 million people, much larger than the population then of the entire United States. For the Chinese of Central China the Yangtze was the main, indeed often the only, artery of transportation; some twenty thousand large junks, a few passenger steamers, and uncountable smaller boats used the river every day to move people and goods.

To take aerials, I first needed a plane. The U.S. Army Air Force in Shanghai agreed to lend me a DC-3 for a couple of days. We flew from Shanghai towards Chungking, about twelve hours away. En route lay the gorges I wanted to shoot. Over Wushan, I looked down and gasped. Deep in a canyon dwarfed by rugged mountain peaks, glistening through layers of mist, was the river. It was a fantastic sight. We were over Wushan Gorge (Magic Mountain Gorge to the Chinese).

I asked the pilot to make another, lower pass. But we ran into heavy clouds, and, not wanting to risk running into a mountain, he pulled straight up. We circled the spot at higher altitudes hoping the clouds would lift, but the mist was so heavy we could not even see the river.

The pilot set down at Hankow that night instead of Chungking so that we could try shooting again the next day. We spent the night at a guest house run by two elderly Russian women who gave us a wonderful Russian dinner, including Russian vodka. They had fled Russia during the war and revolution but instead of going west into Europe, they headed south and east, as did many others, for China. The two ladies regaled us for hours with how wonderful life in Hankow had been before the war: there had been a large colony of well-to-do Russians, French, and English, and the social life, including full-dress balls, had been marvelous.

Early the next morning we took off for Chungking. I shot some more pictures, but the pilot, taking no chances, was flying well above the peaks. From the higher altitude the long stretch of river winding its way through the gorge was still a breathtaking sight, but different and not as impressive as it had been seen from the lower altitudes the day before.

In Chungking I decided to go up the river by steamer to Suifu, a distance of about three hundred miles, to photograph the junction of the Gold Sands and Min rivers, which forms the great Yangtze. The trip took five days. Moving slowly against the strong current, it took our boat more than an hour just to cross the one-mile stretch of the Little Southern Sea rapids between Chungking and Luchow. The return trip from Suifu to Chungking, going downriver, took only two days.

Down the Min River a busy traffic of junks loaded with rice and salt from the rich Chengtu plain puts in at Suifu. Small steamers travel the Gold Sands River for about thirty miles. From there up, the river is not navigable. Wild mountain tribes lived along its upper reaches, and very few people dared to venture into that country.

John Hersey was waiting for me at Chungking when I returned from Suifu. For our trip on the river the U.S. naval station supplied us with a dozen jerry cans of drinking water. A chief petty officer pumped us with inoculations against cholera, smallpox,

etc. We protested that we already had them, but he said extra ones would do no harm. In Shanghai a young army doctor had already given us a first-aid kit and some medications. He made us a list of the symptoms of several diseases and what drugs to take in case they appeared. Then he said, "If you have diarrhea followed by vomiting, low blood pressure, slow pulse, and severe cramps in your arms and legs and stomach, you have cholera. In that case, just relax and die because nothing you can do will cure it."

The Chinese government provided us with a diesel-powered boat, about forty feet long, complete with a crew that included an excellent cook. The boat had been used previously by the Chinese customs as a harbor patrol boat. There was one small cabin below deck, which I shared with Hersey and an engineer from the U.S. Reclamation Department who was surveying the Yangtze gorges for a dam site for the Chinese government. Our cabin held three cots side by side, almost touching. There was a modern washroom with a toilet, which had never been used and was not functioning.

We began our voyage from a village a few miles from Chungking. Before shoving off, the crew killed a rooster, cut its throat, spread the blood across the bow of the boat, and pasted the rooster's feathers to it—the traditional ritual to insure a safe voyage. A few moments later, the boat ran aground on the rocks and nearly capsized.

The six-man crew slept either below deck, in the pilot house, or on the deck. In addition to these six there were four people aboard who were supposedly part of the crew, but who never seemed to do anything. We were told by our government escort not to ask who they were. Our guess was that they were probably hitchhikers who had given either the captain or the government official some money to take them along.

Our first day out John Hersey, who was sitting on the deck up front near the bow, suddenly shouted: "Look, Dmitri! Look!" The body of a small child wrapped in rags

floated past. Our escort explained that when a very young child dies, the Chinese believe that an evil spirit might come to the parents in the guise of their child. A dead child, therefore, should never be buried but instead cast away. And the child should never, never be dressed in good clothes: the evil spirit may come to the family just to steal the clothes.

We traveled by day and docked each night at riverside villages and towns. Our second day on the river we heard a haunting chant and saw, coming out of the early morning mist, trackers, a type of Chinese Volga boatmen, bent forward in their harnesses, pulling a junk. At every slow step they chanted, "Ayah! Ayah!" Raggedly dressed, they moved barefoot over the rough pebbles of the river's edge. We were to see them almost daily. Sometimes there were only three or four hauling a small junk, sometimes as many as fifteen or twenty.

Theirs was a hard life. From daybreak until sundown they hauled the junks upstream. When the river current was mild, they pulled without much effort. But when the current was strong, they strained in their harnesses, leaning far forward, almost crawling on their knees, their hands clawing the ground, moving in short painful steps. They never stopped chanting. Most of them had no permanent homes or families; they lived on junks, which they pulled upstream and rowed down. All they owned was a bedroll and what clothes they wore. The pay was the equivalent of $1.25 plus five bowls of rice per day pulling the junk upriver and about 80 cents and only four bowls of rice per day when they rowed the junks downstream.

As we moved down the river, I was always on deck with my cameras, waiting for something unexpected to show up around the bend. There were always surprises: a beautiful pagoda on a hill standing guard against an evil spirit, a walled castle, or, near Wanhsien (The Myriad City), opposite Yünyang (The Clouded Sun City), a beautiful temple in memory of the king who was stabbed to death with scissors by his tailor. (Since that time, all

tailors' scissors in China have rounded, blunted ends.)

Most cities along the river are built on peaks and plateaus high above the riverbanks. To reach Wan-hsien, for example, one has to climb 218 steps from the bank. Still, during the summer the river, fed by melting snows from Tibet, rises suddenly and Wan-hsien often gets flooded. The year before our visit flood waters had reached the second stories of Wan-hsien homes—a height of more than 150 feet. Below Chungking, where in three days the river may rise as much as one hundred feet, is a huge statue of Big Buddha on a hill. It was erected to protect the country from floods; the Chinese believe that the water will never rise to the level of Buddha's feet.

Near the riverbank at Kwei-Fu, about halfway between Chungking and Hankow, we came across a wide, square pit, at the bottom of which was a well of salt brine, fed by an underground source. Hundreds of men were carrying brine, in buckets slung on a pole over their shoulders, up the steep steps to a processing plant near the top of the pit. There the brine was reduced in steaming cauldrons to salt. The plant operated for only about six months a year, during the low-water season; during high water, the plant and the village above it were completely submerged. The villages along the riverbanks were strictly temporary structures—huts, teahouses, stores built of bamboos and mats; they could be dismantled or simply abandoned when the river began to rise.

Along the river we would linger at places we found interesting for our story. Sometimes we met large groups of people, some of them rather well dressed in Western clothes. Refugees from northern China who had left their homes when the Japanese invaded China in the 1930s and moved south ahead of the advancing Japanese army, they were now making their way back north. It was not easy going, especially for those who had little or no money. Those with means managed to buy space on junks, and they were packed on decks with hardly enough room to sit down.

I had photographed the Yangtze gorges from the air; now I was seeing them from the level of the river. Some of them bore names like "Yellow Cat Gorge," "Ox Liver Gorge," "Horse Lungs Gorge," "Witches Mountain Gorge." Into the rock wall of "Wind Box Gorge" narrow paths had been hewn for the trackers. We were told that if a tracker slipped and fell down the cliff, his comrades would slash the twisted bamboo lines to which they were all attached so that his fall would not drag the rest of them down. The walls of the gorges showed traces of high water marks. In Wind Box Gorge the river sometimes rises to three hundred feet.

From Hankow the river flows through monotonously flat agricultural plains, so we decided to finish our story there. We reported in at the United States air base for a flight back to Shanghai. Hersey, who had had a couple of close calls in military planes as a war correspondent in the Pacific and was leary of flying with inexperienced kids, was dreaming of hitching a ride to Shanghai in a B-25 piloted by a young colonel. We left our luggage at the base and went to the airfield to see what flights were available. It was late in the afternoon. We saw a B-25 preparing for flight and ran over to it. Sure enough, there was a handsome, young colonel about to take off for Shanghai. He told us to get on board, but said he could not wait for us pick up our gear. Shanghai had no night landing facilities and it was impossible to land there after dark.

Dejected, we went back to town and had an American meal at the officer's mess. After six weeks of nothing but Chinese food, it tasted fantastic. We were to fly the next day with the pilots of the Air Transport Command who were ferrying Chinese troops north in C-46s. That night we slept on cots in a large dormitory with about thirty airmen. One young pilot, my neighbor, was very talkative. He began to tell me about the hazards of flying C-46s; they were called "flying coffins" by the air force boys. He said that we, as Americans, must have parachutes before we could get aboard and that we should sit up front near

the entrance to the pilot's cabin; that way if the plane had to be abandoned, we could enter the cabin and parachute from there with the crew. As far as the Chinese on the plane were concerned, there were no parachutes available for them. It was too bad, he said, but they would have to go down with the plane. A couple of weeks earlier one of the engines on a C-46 carrying a load of fifty Chinese troops had quit while the plane was flying over the mountains. The C-46 began to lose altitude, and the crew decided to parachute. The commanding officer of the Chinese detachment smelled a rat. He walked into the cockpit, stuck a gun against the pilot's head, and ordered him to fly "or else." The pilot called the base and reported what was happening; a few minutes later radio contact was broken. The plane crashed, and there were no survivors.

Finally, my friend went to sleep, and so did I. The next morning, Hersey said to me, "You bastard! You and your talkative friend! I didn't sleep all night thinking about that flight on the C-46."

After an early morning breakfast of bacon and eggs and pancakes, we went to the airfield and were issued parachutes. We boarded the plane, which was already loaded with Chinese troops. They were smirking at the sight of our parachutes, and we felt lousy as we went through the plane's cabin toward the front section.

Fortunately, our plane made it without incident. Back in Shanghai we checked into our penthouse apartment in the Broadway Mansions. After soaking for hours in a bath, we had ice-cold martinis in large champagne glasses, served us by our number one boy, who not only made great martinis, but was also the best cook in China.

What impressed me most about China at that time was the disregard for human life, the medieval exploitation of labor, and the corruption. I have no idea what went on in the high levels of government and society, but on the lower, petty-officialdom level, which affected ordinary people's lives the most, extracting bribes seemed to be a way of life. I remember our office manager in Shanghai, a very dignified, efficient, Chinese lady, returning one day to the office almost in tears. She had been carrying some sugar when she was stopped on the street by a policeman. He accused her of having purchased the sugar on the illegal, but flourishing, black market and threatened to put her in jail—unless she gave him some money. She refused. She had bought the sugar legally and had no intention of either surrendering it or paying a bribe. She eventually won the argument, but the experience left her shaky all day.

On another occasion in Shanghai, while I was out strolling I came across a crowd of rickshaw drivers squatting around one of their colleagues, an old man who was sobbing in great anguish. What had happened was this: A policeman on the beat had come by to pick up his regular payoff from all the rickshaw drivers. The old man had not been able to pay; he had no money. The policeman simply picked up the seat cushion from the old man's rickshaw and sauntered away with it, effectively depriving the man of his livelihood. Without a cushion in his rickshaw, he couldn't get any passengers.

It has been many years since that trip to China, but I can still hear the haunting chant of the trackers coming through the rolling mists of the Yangtze. In his novel, *A Single Pebble*, based on our journey on the river, John Hersey described it this way: "The head tracker's formal title as a crewman was Noise Suppressor. With a thread of sweet song he was supposed to suppress the groan-shout that marked each painful step. He sang songs of incongruous beauty, that were like dreams—of palaces and of roasted doves' wings and of the daughter of the mist laying her cheek and her love on a prince's pillow, while they, hauling, protested: 'Ayah!... Ayah!'"

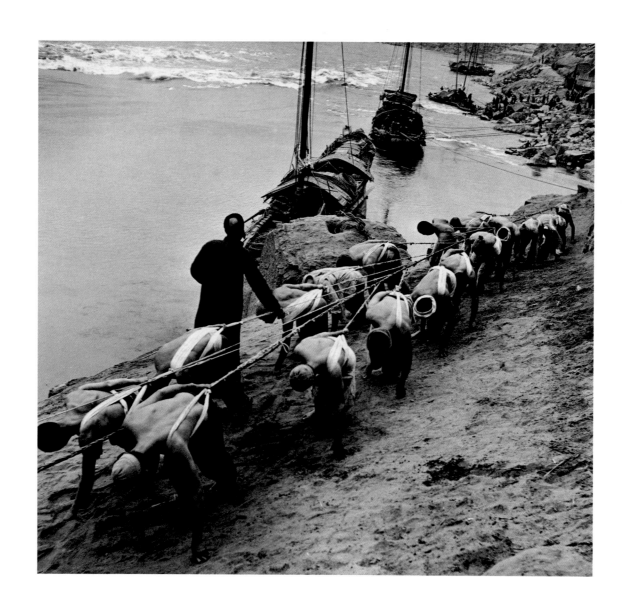

In hot weather or cold, whatever the terrain, the trackers' job is to
keep the junks moving.
Above: Urged by the head tracker, they strain and claw along a
slippery bank to move a heavy junk upstream near Wan-hsien.
Opposite: On another stretch of the river, trackers have a rocky,
treacherous footing to cope with.

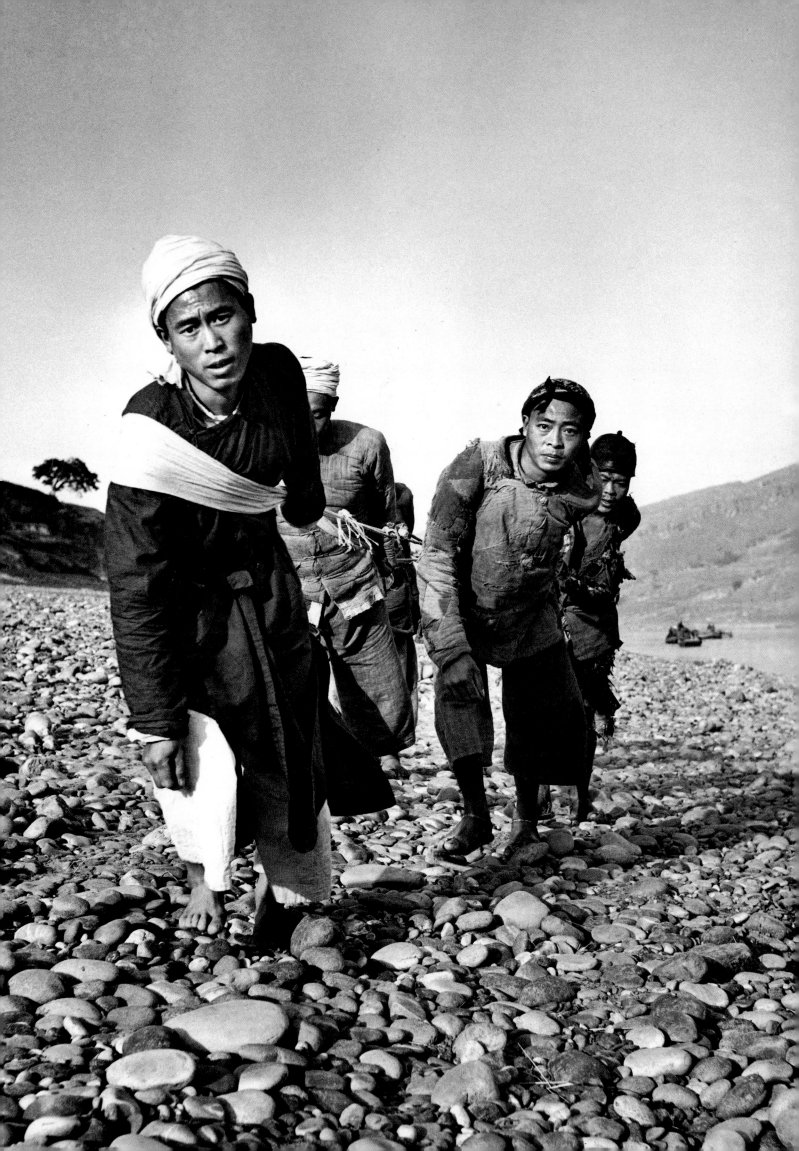

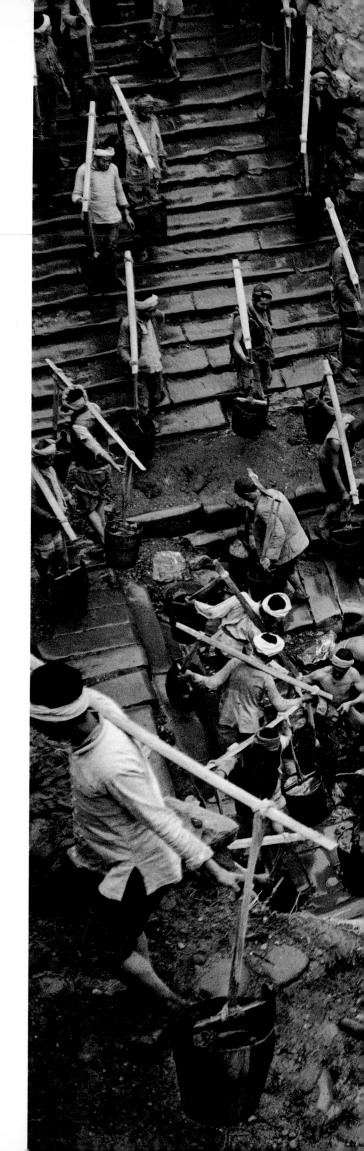

At Kwei-Fu on the Yangtze villagers collect salt brine from a well
fed by an underground source for processing into salt.
Overleaf: Women doing their laundry in Duck Creek, which joins
156 the Yangtze not far from the ancient arch.

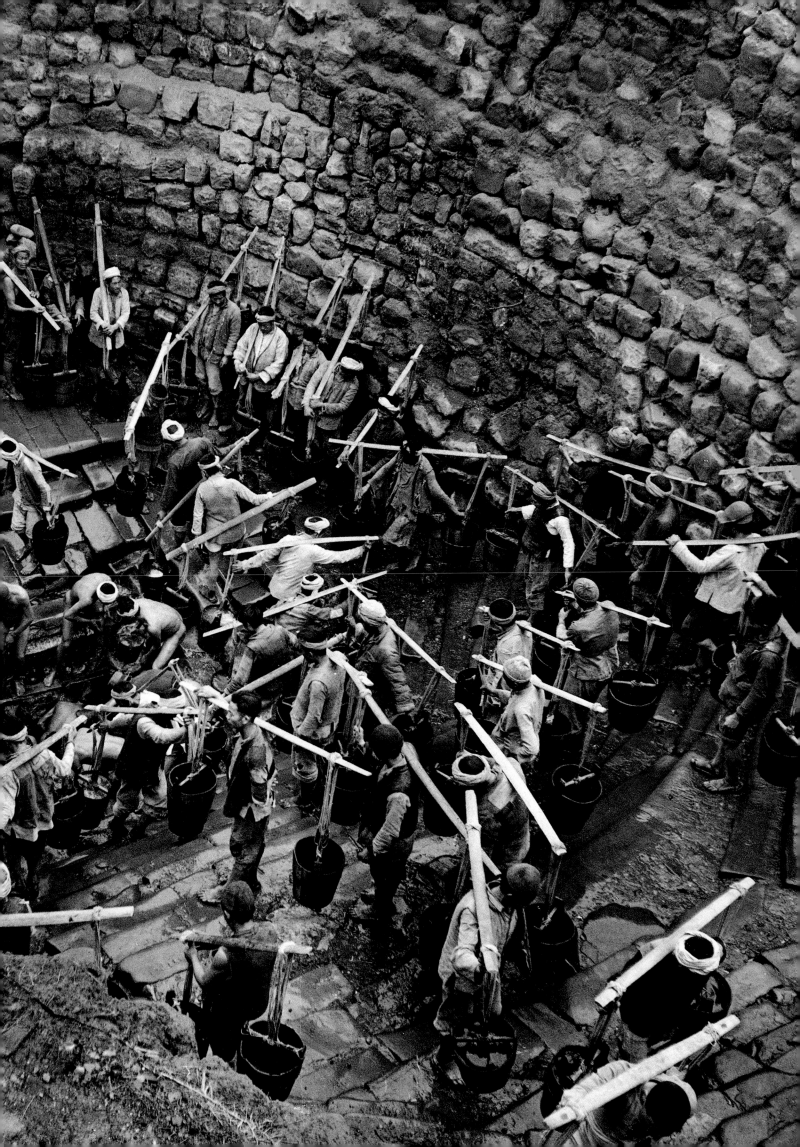

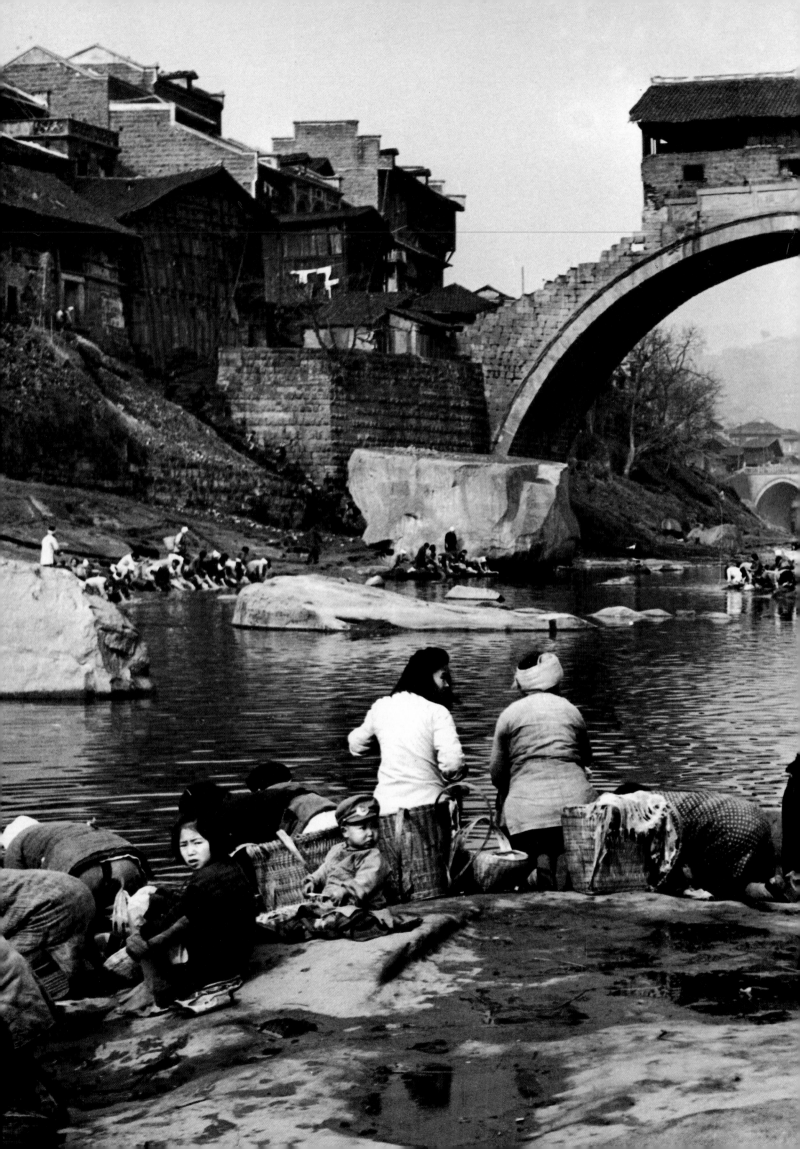

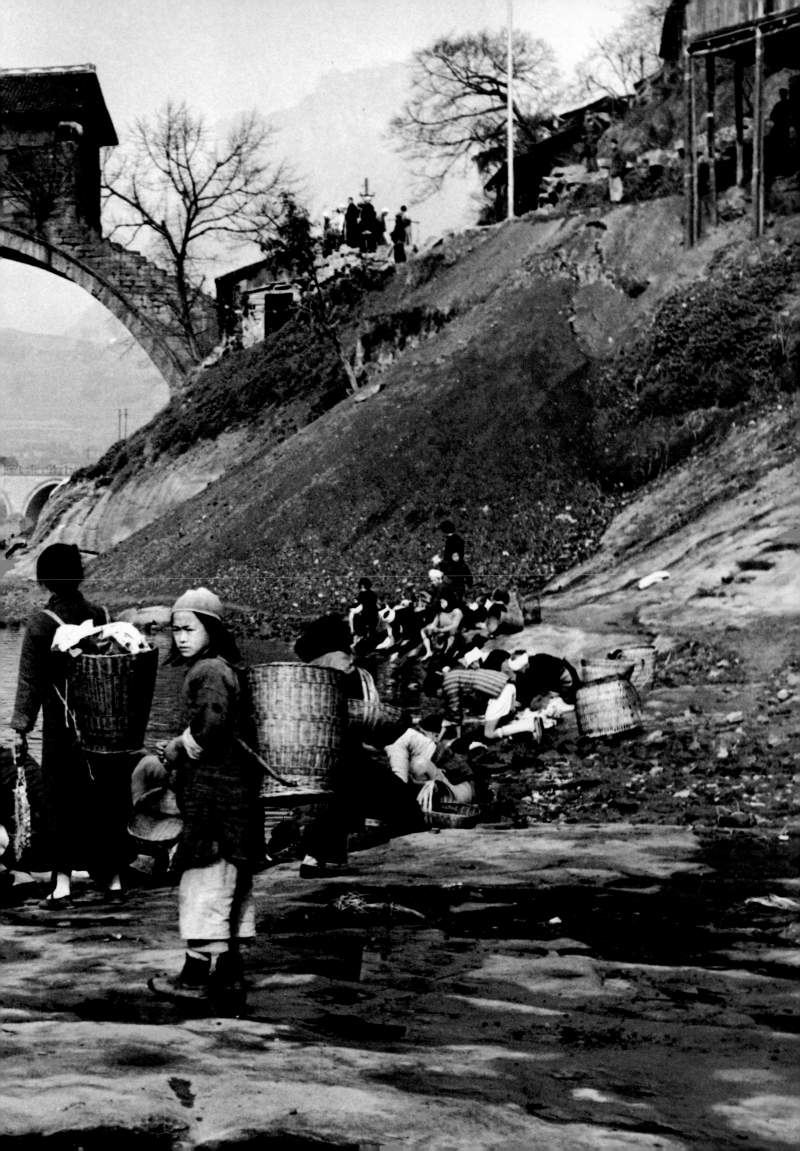

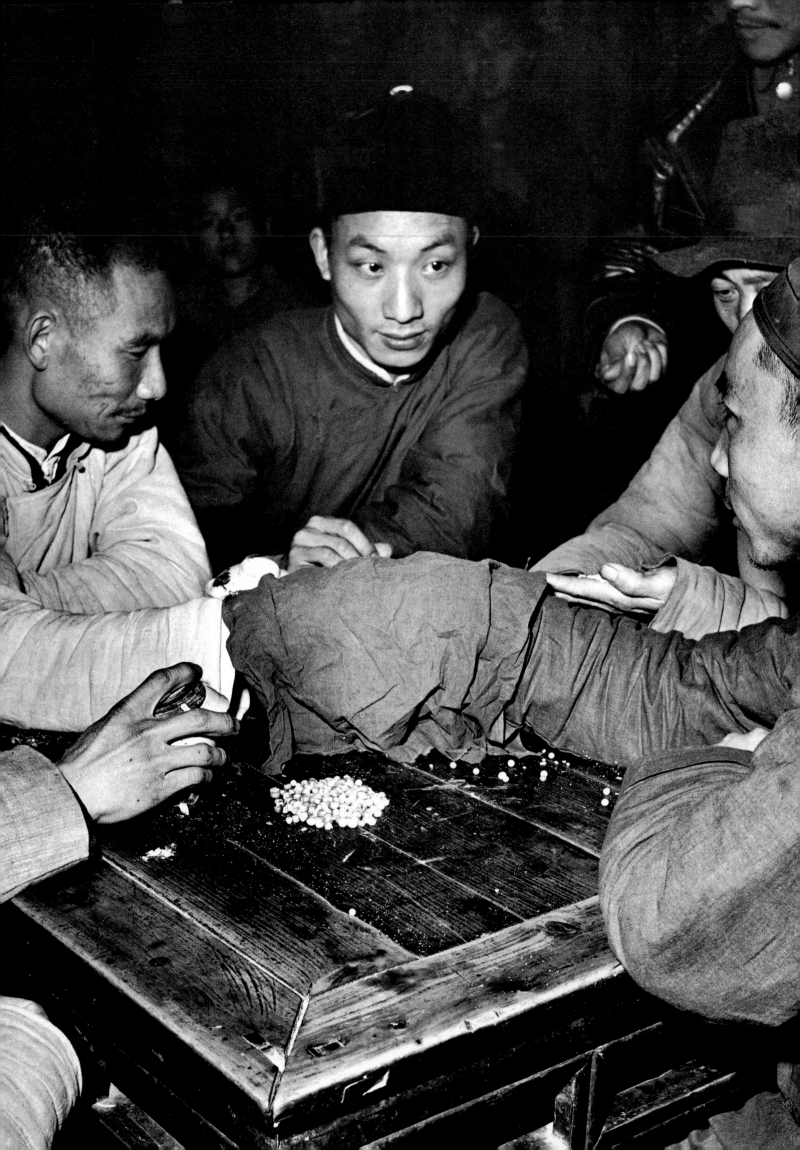

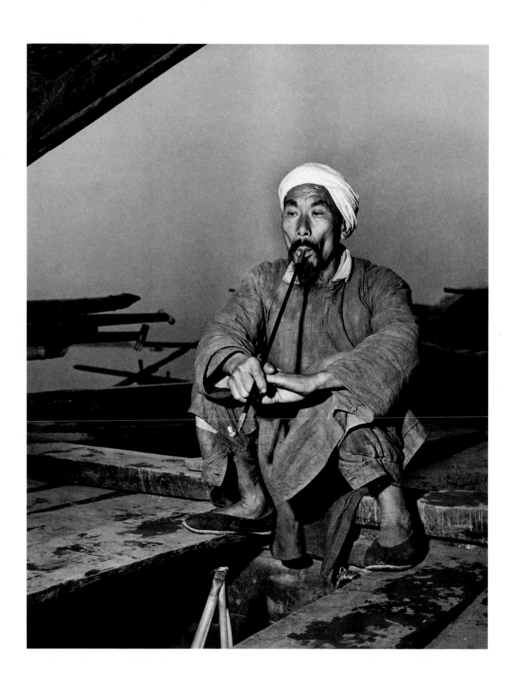

Above: A junk captain takes a break, smoking his pipe. When asked why it had such a long stem, he replied: "So I can get a light by reaching out to a passing junk."
Opposite: In a secret, complicated bidding system, a local merchant (right) makes a bid for the junk's cargo to its captain (far left) under the black cloth covering their hands. Other merchants · wait their turns.
Overleaf: Whangpoo Harbor, Shanghai, one of China's busiest ports, in February 1946.

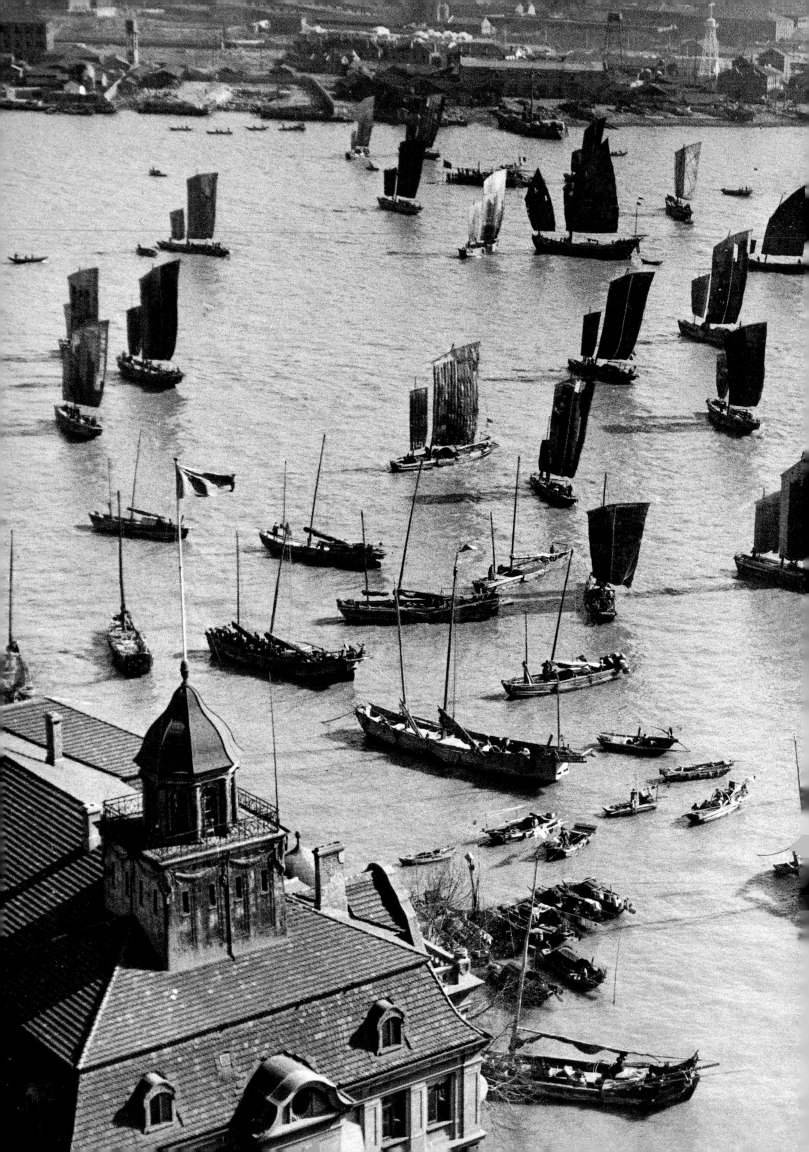

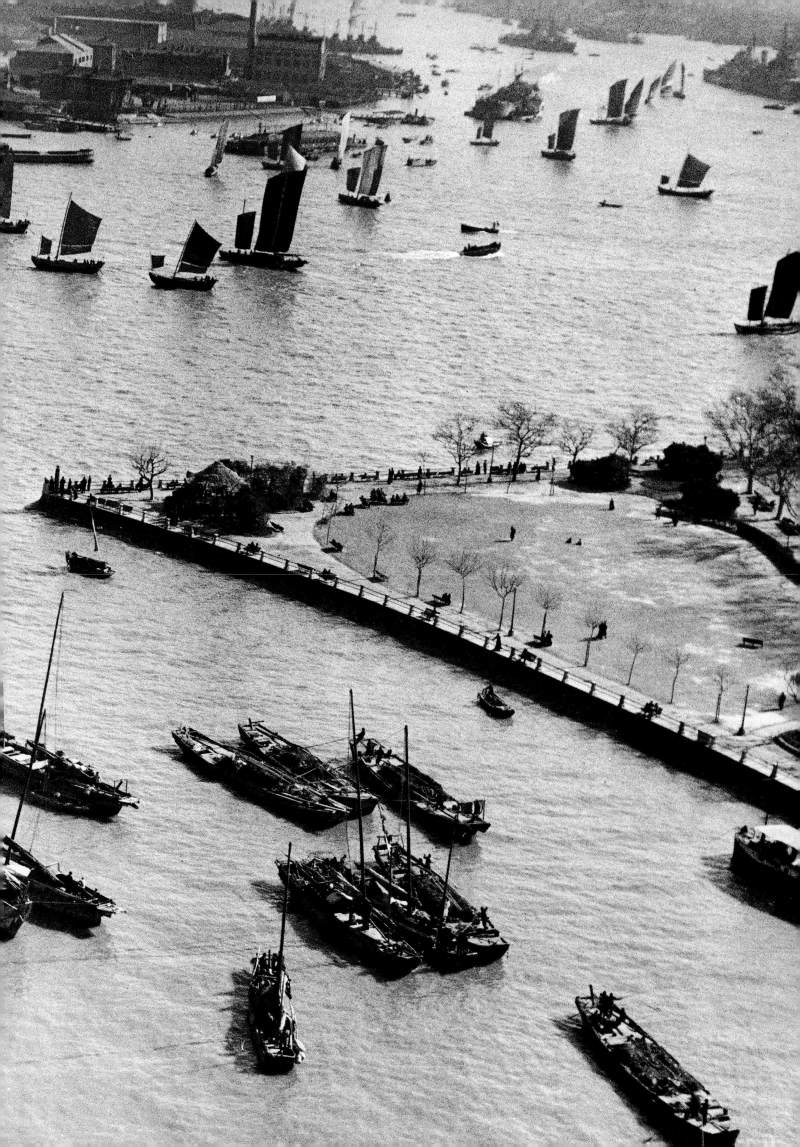

CHAPTER 6:
PEOPLE

Above: A Russian soldier takes a fling on a swing in the Prater, Vienna's famous amusement park, in 1948. The city was then occupied by troops of four powers; the park was in the Russian Zone. One Russian soldier gave me a hard time about taking this picture, saying that it was forbidden to photograph a military installation—which the swing was, he claimed, because there was a Russian soldier on it!

Opposite: Three years after the war, Vienna had not yet recovered, but the stores were beginning to display more things to buy. Most Viennese, however, could not afford to do more than look at the goodies in the windows.

Preceding page: A rain-soaked Charles de Gaulle prays in the Cathedral of Notre Dame in Nice in September 1948. He was campaigning for reelection when he was caught in a downpour and refused an umbrella.

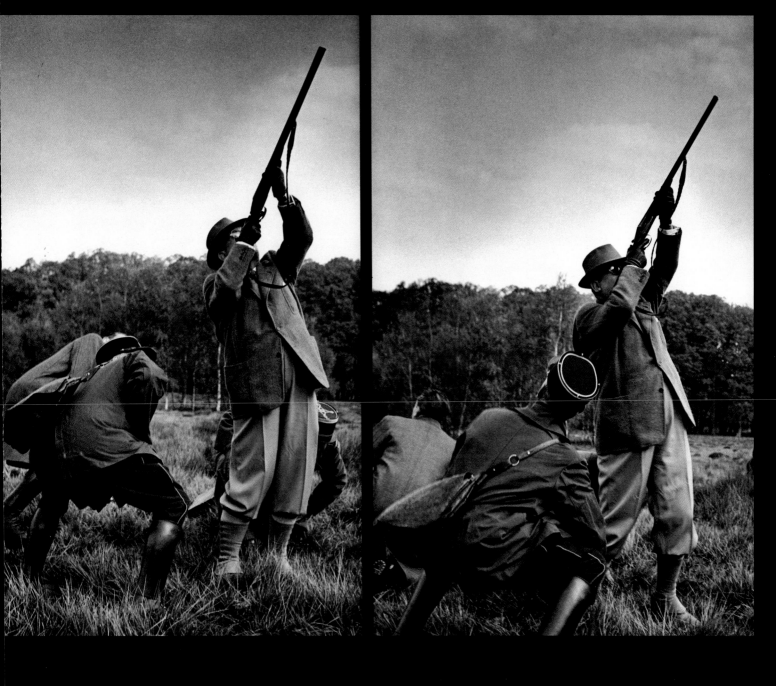

As his aides duck for cover France's President Vincent Auriol
attempts to down pheasants in the park of the Château de
Rambouillet during the annual *Chasse de Corps Diplomatiques*
in October 1950.

169

During the course of my assignments I have photographed people from many different stations in life—princes and peasants, scientists and soldiers. I never specialized in formal portraiture; I preferred to photograph people in the context of their lives, at work or at play. Play, as might be expected, yielded more interesting pictures.

When I was given permission to photograph very important and very busy people, I never knew what to expect. In some cases, I was warned in advance by the subject's staff that I would be given no longer than ten minutes and then out! Yet, in 1948 when LIFE reporter Lee Eitingon and I went to the Greek royal palace to photograph King Paul and his family, the king invited us to stay after the pictures were finished and made us martinis himself. And once when Pope Pius XII was very ill in 1956 and believed to be on his deathbed, I photographed Cardinal Roncalli as one of the Pope's possible successors (he later became Pope John XXIII). His secretary had given us fifteen minutes for the session. But at the end, the cardinal kept Dita Camacho and me for more than an hour, talking in French mostly with Dita about France. He had been Papal Nuncio there earlier in his career and he loved the country.

Dignitaries were usually considerably less dignified, hence easier to photograph, when they themselves were having a good time. French President Vincent Auriol, for example, was an avid hunter. During the season he held an annual hunting party for foreign diplomats (La Chasse du Corps Diplomatique) at Château de Rambouillet, about thirty-five miles from Paris. I covered one such shoot for LIFE in 1950.

The hunt in the park of the château was for pheasant and rabbit. The hunters lined up along the road that ran through the forest while beaters drove the game toward them. Some of the wiser birds would take one look down the gun barrels pointed their way and make a hasty U-turn back into the forest. Others simply refused to fly and strutted across the road, arrogantly looking left and right, and then disappeared into the forest on the other side. The frustrated hunters would eye them and shoo them to fly. But they did not dare shoot walking birds.

After the first drive the hunters got into their Mercedeses and Rolls-Royces and were driven deeper into the forest for the next shoot. At the end of the day the hunters retired to the château for cocktails and a fine meal. The day's bag was laid out in rows forming a square on the lawn for the hunters on the balcony to view and so that they could have their pictures taken with the dead birds and rabbits in the foreground.

Traditionally, the members of the press who covered the event were given a present of either a dead pheasant or a dead rabbit, depending on their rank. I got a small rabbit.

Generalissimo Francisco Franco of Spain was also a hunter. In 1949 we were doing a LIFE essay on Spain, to show what the country looked like ten years after the end of the brutal civil war. We needed a picture of Generalissimo Franco. When we found out that he and some of his friends were going hunting in nearby Aranjuez Park, we applied for permission to photograph the hunt. To our surprise, it was granted. We were to be at Aranjuez the following morning about ten o'clock.

We traveled there on a deserted road, not a vehicle in sight. But on both sides of the road, every hundred yards or so, was stationed a guardia civil on foot or on horseback.

We were introduced to Franco. A true Spanish gentleman, he was very cordial to Dita Camacho, who spoke Spanish. When the hunters had taken their positions along the shore of the lake of Aranjuez Park, Franco, who had a Leica camera hanging from a silver strap around his neck, told Dita to relay to me his suggestions as to where I should stand to be in position to get the best pictures of him. I was posted behind a tree a few feet away. Soon

171

the ducks began to fly. Franco missed his first shots and I lowered my camera after each shot to show him that I had not taken the picture. An aide would hand him a reloaded shotgun as soon as he had fired both barrels of the first one. Franco did not do very well, but after about an hour of shooting I took a picture of him with the dead ducks that had been shot by the rest of the party.

After lunch, we went to a nearby field for pheasant shooting. There it was a different story. Franco sat behind a little blind formed by cornstalks. The fat pheasants seemed to fly only with an effort. As soon as one rose a few feet above Franco's gun muzzle, he fired and the pheasant burst into a cloud of flying feathers. Each time Franco turned around to see if I had taken the picture. I made an "okay" sign to him. Content, he smiled.

In September 1948 I followed General Charles de Gaulle on the campaign trail. He had assumed the presidency of France after elections in October 1945; less than three months later, he had resigned in a huff. Now he was seeking a political comeback as the leader of a new three-party coalition known as the *Rassemblement du Peuple Français.*

We joined de Gaulle's motorcade in Toulon and followed it to Nice. Along the way he stopped in small towns and villages; he would always make a short speech, end with the singing of the *Marseillaise,* then shake some hands and kiss a few babies. Besides the LIFE team—myself and Dita Camacho— there was a *Paris Match* photographer, Walter Carone, who was hitching a ride with us. Whenever the motorcade halted, Walter and I would jump out of the car and be ready to take pictures of de Gaulle kissing a baby. He, of course, was aware of us, and it got so that he would look to see if we were ready before kissing the baby.

In Nice, on his way to the cathedral of Notre Dame, de Gaulle was caught in a downpour. When an aide with an umbrella approached him, he waved him away and proceeded unprotected from the cathedral to a reception. Thoroughly drenched, he shook hands with the bejeweled, glamorously dressed women and the formally attired men who lined up to greet him.

Bernard Berenson, an American art historian and critic, was one of the world's greatest authorities on Italian art, especially of the Renaissance. He was also a vain little man, always nattily dressed with a flower in his double-breasted suit lapel. Around 1900 he had settled in Settignano, near Florence, Italy, where he built a magnificent home, which he filled with his own art collection. He called it "I Tatti," and it became a kind of mecca for visiting intellectuals.

In 1949 I was sent to Florence to do a story on Berenson. The first picture was to be of a ceremony in the city hall with Berenson being presented by the mayor with a certificate of honorary citizenship of Florence. I held my camera at the ready as the mayor was about to hand over the certificate. Suddenly, the two of them disappeared in a cloud: an Italian news photographer had shot his picture of the transfer with flash powder. My picture, literally, went up in smoke.

I spent a few days with Berenson, photographing I Tatti and his art collection; with friends at dinner in his beautiful dining room, Renaissance masterpieces hanging on the walls; in his library at work, etc. I also photographed him in his bedroom. At the foot of his bed was a large mirror. I asked him what it was for. "So that I can look at myself."

For a text piece LIFE writer Robert Coughlan was doing on Aga Khan III, I was assigned to take pictures at the Aga's family villa on the Riviera. I photographed the family at the lunch table without the Begum, Aga Khan's wife, who had not shown up for the meal. When I was told by a butler that the Begum was now ready for me, I found her in the garden. She was dressed in a sari, and she looked stunning. The reason she was not at lunch with the rest of the family was that she was having her hair done and her face made up for the photo session. I spent almost an hour photographing her among the flower beds in the garden.

When lunch was finished, we arranged a portrait of the entire family, including Rita Hayworth, who was to marry the Aga Khan's son, Ali Khan. Later I took some pictures of the Aga Khan and Begum, and then others of Ali Khan and Rita. A few months later when Nat Farbman, a LIFE staff photographer based in Paris, was covering the wedding of Ali and Rita, Rita told him that I had deliberately made the Begum look more glamorous than she that day.

I got a very warm reception from Aristotle Onassis. George Abell, who covered European royalty and society for LIFE, had managed in 1954 to get permission from Onassis to do a story on his yacht, the *Christina*. George was a guest on the yacht when I received word to join him in Palermo where the *Christina*, with Onassis and his friends aboard, was anchored.

When Dita Camacho and I arrived in Palermo, about 11:00 P.M., we found a message asking us to call George Abell immediately. He was at the palace of Prince Raimundo Lanza di Trabia, about an hour and a half drive from our hotel. "Come on over," George said. "Not at this hour!" I protested. "The party is just beginning," said George, "and Ari wants to meet you." So we took a cab to the palace, and from there a motor launch to the *Christina*.

Onassis was a very gracious host. While the party continued aboard the yacht, he took us aside to discuss the picture possibilities. Originally an American destroyer escort bought by Onassis as war surplus, the *Christina* had been converted in West Germany into a luxurious yacht. The captain and the officers and most of the thirty-two-man crew were formerly in the German navy. There was a seaplane aboard with an Argentine pilot and copilot, in case Mr. Onassis was suddenly called to attend to business ashore. The yacht had eighteen luxurious staterooms, and there were twenty guests staying aboard.

Ari was an extremely well-informed man. He spoke fluent Spanish, French, Italian, English, Greek, and Turkish. "You know," he

Aristotle Onassis playing in the pool on his yacht with daughter Christina, for whom the yacht was named. When this picture was made, in 1954, Christina was three years old.

told us, "I am probably making a mistake letting you do this story. When your American millionaires see it published in LIFE they will say, 'Look at the greasy Greek. He can afford this wonderful yacht with a thirty-two-man crew, but we can't. We have to pay taxes, not he.' But in comparison with American millionaires, I am a small fry." (We were told at the time that Onassis was worth about fifty million dollars. When he died his net worth was many, many times that.)

We made arrangements to start working the next day. Onassis was planning to remain around Palermo for about four more days and he told us we could photograph whatever we liked. He invited us to stay aboard, but we preferred to stay ashore in the hotel and commute. We excused ourselves at 3:00 A.M.

We arrived the following morning at eleven o'clock. There was nothing available to transport us to the yacht except a local fisherman's dilapidated, grimy boat. When our boat, loaded with my boxes of equipment and cardboard cases of flashbulbs, pulled alongside the gangway, there was a look of consternation on the face of the young officer on deck. He must have thought we were peddlers. He motioned to us to wait and ran off to consult with his superiors. A few moments 173

later a tall, haughty officer came. He looked down at us disdainfully, but after we told him who we were he motioned us to come aboard. Evidently he knew we were coming. There was not a soul around. A young Greek bartender whom we had met the night before helped us store our gear. When we asked him why no one was about he said it was too early, only eleven o'clock. "The only one around is the boss," he said. "Mr. Onassis is with the children in their playroom." We often saw Onassis playing with his children, Alexander and Christina. It was then that he looked most relaxed and happy.

The stewards were preparing a long table on the deck for brunch. Around noontime some groggy-looking guests began to drift on deck. A white-jacketed steward served coffee and Bloody Marys. Beautifully arranged and decorated dishes of caviar, fois gras, quail in aspic, prosciutto, and melon were placed on the table. Lunch was served buffet-style; the guests ate sitting on deck chairs or standing on the deck in small groups. Stewards moved about offering champagne and red wine.

After lunch the guests were on their own. Those who wanted to go ashore had the boat at their disposal. Tina Onassis, Ari's wife, waterskied; Ari rowed a skiff he kept aboard for exercise. The others were around the pool sunbathing or swimming.

By five the deck was deserted. The guests were having a "rest" for the night to come. They reappeared between eight and nine o'clock dressed for dinner. After a long cocktail period dinner was served, then more drinks and talk until about 4:00 A.M.

On the third day everyone was invited to a late dinner at Prince Lanza's palace. After they had left we went to work photographing staterooms, salons, etc. Around 1:00 A.M. we were called by the steward to come on deck to watch the fireworks. The fantastic display, almost as grand as the Bastille Day spectacle in Paris, had been arranged by the prince on the grounds of his palace as part of the entertainment for his dinner guests.

About an hour later Onassis came aboard.

He looked tired and bored. "I've had enough," he said. "I'm going to sleep." I told him that we were almost finished, and he suggested we stay on board that night. We did. Late the next afternoon we finished our shooting. We said good-bye to Tina Onassis and asked where Ari was. "You will see him at the hotel," she said. He was there in the bar alone having a soda. "What are you doing here?" I asked. "Oh," he replied, "I came to have a little rest." He did not say that he had come to the hotel to get away from his guests.

Sometimes the most ordinary assignment wound up with an unexpected fillip. In 1942 I was sent to Stratford, Connecticut, to do a short story on the helicopter Igor Ivanovich Sikorsky had designed. When Sikorsky told me that I would have to wait until the next day because his test pilot was away, I suggested that it might be a better story if he flew the helicopter himself. It was, after all, his baby. After some hesitation he agreed.

Sikorsky's helicopter was a primitive contraption that bore little relation to today's giant workhorses or formidable gunships. It was a toylike machine, part metal, part wood, and its landing gears were inflated rubber pontoons so that it could land on water or on the ground.

For the LIFE story, one of the points I had to show was that the helicopter could be a vehicle for the busy executive; he could take off from his suburban or country home, fly to his factory, and set down in the parking lot. The helicopter was brought to the area where we were to shoot the sequence. It was lunchtime, and hundreds of workers were watching us. We were to begin with a picture of Sikorsky hovering in the copter a few inches off the ground while his secretary handed him his briefcase which he had "forgotten." As he got into the cockpit, Sikorsky crossed himself. "Does that mean you don't have confidence in your invention?" I asked him in Russian. "I am an old man, Dmitri," he responded. "I say my prayers even before I start driving a car."

We shot several sequences showing what the helicopter could do. Then I wanted to

take a worm's eye view of the copter. I was on my back on the concrete parking lot while Sikorsky hovered about fifty feet directly above me. Suddenly I heard a sharp crack and, from the corner of my eye, noticed workers running in all directions from us. Instinctively, I jumped to my feet and ran, too. A few seconds later the helicopter landed with a bang on the spot where I had been lying. It hit the ground, bounced back into the air, then came down with a bigger bang and bounced back a few feet higher. After several more rough bounces, it stayed put. I took a picture of Sikorsky climbing shakily out of the cockpit while the public relations man congratulated him on his wonderful handling of the crippled helicopter. That "sharp crack" had been the wooden tail propeller suddenly flying off, hitting the body of the craft, and disintegrating.

As part of a LIFE assignment on Darwin's studies in Brazil I was sent to photograph Bernard Kettlewell, a geneticist doing research on Brazilian insects. I was told to be prepared to work with him deep in the jungle. The "jungle" turned out to be a big resort hotel on a hill overlooking Rio de Janeiro. Bernie, as he preferred to be called, a big, jolly Englishman, was camped on the ground floor in a wing of the Grand Hotel. In a large room with French windows facing the surrounding forest he had set up a contraption with powerful ultraviolet lights. At night thousands of creatures, attracted by the lights, would fly into the room. Bernie would stand there, stripped to the waist, a large butterfly net in his hand, and scoop up specimens.

Originally, he told me, he did his work at a Brazilian government research station not far from Rio. But at night his Brazilian colleagues used to raid the traps he had set up in the jungle. "Maybe they were just doing it for fun," he said. But he was bitter about it, so he moved to the new location. It was just as productive and much more comfortable. It was only a short taxi ride to the center of Rio, where he would go on his night off.

I was rarely assigned to fast-breaking news

British geneticist Bernard Kettlewell, netting insects in 1958 in "the South American jungle"—actually his room in a big resort hotel overlooking Rio de Janeiro.

stories. But one time I was thrown into that breech, and it worked out very well indeed.

By June of 1954 France, having been bogged down in the Indochina War for seven years, was finally trying to extricate itself with dignity. Pierre Mendès-France, the new French premier, declared in his investiture speech to the National Assembly on June 17 that he would achieve a cease-fire in Indochina by the 20th of July—or resign.

The LIFE bureau in Paris had been staffing the Geneva Conference since its opening. It was a frustrating assignment for photographers because of the tough Swiss security measures. All they could do was plant themselves outside the gate of the Palais des Nations and shoot the delegates as they went to and from the conference. It was especially difficult to photograph the Chinese. This was the Chinese Communists' first official appearance in the West, but most of the time

they were holed up in their private villa, far out of sight of prowling photographers.

One day LIFE correspondent Milton Orshefsky, who was in Geneva covering the conference, learned that Mendès-France was going to Bern to meet for private talks with Chou En-lai, China's premier and foreign minister. He telephoned the Paris office to send a photographer to go with him to Bern. I was the only one available. During the previous five years I had covered no news events; but I was willing to go.

The next morning we were outside the French embassy, where the meeting between Mendès-France and Chou En-lai was taking place. The closed iron gate of the embassy was guarded by police; a horde of photographers and reporters milled in front of it. The meeting lasted only two hours. Around lunchtime the gates opened, and we caught a fleeting glimpse of Chou En-lai through the window of his speeding car as it left the embassy.

We heard from a colleague that Chou En-lai would return to Geneva by train. It seemed unlikely, but to be on the safe side we went to the railway station. There was only one other photographer on hand. On the tracks at the platform was one first-class car. We asked a railway official whether the car was for Chou En-lai, and he said yes.

Suddenly, down the platform came a group of Chinese led by Chou En-lai. He was not wearing the severe Chinese tunic-style jacket the world had almost always seen him in; he was dressed instead in a Western-style, well-tailored, gray, single-breasted suit, white shirt, and pearly gray tie. He looked the very model of a modern big businessman who had just pulled off the coup of his life. He smiled at us while we took pictures of him with his aides. Then he and his party boarded the car, stopping in the corridor at a closed window facing us. As there was not enough light for a picture I would have had to shoot flash, which would have reflected from the window glass. So I shouted, "Mr. Chou, remember me? Kessel! Chungking, 1946!"

I don't know whether Chou even heard me or understood me, or if indeed he actually recognized me from 1946. In any event, one of his aides reached up and pulled the window all the way down. There, framed beautifully, stood Chou En-lai, smiling at me. I pressed the shutter release. It was jammed. So I passed the camera to Orshefsky, standing beside me, and with another camera shot a few frames before the train pulled out. One of them ran a full page in LIFE the following week.

Mendès-France had kept his promise. On July 20 the armistice agreement was signed in Geneva. France was out of the Indochina War—and the United States was in it.

In the autumn of 1950 I went to see Henri Matisse in Cimiez, on the outskirts of Nice. He lived at the time in a residential hotel, the Regina. Lydia, his secretary, let me in and whispered in Russian to be quiet. I followed her as she tiptoed to the entrance of a large room. She motioned for me to take a chair. I could see Matisse's back as he sat in the middle of the room. Tacked on the wall he faced were a number of large ink drawings of the Virgin and Child. One of them was to be the design for a medallion to be mounted above the twin windows behind the altar of the Chapelle du Rosaire in Vence, which he had designed for the Dominican nuns. Except for slight variations, the drawings all looked alike to me.

After what seemed to me a long silence, Matisse turned to Lydia, who was standing behind his chair, and pointed to one of the drawings. She mounted a stepladder, carefully detached the paper from the wall, and set it aside. Then she pulled down the other drawings, letting them fall to the floor.

"What are you going to do with those?" I asked Lydia in Russian, pointing to the mass on the floor. "I don't know," she shrugged. "Probably throw them all out." I almost screamed, "I want one!" I wish I had.

A year later, on another assignment in Nice, I wanted very much to photograph Matisse in the Vence chapel, which was near completion. I called Lydia and asked her if she

could possibly persuade Matisse to pose for me in the chapel. She said, no, he was very busy. I told her that I would wait for weeks if necessary, not mentioning that I was working on another assignment which would keep me in Nice for some time.

Two weeks later I called again and asked Lydia if I might drop in and say hello to the Master. "Hold on," she said. There was a short pause while she talked to Matisse. "Okay," she said. "Drop in around 9:00 P.M." I told her that Dita Camacho and my assistant, Pepi Martis, were with me and asked if they might come too. "Okay, bring them over," she said.

When we arrived, Lydia led us to Matisse's bedroom. He usually spent most of his days in bed, always working, either making clay sculptures on the table over his bed or cutting colored paper into various shapes for collages. As we entered, he looked up from his work and, turning to Lydia, said crossly, "Who the hell are these people. I know you said Mr. Kessel was coming, but who are the others?" He knew who they were, for he had met them on a couple of occasions before. There was an uncomfortable moment. Then his face suddenly broke into a warm smile. "Sit down! Sit down," he said.

I still planned to bring up the question of the trip to Vence for a picture of him in the chapel. When it came to touchy subjects, I usually communicated with him through Lydia, speaking in Russian, using as an excuse that my French was not good. I knew Matisse liked the sound of Russian; he had visited Russia several times as the guest of his greatest patron there, Sergei Schukin. Whenever Lydia and I conversed in Russian in his presence Matisse would nod and say, "Da, da, da," which means "Yes, yes, yes." It was the only word he knew in the Russian language.

That evening I conveyed to Lydia my request to photograph Matisse in the Vence chapel. She told him what we wanted. "Why Vence?" he asked. "I am finished with it. There is no reason for my going there." "But you just told Mr. Kessel 'da, da, da,'" said Lydia. "As a matter of fact," she continued,

"you are going to Vence next Wednesday." "Am I?" he said, then turning to me. "Well, if Lydia says I will be in Vence on Wednesday, then I will be there Wednesday."

The interior of the Vence chapel is white. All paintings on the walls are black on white tiles. The entire right wall is a brilliant stained-glass window; on sunny days splashes of color are cast all over the chapel by the sunlight streaming through the window. On this particular day, however, the sky was heavily overcast. So, outside the chapel we set up a battery of flashbulbs to act as our sun. When Matisse and Lydia arrived, we were ready. He sat in a chair against the window, and twenty minutes later we were finished.

Three years later I photographed his funeral.

Not every person I photographed was famous. I remember in particular some photographs I made in Vienna in 1948. At the time Vienna was not the gay city of the past. The war had devastated large sections of it. More than 100,000 apartments lay in ruins, and national monuments, such as the Opera House, Saint Stephen's Cathedral, and many palaces, had been badly damaged. In 1948, the city, occupied by the troops of four powers— the United States, Britain, France, and Russia—was busy rebuilding. Previously empty stores in the shopping centers had begun again to display food and clothing—even luxury items, including jewelry, although these bore a sign "For Foreign Currency Only."

The streets were patrolled by jeeps driven by American MPs with MPs from each of the three other countries inside. I was told at American military headquarters that we could move around the city and photograph freely, except in the Russian sector. There we were on our own, and, if the Russians decided to detain us for whatever reason, there was little the Americans could do for us.

One day Barbara O'Connor, Pepi Martis, and I drove to Vienna's famous Prater amusement park in the Russian zone. We left our American car at the entrance to the park and continued on foot. I noticed a young Russian

soldier on a swing, having the time of his life, so I took a picture. Immediately, another Russian soldier came over and told me in Russian that it was forbidden to take pictures. "Why?" I inquired. "It is a military installation," he said. "A swing is a military installation?" I asked incredulously. "Yes," he replied, "because there are soldiers on it."

I was not going to argue further because he was joined by other soldiers who began to sound threatening. I told Pepi under my breath to move quietly toward the car. The Russians began to swear, using some quite foul words. "Okay," I said. "No pictures." And I began walking casually toward the car. Fortunately, it was less than a block away. Other Russians arrived and began shouting and shaking their fists at me. I called to Pepi to get in the car and start the motor. As soon as I heard the motor, I ran, and I jumped in just as the Russians started running toward us.

Another day we followed the four-power military patrol on its rounds in Vienna. I asked our American military policeman to invite his colleagues for ice cream so that I could photograph them together. Just as I was about to take the picture, the Russian soldier refused to be photographed. "Hell," I said. "It is an innocent picture of soldiers of four friendly powers having ice cream together." "I agree," said the young Russian. "There is nothing offensive about the picture. But it is the *caption* for the picture that may not be so innocent." He was right, of course, but he finally agreed to be photographed.

We also wanted to show something of the Viennese digging themselves out of the rubble and getting back to normal. It was suggested that we visit a beautiful, young Austrian countess who lived in her once-grand mansion on the outskirts of Vienna. We found her dressed in overalls on a stepladder, painting her living room. She climbed down to greet us; even in worker's clothing, splattered with paint, she looked glamorous. We talked to her for a while, then photographed her on the stepladder. As we were about to leave she suggested that we meet her Hungarian cousin who lived in the garage on her estate. She took us to see him, a young aristocrat working as a cobbler. He sat on a low stool, resoling shoes with rubber soles cut from discarded tires; that was how he was now making his living. In the background hung a huge oil painting of a nude.

We were taking pictures of the count-cobbler when Barbara O'Connor, who was near the half-closed door, shouted, "My, God! The Russians!" The countess assured her there was nothing to worry about; they visited often. I peeped out the door and saw Russian soldiers taking pictures of each other with the mansion in the background.

Opposite: The Right Honorable Aga Khan III and his wife, the Begum, at their villa on the French Riviera in 1949. His bulk was of value three years before, when, in honor of his 60th jubilee, he twice assessed his subjects his weight in diamonds.

Above: Actress Tammy Grimes poses for her portrait by the
French artist Rene Bouché in his New York studio in May 1961. In
the background are Bouché's portraits of Dorothea Tanning and
Marcel Duchamp.
Opposite: Bernard Berenson often worked in bed at his villa "I
Tatti" just outside Florence. Here, in 1949, he is seen reflected in
the large mirror at the foot of his bed, placed there simply so that
he "could look at himself."

Above: Igor Sikorsky at the controls of the first helicopter he
designed, in 1942 at Stratford, Connecticut, just before the tail
propeller flew off.
Opposite: China's Chou En-lai leaving the Bern, Switzerland,
railroad station in June 1954. Then premier and foreign minister,
Chou had just completed negotiations with France's premier,
Pierre Mendès-France, for a cease-fire in the Indochina War.

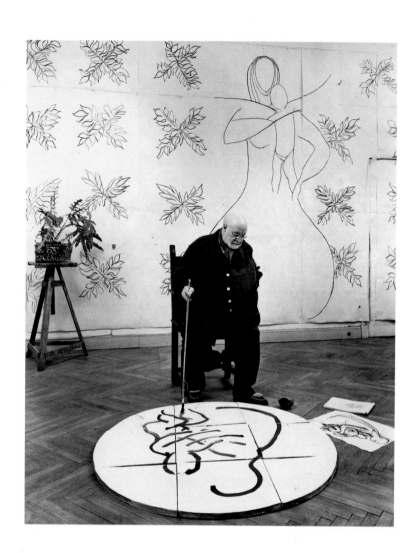

Above: Henri Matisse, in his studio in the Hotel Regina, Cimiez near Nice, in 1950, works on medallions for the Chapelle du Rosaire in Vence, which he was designing for Dominican nuns. On the walls are his designs for panels in the chapel.
Opposite: Matisse splashed with colors from his stained-glass window in the nearly finished Vence chapel.

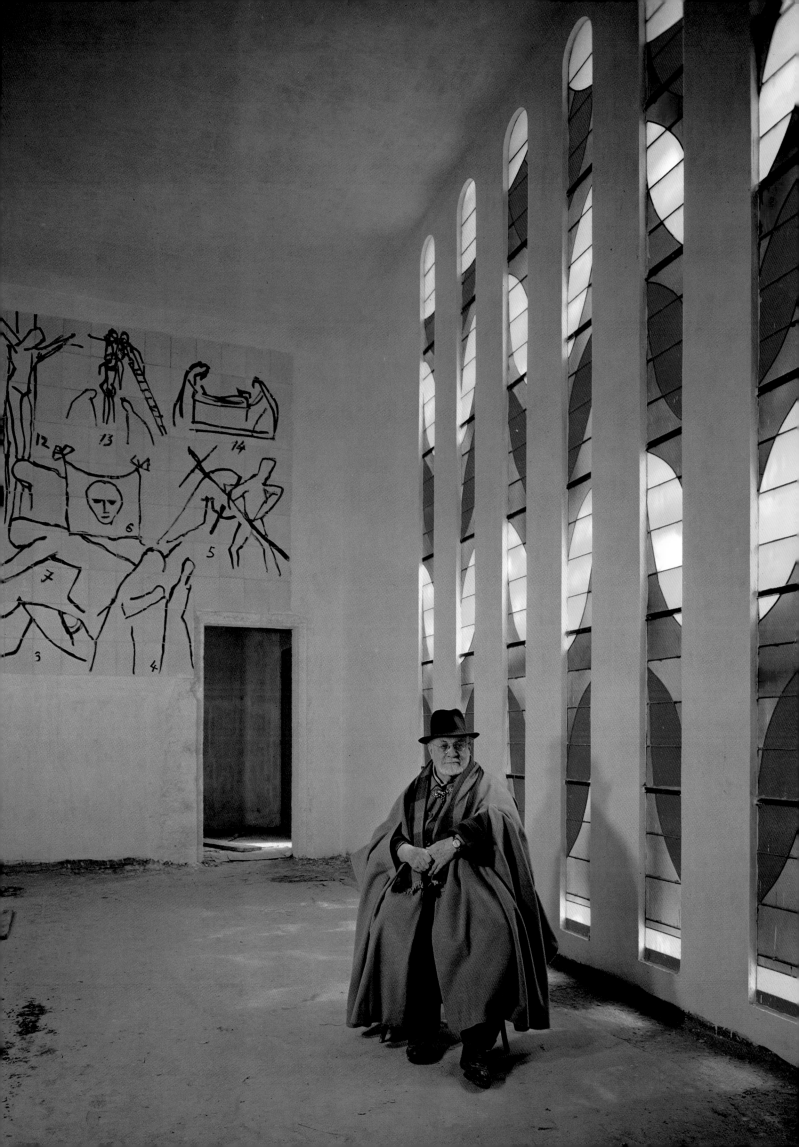

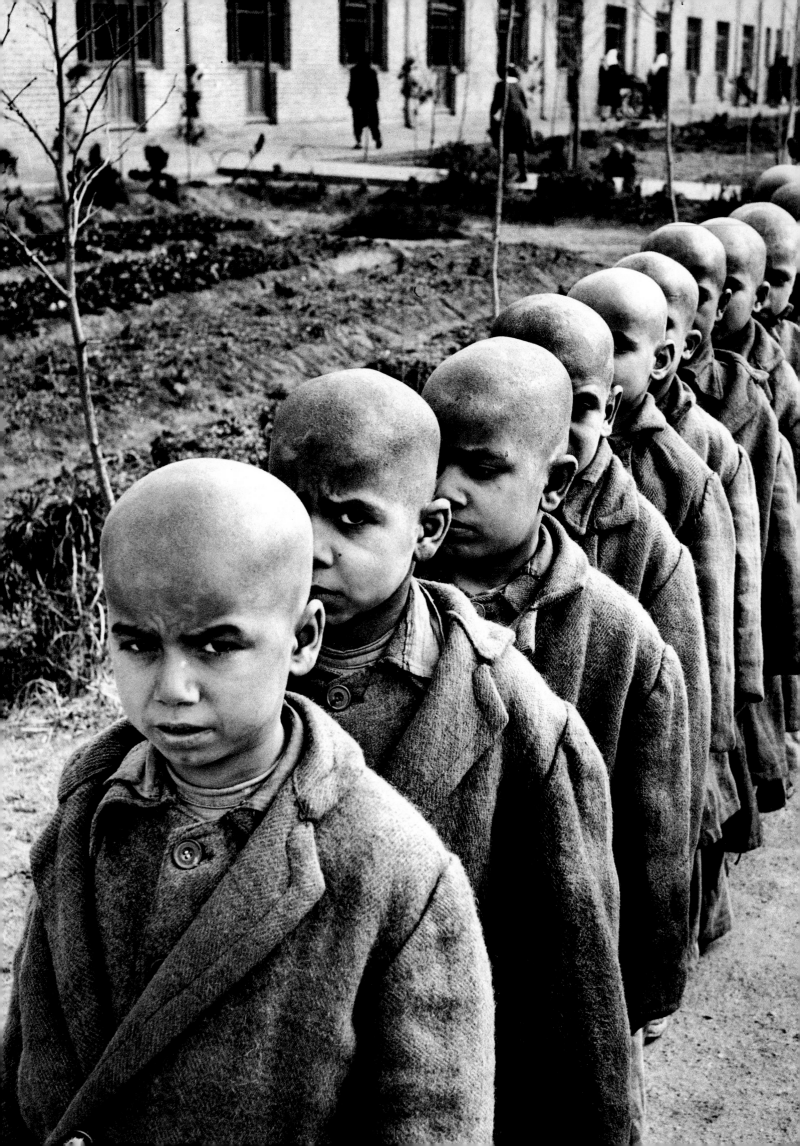

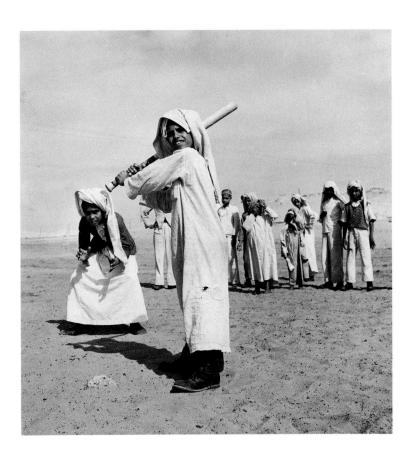

Above: In Saudi Arabia, 1945, office boys, sons of Aramco (Arabian American Oil Company) workers, play softball during their lunch break.
Opposite: In Teheran in 1951 Iranian orphans who live and work at a rehabilitation center line up for inspection. Their heads have been shaved in an effort to help clear up scalp infection.

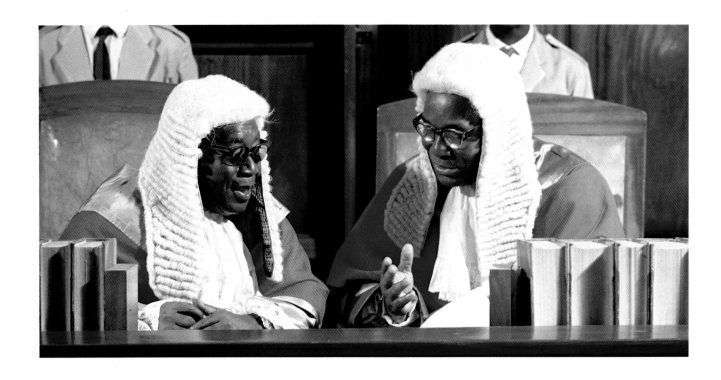

Above: In Accra, capital of Ghana, justices of the High Court wear the British-style wigs of office. The former British colony— called the "Gold Coast Colony"—was the first black African colony to be granted independence by Britain, in 1957.
Opposite: Mr. Hsu, an elder of Red Pepper village in north-eastern China and a venerated trainer of larks, plays with his great-granddaughter in 1946.

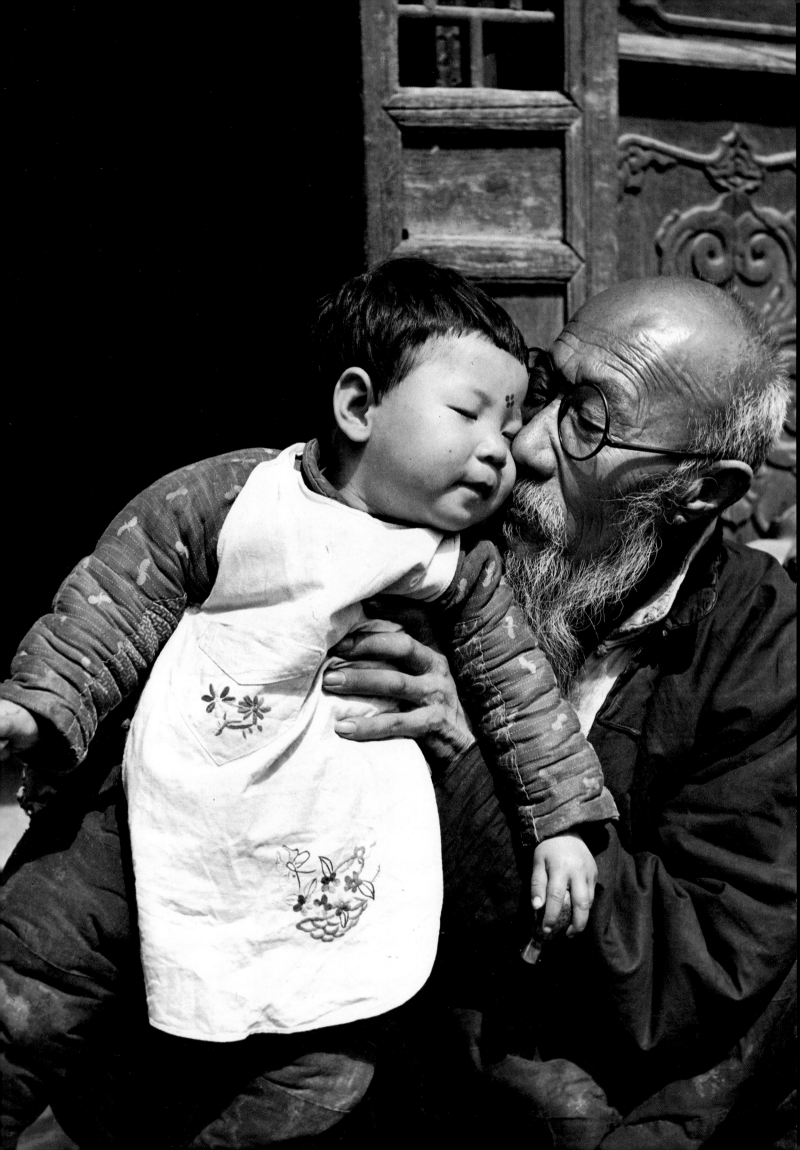

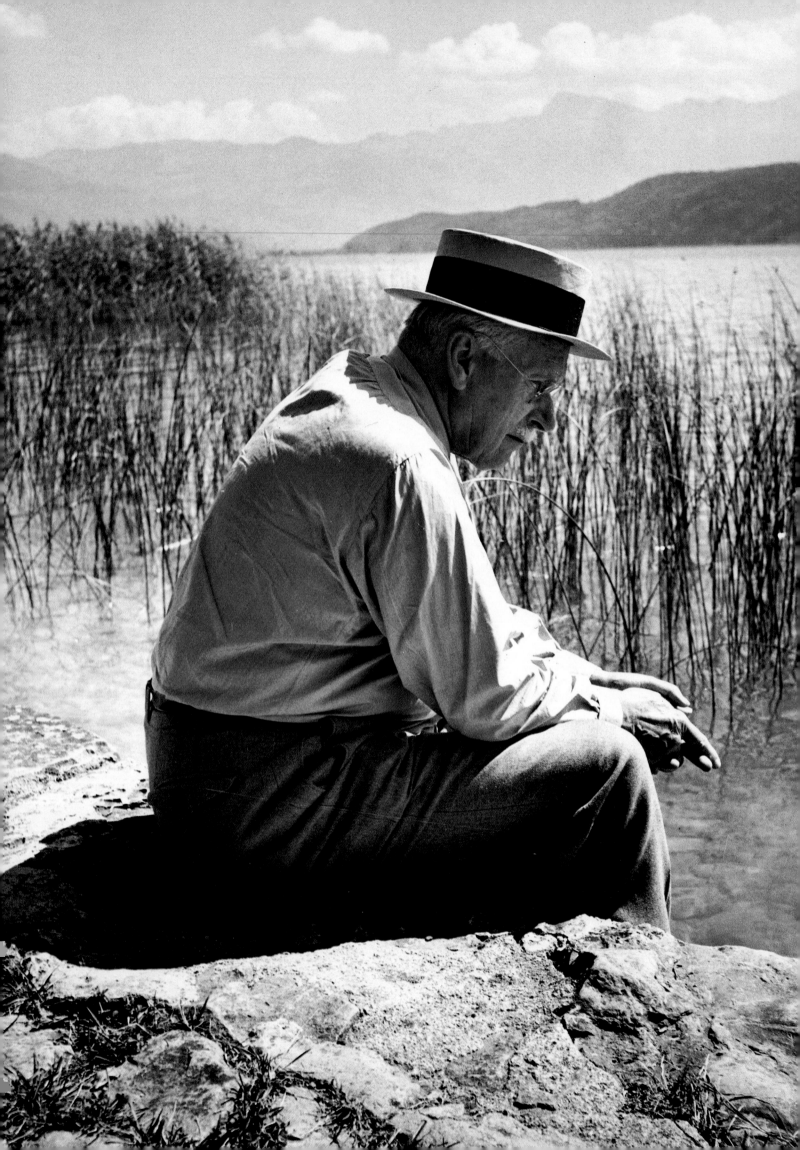

Above: Generalissimo Francisco Franco, dictator of Spain, in 1949. Franco had invited me to photograph him during a private duck and pheasant shoot with some of his friends.
Opposite: Carl Gustav Jung, the Swiss psychiatrist who broke with Freud and founded analytical psychology, at his country place at Bollingen, Lake Zurich, in 1950.

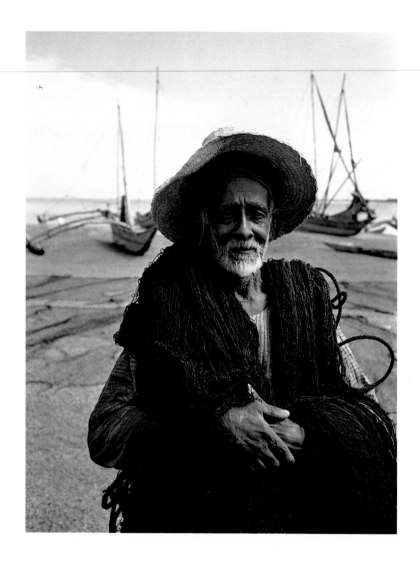

Above: A Ceylonese fisherman, hands gnarled by years of hard labor, poses for his portrait with the tools of his trade—a hand-made fishing net and the wooden ships in the harbor off Ceylon's west coast—in 1956.
Opposite: Greek tycoon Aristotle Onassis (left) shares a joke with his dinner-party host, Prince Raimundo Lanza di Trabia, at the prince's palace near Palermo in 1954.

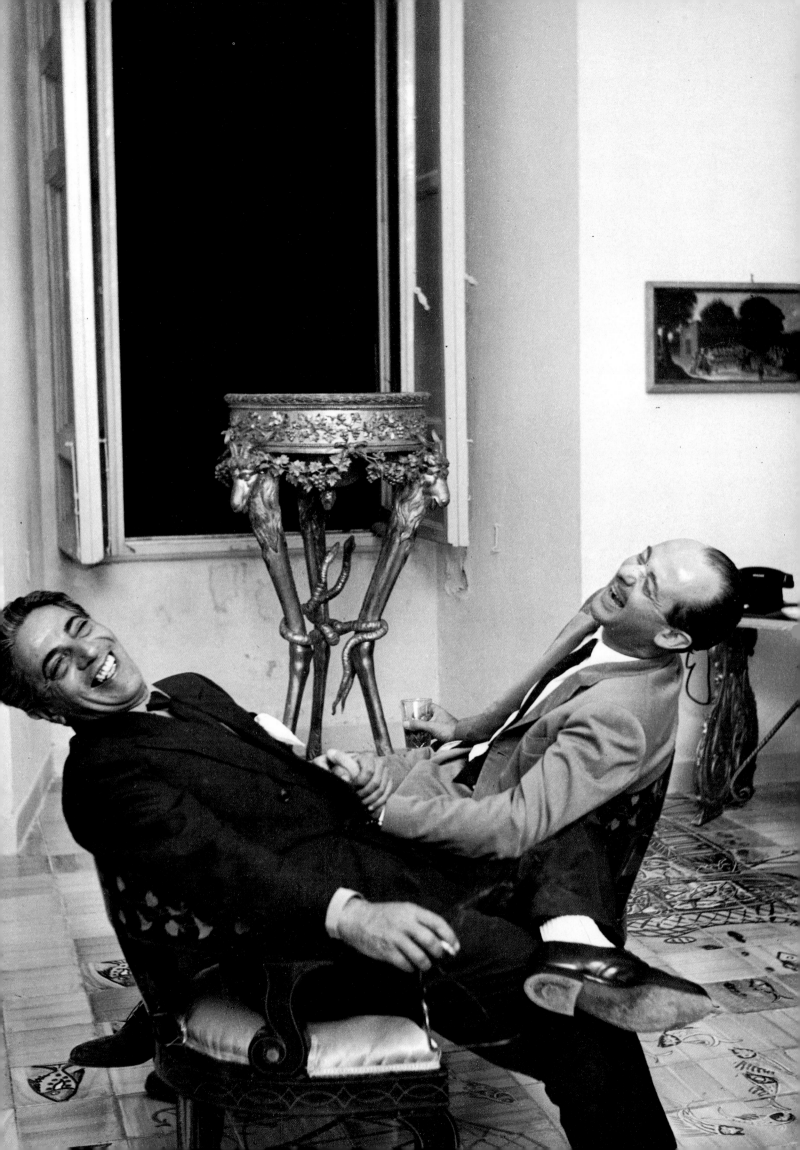

CHAPTER 7:
THE BELGIAN CONGO

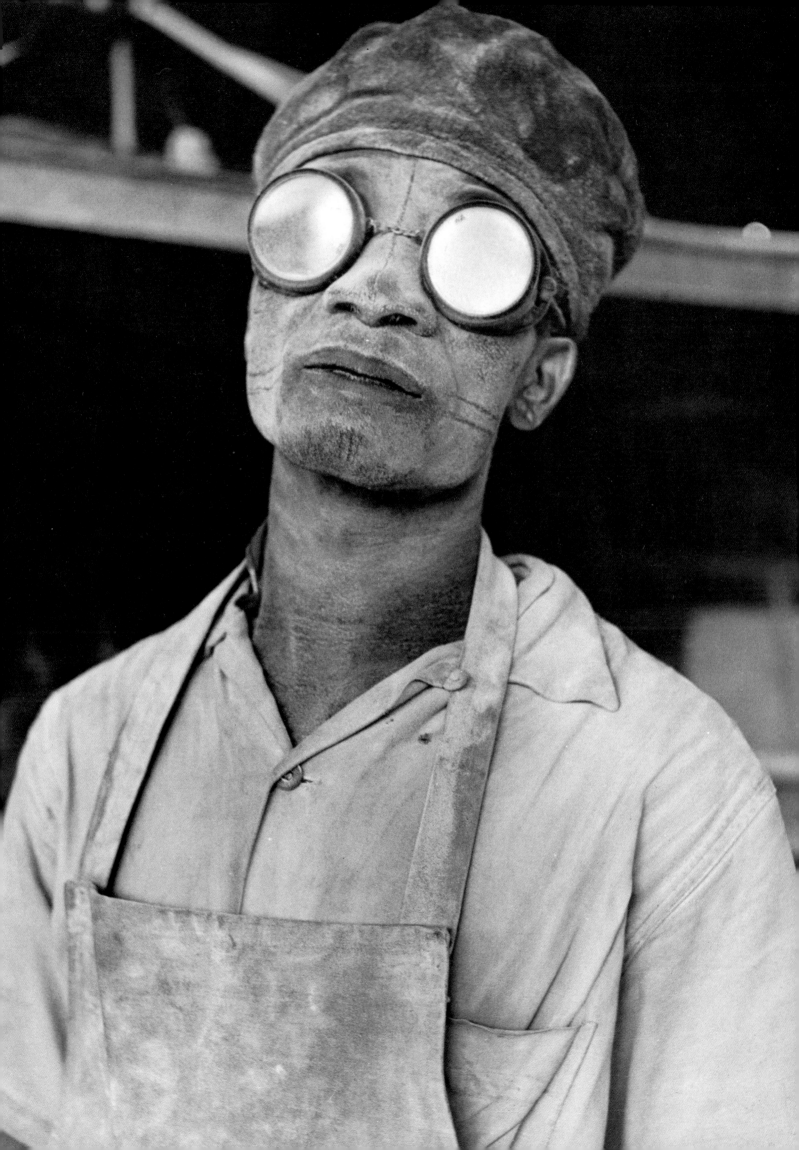

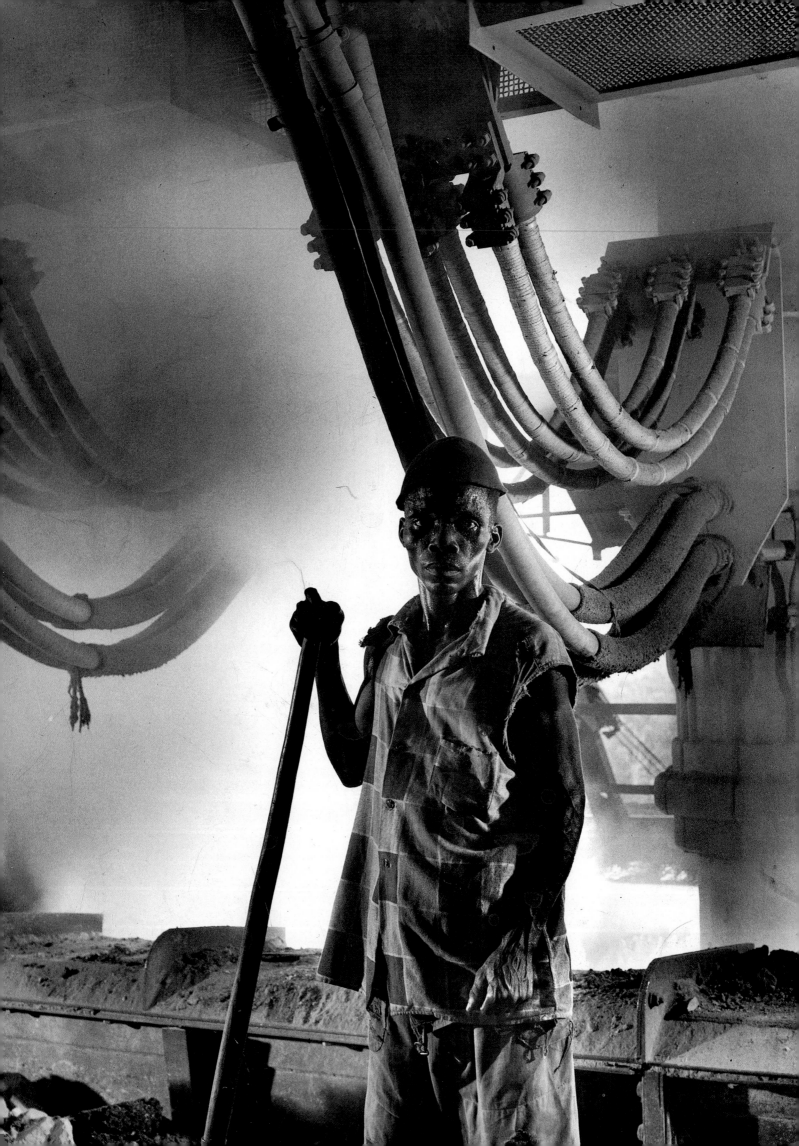

The most interesting LIFE assignments, for me at least, were photo-essays on countries. The picture editor might phone one day and ask, "How would you like to do an essay on Brazil . . . or China . . . or the Belgian Congo?" That wound up as a first-class tour of a country with LIFE's cachet insuring the fullest cooperation and the kind of reception by the nation's government usually reserved for ambassadors. After months of that kind of detailed reporting on a country you knew a great deal about it—its geography, its people, its government, its economy, its art, its way of life.

In 1953 LIFE editors decided to do an entire special issue on Africa: "A Continent in Ferment." The decision was triggered by what LIFE referred to as an "eloquent dispatch" from Alexander Campbell, the chief Time-Life correspondent in Africa, pointing out that "the rising tide of nationalism—and perhaps Communism—" in Africa was changing the whole face of the continent and that it was time for LIFE to make a massive effort to tell its readers about it.

The "massive effort" took four months of planning and execution. The issue was to take the reader on a ten-thousand-mile trip starting in Tangier in the north, crisscrossing the continent east and west, and ending in South Africa.

When I walked into my office in the Paris bureau one day, the bureau chief waved a cable from New York at me and sang, "Bingo, bango, bongo, you are going to the Congo." I had been assigned, with bureau correspondent Dita Camacho, to do an essay on the Belgian Congo (now Zaire) for the special issue.

We flew from Brussels to Leopoldville, the capital of the Belgian Congo. By coincidence, on the same plane was the governor of the Belgian Congo, the ranking official in the colony. When we introduced ourselves, he

invited us to call on him in Leopoldville. He thought that what we wanted to do was a large assignment but he promised full cooperation. To begin with, he suggested we go to Elisabethville, the Congo's industrial heart.

Elisabethville, at the southern tip of the Congo, was the capital city of Katanga province and the administrative center of the Union Minière-du-Haut Katanga, a mining combine that was one of the world's largest producers of cobalt, zinc, tin, and uranium. Unlike Leopoldville, whose old colonial Hotel Victoria was infested with insects and lizards, Elisabethville had a modern air-conditioned hotel with a very good restaurant. On its way to South Africa Sabena Airlines would bring in fresh meat, sole, and other delicacies from Brussels; the next day, on its return trip it would arrive with lobster, fresh fruit, and vegetables from Johannesburg, South Africa.

In Jadotville, the second most important city of the province, ore from nearby mines was smelted and refined. Most of the workers in the mines and smelting plants were members of the Baluba tribe from Kansai province.

The miners were recruited from jungle villages and brought to Elisabethville and Jadotville by bus or flown in in old DC-3s. They were given special training before they were put to work. If they could not adjust to city life, they were sent back to their native villages; no unemployed natives were allowed in the cities or mining centers. The workers who remained (and their families) were well taken care of by the company; there were hospitals, schools, and special day-care centers for children. The new miners began to copy the white man's way of dress. The first thing each miner bought was a white pith helmet, which he would wear on Sundays and holidays. On Sundays the miners went on picnics and got drunk on beer mixed with cola.

From Elisabethville, we flew on to Stanleyville, the principal city of the northern Congo. By then we had spent considerable time showing the modernization side of the Belgian colony—the industries, the booming

cities (actually more like frontier towns). But we also wanted to show that eighty-five percent of the eleven million Congolese still lived in primitive villages and still practiced their ancient ways. The district commissioner of Stanleyville volunteered to take us into the jungle.

We traveled by jeep. On the way the commissioner lectured us on the life, customs, and traditions of the Congolese tribes, their secret societies, and the rites of initiation of eligible natives into those societies. To become eligible, a man must first kill a member of his family, usually by hanging; a mother, father, brother, or sister was the likely victim. After committing the ritual murder the candidate, with the help of the medicine man and other dignitaries of the sect, carves a wooden image, or fetish, of the deceased and gives it the name of the dead person. This statuette is then presented in the initiation ceremony to the new member of the society. Its possession is supposed to give him magic powers of healing, of seeing into the future, or of chasing away evil spirits. It also gives him high standing in his village; a society member becomes an important person in all village affairs.

The statuette must be kept in a special sanctuary, and no one but the members of the sect are allowed to lay eyes on it. If by chance a woman or a child or a nonmember stumbles on it, he or she must be put to death.

About forty miles from Stanleyville we came to the village of Yalikanda. The village chief came riding up on a brand-new bicycle. He wore a ceremonial headdress made of leopard skin and birdfeathers. Around his neck was a heavy necklace made from some kind of shells; from it dangled a large medal that signified him as chief, even in the eyes of white men. On each bar of his bicycle was a bell, another sign of his rank. The chief was a high master of the society known as Lilwa; his name was Lusambo, and he was a member of the Bombole tribe.

Lusambo took us on a tour of his village. The usually busy streets were almost desert-

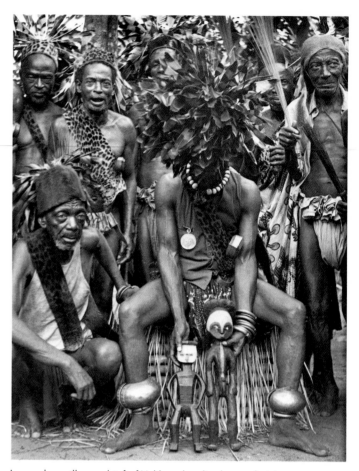

Lusambo, village chief of Yalikanda, displays a fetish representing his dead father at a ceremonial meeting of the village's secret society, known as "Lilwa."

ed. The commissioner entered into a lengthy discussion with the chief to find out what was going on. Finally, he said to me, "A meeting of the secret society is about to take place. We may be able to buy our way in. How much are you prepared to pay?" "Ask him how much he wants," I said. The commissioner said, "The thief wants two thousand francs." At that time two thousand Belgian francs equaled forty dollars. "Fine," I said.

The chief led us to the outskirts of the village. An unusually tall, elderly woman, completely nude except for a small patch of cloth tied by a string around her hips to cover her pubic hair, took hold of Dita Camacho's hand and led her to a group of women farther down the street. No women were allowed near the ceremonial grounds. We men followed the chief out of the village into the nearby forest. There, in a clearing approximately one hundred feet long by fifty feet wide, fenced in by bamboo stalks about eight

198

feet high, were forty men squatting along the bamboo walls. At the far end of the enclosure the chief sat on his "throne," really a low bamboo stool, entirely covered by a ruffle made of palm leaves.

The commissioner and I were seated against the end wall, facing the chief. The men rose and began to chant slowly, swaying from side to side. In single file, they started dancing around the compound. Many of the dancers had machete-like knives, which they would occasionally swing above their heads. The dance accelerated, the chanting became louder. Meanwhile the chief was working himself into a frenzy. He was on his knees, rocking from side to side. His hands were between his legs holding something covered by a piece of rag; we could not see what it was. Then the dancers broke rank and began to whirl around in the center of the compound, chanting wildly, occasionally screaming. My guide leaned over to me and whispered: "Stop now. No more pictures!" He was very pale. Suddenly, there was a piercing shriek. The chief lifted the rag for a split second and we had a glimpse of the fetish, a statuette representing the spirit of the murdered relative.

The ceremony was over. The men knelt in two rows facing each other, forming a narrow corridor. The chief told the police commissioner that we would have to walk through the corridor and submit to a ritual beating across the legs with twigs so that we would always remember not to reveal to anyone what we had seen. Fortunately, I had on long pants and felt only a stinging pain. The commissioner, however, wore shorts, and his legs were bleeding.

The thrust of LIFE's essay on the Congo was basically upbeat. The opening headline read: "From a Jungle-Edged River and a Sorcerous Past Modern Congo Is Born." The opening textblock concluded: "out of the savage land and the savage people the Belgian government and Belgian businessmen have created a prosperous colony where the Congolese lead a fuller, healthier life at the same time that European capital makes a handsome profit . . . the Belgian Congo is an outstanding argument for 'enlightened colonialism. . . .' " The text also pointed out, however, that although there were only seventy thousand whites in the Congo amid eleven million Congolese, "a main feature" of Belgian policy in the Congo was to increase the African's economic benefits while giving him "little social standing or political power."

The story then was basically fair and reasonable: that *was* the situation in the Congo in 1953. What none of us could have foreseen then was that seven years later, in 1960, Belgium would be forced to give up the colony, the victim of the same flames of nationalism that had transformed, and would continue to transform, Africa. We were journalists, not political soothsayers.

No LIFE photographer is ever completely satisfied with the editors' choice of his pictures, or the way they are laid out, or the amount of space given them. That's an occupational hazard in group journalism. Still, I was disappointed when I learned that my essay would run only eight pages; I felt that after two months in the Congo I had shot enough good material to fill a book. I was aware, however, of the managing editor's space problems. There were a maximum of eighty editorial pages in the issue. Four of them suddenly disappeared when the first prisoner of war exchange took place in Korea; though that had nothing to do with Africa, the editors felt that LIFE, as a newsmagazine, could not ignore the event. That left only seventy-six pages for the African stories—all twenty-four of them.

I felt somewhat better about my space when I received a cable from the managing editor saying that it was the toughest time of his career, trying to squeeze my pictures into eight pages.

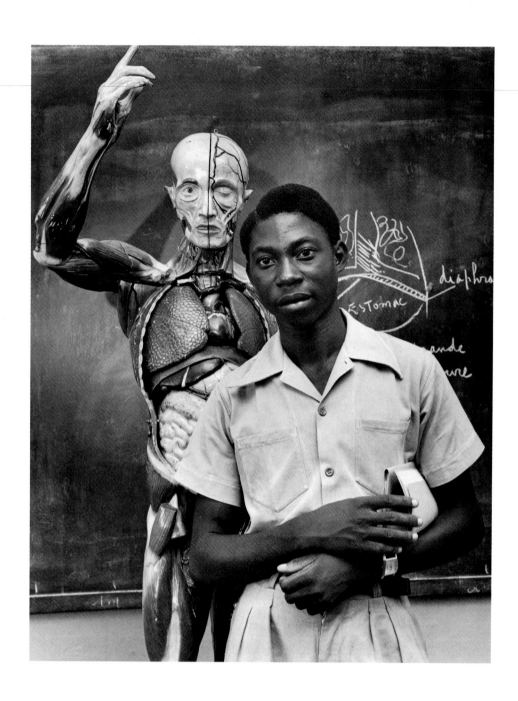

Above: In front of a model of the human body stands a medical
student, Katanga Paul, 18, studying in Leopoldville to become an
"assistant médical." At that time Congolese were permitted to
be only nurses and assistants, not doctors.
Opposite: Scarred with his tribal markings, a witch doctor in the
Belgian Congo poses for his formal portrait.

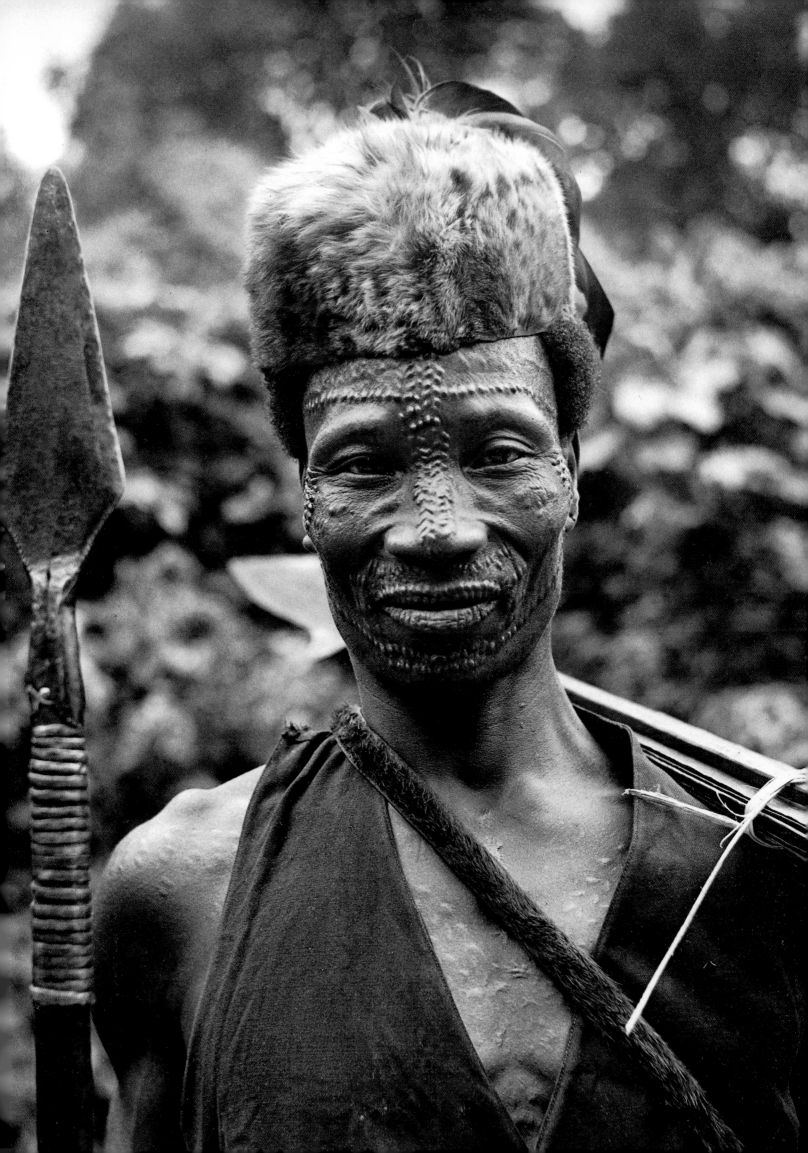

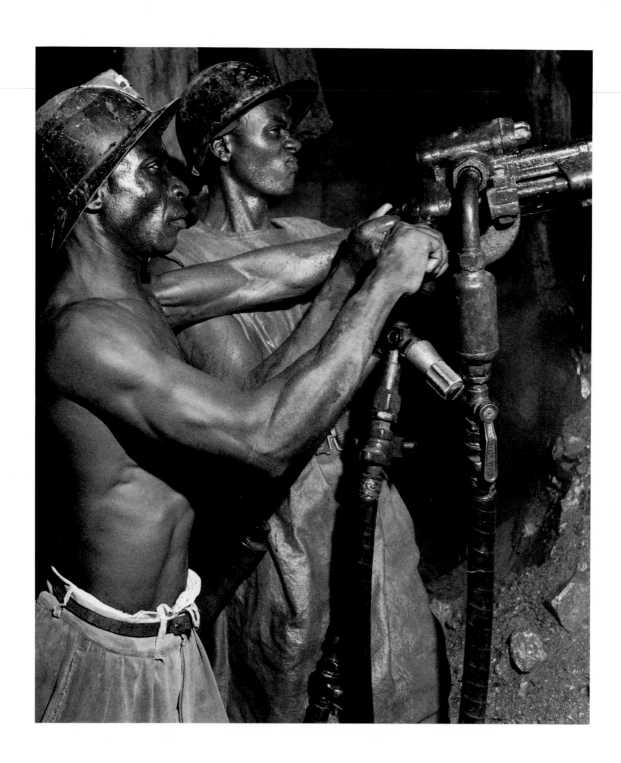

Above: Thipama Léon and another worker drill holes for
explosives at the Prince Léopold copper and zinc mine in
Katanga. Léon came to the mine in 1930; when I shot this story in
1953 he was a gang foreman making $70 a month. In addition
the company provided him with a neat, brick house, and his chil-
dren and grandchildren attended company-run schools.
Opposite: A teen-age fishergirl of the Bombole tribe near
Yalikanda, about 40 miles from Stanleyville.

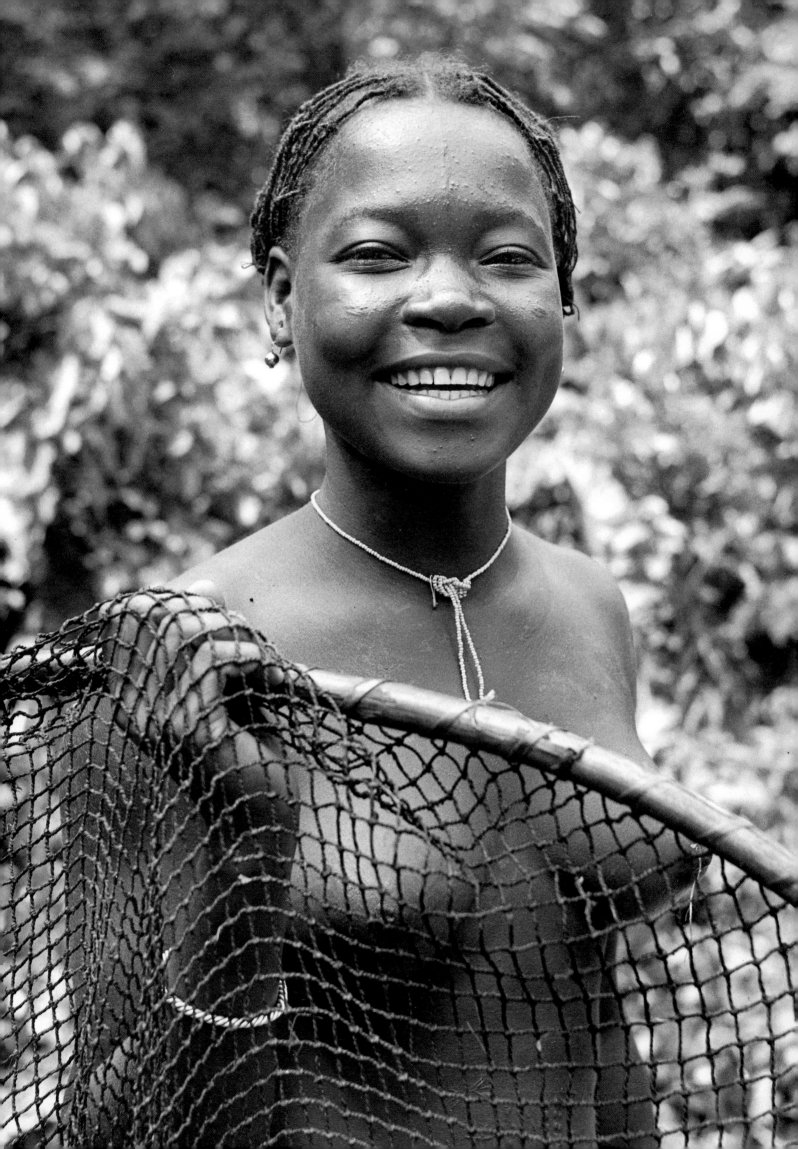

CHAPTER 8:
SPECTACLE

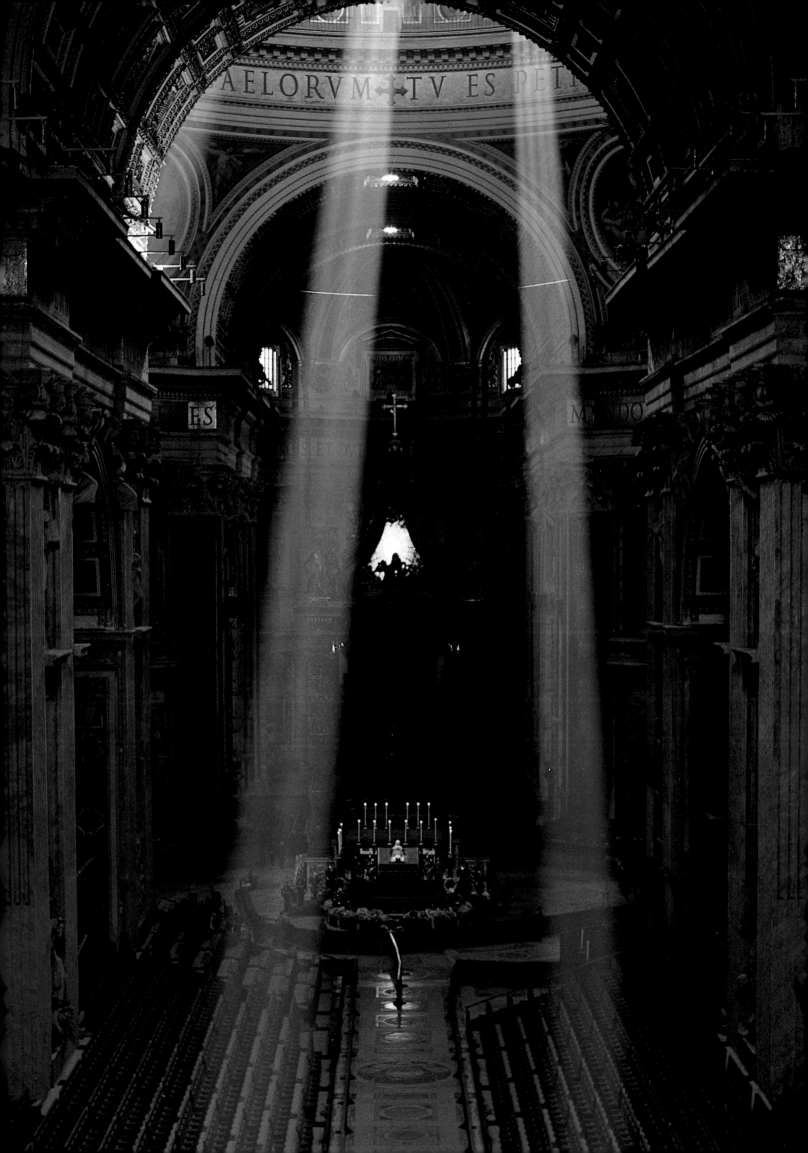

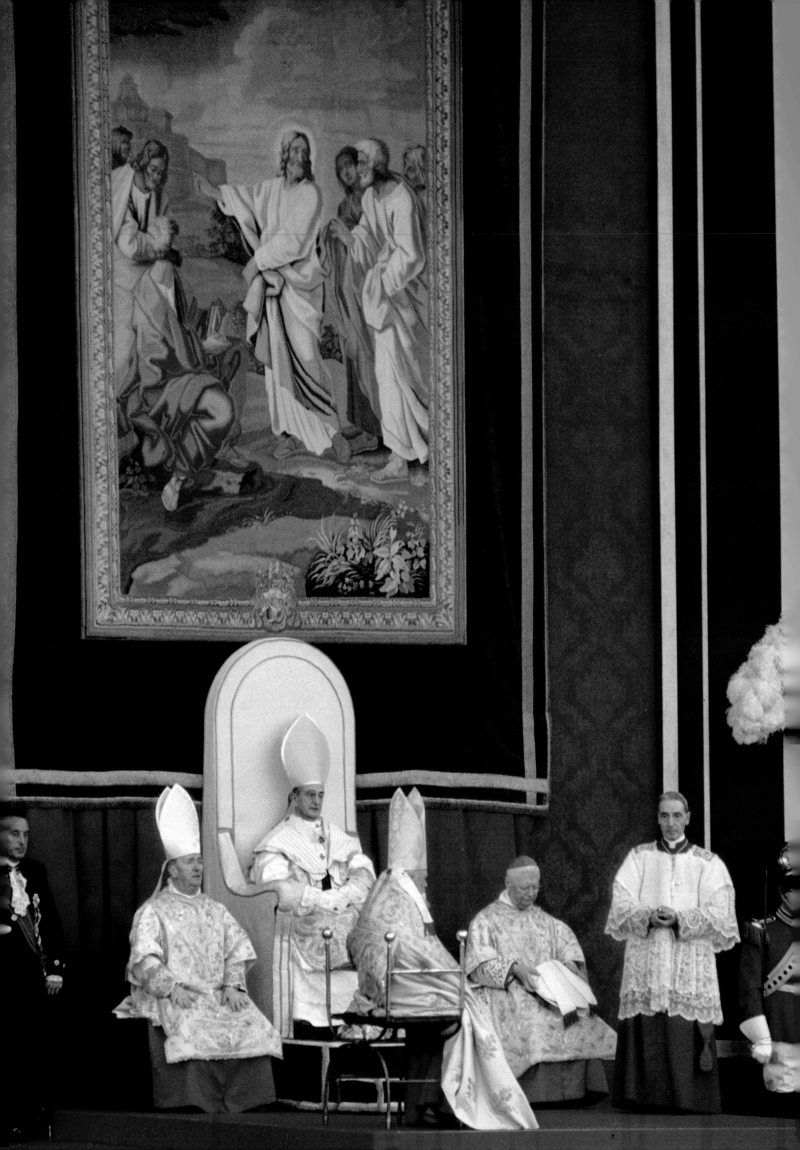

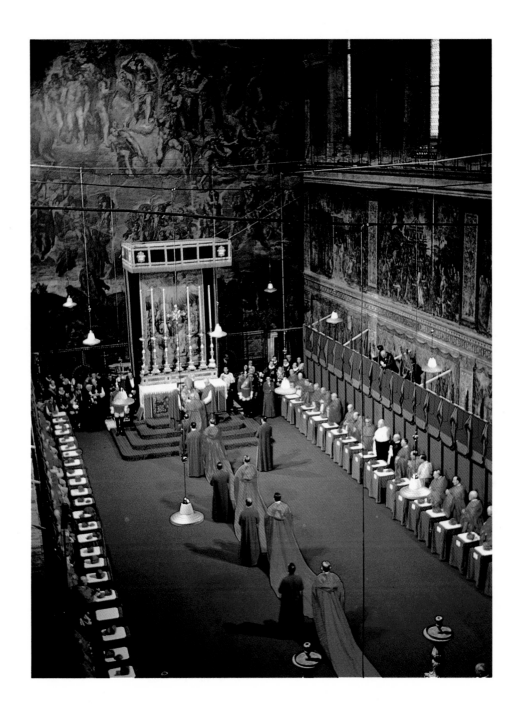

Above: Seated on his throne in the Sistine Chapel, newly elected
Pope Paul VI receives the homage of his cardinals, who kneel,
one by one, to kiss his ring. Behind the throne is Michelangelo's
Last Judgment.
Opposite: Pope Paul VI and his attendants in Saint Peter's just
after his coronation in 1963.
Preceding page: The body of Pope John XXIII lying in state in
Saint Peter's. He died in June 1963.

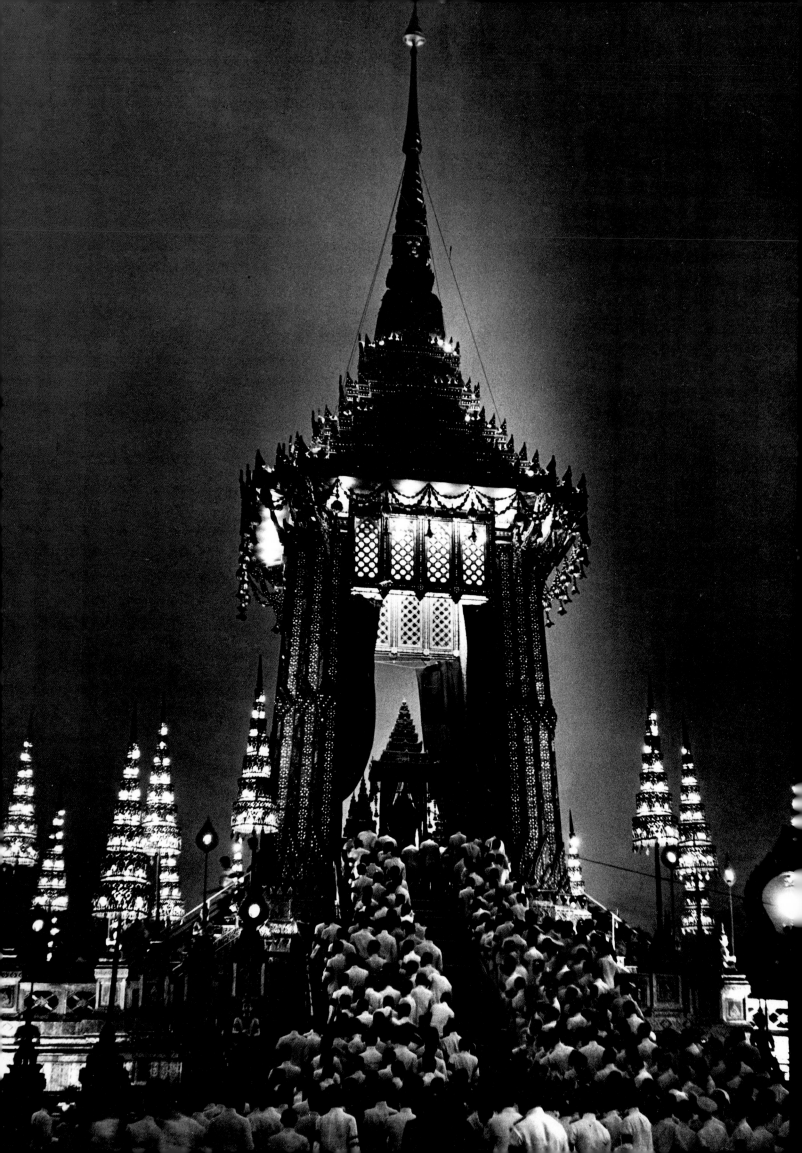

When I showed up in Rome in 1963 to cover the funeral of Pope John XXIII, a French colleague from *Paris Match* magazine greeted me: "Ah, voilà! Dmitri, *le croque-mort*" (the undertaker). He had seen me at these functions many times before: I have photographed the funerals of three kings, two popes, and three prime ministers.

LIFE was very big on spectacle and pomp. In addition to the great state funerals I also covered coronations—of Queen Elizabeth II, the Shah of Iran, Pope John XXIII, and Pope Paul VI—and royal weddings—of the Shah of Iran and of the Caliph of Spanish Morocco.

Most of these spectaculars were photographed by hordes of LIFE photographers; there were fourteen at Queen Elizabeth's coronation, fifteen at Churchill's funeral. But at the funeral of Sweden's King Gustav V and the weddings of the Shah of Iran and the Caliph of Spanish Morocco, I was the only LIFE photographer.

The first royal funeral I photographed was that of King Gustav V of Sweden in 1950. After the ceremony there was a formal dinner in the royal palace for Scandinavian royalty, chiefs of state, and diplomats. Photographers and correspondents had been told to be at the palace at 8:00 P.M. I arrived with our Swedish stringer and was surprised by the seemingly total lack of security. No one stopped us at the gate when we entered the palace; no one challenged us inside. Mounting the stairway to the balcony overlooking the grand ballroom where the dinner was to take place, I noticed a middle-aged woman wearing a black dress and a white apron. I thought she was a maid. I asked her if she spoke English. She did, she said. I asked her if I were going in the right direction for the ballroom. I was, she said. Then I heard the stringer behind me greet her, "Good evening, Your Royal Highness." She was the queen of Sweden wearing the traditional mourning dress of white on black.

Opposite: In Bangkok, April 1950, four years after the death of King Ananda, Siamese royalty, government officials, and diplomats carry tapers to the king's funeral pyre at Meru Tower, built for the ceremonial cremation of his body.

In February of 1952 I was in Kenya covering the visit of Princess Elizabeth and Prince Philip when the princess was called back to London because her father, King George VI, had just died. The day the princess left I found a message in my hotel from André Laguerre, the Time-Life bureau chief in London: "Move heaven and earth to come to London immediately."

There were eight LIFE staff and stringer photographers in London when I arrived two days later. I was assigned to photograph the king lying in state in Westminster Hall. A mob of photographers from all over the world was waiting at the entrance to the hall. We were admitted in groups of twelve, given five minutes to set up our cameras, take the picture, and get out. It was a bum's rush.

I worked with an assistant who handled the extension reflectors with flashbulbs. Only one English photographer had a flash. Everyone else in the group would have to depend on our lights. I was asked by the other photographers to signal when they should open their shutters. "Okay," I said, "I will shout 'open.'" The English photographers preferred "caps off," their jargon for opening shutters. I insisted on "open." We got ready, I shouted "open," and we shot the first exposure. While my assistant was changing bulbs, the British photographer got ready. He shouted "caps off," and we shot another picture. We shot a third exposure with my bulbs and then were hustled out of the hall. Someone later spread the word that when the English photographer shouted "caps off" I automatically took off my hat, thus missing the picture. Actually, I wasn't wearing a hat.

Sixteen months later I was back in London, one of fourteen photographers assigned by LIFE to cover the coronation of George VI's daughter Elizabeth. The reason for the large number was a simple matter of logistics. Officials in charge of the ceremony, which included the traditional procession of the royal coach and horsemen to Westminster Abbey, did not want their event ruined by the sight of scores of photographers running

alongside the coach or darting in and out of the procession, maybe even being trampled to death by the horses. And so, each photographer was assigned to a fixed position along the route of march; he had to be in that position by five o'clock the morning of the coronation (no traffic would be allowed on the route after that time) and he had to remain there until the entire ceremony was over, about seven hours later.

That meant that each photographer would be able to shoot only the approach of the procession to his position and then—pouf, pouf, pouf—a couple of closeups as the royal carriage was abreast of him, then a few more as it disappeared from sight. It was not an ideal photographic situation. It seemed even less ideal when we learned the weather prediction: no sun, gray skies, and a strong possibility of rain.

Hotel space in London during Coronation Week was very, very tight. Six LIFE photographers, including me, and one correspondent, Milton Orshefsky from the Paris bureau, had all been booked into Brown's, one of London's best lodgings. I wound up in a cot right next to the bathroom, in the direct line of traffic all night long.

Since we all had to be in position by five o'clock, none of us got much sleep the night before the coronation. Instead, the photographers sat on their beds, taking all their equipment apart, tinkering, inspecting. From time to time mutterings arose: "Should I use a 135mm lens and concentrate on closeups of the royal coach, or should I use a 35mm and settle for wide-angle overalls?" "If it's a gray day, I'd better have some filters." And so on. There was a momentary silence when, suddenly, the voice of Orshefsky could be heard: "Should I use a No. 2 or a No. 3 pencil? Should I use a lined or unlined notepad?" We photographers stared at him as if he were out of his mind and then went back to our own musings.

As we straggled back to the office, tired, cold, and damp after having stood in one place about seven hours for about three minutes of shooting, Orshefsky asked us how we had

done. Nobody wanted to commit himself—it was too gray, too rainy, the procession went by so fast, there were too many photographers in the same position. Finally, in exasperation Orshefsky said, "For Chrissakes, Ed Thompson just phoned. He's got four blank pages of color staring him in the face that have to close tomorrow. If you don't think your pictures are good enough to fill it, he's going to have to substitute another story."

That did it. Everyone began speaking up at once: Oh, with some luck, I think I got a full page; there should be something in my take that might make a double-truck; etc. To judge from our comments we had enough to fill a magazine, let alone four pages. Actually, the pictures were not the most dramatic or colorful that LIFE has ever published. But there were enough to fill four pages. Out of the eight pictures LIFE ran in color, I was lucky enough to get two.

One summer night in 1954 I was awakened in my Paris apartment by the persistent ringing of the telephone. It was the LIFE Paris bureau chief. New York had just phoned after hearing on an evening news broadcast that Pope Pius XII was seriously ill. They wanted me to go to Rome immediately. It was 2:30 A.M. At seven that same morning I was picked up and driven to the airport. The Pope *was* ill (he had a serious, debilitating case of the hiccups), but he didn't die.

Four years later, in October of 1958, I was on vacation, fishing on Saranac Lake in upstate New York with my brother-in-law. A warden's boat came alongside ours. I thought he wanted to check our fishing licenses.

"Are you Dmitri Kessel of LIFE magazine?" he asked. "They want you back in New York immediately."

We returned to the camp, and I telephoned the New York office. Pope Pius XII had died. They wanted me to go to Rome that day, if possible. I had missed the last plane out of Saranac, so I chartered a small plane and flew to New York. I was on my way to Rome the next day. Six LIFE photographers were already there, one staffer from each of the Rome,

London, and Paris bureaus and three stringers.

At that time the official Vatican photographer and the photographer from the Vatican newspaper, *L'Osservatore Romano*, had exclusive rights to take pictures of any event inside the Vatican. It was next to impossible for a press photographer to get in unless he had strong connections with the Vatican administration or its police.

The simplest way was to make a deal with one of the official photographers to be taken in as his assistant. That was what I and one other LIFE photographer did. The other photographers, including LIFE's, worked in various positions *outside* Saint Peter's.

There were a number of events to be photographed: the spectacular funeral service in the cathedral; the election of the new pope; and, finally, the coronation. The whole process took about six weeks. Between the funeral and the election of the new pope we photographed the "papabili"—the cardinals who were favored in the election.

During the voting by the cardinals in the Vatican, photographers sat behind their cameras in Saint Peter's Square and on top of the Bernini colonnade, intently watching the small chimney of the Sistine Chapel. If at the end of the day's voting the smoke from the chimney was black, it meant that no pope had been elected. When, after a few days, the smoke came out white, there was great cheering and applause: we had a new pope. Then came the critical moment of suspense: no outsider knew yet who the new pope was. Every eye and telephoto lens was focused on the small, central balcony above the entrance to Saint Peter's. The doors opened, the ushers draped the Vatican flag over the balustrade of the balcony, and soon the procession of cardinals filed onto the balcony. Then the senior cardinal in a squeaky voice announced: "Habemus papam (we have a pope), Cardinalem Sanctae Romanaem Ecclesiae Roncalli". . . Pope John XXIII.

In January 1965 I was in Spain doing a story on director David Lean's filming of *Dr. Zhivago* when Winston Churchill died. I received a telephone call from New York telling me to go to London for the funeral. I protested that there were already a dozen LIFE photographers in London and that I would miss the spectacular scenes that were about to be shot in Spain, but it did no good. I had to go to London.

Churchill's funeral was covered by sixteen LIFE staff and stringer photographers posted in assigned spots along the route of the cortège. I was given a spot in Saint Paul's Cathedral as a pool photographer to shoot not only for LIFE but for British and other foreign magazines as well.

LIFE had set up a darkroom in the London office and had brought over two lab technicians from the Paris office. All our pictures were to be developed there immediately and duplicated for other magazines. But this plan was changed when LIFE, to save production time, decided to charter a DC-8 in New York to fly George Hunt, managing editor at the time, and a staff of thirty-four editors, writers, and technicians to London to collect the film, process it en route to the United States in a lab installed on the plane, and lay out and write the story as they flew directly to the Chicago printing plant. The change in plans meant that I had to duplicate for other magazines every picture I took for LIFE.

I set up three cameras on two tripods in the spot assigned to me—in the cathedral choir, among dozens of television and newsreel cameramen and commentators. It was a very tight squeeze. On one tripod I had a 2¼ x 3¼ Linhof camera with a wide-angle lens to photograph the entire interior. On the second tripod I had mounted a special bracket for two motorized Nikons for closeups. To duplicate pictures on the Linhof was comparatively simple: I had extra film magazines which I kept changing. On the Nikons I would shoot fast continuous sequences of about twelve frames on each situation, which earned me murderous glares from the commentators: a motorized camera makes a hell of a noise.

For all the funerals I photographed, still I was not always Monsieur Croque-mort.

Sometimes I photographed happier events, like weddings. The most spectacular was the wedding of Caliph Sidi Muley Hassan ben el Mehedi ben Ismael ben Mohamed, the civil and spiritual ruler of the 750,000 people of Spanish Morocco, a Spanish protectorate at the time, to Princess Lal-la Fatima Zohora ben Muley Abd-ul-Aziz ben el Hassan ben Mohamed. The festivities lasted fifteen days. There were daily receptions in the caliph's palace—lunches and dinners where men sat on cushions around low tables and consumed great quantities of roast lamb, chicken cooked with almonds, chicken cooked with green olives, chicken cooked with honey. During the celebration the guests ate fifteen thousand chickens and three thousand lambs washed down with vats of fruit juices; good Muslims, they did not drink alcohol. No women were present except at the last dinner, when the Spanish governor of the protectorate, his wife, and other nobles sat at the caliph's table. The bride-to-be was never seen.

When we were given clearance in Madrid to cover the wedding, we were told by a pompous Spanish official that we would never get to see the bride. He was mistaken. A few days before the wedding ceremony we were invited by the caliph's secretary to come to the palace with our cameras. At the entrance my male assistant was told to stay behind. A palace usher asked me and reporter Dita Camacho to follow him. One of the servants carried my photographic equipment. We were brought into a great hall decorated in Oriental style; colorful mosaics covered the walls. A few minutes later the caliph came in. "I have a surprise for you," he said. "I want you to meet my bride-to-be." Princess Lal-la Fatima walked in wearing a long damask dress, a gold belt around her narrow waist, and heavy gold jewelry around her neck. She was very beautiful. She spoke perfect French and some English. While Dita talked to her, I began to set up my camera and lights. I used flashbulbs and needed someone to hold an extension light at some distance from the subject. Since my assistant had not been allowed in, the

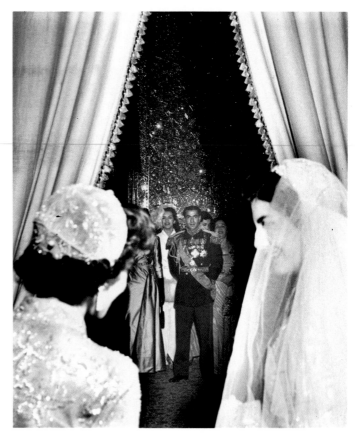

At the wedding of the Shah of Iran to Princess Soraya in 1951, the shah, framed by his sister Princess Chams (left) and Soraya, awaits the entrance of his bride in the Hall of Mirrors. He later divorced her because she produced no sons.

caliph himself volunteered to help. He climbed on the table and held the light reflector high above the princess while I photographed her. He even changed the bulbs for me. Dressed in a long white burnoose, holding a refector high above his head, he was quite a sight. I wonder how much face he would have lost if one of his subjects had peeked in.

The marriage was the result of a business contract drawn up in 1946 between the caliph and the bride's family, who paid him four thousand dollars. On the day of the wedding, the princess with her entourage was settled in a colorful tent camp outside Tetuán, the capital. Dita Camacho had permission to visit and photograph her there; I gave her one of my cameras. That night a closed royal carriage drawn by white horses and accompanied by two hundred horsemen on Arabian chargers entered Tetuán. Thousands of people lined the street, but they were unable to see the princess because the windows of her

212

carriage were curtained. The carriage drew up to the entrance of the palace. Accompanied by her retinue, the princess entered. In the background a choir sang a haunting melody.

The next day Dita and I were summoned to the palace and decorated with the Spanish Moroccan order of El Wissan al Machdawi.

In February 1951 I photographed another royal wedding, this one of the Shah of Iran to Princess Soraya. I had photographed the shah once before, in May 1945. He was married then to Fawzia, Egyptian King Farouk's sister. She was regal in bearing and very beautiful. They were later divorced because, reportedly, she could not produce a boy; they had one daugher, but only males could succeed to the throne of Iran.

At that time, 1945, the shah was only a figurehead; his father, who had been pro-German during the war, was in exile in South Africa, and Iran was occupied by the Allies: British, Americans, and Russians. I went to the palace accompanied by two young Iranian newsmen. First I photographed the shah with Fawzia and their daughter, then by himself. He suggested one more picture in his study, behind an empty desk against a book-lined wall. That done, I thanked him very politely, shook his hand, and started for the door. Suddenly I sensed that something was wrong. The two Iranians were not following me. I looked around and saw them bowing very low while the shah was heading for the door. I realized my *faux pas*: I should not have turned my back on His Majesty. I stopped at the door and stepped aside to let him go out. Before exiting, he gave me a very dirty look.

When we arrived at the palace the night of the wedding we had to go through a strict security check. The previous year the shah had been shot by a photographer who had a gun concealed in his 4 x 5 Speed Graphic camera. He emptied his gun at the shah, hitting him with every bullet, but causing only superficial wounds. When the photographer finally threw his empty gun at the shah, one of the bodyguards shot and killed him.

Now the young security officer was going carefully through every piece of photographic equipment. Among the correspondents was Flora Lewis of *The New York Times*. She was about seven months pregnant and was wearing an overcoat. The young officer asked her to open it to see what was inside. When she did, he blushed and waved us on.

In contrast to the caliph's Oriental wedding, this was a glamorous, Western-style affair. Bejeweled women were dressed in Dior and Jacques Fath creations; the men's formal wear had been tailored in Paris or Rome. The Iranians, unlike the orthodox Muslims of North Africa, drank alcohol. The champagne flowed freely, and large silver platters of caviar were passed around.

The short and simple marriage ceremony was followed by a banquet. After dinner, Princess Ashraf, the shah's twin sister, asked me if I had got a good picture of the couple. I told her that I had not. She said that I should pick a spot, set up my camera and lights there, and she would have the royal couple pose for me. I set up in one of the small salons off the grand ballroom; Dita Camacho was to help me change flashbulbs. When the shah and Soraya came in I asked them to sit on a small love seat against a beautiful wall tapestry. Suddenly, the shah's mother walked in and squeezed herself in next to her son. I did not want her in the picture; I wanted only the newlyweds. So I asked a nearby palace public relations officer to get the queen mother to move. "Are you crazy?" he responded. "Do you want me to lose my head? Ask her yourself!" I went over to the shah and said that this was a formal portrait of him and his bride. "Would you mind if your mother moved?" I asked. He turned to her and said something in Iranian. She stood up, glared at me, and moved. Later, the public relations man translated for me what the shah told his mother: "Move, mama." He suggested that I stay out of mama's way if I knew what was good for me.

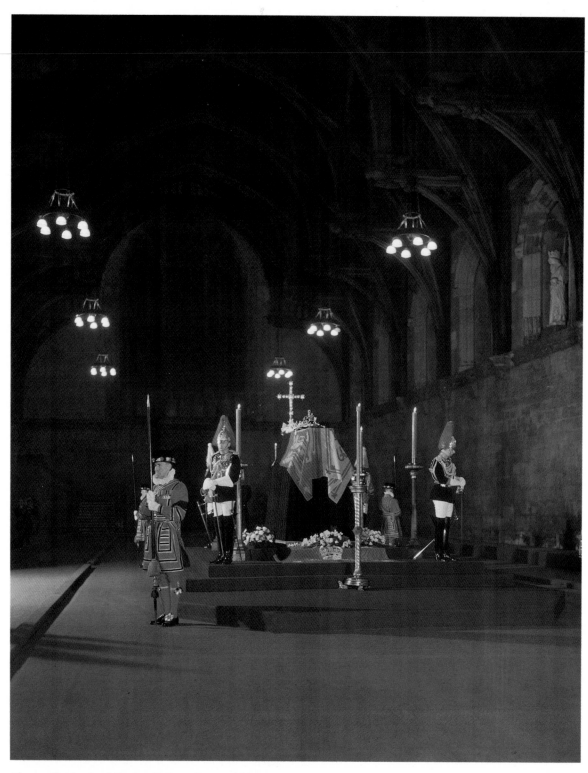

Above: The body of England's King George VI lies in state in
Westminster Hall in February 1952. The coffin is draped in the
colors of the royal standard and attended by Yeomen of the
Guard and members of the Household Cavalry.
Opposite: The coffin bearing the body of Sir Winston Churchill
is borne slowly down the aisle of Saint Paul's Cathedral in his
funeral ceremony in January 1965.

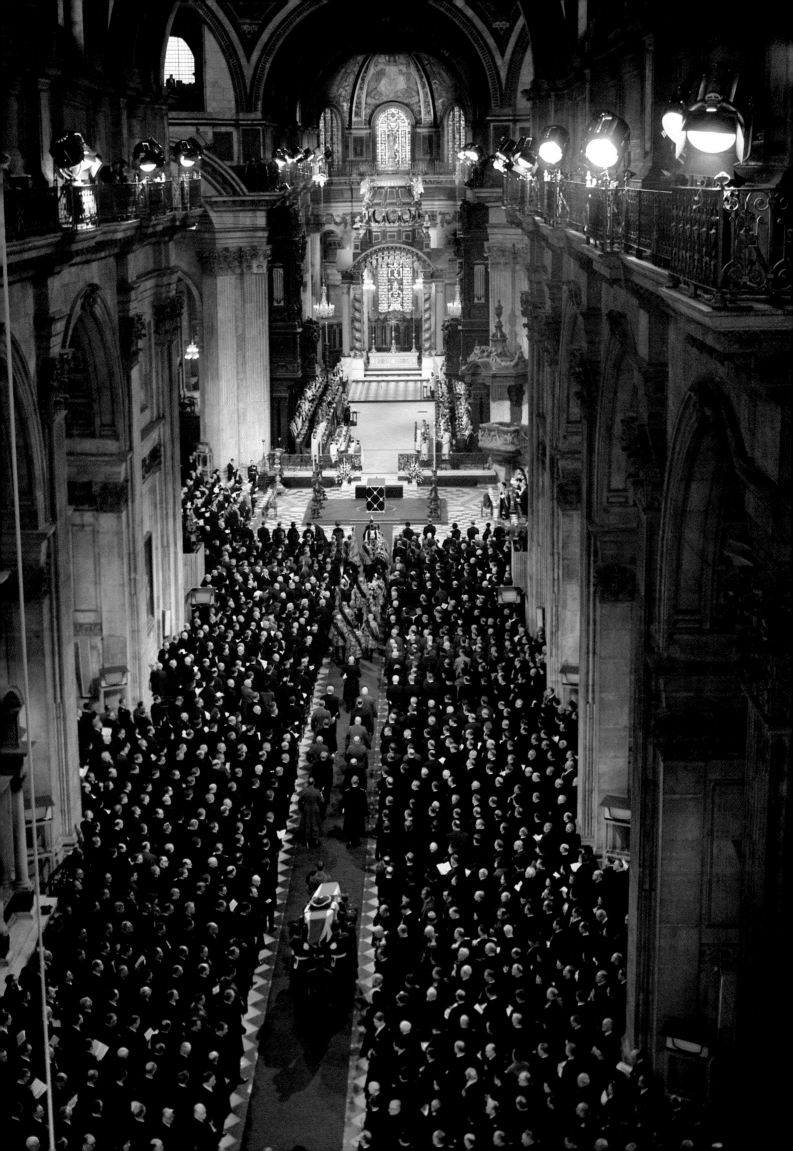

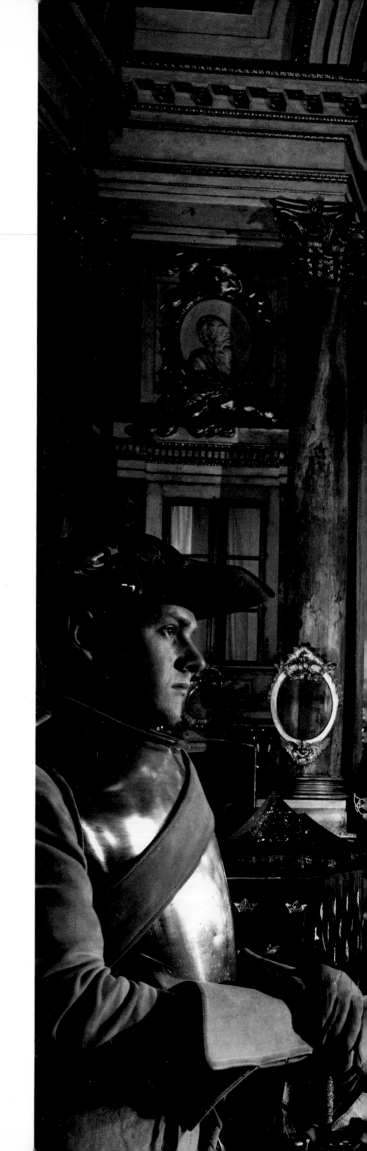

The body of King Gustav V of Sweden lying in state November 1950 in the Royal Palace Chapel in Stockholm. The coffin is draped in a royal mantle adorned with three different crowns— of the Goths, the Swedes, and the Wends.

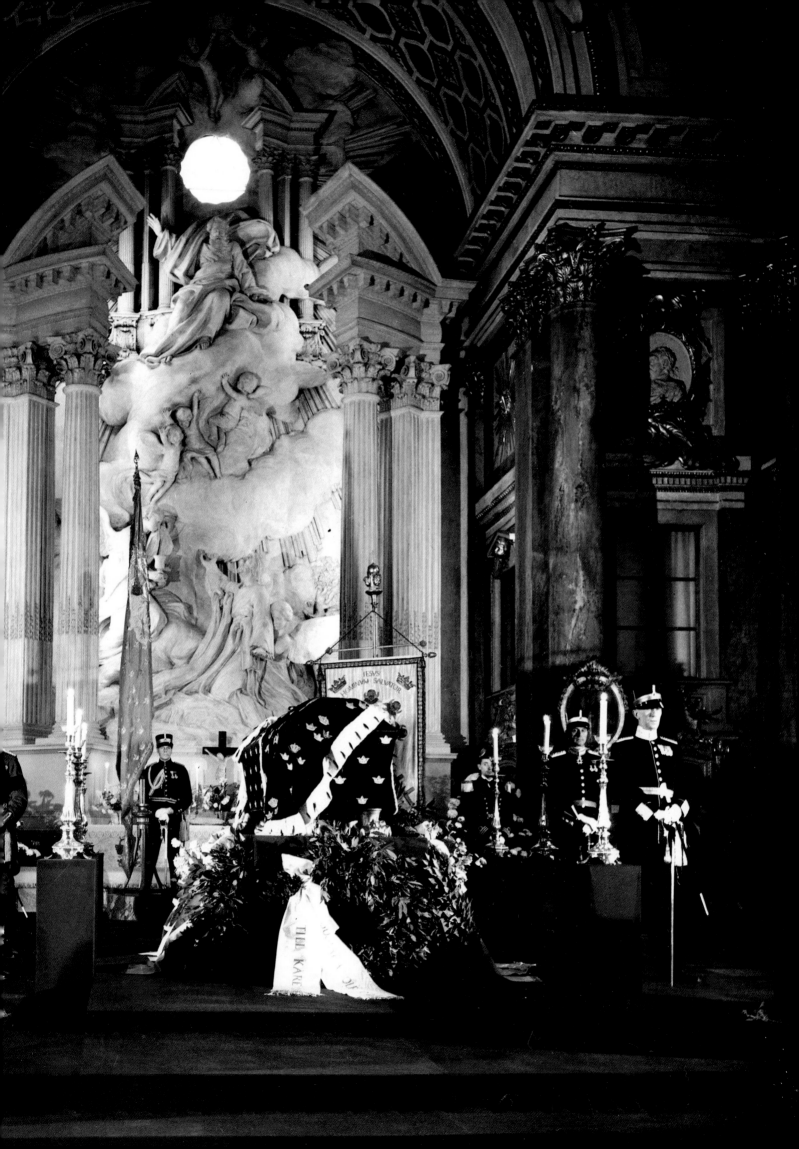

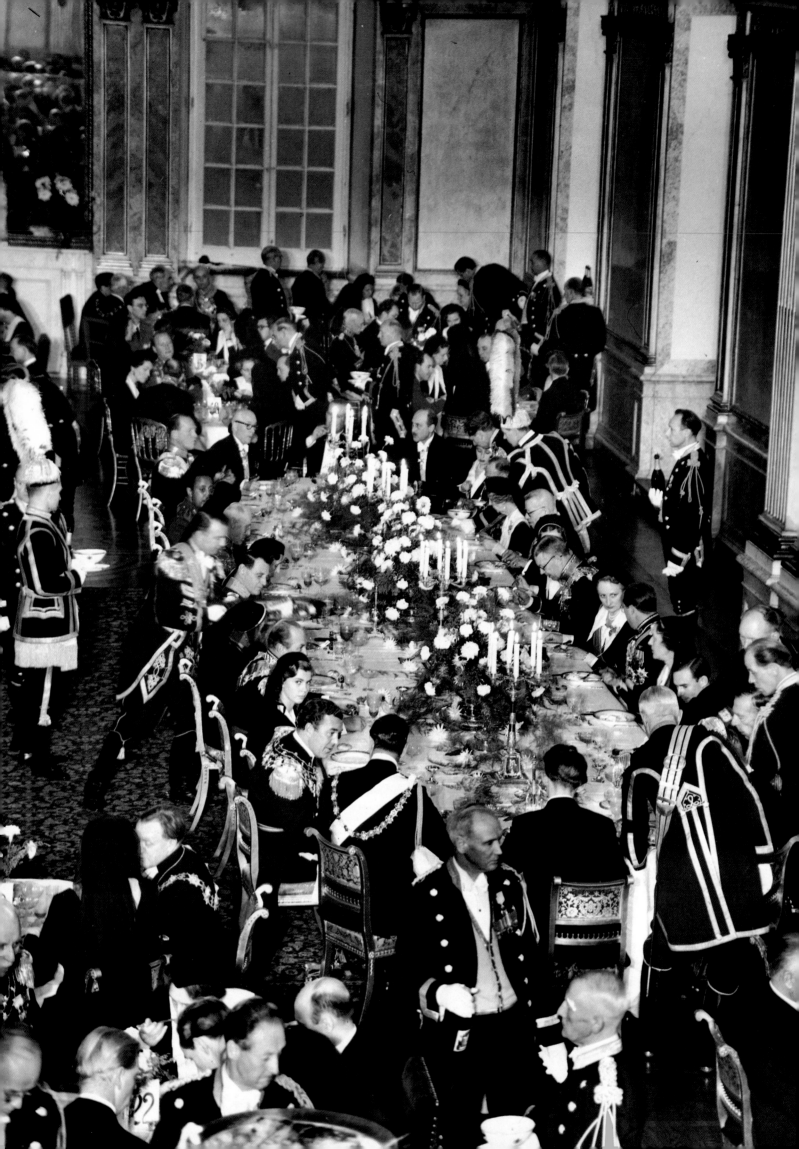

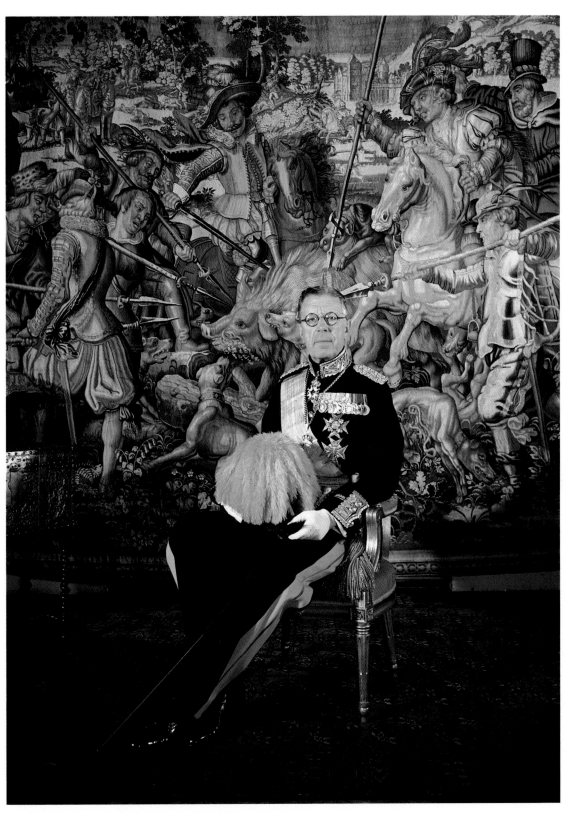

Following the funeral of King Gustav V a reception for royal
guests and chiefs of state—490 in all—was held in the Royal Pal-
ace (opposite). The new king, Gustav VI (also seen above), is
seated center right (in front of the champagne-bearing waiter).

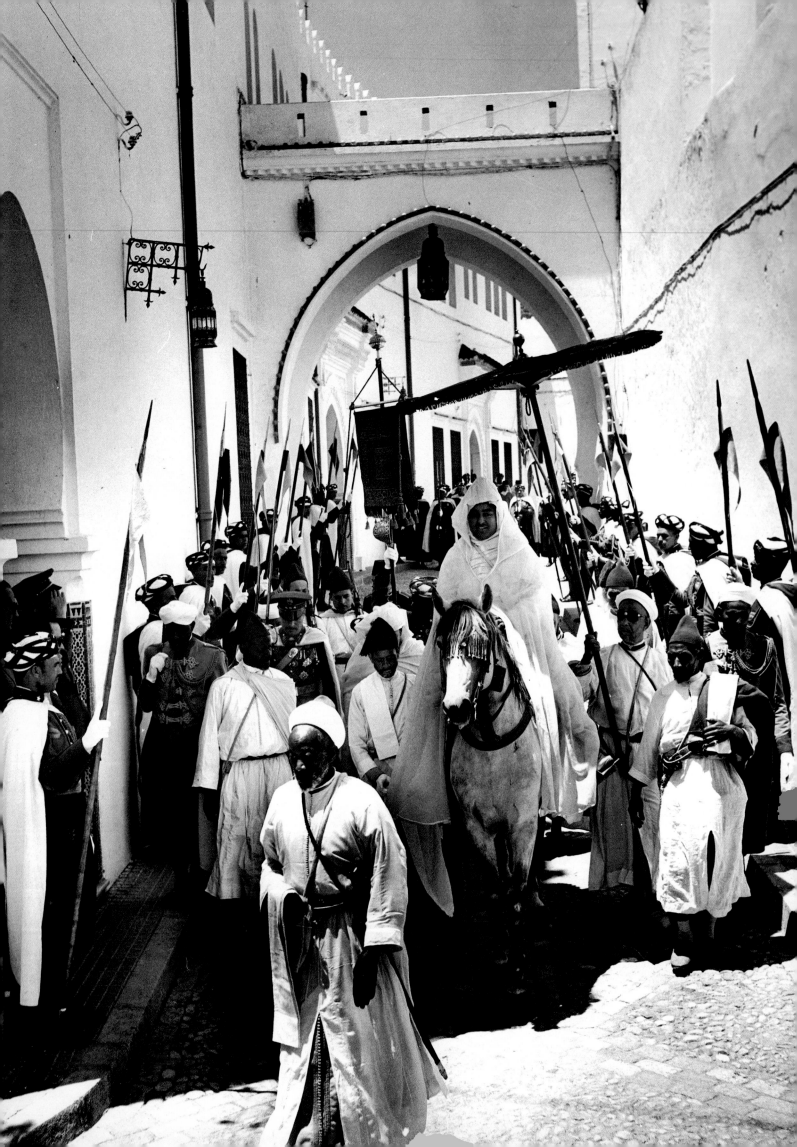

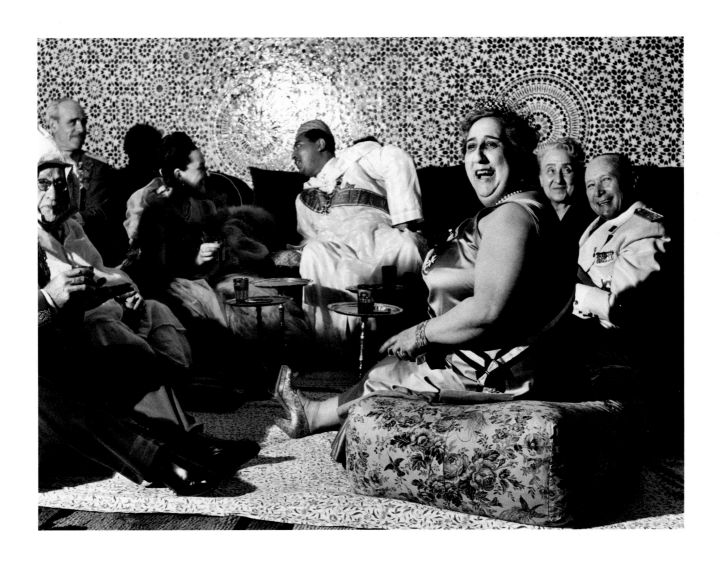

Opposite: The caliph of what used to be Spanish Morocco and his retinue leave the mosque in Tetuán, the capital, prior to his royal marriage in June 1949 to the daughter of the late sultan of French Morocco. Festivities lasted for 21 days, including (above) the wedding feast at the caliph's palace. The caliph was there (in uniform, on the couch, center) but not, as per custom, his bride. In the foreground above is the Dutchess of Monpassier.

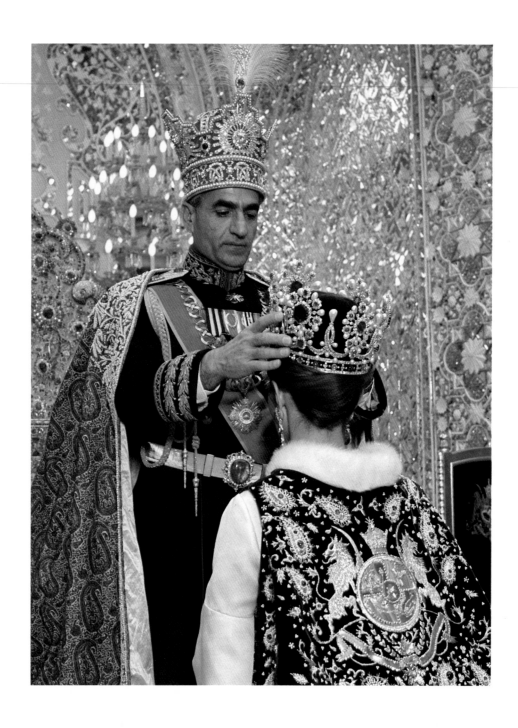

Twenty-six years after he became the Shah of Iran, Mohammed
Pahlavi had his official coronation, on his 47th birthday, in
November 1967.
Above: He crowned his wife, Farah—naming her Empress, the
first in Iran's history—in front of the Peacock Throne in Teheran's
Golestan Palace.
Opposite: Wearing his formal-dress uniform, the shah poses in
the Hall of Mirrors in the Marble Palace.

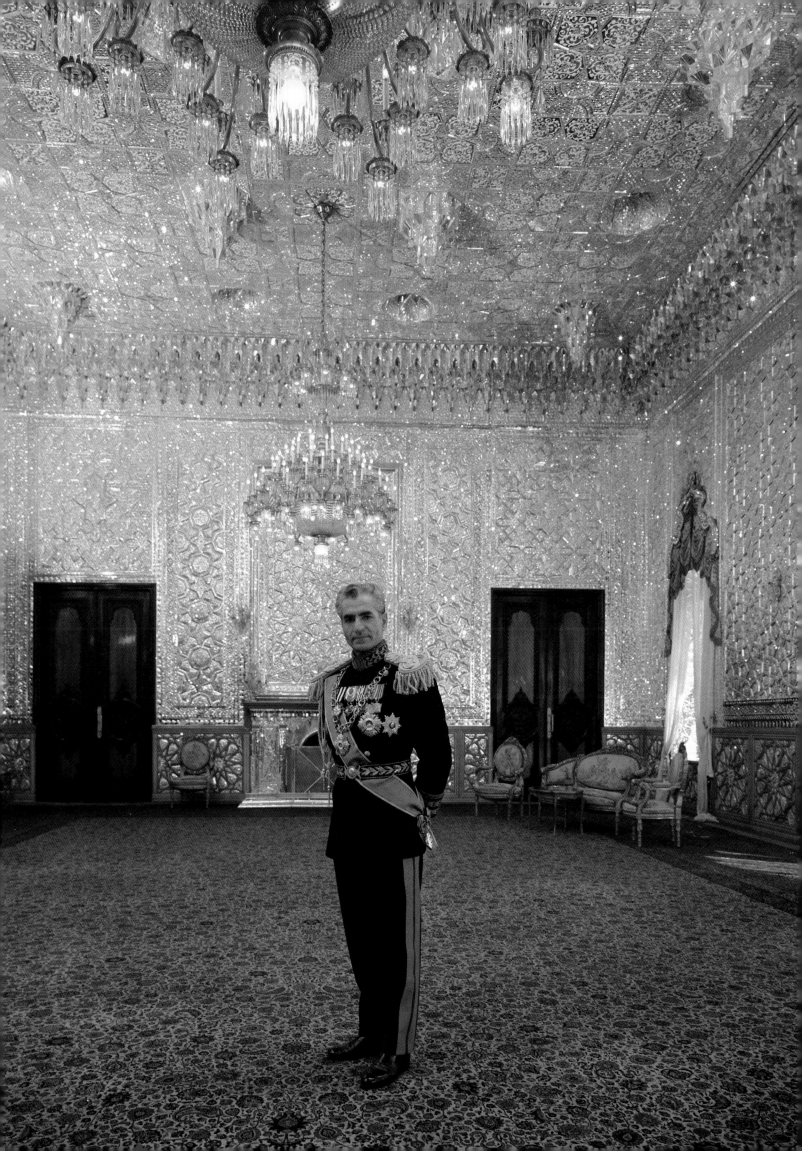

CHAPTER 9:
BERNINI'S ROME

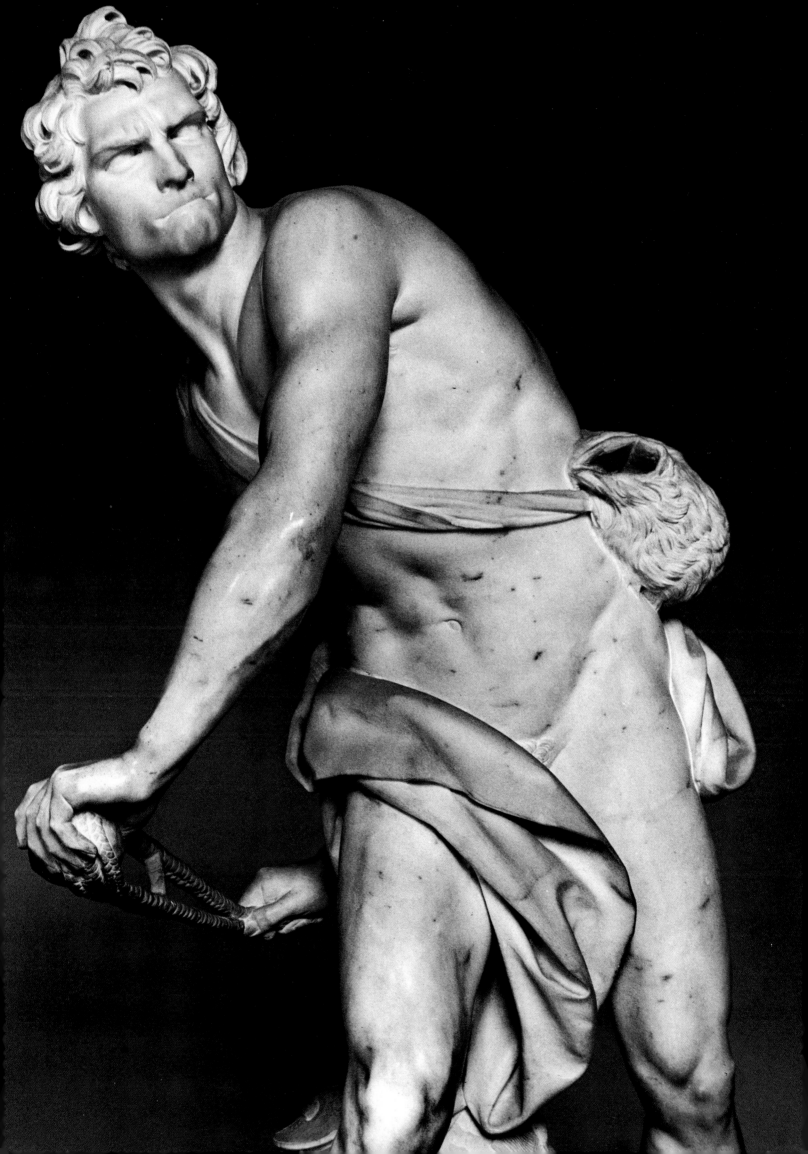

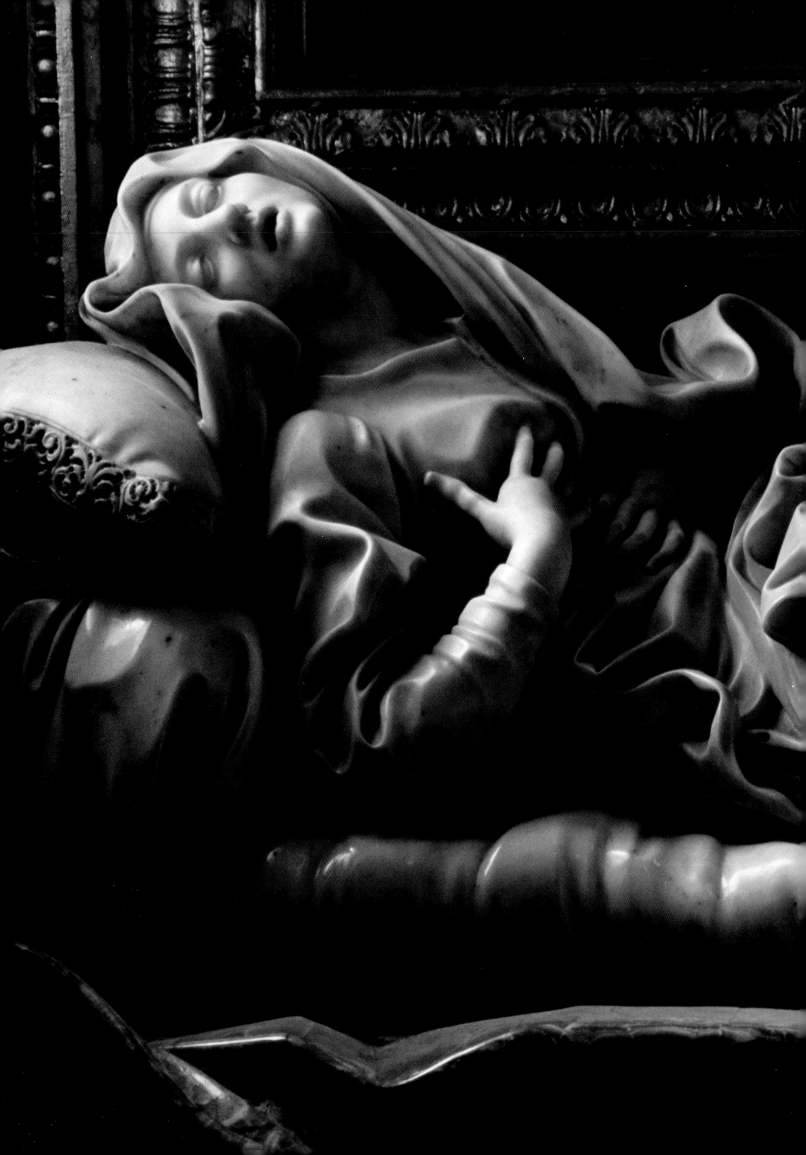

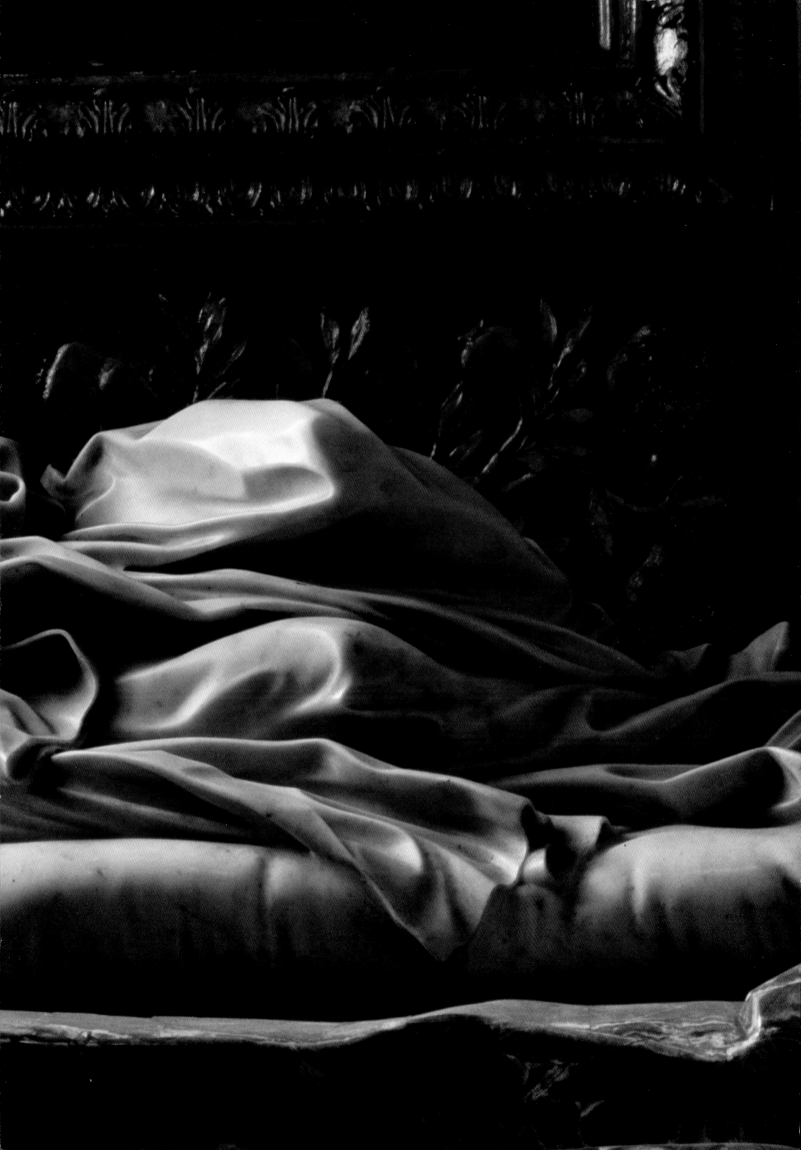

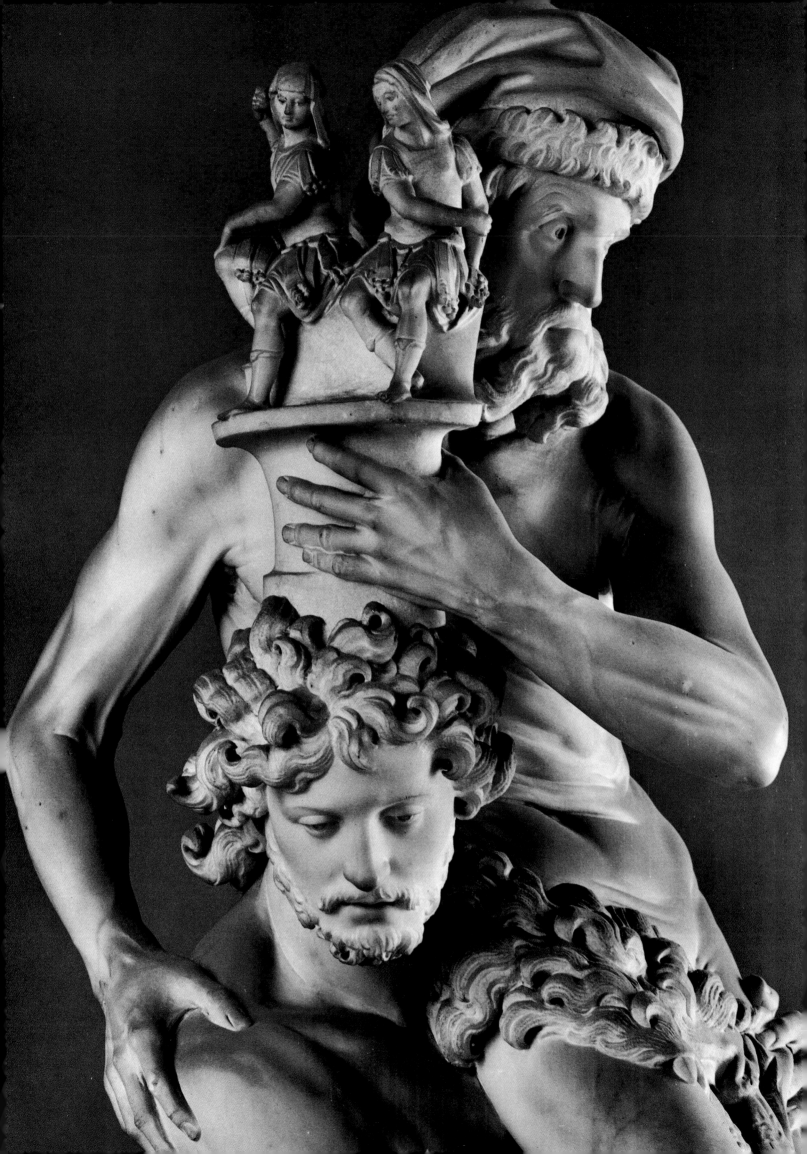

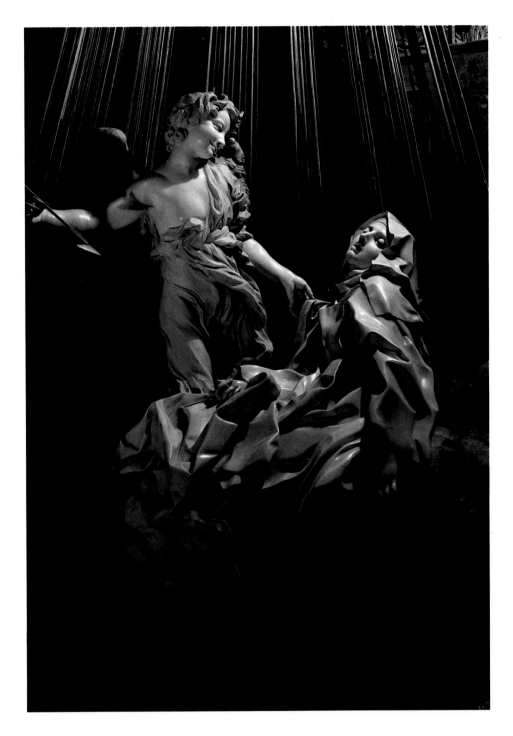

Above: *The Ecstasy of Saint Theresa* (1645–52) in the Cornaro Chapel, Santa Maria della Vittoria church.
Opposite: *Flight from Troy* (1618–19), a very early work depicting Aeneas carrying his father, Anchises, from war-torn Troy. The Borghese Gallery.
Preceding pages: *Death of the Blessed Ludovica Albertoni*, in the Altieri Chapel of the church of San Francesco a Ripa, sculpted in 1674, when Bernini was in his seventies.
Page 225: *David* (1623–24), poised to fling the fatal stone at Goliath. The Borghese Gallery.

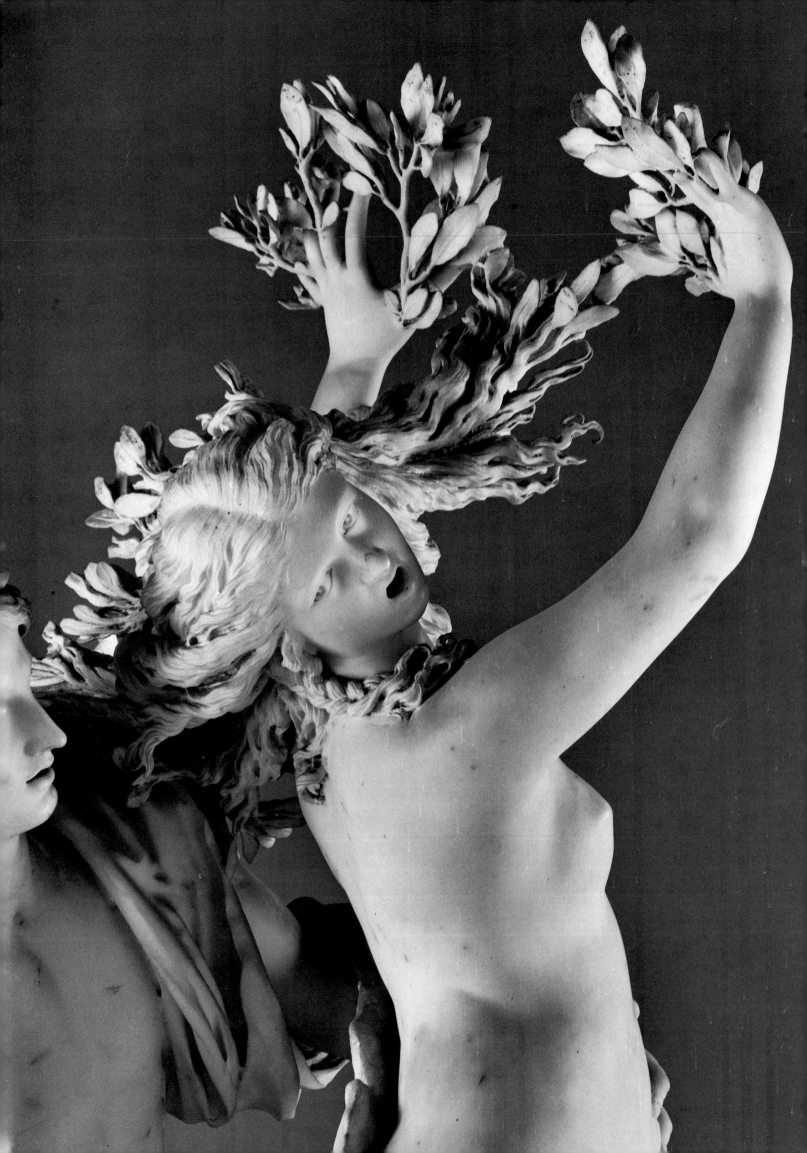

Rome, in one sense, is Gianlorenzo Bernini. The seventeenth-century sculptor-architect, although born in Naples, spent almost all his eighty-one years living and working in Rome. Commissioned by eight successive popes over a period of fifty years, beginning with Urban VIII, his patron and good friend, Bernini's works are visible all over the old sections of the city: in the Piazza Navona, the Fountain of the Four Rivers; in the Piazza Barberini, the Triton Fountain; at the foot of the Spanish Steps, the *Barcaccia* (the Old Boat); at Saint Peter's, the vast colonnade, and inside almost a dozen creations, including the immense bronze canopy, the *Baldacchino,* above Saint Peter's tomb. And the designs of countless other palaces, churches, monuments, and tombs were directly influenced by his overpowering style. If Old Rome seems largely seventeenth-century Baroque, it is because of Bernini.

In April 1962 I received a short memo from Dorothy Seiberling, LIFE's art editor in New York: Let's shoot a color essay on Bernini's Rome. She listed twelve of his works, architecture and sculpture, that she wanted me to photograph. That was it, and off I went.

Photographing sculpture poses only one problem: how to make a marble shape seem alive. But bringing that off is very difficult. Anyone merely looking at a piece of sculpture has the luxury of slowly moving around, letting one's eye move up and down, settling on details, getting the full three-dimensional effect from every angle. A photographer, on the other hand, doesn't have that luxury; he must decide on the single best angle that, with lighting, captures what the sculptor is trying to express.

Bernini made the task easier than most other sculptors. For one thing, wherever possible he placed his sculptures in tight niches or smack against blank walls so that the viewer had to look at them from the one angle Bernini wanted them seen for the fullest

Opposite: *Apollo and Daphne* (1622–25) captures the exact moment, according to the myth, of her transformation into a laurel tree. The Borghese Gallery.

impact. In addition, Bernini had a tremendous sense of drama. (He has been said to have had "the hands of a sculptor and the instincts of a stage designer.") In his sculptural depictions of famous Greek mythological or religious events he would choose the most dramatic moment and then, with extreme realism, carve the intense emotion the subject was feeling into the stone itself. He wanted the viewer to experience the same powerful emotion that the subject—and he, the artist—had experienced. If, at times, the drama pushed over the line into mere theatrics, there were many more instances where Bernini's conception and execution produced the kind of intensity of emotional expression that few sculptors, if any, have ever done better.

Bernini himself showed how to light some of his sculptures. In 1674, when he was in his seventies, he finished a tomb portrait of the Blessed Ludovica Albertoni, a relative of Pope Clement X. It was to be placed in a dark narrow chapel of the church of San Francesco a Ripa. Bernini designed the stagelike setting. Overhead he placed two small hidden windows; they were to provide the only illumination for the sculpture. The window on the left spotlighted her face: eyes shut, mouth slightly open, throat contorted in the agony of death. I wanted to duplicate Bernini's daytime lighting at night. I placed my light at the window on the left directed at Ludovica's face and lit the rest of the tomb with reflected light from the right. (In photographing sculpture I never use direct lighting; instead I bounce light off a white paper screen, thus getting the texture and intricate modeling of the sculpture without interfering shadows.)

I used that same kind of lighting in photographing *The Ecstasy of Saint Teresa* in the Santa Maria della Vittoria church. Teresa de Cepeda Dávila y Ahumada, born in Avila, Spain, in 1515, was a remarkable woman, a Carmelite reformer who is today regarded as one of the greatest saints. The moment in her life that Bernini chose to depict, one of the many visions she reported, was described in

her autobiography: "I saw an angel close by me, on my left side in bodily form. This I was not accustomed to see, unless very rarely. . . . He was not large, but small of stature and most beautiful. . . . I saw in his hand a long spear of gold, and at the iron's point there seemed to be a little fire. He appeared to me to be thrusting it at times into my heart, and to pierce my very entrails; when he drew it out, he seemed to draw them out also, and to leave me all on fire with a great love of God. The pain was so great that it made me moan; and yet so surpassing was the sweetness of this excessive pain, that I could not wish to be rid of it. The soul is satisfied now with nothing less than God."

Bernini's *Saint Teresa* was designed to be placed in a shallow transept and to be illuminated only from overhead. Once again, I merely duplicated Bernini's original theatrical lighting to dramatize the ecstatic expression on Saint Teresa's face, accent the golden rays streaming down, and heighten the marble folds of her robe.

Bernini's desire to capture the climactic moment in a subject's life is shown in other pieces of his sculpture I photographed in black and white on a later assignment. Renaissance sculptors—Donatello, Verrocchio, Michelangelo—had portrayed David, the slayer of Goliath, as a largely inanimate figure, standing there either before or just after having slain the giant. Bernini chose instead to show David at the exact instant he flings the deadly stone. His mouth is tightly pursed and his eyes, turned slightly to the left, are narrowed in concentration and anger. For me, the facial expression was the key to the statue. I wanted to emphasize it. By moving a light, bouncing it off the white paper screen, inch by inch, one can slowly change the expression on a face. I experimented many times before I got the light in what I felt was exactly the right place to bring out the fierce expression.

Bernini's *Flight from Troy* shows Aeneas carrying his father Anchises from Troy after it was put to fire. The realistic expression of

horror in the old man's eyes as he, in a daze, hangs on to a statuette of household gods he has salvaged from the fire is, for me, the most impressive part of the sculpture, and I wanted to highlight it.

In his rendering of the Greek legend of Apollo and Daphne, Bernini catches the moment when the sun god catches the fleeing nymph who then, before your eyes, turns into a laurel tree. Leaves sprout from her fingers, her hair; tree bark begins to grow round her body. It is such a spectacular achievement in sculpting that a photographer need only focus and throw some light on the couple. Bernini has done everything else.

If Bernini's sculptures are relatively easy and fun to photograph well, his architecture is another matter. Saint Peter's Square and the fountains at Piazza Navona had been photographed so many times, by so many photographers, that I felt I had to do something different.

When Bernini designed the colonnades that enclose the piazza of Saint Peter's, he envisioned them as two enormous arms of the Church embracing its children, 250,000 of whom could gather at one time in the piazza below. From previous assignments at the Vatican I was familiar with the best spots from which to shoot various angles. The only place to show the complete circle of Bernini's "arms of the Church" is from a high balcony of Saint Peter's itself. But then neither Saint Peter's nor the Vatican palaces are in the picture; instead, in the background, there are low buildings of the city of Rome sweeping to the south. I had to try a different angle. It meant sacrificing some of the circular sweep of the colonnades, but in compensation it would show all of Saint Peter's Basilica and the Vatican palaces in the background and also give a sense of the height (fifteen feet each) of the ninety-six saints and martyrs that many sculptors, under Bernini's direction, had carved for the top of the colonnades.

I shot my picture from the top of the colonnade at sunrise, using a panoramic camera. The stairway leading there is closed to the

public but we had arranged with the Vatican police to let us in. My assistant and I climbed to the roof at 4:00 A.M. to set up. We then waited for the sunrise. The sun, hidden behind a heavy layer of morning haze, never showed up. We tried again the next two mornings—same thing. On the fourth morning we took some pictures, but I was not happy with them. Finally, on the fifth day, conditions were perfect. I had the picture I wanted, and I was sure that it was different from anything else that had been done before.

Bernini was apparently never completely happy with what he had wrought at the Piazza Navona. He even came to dislike it in his later years. It is reported that when he was being driven through the piazza, he once closed the shutters of his carriage and said, "How ashamed I am to have done so poorly."

Perhaps the fountains are too theatrical. But they are still a very impressive achievement. One huge figure, which Bernini probably intended to be a sea god, looks like a Moor and hence is called *Il Moro*. It is, for Bernini, an unusual piece of sculpture because he designed it to be looked at from all four sides. A freestanding figure, it is the obvious center of any picture to be taken of the fountain.

In those days (1962) vehicular traffic and parking were permitted in the piazza. As a result, no matter what time of day or night one chose to photograph the fountain, there was a clutter of autos, tour buses, and trucks. I was not happy with my picture, which I shot in daylight, but there was little I could do then to improve it.

Seven years later, I got another crack at *Il Moro* and the fountain. Time-Life Books had assigned me to shoot more Bernini for a book they were doing titled *The World of Bernini*. By then all nonofficial cars had been banned from the piazza. I decided to shoot the picture in the evening when there was still some light in the sky, so that the statue and the obelisk behind would be silhouetted. Most of the shops and the apartments were dark; the only light came from streetlights and the regular underwater and side lights of the fountain itself. All I had to do was illuminate *Il Moro* himself. The result was much more dramatic than the photograph I had made in 1962.

Bernini was not my favorite sculptor before I photographed his Rome, and he still isn't. I am in awe, though, of his tremendous technical skill; the profound emotion he conveys, such as the agony of the Blessed Ludovica, the ecstasy of Saint Teresa, and the fury of David, has never failed to move me. Indeed, it has made my own work much easier. But if I could own a major piece of sculpture, I would choose not a Bernini, but something by the great contemporary Swiss sculptor Alberto Giacometti. His sense of humor would be much easier to live with!

Every LIFE assignment was a challenge—often a risk to health and, at times, even to life. But what remains in memory above all is how much fun it was. I count myself fortunate to have been able to enjoy it all over such a long period of time. In fact, if I had my life to live over again, I would still choose to live it as a LIFE photographer—"an agent for special missions."

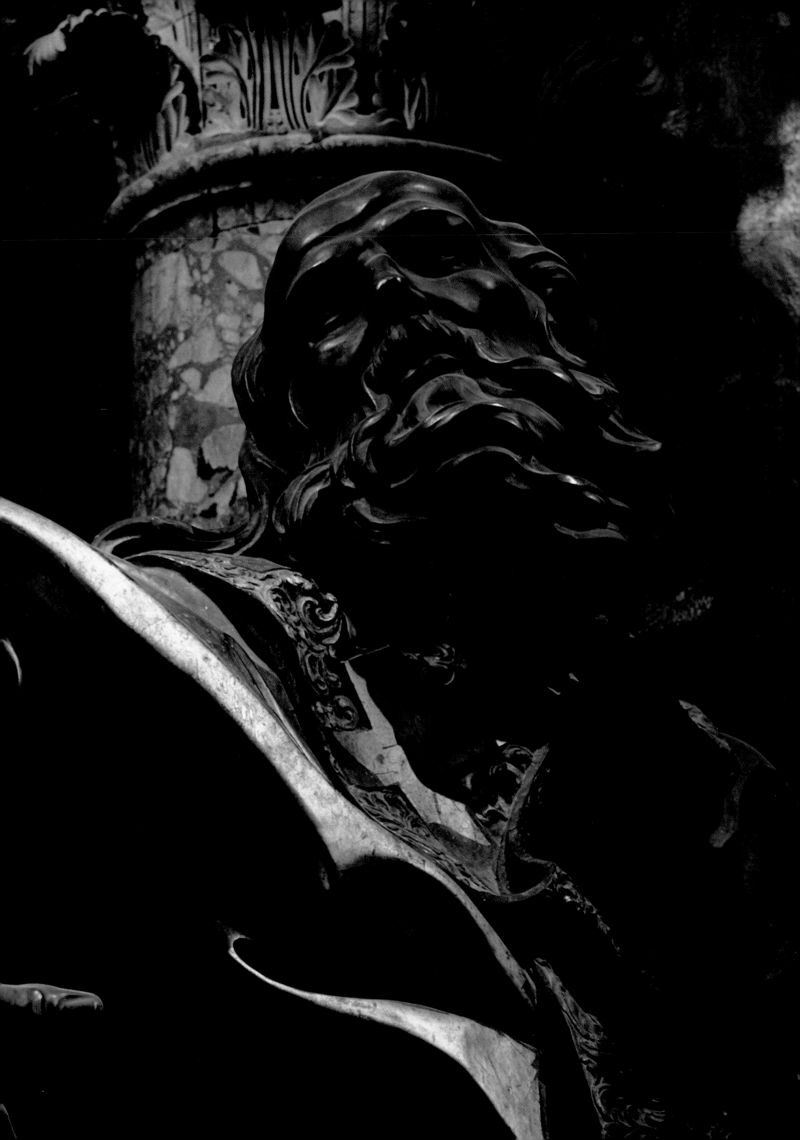

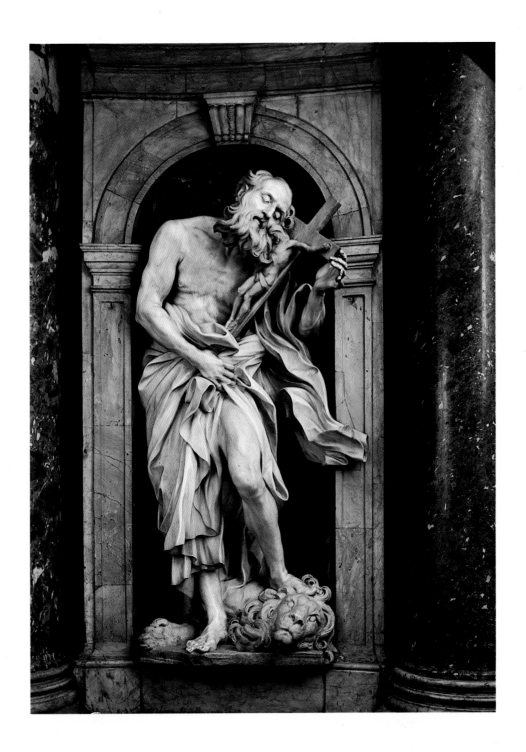

Above: *Saint Jerome* (1661–63) in the Chigi Chapel, Cathedral
of Siena.
Opposite: *Saint Athanasius, Guardian of Doctrine* (1657–66), one
of four bronze statues beneath the *Cathedra Petri*—the Chair of
Peter—in St. Peter's Basilica.
Overleaf: The fountains in Piazza Navona; *Il Moro*, center.

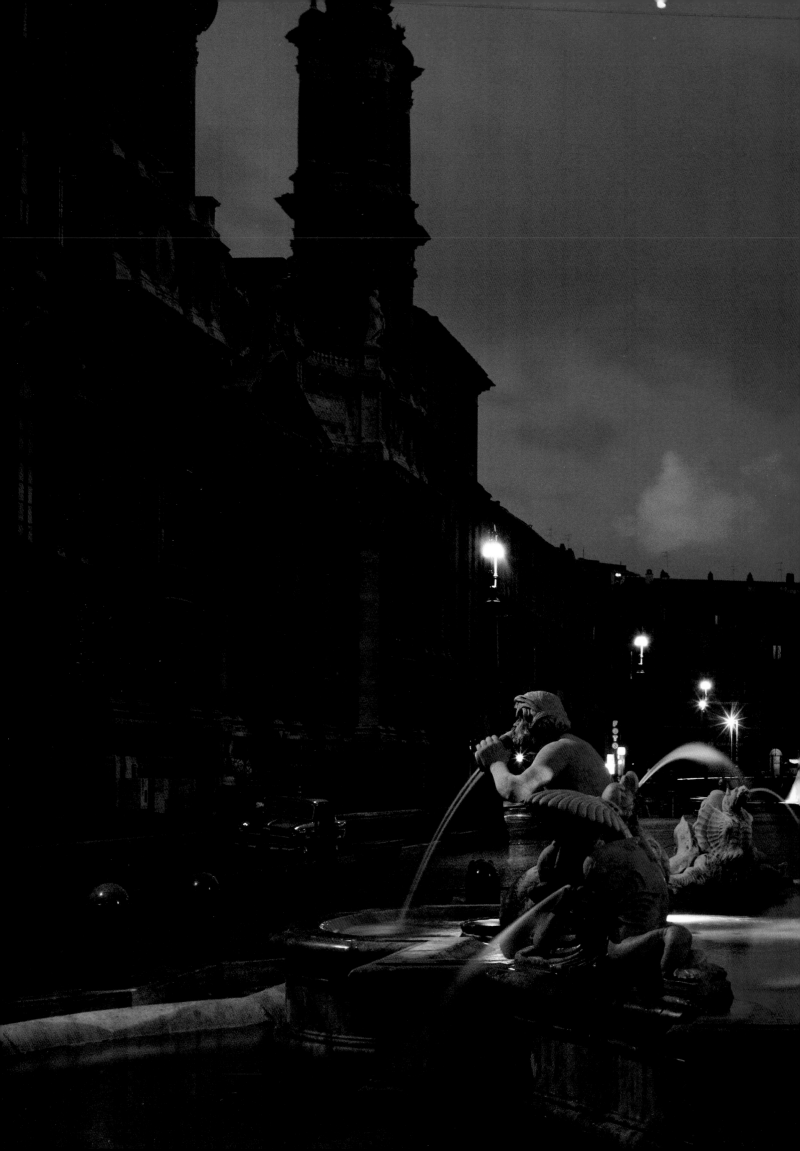

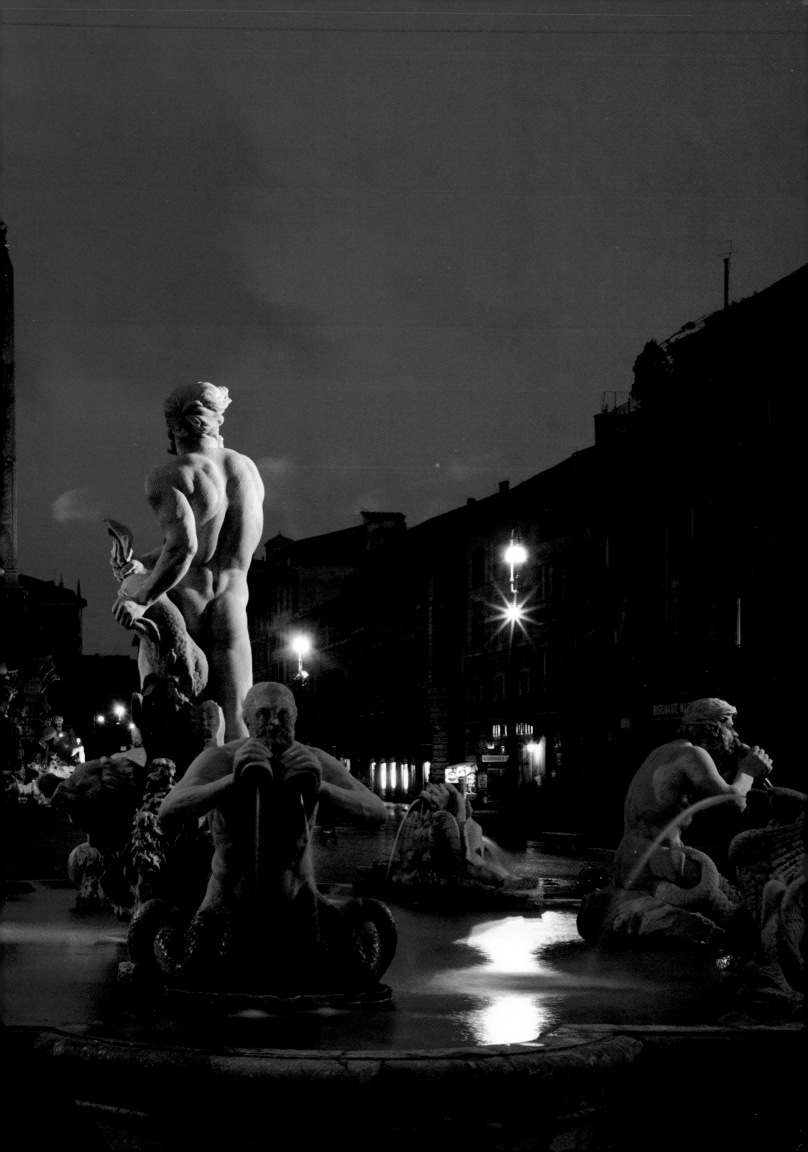

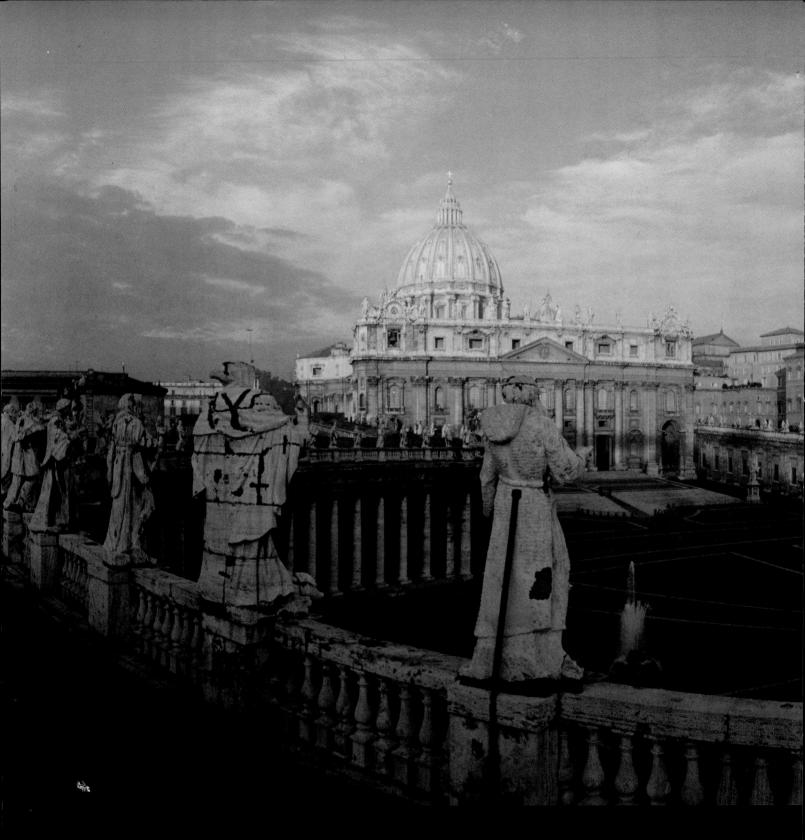

Saint Peter's Square as seen from the southeastern balustrade. In
the foreground are a few of the 96 statues of saints and martyrs
that look down, open-armed, onto the square.

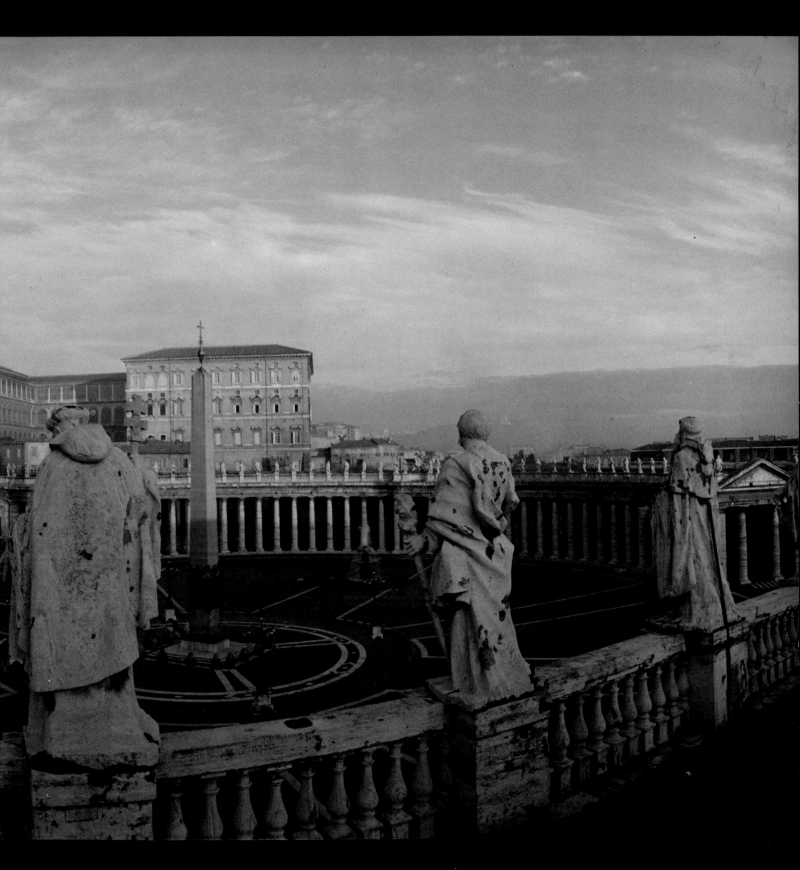

Overleaf: A multitude of gilt bronze angels and cherubs strain to reach out to the dove of the Holy Spirit painted on the window in *The Gloria*, above and behind the *Cathedra Petri* in Saint Peter's.

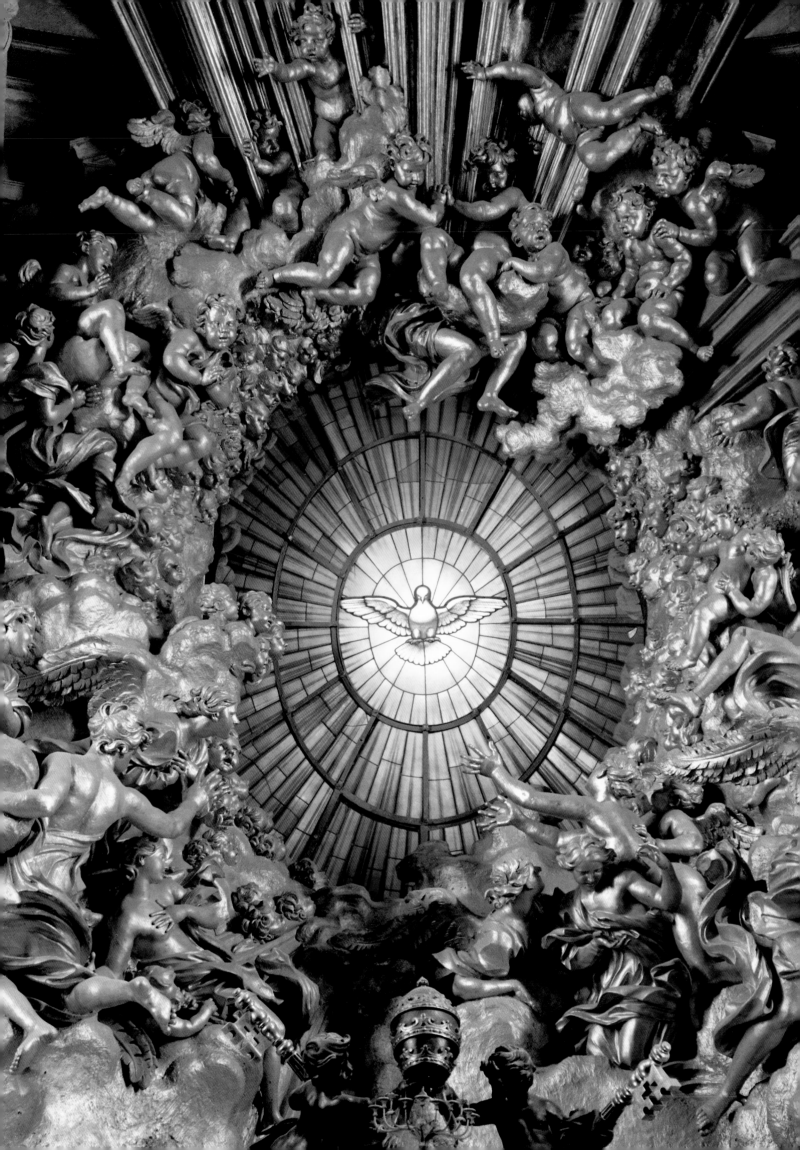